THE
Viking Isles

TRAVELS IN ORKNEY
AND SHETLAND

Paul Murton

BIRLINN

Title page: Burning of the galley at the
Up Helly Aa festival, Lerwick.

First published in 2019 by
Birlinn Limited
West Newington House
10 Newington Road
Edinburgh
EH9 1QS

www.birlinn.co.uk

Copyright © Paul Murton 2019

The moral right of Paul Murton to be identified
as the author of this work has been asserted by
him in accordance with the Copyright, Designs
and Patents Act 1988

All rights reserved. No part of this publication
may be reproduced, stored or transmitted in
any form without the express written
permission of the publisher

ISBN: 978 1 78027 580 2

British Library Cataloguing-in-Publication Data
A catalogue record for this book is available
from the British Library

Designed and typeset by Mark Blackadder

Printed and bound by PNB, Latvia

CONTENTS

Introduction vii

Part 1: Shetland

Introduction 3

1. South Mainland and the Southern Isles 7
 Sumburgh Head, Lerwick, Scalloway, Walls, Sandness,
 Mousa, Noss, Bressay

2. North Mainland 45
 Mavis Grind, Hillswick, Ronas Voe, Isbister, Whalsay, Muckle Roe

3. Island Outliers 71
 Foula, Fair Isle, Papa Stour, Out Skerries

4. The North Isles 99
 Yell, Fetlar, Unst

Part 2: Orkney

Introduction 125

5. Mainland 129
 Deerness, Kirkwall, West Mainland, Stromness

6. Northern Archipelago 155
 Shapinsay, Egilsay, Wyre, Rousay, Stronsay, Auskerry, Papa Stronsay,
 Sanday, North Ronaldsay, Eday, Westray, Papa Westray

7. Around Scapa Flow 201
 South Ronaldsay, Lamb Holm, Hoy, Flotta, Stroma

Further Reading 225
Index 226
Picture credits 231

INTRODUCTION

I have felt the call of the Northern Isles – Orkney and Shetland – since childhood. I'm not sure why they've had this fascination for me, but perhaps it has something to do with my father's Norwegian background. When I was a boy, he introduced me to the delights of the higher latitudes. Sailing with him among the islands of Norway's fjord-riven west coast or tramping the snowfields of the Hardangervidda in spring were experiences that put me in touch with nature and the unique quality of northern air and northern light.

When I was a teenager, I hitch-hiked and travelled through arctic Norway and Sweden, but our own Scottish 'far north' remained a mystery. As the years went by, the desire to visit grew stronger and stronger, but it wasn't until I was in my 30s that work in television enabled me to travel to Orkney for the first time, to film a sequence about ancient human bones with an archaeologist in a laboratory. As soon as we had finished, I seized the opportunity to spend the rest of the day seeing as much of Orkney as I could. And I was impressed. The scenery was completely different from Norway's west coast, of course, but there was something in the air – a chill in the breeze, the big skies and wide horizons that was the same. And then came the link back to Norway: in the town of Kirkwall I was surprised to see the Norwegian sail-training ship *Statsraad Lehmkuhl* berthed down at the quay. She was a familiar sight to me – I had seen her many times before in Norway during those early visits. She was from Bergen – my father's home town.

Since then, over the years work and leisure have enabled me to explore both Orkney and Shetland in depth, often with a copy of the Victorian *Black's Picturesque Guide to Scotland* in my rucksack. This book was once a family treasure and was kept in the glove compartment of our car whenever we went on holiday in. Sadly, my father and I never travelled as far the Northern Isles together, but using *Black's* as a reference kept him – and those family holidays from years before – alive in my mind.

This book of my travels in the Viking Isles is necessarily a personal one and is dedicated to the memory of my father and his northern soul.

Paul Murton
August 2019

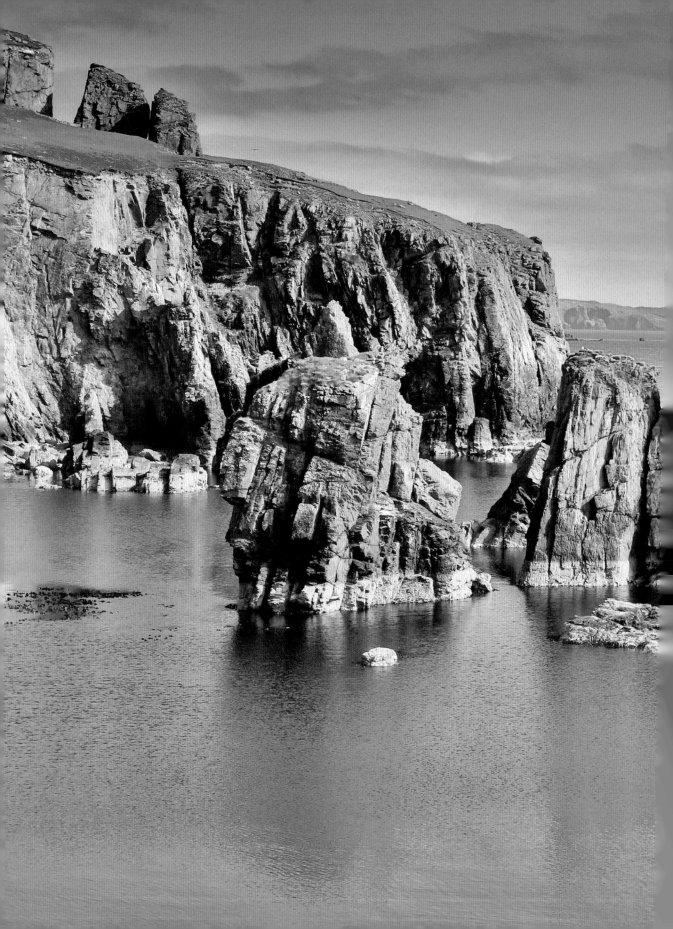

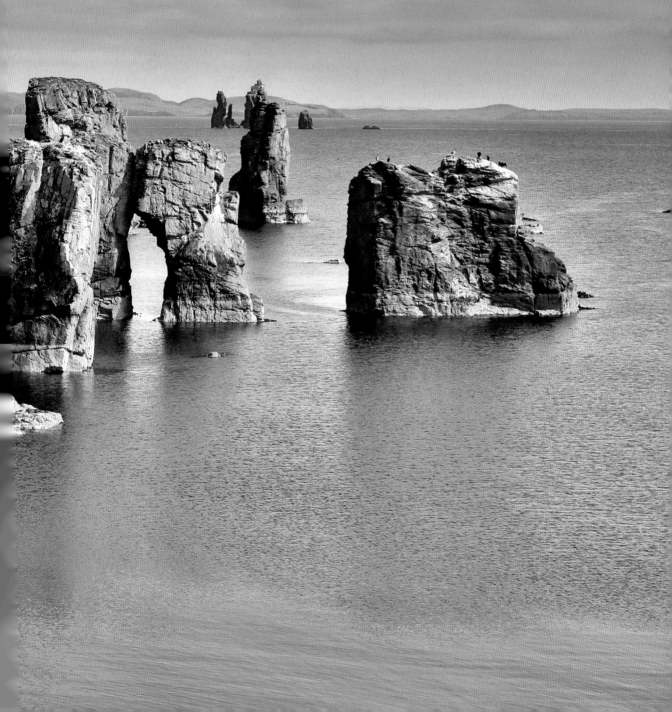

PART ONE SHETLAND

Muckle Flugga Out Stack
Hermaness
Haroldswick
Unst
Baltasound
Uyeasound
Gloup
Uyea
Gutcher
Fetlar
Vord Hill △
Mid Yell
Yell
Funzie
Yell Sound
Burravoe
Ronas Hill △
Ronas
Northmavine
Out Skerries
Eshaness
Stenness
Hillswick
Sullom Voe
Whalsay
Dore Holm
Isbister
The Drongs
Symbister
St Magnus Bay
Mavis Grind
Muckle Roe
M a i n l a n d
Papa Stour
Sandness
Walls
Bressay
Noup of Noss
Maryfield National Nature Reserve
Da Kame △
Da Sneug
Scalloway Lerwick *Noss*
Foula
Muckle Hell △
Ward of Bressay
Broch of Mousa
Mousa
St Ninian's Isle
Croft House Museum
Fitful Head
Jarlshof
Sumburgh Head

North Haven
Fair Isle

0 2 4 6 8 10 Miles
0 2 4 6 8 10 Kilometres

INTRODUCTION

Shetland – or the Shetland Isles – is often described as the most northerly outpost of the British Isles, a distinction which can give the impression of a bleak, subarctic remoteness. But, for the 22,500 or so people who live there, the islands are home. And, as anyone who has been there will tell you, Shetland is a well-connected place of surprising and rugged beauty, with a history to capture the imagination. True, the weather can be wild, the summers short and the winters ferocious, but there is a warmth among the people which counters even the most challenging days. And, for anyone who thinks that island people are insular, prepare to revise your preconceptions. Shetlanders are amongst the most outgoing folk in the whole of the UK, despite being branded as remote. However, geographic reality can't be denied. Shetlanders live a long way from the rest of Scotland – and it's further than you might think. There has been a long cartographic tradition of including the island group, along with Orkney, in a box at the top right-hand corner of the UK map. This makes Shetland look closer than it really is, which is perhaps why few people in Britain appreciate how far north Shetland is from the mainland and how its geographical position has shaped the character of both the landscape and the people.

Shetland has a history of human settlement going back at least 5,000 years. Although evidence of earlier human occupation may have been lost to rising sea levels, fine examples of Neolithic,

Chapter opening: Eshaness.

Bronze Age and Iron Age artefacts and structures have survived across the archipelago, which consists of 35 islands over 40 hectares and dozens of stacks and rocky skerries strung out along a deeply indented coastline of bays, known as *wicks*, and arms of the sea, known as *voes*. The most southerly point of the main island of Shetland is Sumburgh Head. From here, the nearest point on the Scottish mainland is Dunnet Head in Caithness, lying 166 kilometres across the sea to the south-east. Edinburgh is more than 450 kilometres away to the south as the crow flies. But Bergen in Norway is much closer – a mere 366 kilometres across the sea to the east. And it's the proximity and influence of this Nordic neighbour that has helped give Shetland its unique identity. Invaders from Norway poured into Shetland from the about AD 800, obliterating the native Pictish culture. What happened to the original inhabitants is a matter of much speculation. Were they driven out of the islands completely, displaced to poorer land as some place names suggest, or were they absorbed by intermarriage with the invading Vikings, whose culture reigned supreme for six centuries? Today the Norse legacy lives on just beneath the surface and is perhaps most noticeable in Shetland place names and the dialect of the islands, which both derive from Norn – the old language of the Vikings whose deep-rooted culture has survived in various guises. Norn was still spoken in parts of Shetland up until the 18th century and a recent genetic survey has shown that 60 per cent of Shetland men can trace their

ancestry back to a western Norwegian lineage. From a personal point of view, it was this Scandinavian connection that first drew me to the islands.

Shetland has always had a place in my heart and in my imagination. My father, who lived for many years in Bergen, Norway, used to sail along the Norwegian coast for pleasure in his old wooden gaff-rigged fishing boat called *Blid*. During the school holidays, he would take his sons for trips to explore the myriad rocky islands close to Bergen that form a sort of marine labyrinth of narrow channels and rocky skerries covered in heather and juniper. As summer days turned slowly into the magical half-light of midsummer nights, we'd moor *Blid* alongside an uninhabited rocky island and clamber ashore. After making a campfire, we'd grill freshly caught mackerel and talk about seafaring and the heroic age of the Vikings. Beyond the horizon, a mere 182 nautical miles to the west, lay the Shetland Islands. For centuries, they were firmly part of the Viking world and an integral part of Norse culture. The archipelago was a hub for all the maritime traffic heading west from Norway. Longships making for the Faeroes, Iceland or Greenland sailed first to Shetland or *Hjaltland* as it was known to the writers of the Icelandic sagas. Vikings, sailing between Norway, its colonies in the Hebrides and around the Irish Sea, would also stop over in Shetland. The islands were at a crossroads of the western Nordic world and occupied a pivotal trading and cultural position within it. A thousand years later, as we watched the sun disappear over the northern horizon in a halo of golden light, Shetland still seemed part of that lost world, despite being annexed by the Scottish crown in 1472. This happened after the marriage of James III of Scotland and Margaret of Denmark when the islands

were pawned to raise money for a dowry. Although sovereignty was lost to Scotland in the 15th century, many Norwegians continued to regard Shetland as essentially part of their world – and still do. As a teenager sitting with my father in the half-light on our rocky skerry, this seemed entirely natural. Accordingly, we made plans to sail one year to discover the Viking connection for ourselves.

Sadly, I never made that trip with my father. But, years afterwards, just months before my father died, I eventually fulfilled my dream to follow in the wake of the Viking longships. In June 2012, I joined a Norwegian crew on board the yacht *Hawthorne* for the annual yacht race from Bergen to Lerwick. Over 40 yachts gathered at the entrance to *Hjeltefjord* or 'Shetland's Fjord'. A weathered lighthouse perched on the rocky summit of the surf-fringed island of Marstein served as the starting line. Leaving the Norwegian coast and heading due west, we watched a spectacular sunset as the flotilla of yachts gradually dispersed on the surface of the shimmering sea. Some 30 sleepless hours later, we caught our first glimpse of Shetland on the horizon – the great wedge-shaped cliffs of Noss, rising proudly from a churning sea of white-capped waves, just as they must have appeared to Viking navigators over a thousand years ago – and, to greet us, the unforgettable sight of a pod of killer whales. We rushed to the side of the boat to get a better view as they raced past. There were about a dozen of them, their backs breaking through the sea surge, the sound of their snorting breath mingling with the cries of gulls wheeling overhead. It was a truly primal moment that seemed to put us in direct touch with the Vikings of old. Unfortunately, we were brought back to reality with a bump – almost

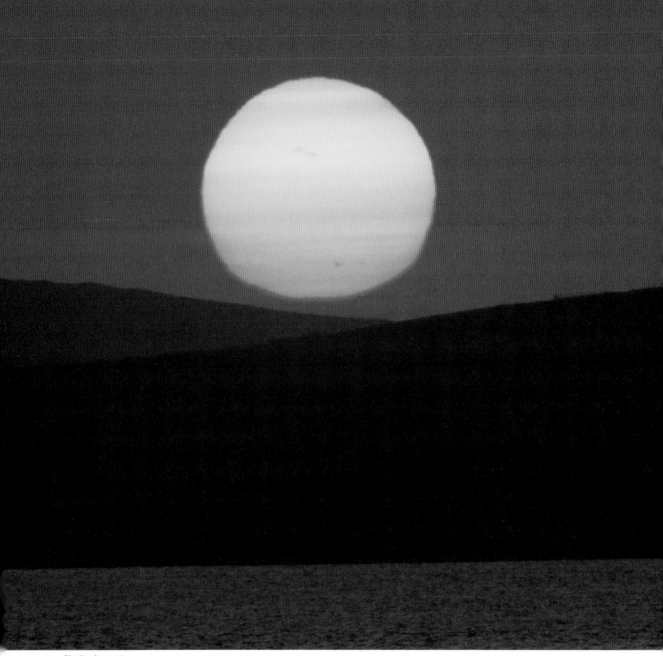

Shetland sunset.

literally. A few moments later, *Hawthorne* was involved in a near collision with another yacht from Bergen. Angry words and Viking expletives were exchanged as we forced the other competitor to change course. The following morning, bleary-eyed after a night of celebration, we were summoned to appear before the race committee. We were told that we'd broken the rules of the road and were disqualified – a disgraceful episode, surely? Yes. But, since we were already last in our class, this seemed, at the time, a less humiliating and more Viking-like outcome!

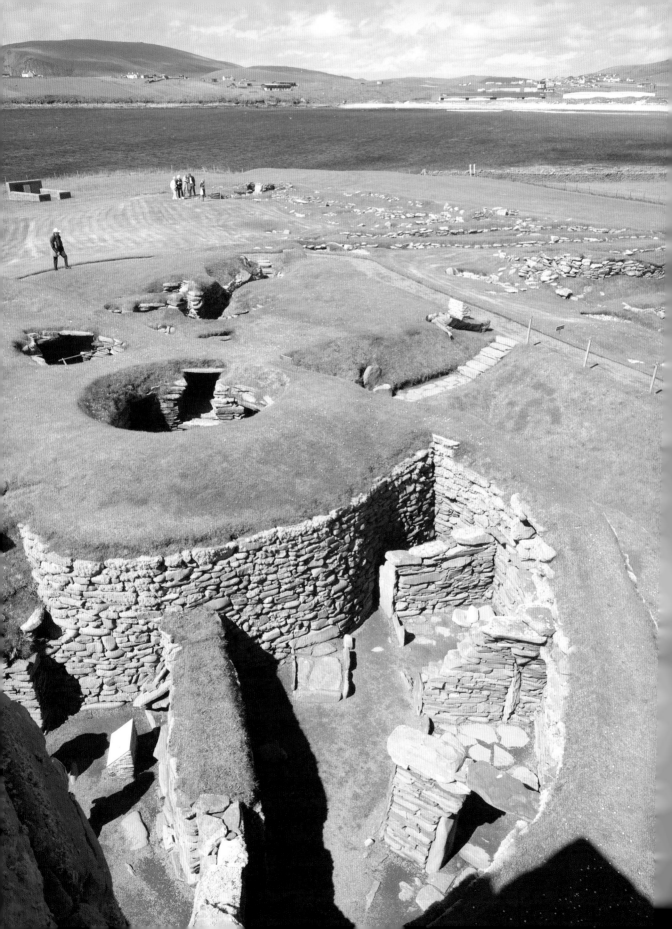

SOUTH MAINLAND AND THE SOUTHERN ISLES

Sumburgh Head, Lerwick, Scalloway, Walls, Sandness, Mousa, Noss, Bressay

SUMBURGH HEAD

The biggest of the Shetland Isles is also the fifth largest of the British Isles. It has a population of nearly 19,000 and is known as Mainland, which can be confusing in conversation. When a Shetlander says he or she is going to the Mainland, they invariably mean they are travelling to the largest island in the archipelago – and not mainland Britain, which is usually referred to as either Scotland or England, as the case may be. But Mainland has had other names. I have an old map in the house which calls the main island Zetland. In fact, Zetland was an alternative name for Shetland for many years and, until local government reorganisation in the 1970s, the island administration based in the capital Lerwick was known as Zetland Council. Apparently, the confusion is due to the written Scots version of *Hjaltland* – the old Viking name for the islands. The first two letters of *Hjaltland* sounded the same to 15th-century Scots ears as the old Scots letter yogh, which is written thus – ʒ. In this way, *Hjaltland* became *ʒetland* and finally Zetland.

Sumburgh Head marks the most southerly point of Mainland and is often the first glimpse

Opposite. The historic settlement of Jarlshof, near Sumburgh.

air passengers have of Shetland as their plane makes its final approach towards Sumburgh Airport. Sometimes this can be an alarming experience. The first time I flew into Sumburgh, the weather was appalling. The cloud base was not much higher than the cliffs and the twin-prop plane was bouncing around like a runaway tractor on a badly rutted field. Glancing out of the window, I saw Sumburgh Head Lighthouse through a squall of rain. I gave an involuntarily gasp as we banked steeply to line up on the runway. We were now clearly lower than the lighthouse and the cliffs and, for a moment, I was convinced that we were going to crash, which of course we didn't. Bumpy landings in poor visibility are par for the course in this part of the world and Sumburgh Head is a formidable place whatever the weather.

Sumburgh Head is home to Shetland's oldest lighthouse, which is perched 87 metres above wild seas on a narrow finger of cliff-girt land. Built to a design by Robert Stevenson, the grandfather of author Robert Louis Stevenson, it has braved the ferocious elements since 1821 and has witnessed a sad litany of shipwrecks and tragedy down the years, including the story of the *Royal Victoria*, which was on her way to India with a cargo of

coal when she sank in a freezing storm in January 1864. Although 19 souls were saved, Captain Leslie and 13 others perished. He and five of his crew are buried in the parish church of Dunrossness. Inside the humble church, there's a bell which was donated by the captain's grieving parents. For many years, it hung outside the lighthouse where it served as a fog warning until a foghorn was installed in 1906.

In more recent times, Sumburgh Head bore witness to an environmental disaster when the Liberian-registered oil tanker *Braer* lost power and ran aground in hurricane-force winds on 5 January 1993. The ship was on its way from Norway to Canada with over 85,000 tonnes of crude oil, which poured into the sea when its tanks ruptured. According to the World Wildlife Fund, at least 1,500 seabirds and up to a quarter of the local seal population died. There were fears at the time that *Braer*'s spilt cargo would result in an environmental catastrophe similar to the one caused by the *Exxon Valdez* when she ran aground in Alaska four years earlier. When I visited Sumburgh in 2004, I spoke to an eyewitness who remembers standing on the cliffs at the height of the storm.

'You could smell the oil before you could see it,' he said, grimacing at the memory. 'The stench filled the air and made you feel sick. The storm-force winds and churning seas were turning the oil into an aerosol and blowing inland. We thought it would contaminate the whole island. And the oil slick was also threatening the entire coastal ecosystem of Shetland. *Braer* was carrying twice as much oil as the *Exxon Valdez* and we feared the worst. Salmon farmers and fishermen thought their livelihoods would be destroyed for a generation.'

But, in fact, the strength of the wind and the violence of the seas were a saving grace and quickly helped to disperse the oil – a light variety of crude that was more easily broken down. As a result, there is no evidence at Sumburgh today of Shetland's worst environmental disaster, although broken sections of the giant wreck still lie at the bottom of nearby Quendale Bay.

Thankfully, Sumburgh Head has been restored to nature. Although the lighthouse is no longer manned, it is still operated by the Northern Lighthouse Board and forms the centrepiece of a visitor centre and nature reserve. The awe-inspiring cliffs are home to thousands of breeding seabirds whose raucous numbers make it an internationally important site. The reserve, run by the RSPB, is home to one of the most accessible seabird colonies to be found anywhere in the British Isles and, in the past, I have been lucky enough to spend many hours watching the ever-changing scene from the cliffs. Perched in a sheltered nook, framed by sea pinks and high above the waves, I have been enthralled by the avian dramas unfolding hourly – gannets returning from fishing expeditions are attacked by ruthless and piratical skuas to give up their catch, guillemots encouraging their chicks to take their first plunge from high ledges into the waves below and, of course, the endlessly fascinating antics of puffins, which seem close enough to touch.

Just over a kilometre down the road from the lighthouse and overlooking the sheltered waters of Sumburgh Voe is the historically fascinating site of Jarlshof. Jarlshof might sound authentically Shetland, with echoes of a heroic Nordic past, but, in fact, it's a fictitious name, which was made up by the great romantic writer Sir Walter Scott. In 1814, Scott joined his friend the lighthouse engineer Robert Stevenson on a voyage to survey sites for

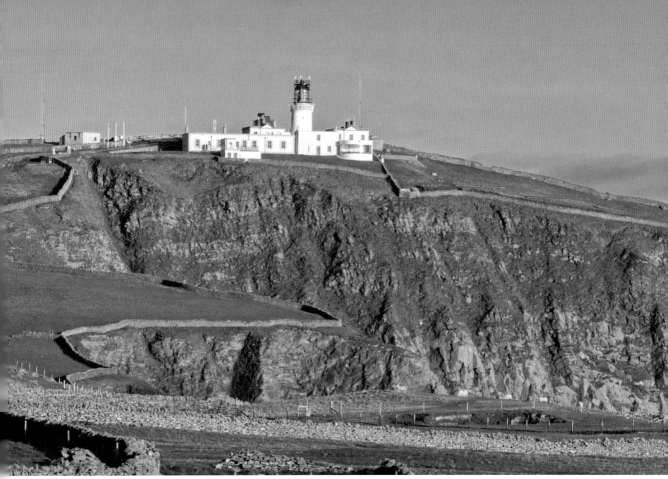

Sumburgh Head lighthouse.

future lighthouses. Scott's creative imagination was inspired by his experience of the Northern Isles – the drama of the scenery, residual Norse culture and tales of an 18th-century local pirate John Gow (who actually came from Orkney). Returning home, Scott wove these disparate elements into a thrilling tale which he published in 1822 as the novel *The Pirate*. In the book, Scott gave the local laird's house the fanciful Norse name of *Jarlshof*, which translates as 'Earl's House'. With the publication of his novel, fiction became fact and the laird's ruined house, which had been abandoned since the 17th-century, has been known as Jarlshof ever since.

However, there is much more to the site at Jarlshof than Scott could have ever imagined. Some

60 years after his death, a series of violent storms eroded the land surrounding the old ruin revealing the remains of several ancient buildings which together have a history of continual human habitation going back to the Stone Age.

When I visited Jarlshof for the first time, I was shown around by local man Douglas Smith, who surprised me with a Norwegian greeting, '*Hei, hvordan går det?*', to which I naturally replied, '*Bare bra, takk!*' just to show off. It turned out that Douglas is a keen linguist and, during the summer months, often guides Scandinavian tourists around Shetland's more popular historic destinations. The salutations over, we reverted to English as Douglas took me for a wander through the complex jumble of ruins that represent several

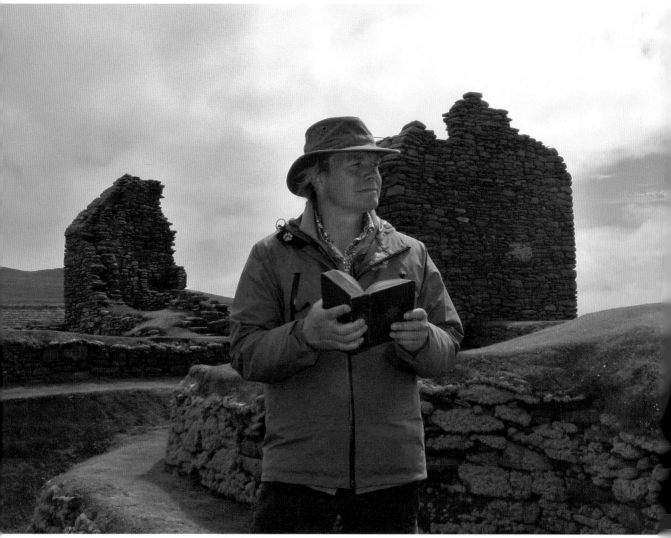

At the ruins of Jarlshof with my copy of *Black's Picturesque Guide to Scotland*.

distinct eras of human occupation. The earliest fragmentary remains date from approximately 4,700 years ago. More substantial are the Bronze Age dwellings, including a Bronze Age smithy. The next layer is the most complete and belongs to the Iron Age. Some of the houses from this period are connected by narrow underground tunnels called souterrains, which I found somewhat damp and claustrophobic. There is also the base of a broch – or defensive tower – from a later period, along with four wonderfully preserved 2,000-year-old wheel houses, so called because the domestic chambers radiate from a central area, like the spokes of a wheel. When a wheel house

was occupied the whole structure would have been sunk into the ground so that, to modern eyes versed in the works of J. R. R. Tolkien, it would have looked rather like a prototype hobbit burrow.

I was especially keen to see the Viking remains which have been discovered at Jarlshof. They date from about AD 850 and form part of a farming settlement. The longhouse at the centre is clearly visible and would have been occupied for up to 16 generations until about AD 1200 when a new farm and outbuildings were constructed close by. I was curious to know what present-day Scandinavian visitors make of these ruins.

Douglas chuckled. 'The Norwegians say that only seasick Vikings settled here in Shetland. The real Vikings went further west to Iceland and beyond!'

I wanted to know if Douglas felt a connection to the Viking past. 'Oh, it's our heritage. A lot of us Shetlanders feel a bit Norwegian – part Viking. I know I certainly do. And I must be a real Viking. I've never been seasick in my life!'

The island of Mainland is pinched into a narrow neck of land just over 200 metres wide at Jarlshof, which overlooks the waters of Wester Voe and the Ness of Burgi with its Iron Age fort. Around Jarlshof, the land between the two coasts is almost entirely taken up by runways of Sumburgh Airport. The road north actually crosses the runway and traffic has to be stopped whenever an aircraft takes off or lands.

Making my way around the southern end of the airfield, I came to the little village of Grutness, from where the ferry to Fair Isle leaves. There isn't much to Grutness these days, but in 1886 this quiet corner of Shetland was caught up in the blaze of publicity that surrounded Betty Mouat and the amazing story of her Norwegian adventures. Betty

was a 59-year-old spinster who lived with her half-brother and his wife in a croft at nearby Scatness. Like many women in the district, Betty made a living knitting garments and shawls, which she sold to various shops in Lerwick. In January 1886, she packed a creel full of woollen shawls that she and her neighbours had made and set sail for Lerwick on board the cutter *Columbine*. The crew consisted of the 36-year-old skipper James Jamison and two deck hands. Betty was the only passenger when the *Columbine* left Grutness and headed out to sea in a rising wind. Half an hour later, disaster struck. Skipper Jamison was knocked overboard. The two crew immediately launched a dingy but failed to save the drowning man. The shock at losing their captain was immediately compounded when they realised that the *Columbine* had sailed unaided beyond their reach. Despite rowing heroically as fast as they could, the distance between them and the *Columbine* increased with every oar stroke. Realising they would never catch her, the men returned to the shore. Meanwhile, the *Columbine* sailed on with Betty Mouat. Darkness fell. The wind increased to a full gale. In such bad weather, people on the shore assumed that the *Columbine* would come to grief without a crew but on she sailed. Betty hunkered down in the passenger cabin, clinging on like grim death as the little ship was tossed around in mountainous seas. Her only provisions were two biscuits and a quarter pint of milk. For eight days and eight nights she endured until, miraculously, the *Columbine* drifted through a maze of rocks and skerries to run aground on a beach below the cliffs of the Norwegian island of Lepsøya just 10 kilometres north of the fishing port of Ålesund. After being rescued by friendly islanders, news of her ordeal and salvation spread around the world, being

reported in newspapers from London to New York. Betty could have become a celebrity but turned down tempting offers to appear in public. Queen Victoria was so impressed with her story that she sent her a cheque for £20. Preferring the quiet life, Betty returned with her shawls to her half-brother's croft at Scatness, where she lived until she died in 1918 at the ripe old age of 93. Betty's story is told by T. M. Y. Manson in *Drifting Alone to Norway*.

Dominating the views west across Quendale Bay are the awesome and spectacular cliffs of Fitful Head, a wonderfully evocative and appropriate name for a place of great desolation and beauty. Fitful actually derives from the Old Norse *hvit fugla* or 'white fowl'. It's not surprising that Sir Walter Scott was impressed when he saw the cliffs, which rise over 280 metres above the wildly surging seas. Inspired by their grandeur, he incorporated them in his fictional tale *The Pirate*, making the heights of Fitful Head home to the witch Norna, whose cave was still being pointed out to sceptical tourists in the 20th century. For the author, Norna represented the Old Norse world of the Vikings which, at the time of the narrative, was being supplanted by the new order of rule by Scottish lairds. Scott often drew on real places and characters in his fiction and this is true of the witch Norna, who is based on a well-known Orcadian woman called Bessie Millie (see also p. 149). Bessie was famous for her weather spells and sold fair winds to superstitious sailors for sixpence a time in a cloth bag. Apparently, she did a roaring trade in wind!

To experience Fitful Head and its associated winds, it's worth taking the time to make a 9-kilometre circuit from the beautifully restored Quendale water mill, up a roughly tarmacked road towards the summit, where a white golf ball-shaped radar station perches on the cliff tops. With magnificent views along the coast to the north and across Quendale Bay and its rocky islands to the south-east, the route follows the vertigo-inducing heights back to the mill. But watch out for nesting bonxies – the Shetland name for the great skua. When disturbed, bonxies will take off menacingly and immediately start to dive-bomb any intruder. Carry a stick and hold it above your head if you don't want to lose your hat and your dignity.

Heading up the A970, the main route north from Sumburgh, I was keen to visit the Croft House Museum at Dunrossness which is just south of the small village of Boddam. The original buildings are situated above the voe and offer a glimpse into the world of crofting life in Shetland during the 19th century. In the past, Shetlanders were often described as fishermen who also farmed. In effect, this meant that the man of the household spent a good deal of his time at sea fishing or perhaps spending even longer periods away from home on board one of the many whaling ships that ventured into the wild North Atlantic. While the man of the croft was away, the women and children did most of the agricultural work.

The Croft House Museum is a great place to explore. It comprises two parallel rows of single-storey stone buildings. A thatched roof is held in place with a weighted net. For successive generations, right up until the late 1960s, this simple structure was home to an extended family and their animals. It was also where much of the business of farming was carried out.

Accommodation for the family was provided by just two rooms. The main room or 'but end' was the heart of the household. Here food was

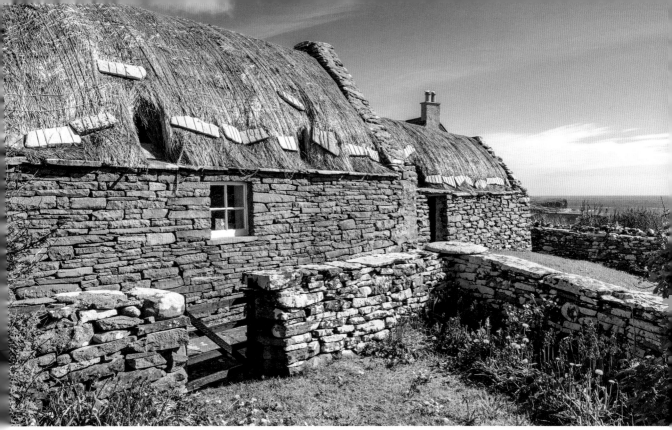

Croft House Museum at Dunrossness.

cooked over a peat fire and fish hung to dry and cure in the smoke. A large box bed still takes up much of one corner of the room. Apparently, it could get quite crowded in there, so despite having curtains to keep out inevitable drafts, there wasn't much privacy to be had. It makes you wonder how intimacy could ever have been possible. But they must have managed. Shetland families tended to be very large. It must have something to do with the long winter nights! The second room – the 'ben' of this 'but and ben' home – was the main sleeping area. Again it has a box bed, cots and another bed. I was fascinated to discover that much of the furniture was made from driftwood that had been collected from the shore. Crofters had to be ingenious as well as self-sufficient. The living quarters of the croft are linked to the byre where the family kept their cattle. This in turn leads through to the rear part of the building,

which is divided into a stable and a barn. At the back of the barn is a stone corn-drying kiln. The entire complex was designed to withstand the worst of Shetland weather and to enable the occupants to move around inside from area to area without having to brave the elements.

Edward Charlton, a medical student from England made several visits to Shetland in the 19th century. In 1834, he vividly described the interior of a house not dissimilar to the croft at Boddam:

> We bowed low to enter to save our heads from encountering the doorway. In true Norse fashion the entry was through the byre, steaming and redolent of all but sweets and from thence we were ushered into the hall of dais, into the sanctum of the edifice. The 'riggin' was above our heads, but a bare riggin we could not term

that which was incrusted with at least three inches of soot. Chimney of course, there was none. An opening in the centre of the roof immediately above the fire allowed the egress of smoke and admitted light enough to see one's way in the apartment. Around the fire were arranged soft seats of turf for the family, and above them were piled chests, skin coats, dried fish etc. in endless confusion.

Set about 200 metres closer to the coast and a short distance from the Croft House Museum is the horizontal water mill. Once common in Scandinavia, Scotland and Ireland, the design of this traditional type of mill changed very little over the centuries. It was built to maximise the power of relatively small streams and didn't require elaborate engineering. Simplicity was key to its success. A wheel consisting of a set of paddles was positioned horizontally into the flow of water, which ran beneath the whole structure. A shaft from the water wheel drove the millstones above, which were housed in a stone-built building not much bigger than a garden shed. Such mills were built and run by a family or small village for their own use. Larger mills were usually owned by the laird who charged a fee for milling grain, holding back a proportion of flour as payment. To ensure they got a decent return, landlords began to insist that estates mills be used, making life more difficult for the tenants. Gradually, many small mills fell into enforced redundancy.

Heading up the east coast, I came to the parish of Cunningsburgh. According to my copy of *Black's Guide to Scotland* published in 1886, the inhabitants of this part of Shetland once had an unenviable reputation. 'For long they have laboured under the stigma of being the most morose and inhospitable in Shetland. When a guest outstays his welcome, he is bidden to depart with these words "Mirk in the ljora; light in the ling, time that the guest be gone".' Apparently this meant that, if was dark in the smoke vent and there was light outside on the heather, then it was time to make yourself scarce. However, my old guidebook doesn't explain why the good people of Cunningsburgh became so inhospitable – if ever they were. I'm happy to report that, a century and a half later, I met no one in the parish who was anything other than a model of hospitality.

The first time I came to this stretch of coast, I was chasing killer whales. I was part of a documentary film crew and we had just landed at Sumburgh Airport. Our wildlife researcher had been in contact with local whale watchers who'd reported that a pod of orcas had been spotted heading up the coast towards the island of Mousa. We jumped in our hire cars and sped towards the waters of Mousa Sound. On the beach above the jetty at Sandsayre, we stared out to sea. One of the crew spotted something. The cameraman focussed his powerful telescopic lens in the direction being indicated. 'It's a pod of orca – no question,' he said emphatically. For us now, the question was how to get closer. Then, almost miraculously, a local man tapped me on the shoulder and said, 'I can get you out there if you want. I've got a boat big enough for filming.' Minutes later and having only been on Shetland an hour, we were alongside the pod of orca. There was a dominant male, with a two-metre dorsal fin, several females and their calves. We were so close I could have touched them. I could hear their rasping breath when they surfaced. It was a primal, awe-inspiring 'wildlife' moment but there was

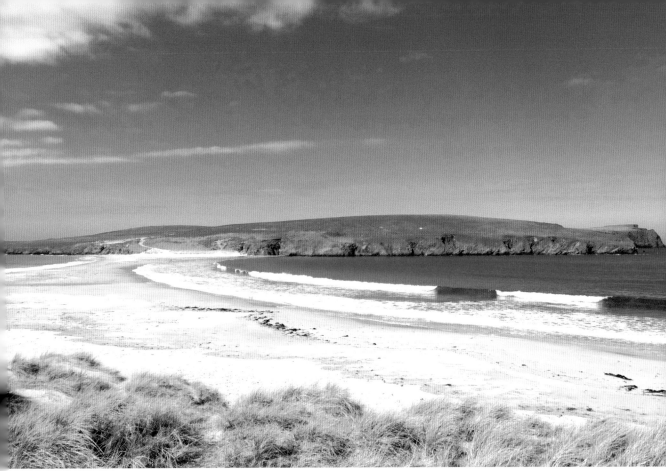

St Ninian's Isle, often described as Shetland's finest beach.

something fearsome and deadly about their presence. They are supreme predators and were probably hunting seals as they headed south down Mousa Sound. These great beasts, which few people realise come so close to our shores, command respect.

Following a zigzagging route north, I headed west again, passing the Loch of Spiggie. The wonderful name of this small body of water apparently derives from an old Scandinavian word for the stickleback fish which I suppose still live in its waters. The Loch of Spiggie and the neighbouring Loch of Brow are both freshwater lochs and, because of the abundance of plants, fish and wildlife that thrive there, they have been designated as a Sites of Special Scientific Interest and Special Protection Areas. Loch Spiggie is also an important overwintering destination for migrating whooper swans which arrive every autumn from Iceland. The Loch of Spiggie is cut off from the sea by a narrow band of dunes which separate it from the beautiful shell sands of Spiggie Beach, a glorious spot to paddle and cool one's tired feet on a summer's afternoon.

Heading north from Spiggie, I arrived at what is often described as Shetland's finest beach – St Ninian's Isle, which is probably one of the most photographed locations in the archipelago. Its image appears everywhere and is frequently used to promote the beauties of the Shetland coastline. Tiny St Ninian's Isle itself lies 400 metres offshore and is connected to the mainland by a spit of sand which forms a double-sided, bow-shaped beach. When I saw it for the first time on a sunny, blustery

day in early May, the beach certainly lived up to expectations. The fresh green of the spring grass of the island contrasted with the brilliance of the sun-drenched yellow sand. The stiff breeze blowing off the Atlantic whipped up the waves. Breaking white horses ran into the blue-and-turquoise tinted shallows. The colours might have been Mediterranean or Caribbean but the temperature certainly wasn't. There was a distinctly invigorating Nordic chill in the air as I made my way across the sand spit towards St Ninian's Isle, making the short walk an intoxicating experience. My senses were dazzled by the cries of seabirds, the sound of the waves and the shimmering sea on both sides. It was almost like walking on water.

The route I took crossed the back of a peculiar topographical feature known as a 'tombolo' or, in Shetland where they are common, an 'ayre' – from the Old Norse *eyrr* for 'gravel bank'. These spits of sand and gravel linking islands to the shoreline are features of a postglacial landscape. Much of the coastline around Shetland disappeared slowly beneath rising sea levels as glaciers and great ice sheets began to melt some 12,000 years ago. The action of the waves and the tides reworked undersea sediments to create beautiful beaches, bars and ayres. The one that links St Ninian's Isle to the mainland is the biggest of its kind in Britain and one of the finest in the whole of Europe.

It only took a few minutes to cross the sandy ayre and set foot on the green grass of St Ninian's Isle, which has a history that predates the Vikings by at least a millennium. Today the most obvious sign of this ancient human past is the ruined chapel, which dates from the 12th century, but archaeology has revealed an older church and a graveyard beneath its foundations. This pre-Norse-era building once stood at the centre of an ancient graveyard, with burials from the Iron Age and Bronze Age.

The medieval chapel made national news in the summer 1958 when a 15-year-old local schoolboy made an astonishing archaeological discovery. Douglas Coutts was on his first day as a dig volunteer, working with a team from Aberdeen University, when he unearthed the St Ninian's Isle treasure. Interviewed some years later, Douglas recalled that unforgettable day. 'I came to the site and was allocated a small area to begin some trowelling, which is the task normally allocated to novices. I had been at work only possibly for an hour when I came across a thin stone slab, which I levered up with my trowel and underneath I saw a hollow with some green material in it. I realised it was something unusual and I called over the professor, and I could see by his expression that this was indeed something unusual. So I was asked to step aside while he and his team investigated further.'

Douglas had no idea of the importance of his discovery. It consisted of 28 pre-Viking silver and silver-gilt objects, including several silver bowls, decorated sword hilts and 12 exquisitely beautiful ornate silver broaches. The items were contained in a larch-wood box which had been placed beneath the floor of the ancient chapel. But how did it get there? Ever since the find, people have speculated about where the treasure came from and who hid it. Did it represent the wealth of the church or had it been hidden in a panic during an early Viking raid? Whatever the truth, whoever had the task of hiding it did a good job. It remained undisturbed for 1,200 years – until young Douglas Coutts made his amazing discovery. The hoard is now kept by the National Museum of Scotland in Edinburgh.

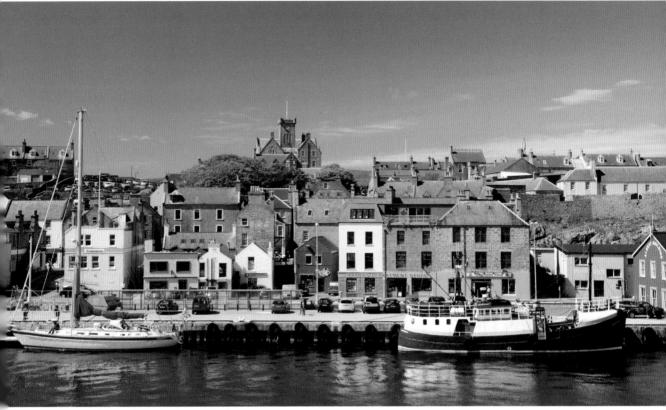

Lerwick, the capital of the Shetland Islands.

The sense of antiquity on St Ninian's Isle is palpable and stirs the imagination. For millennia, it seems, our human ancestors were attracted to its beautiful, green sequestered acres. But why? Was it just the view and the glorious setting or did they sense something else? Did they intuit something spiritual and sacred about the island? Down the centuries, from era to era, epoch to epoch, culture to culture, they came to bury their dead in a place they must have considered to be supremely blessed. As I stood above the ruined chapel with its truly ancient past, I could sense why.

LERWICK

Lerwick is the capital of the Shetland Islands. It has a population of about 7, 000 souls and is the most northerly town in the British Isles. Although it is small, it has a considerable impact on the rest of the island group. Half of all Shetlanders live within 10 miles of Lerwick, where a host of urban amenities are on offer – businesses, shops, restaurants, bars, an outstanding museum and several music and art venues. But Lerwick wasn't always the principal town of Shetland. That title belonged for centuries to Scalloway, which lies eight kilometres away on the west coast. Curiously,

Lerwick's origins owe more to Dutch fishermen than to the Vikings who only seem to have named the place. Lerwick comes from the Old Norse *Leir Vik*, which means 'muddy bay' and appears to have been a place of no significant settlement until the 17th century, when the Dutch came in search of migrating shoals of herring. These highly prized fish were caught by craft known as 'Dutch busses'. They sailed in fleets of several hundred, accompanied by warships for protection, and followed the herring around the North Sea and up to Shetland. The technique of 'gibbing', where the gills and the gullet of the fish were removed before they were salted, enabled the Dutch busses to keep their catch from perishing too quickly and so extended the range of the fishing fleet and the time it could spend at sea. The muddy bay of Lerwick and the sheltered waters of the Sound of Bressay made a natural harbour which the Dutch used as a base for their fishing activities. Canny Shetlanders cashed in on their presence, supplying the visitors with a host of sailing essentials from spare ropes to bars and brothels. Every summer, a shanty town of shacks and tents would spring up to service the Dutch fleet and the improvised town on the shores of the muddy bay soon earned a reputation for drunkenness and licentiousness. One pious resident of Scalloway described the annual debauchery as 'the great abomination and wickedness committed yearly by the Hollanders and country people'. To lance this sinful boil on the body politic, the authorities in Scalloway insisted that the shanty town of Lerwick be destroyed and burned it down twice. But every year, along with the migrating herring and the Dutch busses, it would spring up again on the shores of the muddy bay.

By 1650, there was a more permanent settlement at Lerwick and, because of continuing wars with the Netherlands, the government became increasingly concerned by the presence of the Dutch fishing fleet in the muddy bay. To keep an eye on them, a fort was built overlooking Bressay Sound by order of Oliver Cromwell, the Lord Protector of the Commonwealth. This was later replaced with the pentagonal fort built in the 1660s – not that the Dutch were terribly impressed. They burned it down in 1670. In 1702, when Britain was at war with France and Spain, the French set fire to Lerwick before a new fort could be built. The present defences of Fort Charlotte were named after the wife of George III and were completed in 1781.

Given this chaotic and chequered history, it isn't surprising that the town's fluctuating fortunes are reflected in the look of the place. Early guidebooks were ambiguous in their descriptions. Black's famous *Picturesque Guide to Scotland* says, 'Lerwick is a very irregularly built town. The houses are very plain and not prepossessing in appearance.' But a later edition describes the town more favourably. 'It is very quaint, resembling a Dutch town.' This must be stretching it a bit. I've travelled extensively in the Netherlands and I've seen nothing there that looks the least bit like Lerwick. If I'm wrong – then I'm a Dutchman, as they say. Curiously, there seems to be no agreement on how to pronounce Lerwick. *Black's Guide* from the turn of the last century says emphatically that it's pronounced Ler-wick and not Lerrick, which is what I've heard most often. But across Shetland generally, there seems to be considerable variety – Ler-week, Lerrick and Lerook, depending on the dialect of the area where the speaker comes from.

Whichever way it's pronounced, Lerwick has a subtle, understated charm that grows on you.

Over the years, I've come to love the narrow streets of the old town with its irregular street pattern, its closes and steps and the glimpses of the bay which gave the town its name. Riding on a mooring offshore is a replica Viking longship, which helps give a Scandinavian feel and berthed in the harbour there are usually about a dozen or so yachts. Many come from the Continent or Scandinavia. I've seen French, Dutch, German, Swedish and, of course, Norwegian yachts tied up alongside. These visitors from over the sea create a cosmopolitan atmosphere in this most northern of Scotland's towns. The Norwegian boats especially are a reminder of the centuries old Nordic connections between Shetland and the fjord-riven coast of western Norway.

Every June, the good burghers of Lerwick play willing and cheerful host to boatloads of Norwegians. taking part in the annual yacht race. As previously mentioned, back in 2012 I sailed into Lerwick on the *Hawthorne*, arriving with Morten, Espen and Stig. We'd been at sea for nearly 36 hours and were one of the race stragglers, tying up after sunset alongside the 40 or more other competing boats in the harbour. Although we were exhausted from lack of sleep, we were pumped up with excitement after experiencing all the highs and lows of racing across the stormy North Sea. Having secured the boat, our priority was to celebrate our safe landfall. I'd brought a fine malt whisky as an 'anchor dram' but was dismayed to see the entire bottle consumed in half an hour. My Norwegian shipmates drank it empty in shots. 'Skål! Skål! Skål!' And so began our stay in Shetland – in typical Norwegian, alcohol-fuelled style.

With my fine malt coursing through our veins, we stumbled across the grounds of Fort Charlotte

in the dark, until we came to a wee flat owned by Morten's family. They stayed there whenever they had dealings in town, which was quite often. Fish was their business – buying and selling, importing and exporting. This, I thought, seemed an appropriate occupation given the piscatorial origins of Lerwick.

The following day, we woke late and headed outside to brave the rain and wind of a typical Shetland summer's day. Hungry and seeking shelter from elements, we dived into the New Harbour Cafe which, despite its unprepossessing appearance, served up one of the finest full Scottish breakfasts I've ever enjoyed. My Norwegian pals were similarly delighted. They smiled with satisfaction through the fug of bodies in the crowded room, gulping their eggs, Lorne sausage and black puddings, all washed down of course with piping hot tea.

Having lined their stomachs, the Norwegians were ready to do battle. Stig led the charge into the pubs and bars of the old town. First was Captain Flint's, then Da Wheel, The Lounge Bar, the Douglas Arms and Da Noost. Round and round we seemed to go and so did our heads. Stig was getting very unsteady. Espen seemed to be focussing on objects beyond the horizon. Only Morten appeared unaffected. 'Do you do this every year?' I asked him.

'Yes, of course. We can't buy alcohol this cheaply at home so we have to make the most of it while we can – just like the Vikings of old. You could say it's in our DNA. But we're harmless nowadays. We're just weekend Vikings!'

There was a band playing at the Lerwick Boat Club where the alcohol continued to flow. At some point we returned to the flat. Espen fell over a cannon at Fort Charlotte and hurt his leg. By the

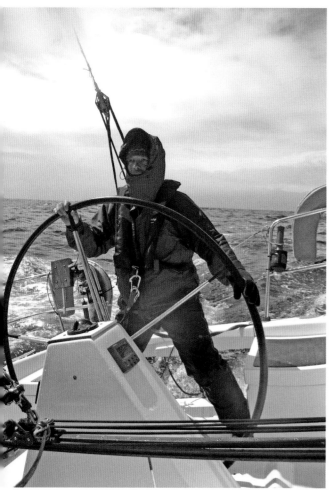

At the helm during the annual race from Bergen to Lerwick.

Roond da boats da tide-lumps makin
Sunlicht trowe da cloods is brakkin
We maan geng whaar fish is takkin
Rowin Foula doon

I don't know about rowing Foula doon – I was just about done in and so was everyone else. There were bodies and bottles lying everywhere. It was carnage. Then Stig came through the front door. He had a large bandage on his head where he'd fallen and cut himself. Someone had found him below the walls of the fort and given first aid before he'd staggered off into the night. He looked at me and grinned broadly. 'Skål!' he bellowed.

We were almost sober by the time we set sail for the return leg of the race. The wind was scream-ing in the rigging as *Hawthorne* left the harbour. Sightseers and well-wishers lined the esplanade as the fleet of yachts sailed down Bressay Sound and headed east under stormy skies. Looking back at the little grey town of Lerwick, I reflected on my time as a weekend Viking. Despite the sore heads and the injuries, it had been great fun. It had also been an authentic experience – one that revived the ancient link between Shetland and its Viking past. I wondered too if this was perhaps more real and relevant than the annual Up Helly Aa fire festival, which takes place every January through the streets of Lerwick.

Up Helly Aa has all the trappings of a pagan Viking festival. There is a torchlit procession of Viking warriors lead by the Guizer Jarl. The event culminates with the burning of a replica Viking longship. But all is not as it seems. This is not an authentic Viking festival. It was concocted in the 1880s and grew out of a tradition of celebrating Christmas and New Year by rolling burning barrels of tar through the streets. For obvious reasons,

time we limped our way home, an after party was in full swing. Morten was singing an old Shetland sea shanty, 'Rowin Foula Doon'. His Norwegian accent certainly helped with the dialect.

Oot be wast o Horn o Papa
Rowin Foula doon
Ower a hidden piece o watter
Rowin Foula doon

there were concerns over health and safety. And the pious disliked the alcohol-induced fun that accompanied the flaming barrels. The town council appointed special constables to police the crowds but they had only limited success. By the 1870s, the tradition began to fade but a group of young men with an intellectual interest in the Viking history and Shetland's Viking past reformatted and reconceived the event. What emerged was the Up Helly Aa of today.

For anyone disinclined to follow the path of Viking mayhem, Lerwick has a lot more to offer than riotous behaviour – although I am forced to admit these other pleasures eluded me when I was a crew member on board the *Hawthorne*. However, on other ramblings around the town, I've enjoyed the mix of old-fashioned shops and businesses that occupy the shore front and the network of lanes and narrow streets. You can get anything in Lerwick, it seems, from a gasket for the return valve of a head pump, to sheet music of traditional songs, from knitwear to silk underwear, from fine art to artisan haggis – a veritable cornucopia of delights awaits the dedicated shopper, if that's your thing.

Leaving the old town, the shore road passes above Bain's Beach. Built on the seaward side of the road is the picturesque old lodberrie – a survivor from an age when Lerwick merchants occupied a complex of buildings that included cellars, sail lofts and store rooms with easy access to the sea. The word lodberrie comes from an Old Norse word *hjøberg* which apparently means 'a place where a small boat could come alongside to be unloaded'. Originally these may have been nothing more than handy rocks where boats could tie up but lodberries later developed to include jetties and warehouses to accommodate small

The lodberrie, Lerwick.

boats carrying goods from a bigger ship anchored offshore.

During the 18th and early 19th centuries, smuggling was big business in Shetland – especially gin from Rotterdam – and many local merchants were involved in the illicit trade, calling themselves 'the Rotterdam gentry'. Smuggling gin had a huge impact on Lerwick and the whole of Shetland. A minister from the Isle of Unst once reported that the gin trade was worth half the rent of the whole country. Another writer complained that gin had 'drained the poor of this country . . . of every shilling they could spare or raise'. By the 1790s, there was actually a shortage of money on the islands because so much cash had been paid to the Rotterdam gentry to buy gin. The old lodberrie on Commercial Street is a relic of those days. Much photographed, it starred recently in the BBC drama series *Shetland*, based on the novels by Ann Cleeves,

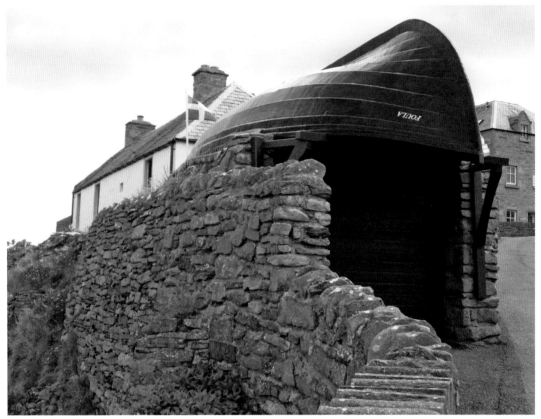

The old Foula mailboat gets a new lease of life.

and was used as the home of the fictional detective Jimmy Perez.

Just up the hill from the lodberries is one of my favourite buildings in Lerwick – a house that incorporates the old Foula mailboat, which once sailed and rowed the stormy passage to the remote island of Foula to the west of mainland. The upturned hull of this pre-machine-age craft now serves as the roof of an outbuilding, which I think is used as the garage for the nearby house.

On the outskirts of Lerwick is the Loch of Clickimin. On a promontory to the south of the loch is the Broch of Clickimin. The broch itself is Iron Age and probably dates from the first century AD. However, the other structures on the site are older and represent a legacy of human occupation dating back 3,000 years. The earliest residents to have left a mark at Clickimin were probably Bronze Age farmers. Over the centuries, their farm became a fortified home, with walls and ditches. During the Iron Age 2,000 years ago, the defences culminated in the building of the broch. Originally it would have stood to a height of about 15 metres but, after it fell into disuse sometime in the 5th century AD, many of its stones were probably 'quarried' for other purposes. By the time the

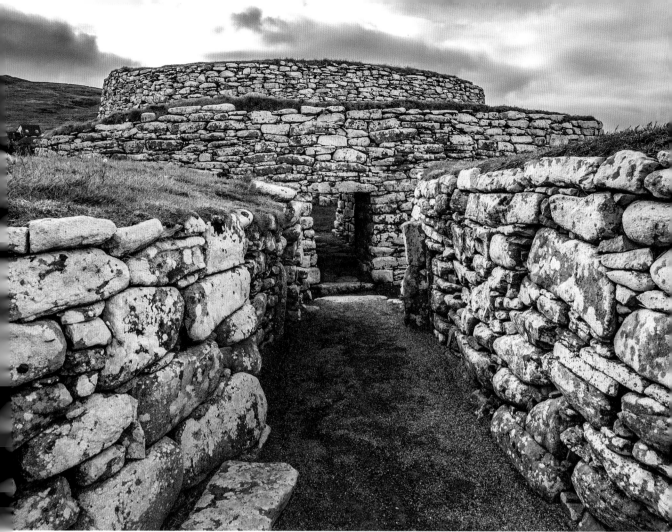

The Broch of Clickimin in the outskirts of Lerwick.

Vikings arrived in Shetland, the site had been abandoned for centuries. A thousand years later, the site had become an overgrown grassy mound. In the 19th century, the mound attracted the interest of amateur gentlemen archaeologists. Their first unofficial dig in the 1860s uncovered the forgotten layers of Shetland's deep past.

The ruins of the Broch of Clickimin demonstrate how early building techniques in Shetland used simple materials that were readily to hand – stone and turf, wood and thatch. For centuries, these were essential in construction. Today, most of the housing stock in Shetland looks solid and

capable of defying the elements and, much like elsewhere in Scotland, stone, slate and roughcast predominate. But in more recent decades, there's been a move away from building in this vernacular style and a far more Scandinavian-looking architecture has emerged. Wooden clad, timber framed houses painted in bright colours have sprung up across the archipelago. The effect is to make the place feel obviously Nordic. I don't know if this was intentional but I suspect the popularity of self-building may have something to do with it. The percentage of self-built homes erected in Shetland is higher than anywhere else in the UK and

the availability of cheap building plots and timber-frame kit homes from Norway makes building your own home a financially viable alternative. As I made my way around the islands, I often had to pinch myself to remember I wasn't in Norway. The timber houses, along with the sight of Shetland's own flag – a simple white perpendicular cross on a blue background – make a strong statement. This isn't the United Kingdom. This isn't even Scotland. This is Shetland!

SCALLOWAY

As I left Lerwick and took the road to Scalloway and the Scord, I passed several of the newer timber-frame type of houses. Here, there's a viewpoint high above the East Voe from where the blue peaks of the island of Foula can be seen on a clear day. Predictably, it was overcast when I arrived and dominating the scene below was the gaunt ruin of Scalloway Castle – home to the notorious Earl Patrick Stewart whose wickedness eventually cost him his life.

Earl Patrick Stewart was born around 1566. His father Robert was a bastard son of King James V. Earl Robert was a man whose iron will was used to exert Stewart power in the Northern Isles but his ruthless son Patrick went much further, initiating a reign of terror and subjugating the people of Orkney and Shetland. He built Scalloway Castle to stamp his authority on the islanders who were powerless to resist his cruel regime. Anyone who stood in his way was crushed, either by twisting the law in his favour or simply by having them killed. According to an old copy of *Black's Guide* from 1886, an iron ring in the chimney of the castle is where 'it is said that the Earl hung victims of his oppression and tyranny'. But Earl Patrick's

rapaciousness eventually got him into trouble when he turned to piracy to pay for his extravagant lifestyle. In 1609, he was summoned by the Privy Council in Edinburgh to account for his misconduct and then imprisoned. But he fought back and ordered his own bastard son to start a rebellion in Orkney against the king. After a bloody battle, the rebellion failed and both father and son were executed for treason. It's said that Earl Patrick attempted to avoid the axe by blaming all on his son. When that failed, execution had to be stayed for theological reasons. The Earl claimed that he didn't know the Lord's Prayer – an essential prerequisite for anyone, including traitors, to meet their maker. After a few lessons, he nailed it – and then lost his head at the Mercat Cross in Edinburgh on 6 February 1615.

Scalloway has a history of human occupation going back millennia. An archaeological dig on land earmarked for housing development in 1989 revealed a settlement with Bronze Age and Iron Age origins. The principal discovery was the remains of a broch, which archaeologists believe was occupied for at least 600 years. Among the fragmentary finds unearthed by the archaeologists were artefacts that linked the pre-Viking world of Shetland to other areas of mainland Britain, from Scotland to as far south as Anglo-Saxon England.

Although the name Scalloway is derived from the Old Norse *skalavágr*, meaning 'a place where there were huts or trading booths on a bay', there has so far been little evidence of a major settlement here during Viking times. However, there is a theory that the sheltered natural harbour was probably used by important Viking chiefs and figures of influence travelling to the Norse parliament – or *ting* – which was held in Shetland at Tingwall. The boats were perhaps moored or

beached at Scalloway before their crews made the short journey five kilometres north, up the valley to the parliament where laws were made and judgements given to settle disputes.

Overlooking the harbour in the centre of town and close to the Scalloway Museum is a simple stone memorial that commemorates a more recent connection to Norway and to ideas of justice – a humble cairn that celebrates the heroic exploits of the men who ran what became known as the Shetland Bus during the Second World War. The significance of the Shetland Bus can only be understood against the backdrop of war. When hostilities in Europe broke out in 1939, Norway was a neutral country. Despite this, Adolf Hitler felt that the occupation of Norway would bring the Reich several benefits. Firstly, it would help the Germans break the naval blockade that the British had established to prevent supplies reaching Germany. Secondly, Norwegian ports would provide ideal bases from where German U-boats and aircraft could launch attacks against British shipping. Thirdly, it was vital that the Nazis controlled the Arctic port of Narvik in northern Norway. Its ice-free harbour allowed essential supplies of iron ore to reach Germany to supply the armaments industry.

Using the pretence of 'protecting' Norway's neutrality from British aggression, Hitler's forces invaded Norway on 9 April 1940 and established a puppet government led by the Norwegian fascist leader and Nazi collaborator Vidkun Quisling. The occupying regime quickly made its presence felt. German troops paraded the streets. The Norwegian flag was removed from public displays and replaced by the swastika, and rationing was immediately introduced. Members of my own extended family in Norway well remember the invasion

and its aftermath. My father's Norwegian partner Turid was a teenager when the Germans occupied her hometown of Bergen. But her feelings towards the invaders were more nuanced than I expected. 'The German's weren't all bad,' I remember her telling me. 'The young soldiers looked rather handsome in their blue uniforms. And they loved to sing as they marched. *"Wir gehen nach England"* was one of their favourites.' I was never sure if Turid was being serious or just provocative. But it remains a disturbing fact that many Norwegians were not altogether unhappy about the new arrangement with Hitler's occupying forces, which is perhaps why this period of history is seldom discussed in Norwegian society. 'What did your grandfather do during the war?' is a question that usually goes down like a cup of sick at Norwegian dinner parties! However, a significant minority of Norwegians did band together to resist Nazi aggression. Among those heroes were scores of fishermen and their crews, who sailed west after Norway capitulated.

During 1940, 30 fishing boats arrived in Shetland carrying over 200 refugees, including women and children. The skippers and crews were soon recruited by British intelligence. Initially under the auspices of the Special Operations Executive, they formed a naval unit dedicated to covert operations in Norway – taking weapons and supplies to the Norwegian armed resistance under the noses of the Germans whom, it was hoped, would assume the boats were simply fishing in their native waters. The boats returned with agents and refugees to Shetland and Scalloway, where they were based. Very quickly, Shetland began to be seen as a symbol of freedom and hope for those fleeing the Nazi regime in Norway and the phrase 'to take the Shetland Bus' became an idiomatic

The Shetland Bus Memorial, Scalloway.

expression for escape. Over the course of the six-year war, more than 5,000 civilians took the Shetland Bus and many of the men amongst them volunteered to continue the campaign of resistance organised from the headquarters in Scalloway.

But the Shetland Bus was no busman's holiday. It was an extremely hazardous operation with a truly horrific level of casualties. The fishing boats, powered by single cylinder semi-diesel engines with a distinctive, slow and rhythmic 'thump-thump' sound when running, were dangerously slow and vulnerable to attack if discovered. The coast of Norway was heavily mined and patrolled by the Luftwaffe. In order to minimise detection, nearly all operations were conducted under cover of darkness in the depths of winter. This made the notorious weather in the North Sea the most feared enemy of all.

Over the course of two years, Norwegian fishing boats from Shetland made almost a hundred missions to the west coast of Norway. The cost was high. Ten boats, a third of the initial force, were lost, along with the lives of 44 of their crew. Some were victims of the weather, others of interception by the Germans. The fate of several remains unknown but the names of these heroes are commemorated on the memorial in Scalloway.

Some of the survivors of the Shetland Bus remained in Shetland after the war and made the islands their home. When I was in Scalloway, I was briefly in touch with Karen Iversen whose

father Kaare Iversen escaped from Norway in 1941 and served aboard the Norwegian fishing boat *Arthur*, skippered by the famous and highly decorated Leif Larsen. The story of that trip, during the worst winter storm in 70 years, is told in David Howarth's celebrated memoir *The Shetland Bus*. It wasn't until Karen's dad wrote his own memoir in old age that she knew about his wartime experiences. 'He never spoke much about what he did during the war. Someone said to my sister at school, "Your dad ran the Shetland Bus." And she said, "Don't be stupid – my dad can't drive." We knew nothing about it!' At the height of hostilities, Karen's dad fell in love with a local Scalloway girl Cissie Slater. 'Something else I didn't know until quite recently was that the night my mother and father got married he went off on a trip to Norway. Some honeymoon!'

Now here's the thing – or should I say ting? Just five kilometres north of Scalloway on a small promontory at the northern end of Tingwall Loch is Tingaholm which, until the 1600s, was the site of Shetland's ting – or parliament. Tings were common throughout the Nordic world, the word coming from the Old Norse word *þing* which roughly translates as 'an assembly or talking shop' – a place where important legal decisions were made and the law was discussed. The Scandinavian world has many tings, things, dings or even fings – place names which denote the presence of such assemblies in the past. There's Tynwald Hill on the Isle of Man, once a major Viking centre; Dingwall near Inverness; Tingwall in Shetland – and there's a Tingwall in Orkney too; Tinganes in the Faeroe Islands; Thingvellir in Iceland; Gulatinget in Norway; and, of course, the modern Norwegian parliament is called the Storting, which means 'the Great Assembly'. The ting at Shetland's Ting-

wall would have been an open-air affair. Until the 19th century, when the level of Tingwall Loch was lowered, the holm where the ting was situated was an island accessed by a causeway. Here, in the open air, the local people and officials tried offenders, interpreted the law and enacted new legislation affecting the wider community. My old *Black's Guide* paints a vivid if somewhat romantic picture of the ting in action:

> Here seated on a great stone with his Raademen and inferior officers around him, the great Foud of Shetland – the governor and law-right man of the islands – administered justice according to the law of St Olaf. When a capital sentence had been pronounced, there still remained an appeal to the people. If the prisoner could break through the surrounding hedge of spectators and touch the steeple of the Tingwall Kirk before the Foud's officers could apprehend him, he was safe from the penalties of the law.

My guidebook also entreats the Victorian visitor to take the opportunity to explore Shetland's west side by taking the steamer *Queen* which plied the scenic coast on a weekly basis back in Victorian times. Sadly, there is no steamer service available today and the road west from Tingwall misses out much of the spectacular and convoluted coastline with its sea stacks, skerries, voes and geos which are such a feature of 'Da Wastside' as Shetlanders call this district. Having said that, from the road that climbs the Scord of Sound to Tresta there are glimpses of the scattered islands to the south of Weisdale Voe, all glorying in names that recall a distant Viking past: Flotta, the Hoggs of Hoy, North

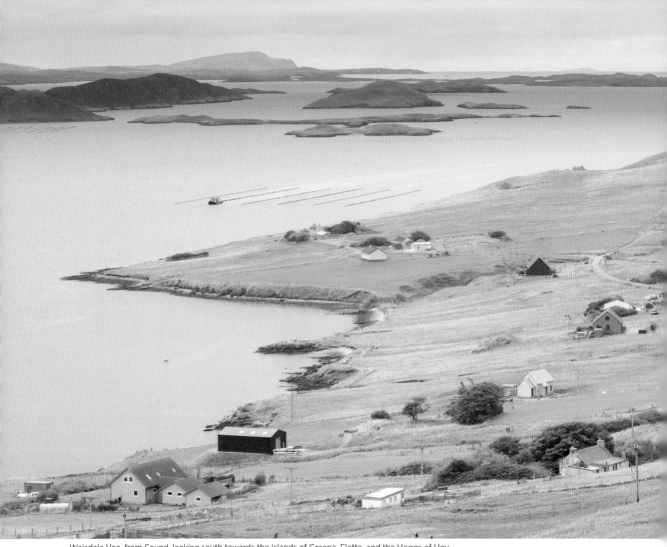

Weisdale Voe, from Sound, looking south towards the islands of Greena, Flotta, and the Hoggs of Hoy.

Havra, Hildasay, Linga, Langa, Lunga, The Nev, The Skult, Swarta Skerry, Oxna and Papa to name just a few.

Passing signs to places with names like Twatt (definitely worth taking a selfie here, I'd have thought) and Gruting, I came to the mysteriously named historic site known as the Temple of Stany-dale. The foundations of this unique Neolithic structure were thought by an archaeologist work-ing in the 1940s to resemble temple sites of the same age on the island of Malta, which is why he named the site a temple. However, later studies have cast doubt on this and it seems more likely that it the 'temple' was more of a great hall – or chieftain's house – than a place of worship. Wood from postholes inside the walls indicates that the building would have been roofed. However, temple or not, it remains the case that nothing quite like this has been found anywhere else in Shetland. Although it stands in an area of extensive blanket bog, there are signs that there was a settlement associated with the main building. Four more conventional Neolithic dwellings have been discov-ered close by, along with ancient field systems.

WALLS

Heading west, I came eventually to the village of Walls, known to Shetlanders as 'Waas', which nestles around the head of a sheltered natural harbour opposite the island of Vaila. Walls was once much busier than it is today. In the 19th century its lifeblood was the migrating shoals of herring. Fleets of boats landed their catch here, where teams of young women and girls gutted and cured the fish for export. Fishing boats still use the harbour, which is also the departure point for the ferry to Foula, when the weather permits it to sail. When I came down to sea level, most of the craft in the harbour were pleasure craft using the marina. Apparently, the old parish church of Walls is said to date originally from pre-Reformation times. When it was being renovated and partially rebuilt in the 1860s, nearly 300 skulls were dug up from beneath its floor, thereby justifying an old Shetland name for a church as a *bane hoose*.

The single track roads that are a feature of Da Wastside are frequented as much by livestock as vehicles, so drivers have to watch out for wandering Shetland ponies, which seem as free range here as sheep are in the Hebrides. Grazing in small groups, they make an endearing sight and provide a more biddable symbol of the islands than the often bellicose Vikings. Much loved and famed throughout the world, the Shetland pony is used to serious heraldic effect on the Shetland Islands Council coat of arms, where it appears with the unicorn of Scotland. Between them, the beasts hold a shield with the symbol of a Viking longship with the raven of the Norse god Odin emblazoned on its sail. Below is the motto of the islands *með lögum skal land byggja* – 'with laws shall land be built'. But, to be honest, the heraldic Sheltie, with its tongue hanging out, doesn't look quite mythic

enough to carry off this symbolic role – more 'My Little Pony' than *Game of Thrones* – and it makes me smile whenever I see it.

A few kilometres up the road from Walls is Thordale Stud, home to Frances Taylor and several beautiful Shetland ponies. Frances has lived on Shetland for more than 20 years and keeps Shetland ponies and their more northerly cousins, Icelandic ponies, on a smallholding where she breeds them and trains them to pull carriages.

Over a cup of tea in her kitchen, Frances enthused about the history of the Shetland breed. She told me that archaeology has revealed the presence of small ponies on the islands since at least the Bronze Age.

'But how did they get here?' I wanted to know.

'There is a theory,' said Frances, 'that small ponies may have migrated from continental Europe during the last ice age, crossing glaciers and land bridges before the sea level rose. These ponies were then crossed with a small breed of pony that was introduced by the Celts who later settled here. Who knows for sure, though? Perhaps science and DNA evidence will one day tell a different story. But one thing is for certain – the Shetland pony is a very ancient breed. And, because of its island home, the breed was cut off from other influences and adapted perfectly to the harsh environment. For their size, Shelties are the strongest of all horses. They can survive the harshest of winters on the poorest of grass. And when conditions get really tough, they have been known to scavenge for seaweed on the shore.'

Outside I met Frances's friend and colleague Jo Tomkinson. She was getting her Sheltie Andy ready for work – pulling a small two-seater driving carriage. As I helped Jo put on Andy's harness, she reminded me that Shetland ponies are first and

foremost workers and not pets. For hundreds of years, they were the engines of the crofts and farms of the islands, cultivating the land, carrying the peat and seaweed for the fields and carrying the owner – no matter how big he may have been or how silly he may have looked, legs dangling to the ground. 'It's when people have them as pets that the trouble begins. They get bored if they don't have enough to do and then they can misbehave and get a bad reputation. If you have a Sheltie, you have to work it. A happy pony is a worker,' Jo explained as she hitched Andy to the carriage.

With a flick of her riding crop and at the command of 'Walk on!', we were off down the track at a sedate three miles an hour. Andy certainly handled his load well and seemed content with the task in hand. As we trundled along, Jo continued with her theme and I was fascinated to learn that the Shetland pony's capacity for work led the breed to a life underground. 'Before the Factories Act of 1847, children were widely used down coal mines to do much of the lifting and carrying. They even pulled wagons full of coal along underground tracks. Really heavy work. But, after the law banned

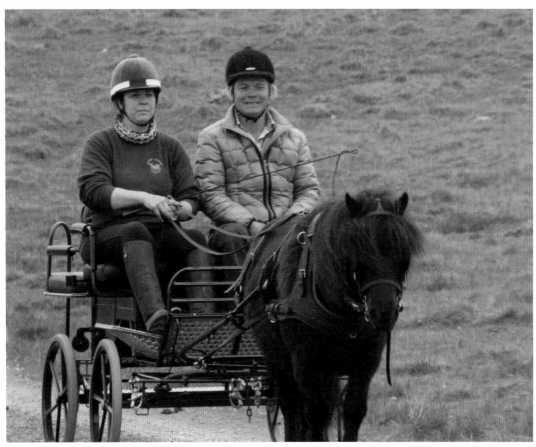

With Jo Tomkinson and her sheltie Andy.

kids from entering the pits, Shetland ponies took over their role. They were shipped out in huge numbers – bred here for the mines.'

'So they were born and bred in Shetland. Raised in the fresh air of Shetland – only to spend their lives in the dark, airless tunnels of Britain's coal mines. What a life!' I said.

'Yes, that's right. But they were generally very well looked after and frequently much loved by the men who were responsible for their care – despite the grim surroundings. But then it's never cold down a mine, and I hear that they were bathed every night with warm water. More than the kids ever were, probably!' Jo surmised.

Shetland not only has its own breed of pony – it's also home to a unique breed of sheep. The Shetland sheep is a very ancient breed of animal. It's classed as primitive or 'unimproved' and belongs to the Northern Short-tailed group whose presence on the islands goes back thousands of years. These small, hardy beasts, which thrive on the often poorly nutritious grass found across much of Shetland, are dainty beasts and often weigh in at around 30 kilograms. Although much sought after for their lean, full-flavoured meat, it's their wool which has made them highly desirable. Shetland sheep produce the finest wool of any native breed and the fleeces come in an amazing variety of colours, shades and markings, with 11 main colours and 30 recognised markings.

For centuries, Shetland knitting and weaving depended on the islands' native sheep. But with the advent of industrialisation and mechanical spinning techniques, the native sheep's wool was considered to be too fragile. To strengthen the fibres Shetland wool and was blended with wool from coarser breeds. As a result, the proportion of soft native Shetland wool dropped to around

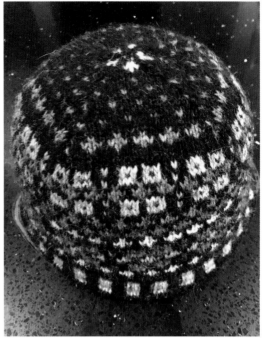

A hand-knitted Shetland toorie.

60 per cent pure. However, there were some people on the islands who held on to the dream of 100 per cent Shetland woollen textiles, produced with modern techniques. Since its inception in 2009, the annual Shetland Wool Week celebrates the islands' continuing love of all things connected to Shetland wool and products made from it. Oliver Henry, patron of the 2019 Shetland Wool Week, described the event, which includes exhibitions and classes in weaving, spinning and dyeing, plus Fair Isle and lace-knitting techniques. Wool Week takes place across Shetland, from the very south to Unst in the north, famous for its beautiful lacework.

Each year, a free knitting pattern for a traditional Shetland toorie, a close-fitting hat, is available to download from their website.

SANDNESS

At Sandness, a village which huddles beneath the Hill of Melby and faces the island of Papa Stour, five generations of the Jamieson family have been championing Shetland wool, ever since Robert Jamieson set up business in the 1890s. From his shop in Sandness, he bought or bartered household goods and groceries for knitwear produced by local women. The knitted garments were of the highest quality and were much in demand, not just in Shetland but across the UK and beyond. Robert Jamieson made a good living meeting this demand and exporting Shetland's quality knitwear across the globe. As the Jamieson family's business grew, so did their desire to improve the quality of their products. Success came in 1978 when they were able to spin 100 per cent Shetland wool mechanically for the first time. Building on this breakthrough, they opened Shetland's only commercial woollen mill in Sandness which handles all stages in the production of 100 per cent pure Shetland yarn.

The Hill of Sandness rises steeply to peaty moorland behind the village, sheltering it to some extent from the weather from the south. At 249 metres above sea level, this is the highest summit on Da Wastside. A longer approach to the trig point can be made from the Dale of Walls along a magnificent coastline of sea stacks and rocky headlands, taking in Mu Ness – not to be confused with Muness on Unst – and the Bay of Deepdale. I took a much shorter route, following the Burn of Mirdesgill behind the village of Sandness to reach the summit from where I drank in the magnificent views of the islands to the north. The whole of Papa Stour was laid out like a map and, away to the west, rising darkly on the horizon, the distinctive heights of Foula.

MOUSA

The name of this small, flat but very green island is thought to derive from the Old Norse *mós øy* – which means 'a mossy island'. It lies just over a kilometre off the east coast of Mainland, opposite the village of Leebitton overlooking the Wick of Sandsayre. It is little more than two kilometres long by a kilometre at its widest. According to old records, the island had a population of 11 families in the 18th century but, by 1861, Mousa was uninhabited and has remained so ever since.

The most striking feature of Mousa is its famous broch, which is clearly seen from the opposite shore. Dominating the view, from almost every angle, its slate grey walls contrast with the green sward of the rest of the island. Rising to a height of 13 metres, the Broch of Mousa is the finest and most complete example of the 500 or so brochs that are scattered throughout the north and west of Scotland. These are uniquely Scottish structures. There is nothing quite like them anywhere else in the world. They are also surprisingly mysterious and unknowable. Despite being so numerous (by far the majority of brochs are nothing more than piles of collapsed stones), they have continued to puzzle archaeologists, antiquarians and historians over the centuries. No one is sure who built them or why. In my Victorian guidebook, Black describes the Broch of Mousa as a 'Pictish Tower', by which the author probably meant that it predated Viking times or the Roman invasion of Britain. Current thinking places the broch during the Iron Age – about 2,000 years ago. But what purpose did they serve? Were they castles, status symbols perhaps for wealthy chiefs

Opposite. The interior of Mousa Broch.

or defensive refuges for the wider community? To date, there has been no definitive answer. But one thing seems obvious. Whoever lived in the Broch of Mousa must have been on the small side – judging by the tiny stone entrance. Visitors have to sacrifice dignity to some extent to get inside. The broch is open to the elements above but, at one time, it would have been roofed and contained probably three or four floors, accessed by landings in the internal stone staircase which climbs within the extremely narrow and claustrophobic double-skinned drystone wall. The base of this circular double wall is wider than at the top of the tower, giving the whole structure an elegant, tapered appearance. The broch was constructed without mortar or cement by extremely skilful masons who built by eye and experience, using nearby stones and simple tools to create a building that has withstood the rigours of time for over two millennia.

A thousand years or so after it was built, the Broch of Mousa appeared in the earliest literature of the north – the sagas of the Viking age. According to the Icelandic *Egil's Saga*, which relates events from about AD 900, a lovelorn lad from Norway called Bjorn (who else?) eloped with his sweetheart, the gorgeous Thora Jewel-Hand. While sailing to Ireland, a storm drove the couple's ship on to the coast of Mousa, where the young lovers spent the winter living in the abandoned broch. Having established their union, Bjorn and Thora eventually settled in Iceland, raised a family and lived happily ever after.

Having been used once as a love nest, it's perhaps less surprising to find the Broch of Mousa playing the same role in another Norse tale, this time in the *Orkneyinga Saga*, which involves the story of a hot-headed, amorous widow called Margaret. When her husband, the earl of Atholl, died, she moved in with the brother of a Viking buccaneer and had a child by him. But Margaret was not the maternal type and quickly grew tired of her domestic situation. She soon caught the eye of an earl from Shetland, who whisked her off to Mousa where they moved into the broch. However, Margaret's 20-year-old son was scandalised by his mother's wanton behaviour and lay siege to Mousa but the defences of the ancient broch proved impenetrable. Peace was declared and the siege lifted when Margaret promised to marry her new beau Earl Erland. All ended amicably when Margaret and her new husband honeymooned in Norway.

A few years ago, I was lucky enough to spend a summer's night on Mousa. We landed late in the evening with the sun low in the north-west. It was June and the 'simmer dim' as Shetlanders call the extended twilight of midsummer meant that the sun would never set far below the horizon. Gradually and imperceptibly sunset moved to sunrise, rendering the northern sky a glow of pulsing crimson and gold. I had come to Mousa to visit the broch and to film some more recent inhabitants who have taken up residence in its ancient walls. As the light faded, my guide told me to listen. I could hear strange noises emanating from crevices and cracks in the stonework. In the not-so-distant past, these sounds once startled local people who thought that the eerie noises were made by *trows* – the mischievous fairy spirits of Shetland folklore who live underground and come out at night. But it wasn't *trows* that I could hear. The underground cacophony was being made hundreds of nesting storm petrels waiting to swap places with their mates. And it wasn't long before they began to arrive – hundreds of

tiny fluttering birds, not much bigger than swallows or house martins, flew in from across the sea. With hurried wing-beats, they gathered around the broch. Their silhouettes against the reddening sky reminded me of bees around an old-fashioned hive. By the light of our torches, we watched each bird locate its mate inside the drystone wall, change places with it and take its turn to incubate the eggs on the nest. It was a magical and unforgettable sight.

NOSS

The name of this great wedge of rock lying a short distance to the east of Bressay means either 'ness' or 'nose' in the old language of the Vikings. Separated from Bressay by the tide-funnelling and dangerously narrow Noss Sound, which is little more than 200 metres wide, the island rises steeply for two kilometres to the Noup of Noss at 181 metres in height. Here the land ends dramatically in perpendicular sandstone cliffs which plunge unbroken into the churning seas below. This is an awe-inspiring place where the senses are challenged by the height, the buffeting winds, the sound of the ever restless waves beating on the base of the cliffs and by the raucous cacophony of tens of thousands of nesting seabirds crowding on the rocky ledges below. Noss is uninhabited by humans today and, because of its wildlife riches, was designated a National Nature Reserve in 1955.

I first visited Noss on a wild and windy summer's day in the month of June. My guide was the ornithologist and wildlife tour operator Jonathan Wills, who picked me up in his launch from Lerwick harbour at an unearthly hour in the morning. It wasn't easy for Jonathan to bring his boat alongside the harbour wall. His passage was hampered by a great raft of Norwegian yachts that had arrived overnight from Bergen, having taken part in the annual Shetland race. After cursing our Nordic cousins for taking his berth, Jonathan managed to get me on board and we headed across the Sound of Bressay, the powerful tour boat roaring and crashing through rough seas and gale-force winds. We followed the coast of Bressay until we came within sight of the great cliffs of Noss, which rose to nearly 200 metres above our heads and plunged for another 30 beneath our keel. Noss is not a place for the faint-hearted. It's wild and remote but, for the many tourists who venture with Jonathan on his wildlife safaris, the rewards are great. Above us, occupying every square inch of the guano-streaked cliffs were hundreds of thousands of seabirds. The air around assailed my senses with the smell and the noise. 'Welcome to seabird city,' said Jonathan as I gazed upwards at the swirling myriads of gannets, puffins, guillemots, razorbills, fulmars and innumerable gulls. Jonathan continued, 'People think they know what to expect when they come here but Noss always astonishes and enthrals. There are lots of seabird colonies in Scotland – and there are bigger ones – but Noss has the greatest concentration and variety of species in one place that you'll find anywhere and it's been knocking people's socks off for years.'

Jonathan went on to describe other wildlife encounters to be had at Noss. There are seals in abundance, swimming in the deep but remarkably clear waters beneath the towering cliffs, and, occasionally, whales are spotted offshore.

'I'm guessing that, for you and your business, wildlife is a pretty important feature of the tourist industry on Shetland,' I said.

'Absolutely,' he answered. 'It's a vital compo-

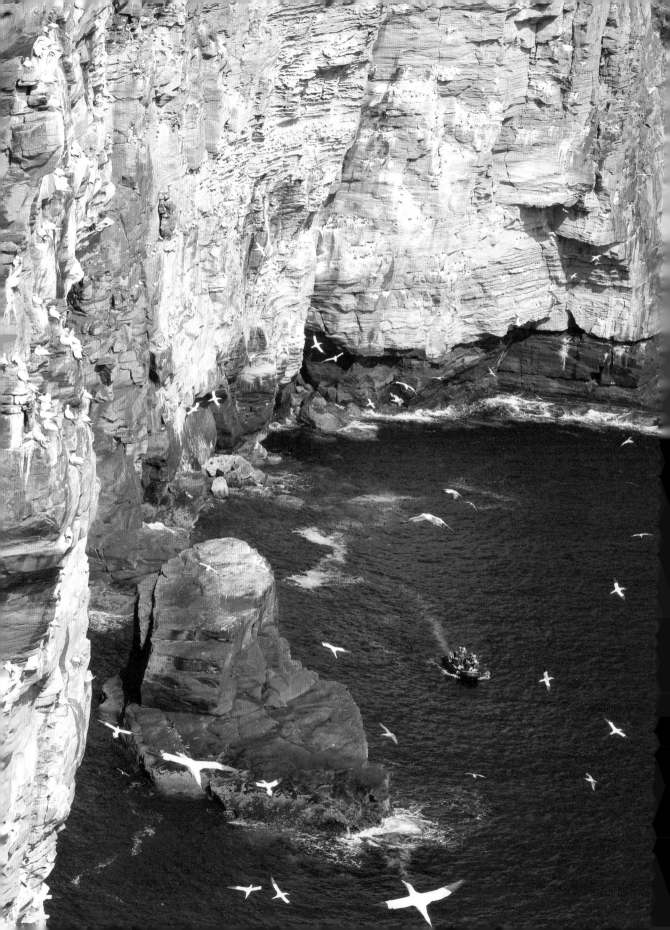

nent. Without the wildlife, there would be no tourism in the 21st century.'

Most tourists who come to Noss have a completely different relationship with the natural world from their Victorian counterparts. Back in the 19th century, an interest in wildlife usually meant an enthusiasm for shooting things and the sporting tourist would have come to a place like Noss to blast away at the birds and the seals and anything else that moved. Even those who professed a more scientific interest in nature resorted to the gun to collect specimens. The student traveller Edward Charlton came to Noss three times in the 1830s. On every visit, he brought his gun, hoping to bag some seafowl.

> The shrill pipe of the oyster catcher resounded along the shore. My companions went away. Proctor wanted specimens, Chomley wanted sport. They fired three or four times, yet scatheless flew the beautiful bird above my head. For all my veneration of this beautiful bird, I could not resist firing in my turn.

'When you read the lists of what Victorian gentlemen bagged, it's horrifying,' said Jonathan as we bobbed in the swell. 'They shot some really rare birds and thought it was "jolly good sport". The last native sea eagle was shot here at Noss by an English clergyman in 1918.'

The depredations of sporting gents in former years only added to the harshness and cruelty of life on Noss, where the axiom of nature being 'red in tooth and claw' is proven on an almost hourly basis. Above us, guillemot fledglings were being

Opposite. The majestic 200-metre cliffs of Noss.

encouraged by their parents to leave the safety of the cliff ledges where they had hatched and been raised. But the first step to independence would take them over the edge – quite literally. As we watched, several fledglings fluttered in a downy free fall. Some landed in the water, others missed and landed on the wave washed rocks at the base of the cliffs, where hope of survival was extremely slim. But for those who had successfully found water, danger lurked from above. The great skua, the notorious and ruthless bonxie, patrols these cliffs with an opportunistic eye open to exploit the weak and the vulnerable. One of these piratical birds dived on a chick we had been watching as it learned to swim. In sight of its parents, the bonxie proceeded to disembowel the limp and pathetic corpse. Soon a small snowstorm of the chick's feathers was spiralling in the wind. There was nothing we could do.

Feeling helpless, we left this depressing spectacle and headed towards a sea stack called Cradle Holm, named after a remarkable aerial ropeway which once connected the stack to the island of Noss. According to a local account – which has been reprinted over the years in various guidebooks – it was put up in 1660 by a fowler from the distant island of Foula who accepted a wager. If he could climb the sea stack of Holm Ness, he would win a cow. Looking at the sheer cliffs of Cradle Holm, I thought it would take more than the prospect of a cow to tempt me to scale its vertical heights. But the Foula man was made of sterner stuff. He climbed the north side with a rope and two stakes. When he reached the top, he drove the stakes into the ground to make a secure anchor point. He then secured his rope to the stakes, which was then drawn up by others on the cliffs of Noss opposite, some 20 metres

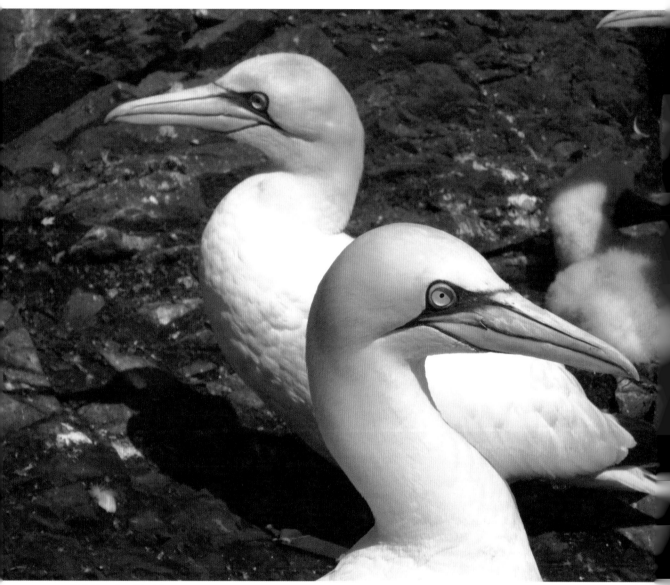

Gannets on the cliffs at Noss.

across a deep chasm. Tragically, the man decided to return by the route of his ascent. Edward Charlton described what happened next: 'and, as might be expected, he fell and was dashed to atoms.'

Having sacrificed his life for the ropeway, the Foula man might have derived some comfort had he lived from the thought that his work was put to good use. A wooden cradle was made and hung beneath the ropes. This crazy, death-defying contraption became a celebrated tourist attraction.

It is described by *Black's Guide* as 'a square box large enough for a man to hold a sheep between his legs, suspended on two parallel ropes stretched across the chasm, and by this perilous means of conveyance, the rich harvest of sea fowls' eggs on the Holm were regularly harvested and sheep transported across for the purposes of pasturage.' However, it became too popular among feckless, daredevil tourists. After a dangerous accident, when the bottom of the cradle fell out, forcing the passenger to save himself by clinging to the rope above the abyss, the cradle was removed in 1864. But, given the current obsession for extreme sports, I wouldn't be surprised if some enterprising soul were to reinstate the Noss Cradle for modern thrill-seekers.

BRESSAY

Bressay is an island lying close to Lerwick – so close, in fact, that its highest hill, the Ward of Bressay (226 metres), casts a shadow across the town on rare sunny days in the depths of winter. The name Bressay is thought to derive from either the name of a Viking chieftain *Brusi* or the Old Norse *breið øy*, meaning 'broad island'. In the Middle Ages, Bressay and its sheltered coves and natural landing places were more significant to the early Norse settlers than the muddy bay on the western shore of Bressay Sound where Lerwick eventually developed. Ships sailing to Lerwick today either pass Kirkabister Ness, where the present lighthouse on Bressay stands guard or come from the north, passing Easter Rova Head lighthouse to enter the narrow channel of Bressay Sound. This was my first experience of Lerwick harbour, sailing at night on board the Norwegian yacht *Hawthorne*, as I anxiously steered a course marked by naviga-

tion lights. These were difficult to discern against the glow of the town's floodlit industrial area. But eventually the sound of a gun fired from the yacht club boathouse told us we had arrived – if somewhat belatedly – as one of the stragglers in the Bergen to Lerwick yacht race. The narrowest point we'd sailed through that night was only 300 metres across, which is all that separates the island of Bressay from the Mainland. A few years ago, plans were mooted to span this gap with a bridge to Bressay, effectively making the island a suburb of Lerwick. The bridge was never built but some islanders think it would be a lifeline for the community of about 350 people, who continue to rely on an hourly, ten-minute ferry service across the Sound. Because most islanders are nowadays employed in Lerwick or beyond, an easy commute to work is considered an important factor for the future viability and wellbeing of the island community.

Taking the little blue-and-white-painted ferry *Leira* from Lerwick, I landed on Bressay at Maryfield, on the western shore, where most of the island's population now live. From here, several single-track roads radiate north, south and east. This isn't a big island, being about nine kilometres from north to south and just 3.5 kilometres wide, so distances are easily walkable.

As you'd expect, Bressay has a history that stretches back millennia. There are pre-Norse remains scattered throughout the island. At the now-abandoned village of Cullingsburgh overlooking the Voe of Cullingsburgh are the ruins of an ancient Celtic church, which was built on the site of an even more ancient Iron Age broch. In the 19th century, a workman made a remarkable find while he was digging in the old kirkyard. Known today as the Bressay Stone, this fine exam-

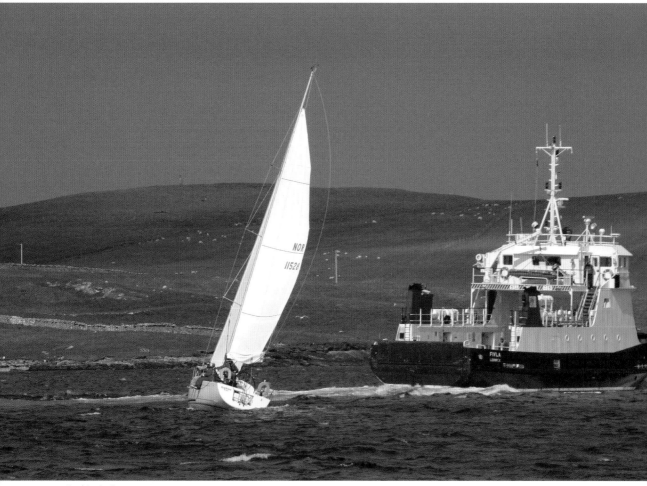

Looking to Bressay.

ple of Pictish art dates from a Christian, pre-Viking period and is thought to be a cross-marked grave slab. The original is now displayed in the National Museum of Scotland in Edinburgh but a replica has been placed close to where the original was found. In the nearby burial ground at St Mary's is the grave of a Dutch merchant adventurer, Captain Claes Jansen Bruyn. In 1636, he commanded the merchantman *Amboina*, taking a cargo of Persian silk from India to Europe. A terrible storm blew up as the ship tried to round the Cape of Good Hope. Later, 29 of his crew died from disease. But still he struggled on, like a combination of the Ancient Mariner and the *Flying Dutchman*, ravaged by the vicissitudes of the ocean and the wild northerly winds. He eventually dropped anchor in Bressay Sound – and promptly dropped dead. The bones of this unlucky but reso-

lute sailor are now mouldering in the grounds of St Mary's – a long way from his home in the village of Durgerdam near Amsterdam.

The sheltered waters of Bressay Sound were once witness to two of the largest assemblies of Viking longships ever seen in British history. In 1066, King Harald Hardrada of Norway gathered his longships and a force of 10,000–15,000 warriors in the sound before they sailed south to take on the upstart Anglo-Saxon king, Harold Godwinson. Harald Hardrada believed that he had been promised the English crown by the recently deceased English king, Edward the Confessor, and was intent on securing his claim by defeating Harold Godwinson. The two kings and their armies met at Stamford Bridge in England. The Norwegian forces were utterly defeated and Harald Hardrada was slain in the bloody battle. In a near carbon copy of hubris and defeat, King Haakon of Norway assembled his mighty war galleys in Bressay Sound in the year 1263. The Norwegian king was on a campaign against the king of Scots and hoped to reassert Viking authority in the Western Isles after the Scottish king, Alexander III, had tried to incorporate the islands into this kingdom. The Scots and Norwegians met at the Battle of Largs on the Ayrshire coast. Although the Scots declared victory after the engagement, only part of the large Norwegian force had been involved. The bulk of its ships and men had still to see action but, because of the deteriorating weather and the onset of winter, King Haakon decided to withdraw to Orkney and shelter there until the spring when he planned to resume his campaign. But, thankfully for Scotland, Haakon died in Kirkwall, along with his plans to keep the Hebrides under Norse control.

Trying to imagine what a fleet of several hundred Viking longships would have looked like sheltering in Bressay sound, I set my sights on 'Da Wart' as locals call the island's highest hill, the Ward of Bressay. According to my map, the route would take me close to several hams – Ham, East Ham, West Ham and South Ham. These of course were no succulent slices of cured pork but the names of former crofting communities. Following the road south, I turned up an unmade track which climbed towards the prominent telecommunication masts that crown the summit of Da Wart and soon reached the trig point where I had been told that, on a clear day, you could see all of Shetland, including Britain's remotest islands – Foula in the west and Fair Isle to the south. Unfortunately, the weather was closing in by the time I got there but, through broken cloud, I could just make out the hills of Unst to the north and, away to the northeast, the lonely scattering of islands that make up Out Skerries.

Later, I got a lift across the island with some birdwatchers who were bound for the island of Noss. They dropped me off at the car park and took the little ferry across the narrow Sound of Noss to the island's nature reserve, where they hoped to spend the day twitching. Wishing them good luck, I turned towards the south, following a coastal walk which led back to old lighthouse that marks the entrance to Bressay Sound.

The first place of note on my map was the ominously named Muckle Hell. Apparently, this is a volcanic fissure vent – or the remains of one. Millions of years ago, gasses from volcanic activity deep beneath the earth were forced through layers of sandstone that make up most of the rocks on Bressay. These sandstones had previously been formed from sediments laid down around 350 million years ago. Today, the sea swirls dangerously

at the base of the cliffs of Muckle Hell. For those with a head for heights and a reckless regard for safety, there are several rock-climbing routes to be 'enjoyed' here, though, I have to say, I wasn't tempted.

Just a couple of hundred metres along the coast is the Mill Burn which flows from the Loch of Grimsetter. Close to where the burn tumbles down the dramatic cliffs are the ruins of an old horizontal click mill – a sure sign that this coast was once well populated. Up until the late 19th century, the eastern half of Bressay was home to several crofting communities whose barley was milled here. But the strips of cultivated land that, for centuries, created a patchwork of varied greens in the bleak landscape are long gone. A few hundred metres beyond the mill, I came to the ruins of Grimsetter and Wadbister. These are ancient places with archaeological evidence of human activity going back 4,000 years. But the continuity of human occupation was broken in 1871 – 'da year' at Walker made da uproar', as they once said on Bressay. The uproar in question was the Bressay clearances, when the laird of the time, a Miss Mouat, sent her factor, Mr Walker, to remove the tenants to make way for sheep farming.

At Grutwick, there is a more recent monument to tragedy – a stone cairn erected to commemorate the bravery of a coastguard helicopter winch man, William Duncanson. He lost his life November 1997 during hurricane-force winds while rescuing the crew from a Norwegian cargo ship which foundered on this stretch of the coast.

The coast south of Grutwick is peppered with sea caves and rock arches, the most remarkable being the triple-arched Stoura Clett stack. On the high ground opposite, lost in the long grass and furze, is the ruined settlement of Stobister. According-

ing to an old local legend, the inhabitants fled during a storm which was so severe that fish rained down on their houses.

It wasn't the prospect of fish falling on my head that spurred me on but the threat of dive-bombing bonxies as I headed past the lonely waters of the Norse-named Sand Vatn towards Bard Head, where I was amazed to discover a massive, rusting six-inch gun, which has been in place ever since it was hauled up the cliffs by a detachment of troops during the First World War.

Conflict has left its mark in a variety of ways on Bressay, just as it has done across the rest of the Shetland Islands. The rusting relic on Bard Head is one of several gun emplacements erected during the wars of the 20th century. But beneath the cliffs of Bressay is a different reminder of wartime – and how it affected the lives of the people who lived on Bressay during the Napoleonic Wars.

When Jonathan Wills took me to visit the isle of Noss on his wildlife safari boat, he also took me on a tour of the sea stacks and caves that are such a feature of the coast of Bressay. There was one cave big enough to accommodate his boat. Known as 'the Orkneyman's Cave', it also features in my copy of *Black's Guide to Scotland*, which describes it as 'a vast cavern with stalactites depending from its lofty roof, and a wonderful echo'.

A seal watched us as our boat slid into the vast interior of the cave. I looked for the stalactites mentioned by my old guide but failed to see any. Had the author been exaggerating? Had he even come to the cave to see for himself, I wondered. But one thing was certain. The cave was huge – big enough for two boats the size of Jonathan's – and there was definitely a strange acoustic inside

as the ocean swell surged and gurgled around us. Letting his boat drift, Jonathan told me that the cave had a dark secret at its heart. Before it became a tourist attraction, it was used as a refuge by Shetland men when the navy press gangs came calling. In the 18th century, the Royal Navy had a licence to kidnap men – usually fishermen – and press them into serving aboard a ship of the Royal Navy.

Taking my imagination back in time, Jonathan continued to explain. 'During the Napoleonic Wars, something like 3,000 men from Shetland served in the Royal Navy – a large and important part of the working population,' he said. 'They are nearly all listed in navy records as volunteers. But this is a lie. They weren't volunteers. They were press-ganged – kidnapped and taken against their will – to serve in the navy.'

He went on to describe how the press gangs in their large, open rowing boats would scour the coast looking for any men who might be hiding. But they never discovered the tunnel at the back of this cave where local men would seek refuge.

'Once you were in there, you were safe,' Jonathan said, indicating a dark opening I could just make out through the gloom.

'But why was it called "the Orkneyman's Cave"?' I wanted to know.

'I don't know if it's true but the story goes that a man from Orkney came here and hid from the press gang. He tried to swim out after they had gone but the water here is terribly cold – cold enough to kill a man in just a few minutes. Luckily, some Bressay men found him before he died of hypothermia. But he was in a very poor condition when they fished him out so they took him home and gave him a shot of rum. This didn't seem to work. Then one bright spark had an idea. They put the Orkney man in bed with a Bressay lass. This warming treatment worked wonders and the Orcadian recovered but, of course, he had to marry the girl who'd brought him back to life! The local story goes on to say that the Orkney man was a winner on two counts – he got himself a wife and never had to return to Orkney!'

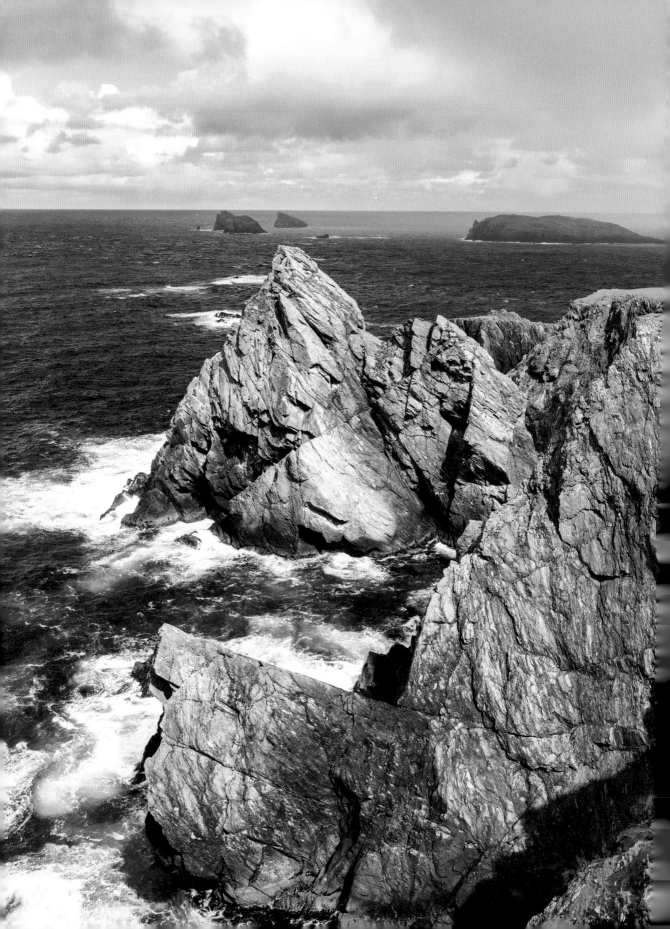

CHAPTER 2
NORTH MAINLAND

Mavis Grind, Hillswick, Ronas Voe, Isbister, Whalsay, Muckle Roe

MAVIS GRIND

Much of Mainland Shetland north of Lerwick consists of a peninsula called Northmavine, also known as Northmaven, which has its own individual identity and character. In fact, Northmavine is almost an island in its own right. Only a narrow neck of land between Sullom Voe and St Magnus Bay connects it to the rest of Shetland. The name Northmavine comes from the old language of the Vikings. *Nord mæveiðs* means 'the land north of a narrow isthmus'. The land bridge in question is not much more than 30 metres wide at its narrowest and bears the curious and wonderfully evocative name of Mavis Grind. Mavis isn't, as you might think, a girl's name. The word derives from the Old Norse *mæveið* for 'isthmus'. *Grind*, while having nothing to do with provocative dance moves, comes from another Old Norse word for 'a gate' or 'an opening in a wall'. So Mavis Grind means 'the opening at the narrow neck of land'.

To take the main road west across Mavis Grind is to enter another world. The land beyond is wild and rugged and rises to Ronas Hill. At 450 metres, this is the highest point in Shetland. Its red granite is a characteristic feature of much of Northmavine,

Opposite. The Point of Fethaland, North Roe.

which boasts some of the most magnificent, rugged coastal scenery anywhere in the islands. The countryside here was described a century ago as 'the largest, wildest and most beautiful parish in Shetland' and my old *Black's Guide* from 1886 says that Northmavine possesses 'the finest rock scenery in Shetland. Nowhere along the whole coastline of the islands is there to be found a more varied collection of fantastic columns and water-worn sea stacks.'

To get to this fabled land, I headed north from Lerwick on a day of preternatural gloom. A thick fog had descended, smothering the landscape in a blanket of grey. It was also raining and blowing a gale. I could hardly believe that the mist persisted, given the strength of the wind. But the fog was not the kind you encounter in more settled climates – a thin vapour which disperses with the heat of the sun or a sudden breeze. This was thick maritime fog – a huge mass of dense condensation that was being blown off the Atlantic in an endless stream. I was told that these conditions can last for days in Shetland. I rather hoped not as I struggled to make out distances greater than five fence posts ahead. I kept on reminding myself that this was high summer but, in the chill half-light, it was almost impossible to imagine that this could be true.

Leaving Lerwick, I took a minor road out of town, following in the footsteps of my Victorian guidebook which described the mist-wreathed landscape beyond the last houses as the *scattald* or common land where crofters once grazed their animals and dug peat for their fires. Beyond the *scattald* was 'The Ladies' Mile', a stretch of ground which, according to *Black's Guide*, provided 'an excellent place for a canter'. Today, the road is called Ladies Drive, which presumably recalls those polite days of carriage driving, when crinoline-clad members of the female sex thrilled at speed but with minimum jolting.

Joining the main road north, I headed through the fabulously named Windy Grind and hoped for the view promised by *Black's*, which insisted that 'a beautiful and extensive prospect north is to be had'. But not today – not in the thick sea fog that continued to envelope the islands. However, I derived some comfort from the thought that I was close to the Viking-sounding Lax Firth, which I judged, from my knowledge of Norwegian, to mean 'salmon fjord'. Etymologically, I may have been correct but apparently this arm of the sea has long been famous for sea-trout fishing.

In driving rain, I continued my journey north on the main road towards Tingwall – the place where the old Shetland parliament or public assembly was regularly held during the centuries of Norse control. Today Tingwall is less famous for flights of oratory or legal speechifying than it is for flights to inter-island destinations, this being the location for Shetland's very local airport – or perhaps airstrip is a word that more appropriately describes this low-key aviation hub. From the Portakabin-styled terminal building, the Shetland Islands Council operates an air service (currently contracted to Airtask Group) linking several of the outlying island communities. When I last visited Tingwall, you could catch a flight to Foula, Fair Isle, Papa Stour and the Skerries. The populations of these remote islands are small, which explains the diminutive size of the aircraft deployed to run the service. For many years, eight-seater Islander aeroplanes have been used to provide the vital link to the remotest and most vulnerable communities in Britain. Not that there was much flying going on when I drove past. The airfield was barely visible through low cloud and rain.

A few kilometres further on, I was visually reminded of the Scandinavian connection at Voe, a small village nestling at the head of Olna Firth. The red-painted wooden buildings that clustered around the pier where a fishing boat was moored resembled the coastal communities I'd know as a boy in Norway when I sailed with my father among the fjords and skerries of the west coast. To enhance this exotic illusion, there were several trees growing around the village. In the almost treeless landscape of Shetland, it was a surprise to see them. They almost seemed to be thriving in the sheltered fold of hills where the land met the water. The sight of Voe across the waters of Olna Firth gave me a sudden and unexpected rush of nostalgia. Thinking fondly of Norway, I made my way down to the pier, where to my astonishment, a group of latter-day Vikings were drinking and cavorting outside the local hostelry, the Pier-head Restaurant and Bar. The Vikings weren't alone. They seemed to be enjoying the company of a couple of police women, Elvis, a large rabbit, Spiderman and several other strangely clad figures of whose provenance I was uncertain. I soon gathered that I had stumbled across a fancy dress party. For some reason, which I have never fathomed,

Shetlanders seem to love dressing up. Of course, the biggest fancy dress date in the calendar is the fire festival of Up Helly Aa. Outside this mid-winter festival, stag nights and hen nights provide the most frequent opportunities for the islanders to don outrageous garb. Whenever I've visited Lerwick, there seems to be a prenuptial celebration going on. I remember on one occasion being followed by a hen-night posse with a police theme. The ladies in question were dressed as officers of the law and went from pub to pub 'arresting' unsuspecting gentlemen, coshing them over the head before handcuffing them. Release was only possible after a forfeit – usually a kiss or a drink. Or both. Fortunately, I was able to avoid being apprehended by the law – that time around at least.

The dreich weather didn't seem to dampen the spirits of the revellers at the Pierhead Restaurant and Bar. Despite their soggy costumes, they were obviously made of sterner stuff. Leaving them to brave the elements, I continued on my way to Mavis Grind, which greets the traveller with a triangular sign warning motorists that otters might be crossing the narrow neck of land carrying the road. Otters, know locally as *dratsi*, are common in Shetland and particularly here where Mavis Grind enables them to cross from west to east – from the waters of the Atlantic in the west, to the North Sea waters of Sullom Voe in the east. Today, the *dratsi* are continuing to do something that the fisher folk of Shetland were once accustomed to doing – apparently right up until the middle of the 20th century. To avoid the dangerous seas of 'Da Wastside' (the west coast), fishermen favoured taking the short cut across the Mavis Grind, where only 30 metres of land separate the two bodies of water. This was something that the young medical

student Edward Charlton wrote about in his 1832 journal: 'At Mavis Grind we unloaded the boat and having first carried over our luggage, the craft itself was dragged by our united exertions across the narrow isthmus, not more in this spot more than a hundred yards in breadth.' I'm sure that Charlton would agree with the boast made in these parts that Mavis Grind is unique. Nowhere else in the world is it possible to throw a stone from the Atlantic to the North Sea!

It takes just seconds to cross the land bridge. A large sign on the hillside opposite proclaims 'Welcome to Northmavine'. Things were looking up. The sea fog which had bedevilled me all day was finally beginning to lift as I headed inland across a boggy moor. In this bleak wilderness, a mysterious discovery was made in May 1951 by two men who were working a peat bank near the junction with the single-track road that leads down to Gunnister Voe. Lying in a shallow grave, they discovered human remains and a remarkably well-preserved set of clothing, which experts have since dated to the late 17th or early 18th century. However, despite the mummifying properties of peat, which impedes decay, there was very little of left of the body which once wore the garments. A fingernail, a toenail and a few fragments of bone were all that was left of the individual who lost had his life all those centuries ago. From a few strands of his hair found in the woollen hat, it seems the owner was dark haired but there is little else to help picture him. The clothes and artefacts fared much better however and represent a find of national significance. Together they make up one of the few complete outfits of an ordinary person who lived three hundred years ago. All the clothing was made of wool and the many layers that were once worn suggest that Gunnister Man,

The road to Northmavine.

as he's come to be known, was dressed for winter – although, to be fair, Shetland summers can be on the chilly side and were even chillier in the 17th century. He wore a woollen shirt, woollen coat and breeches and outer jacket, two woollen caps, woollen stockings and gloves and *rivlins,* or hide shoes. A woollen purse was also discovered with a patterned design that's considered to be the earliest physical example of Fair Isle knitting.

Among other artefacts found with the clothing were several silver coins from Sweden and the Netherlands, with dates ranging from 1681 to 1690. A quill pen and inkhorn suggest that Gunnister Man was probably literate. But he was not a wealthy individual. His clothing was patched and threadbare in places. Intriguingly, he had pieces of material sewn into his jacket so that he could make running repairs. Perhaps unsurprisingly, the 17th century was a time of make-do-and-mend.

The clothes and the artefacts found with them offer a rare glimpse of life in 17th-century Shetland. But so much remains mysterious. Who was Gunnister Man? Why was he buried in a shallow grave and not in a kirkyard? How did he die? Was he murdered? And where is the rest of the body? There's enough sleuthing in these questions to keep a Shetland murder mystery on the boil for a long time. From his clothing, it appears that Gunnister Man may have been a foreigner. His hat and his breeches are similar to ones worn by Dutch fishermen from that time. The coins in his purse are also foreign. But Shetland was at the crossroads of European trade and contact with ships and crews from across Europe and Scandinavia was common. The value of coins depended on their silver or gold content – not on which sovereign's head was stamped on them – so just because his money came from overseas it doesn't

follow that Gunnister Man did too. But what was he doing on the moor? The fact that he carried a quill and ink must be significant. Some people have speculated that he might have been a clerk on his way from the old Hanseatic trading post at nearby Gunnister Voe. These trading posts or *böds* were where Baltic merchants used to exchange goods for Shetland fish and other commodities. Did he get lost in bad weather and die of hypothermia as he made his way from one trading post to another? If so, why was his body not given a decent burial, instead of being covered up in a shallow grave? If he was murdered, then what was the motive? If he was robbed, then it wasn't for the money he was buried with. The questions keep piling up. The more you get to know Gunnister Man, the more mysterious he becomes, which is why it's well worth getting better acquainted with him by visiting the Shetland Museum in Lerwick. Here, a permanent display features a mannequin posing as Gunnister Man dressed in carefully researched replica clothing.

HILLSWICK

The village of Hillswick on the western shore of Ura Firth may well have been a place familiar to Gunnister Man because there was once a Hanseatic trading post here. However, it seems that the Hillswick *böd* was a more established business than the one at Gunnister Voe. Known locally as 'Da Böd', this 300-year-old building, which overlooks the pebbly beach at Hillswick, has the longest commercial history of any building in Shetland. It was originally established by a Hamburg merchant Adolf Westerman. His two ships, *St Johann* and *St Peter*, traded with local crofters and fishermen every summer. Over the following centuries, the *böd* has been used for knitwear manufacture, weaving, fishing, coopering and coffin-making. It has also served as a shop, a post office and a pub and is now run as a cafe and wildlife sanctuary.

Hillswick was once the favourite holiday destination for the early traveller Edward Charlton, who came here to hunt and fish during the 1830s. This part of Northmavine stirred the young medical student's soul. In his journal, he wrote fondly of how his thoughts often returned to the idyllic scenes of his sporting adventures. 'It was on Hillswick, its wild and singular coast, its mineral treasures and wild dark lochs teaming with trout, that my mind has ever been fixed.' Charlton visited Hillswick from 1832 onwards. At that time, there was no hotel offering travellers accommodation so he lodged at the 'mansion' of Hillswick House, which adjoined the Hanseatic *böd*. However, the arrival of steam-powered ships later in the century opened up the west side of Shetland to tourists who arrived on board steamers operated by the North of Scotland, Orkney & Shetland Steam Navigation Company, which encouraged visitors to stay in its newly opened St Magnus Hotel.

Opening for business in 1900, the St Magnus Hotel – now the St Magnus Bay Hotel – is still standing and has become a focal point for Hillswick, both visually and socially. Built entirely of wood, this rambling old building has a distinctively Scandinavian appearance and was once an exclusive resort for the discerning tourist who came to Shetland in search of the islands' isolation and wild beauty.

In the wood-panelled hotel lobby, I met Andrea Manson who owns and runs the hotel to find out why such a remote place was once so popular. As we climbed the stairs to the reception rooms

The St Magnus Bay Hotel, Hillswick.

above, Andrea gave me a potted history of the St Magnus.

'It's all made of wood – Norwegian wood from Norway,' she said.

'I can feel a song coming on,' I joked.

'Yeah, "Norwegian Wood"! I think I've heard that one before! But it's true. All the components were constructed in Norway and then shipped to Glasgow and re-assembled. You could say it was the original Scandi flat-pack.'

'Was it designed as a hotel?' I asked.

'No. It was commissioned by the Norwegian trade delegation as part of their display at the Glasgow International Exhibition of 1896. Later the North Scottish Shipping Company bought it, took it apart, moved it to Shetland and turned it into this lovely, characterful hotel!'

In the panelled residents' lounge, Andrea was keen to show me the visitors' book, which dated back to the turn of the last century. Among the many signatures were some celebrated and historic names. 'The rich and the famous came here – people with money. The poet WH Auden was a guest – with his boyfriend. They'd caused a stir in London at the time and came here for some peace and quiet and to keep out of the public eye. But goodness knows what the folk of Hillswick thought about it!'

Among the other visitors' signatures, I could make out the name of Earl Mountbatten. Even the Iron Lady, Margaret Thatcher once graced the rooms of the St Magnus Hotel. 'She came here in 1976 when she was just an ordinary MP before she reached the dizzy heights of Prime Minister,' Andrea

remarked. I was intrigued to see the former PM's small, neat handwriting. I noticed too that she had not made any comment about her visit – or about the comforts of Hillswick. Nor had she given her address. Perhaps she'd been professionally and personally of 'no fixed abode' back in 1976 – mobile but with an eye to moving onwards and upwards.

At this point in our conversation, Andrea's husband, who worked offshore, came into the room brandishing an old-fashioned chamber pot. 'Every room is fully en-suite these days but this was how guests answered the call of nature when the hotel opened.'

'That must have been a bit whiffy,' I replied.

'Probably and that's no doubt why it was called a "gesunder".'

'From the German *gesund* for "healthy"?' I asked.

'No. Because it goes under the bed!'

Later, as Andrea guided me on a tour of the property and its renovations, I was impressed by her cheerful determination to restore the old hotel to its former magnificence – a big task in this remote corner of Shetland. Out in the garden, she was wanted to show me something 'queer', as she put it. This turned out to be some old wire fence-strainers on a dilapidated post. They looked very rusty and were quite unremarkable, until I noticed that each was stamped with the swastika of the Nazis.

'Do you think it was a secret sign during the war? Do you think Nazi sympathisers could have had something to do with it? There were lots of strange guests coming here in the 1930s,' said Andrea with a note of anxiety in her voice. I reassured her that this was highly unlikely and reminded her that, centuries before the Nazis ever came to power in Germany, the swastika had been

a decorative motif from India to China.

I left Andrea contemplating the rusty swastikas on her fence and set off to explore the Ness of Hillswick – a promontory with many of the characteristics of an island. It lies a short walk to the south of the village and was well known to the medical student Edward Charlton. This is where he came with his gun to shoot ornithological 'specimens' back in the 1830s. Standing on the cliff top looking west, I admired the view, just as Charlton had done two centuries ago. Lying six kilometres offshore were the small islands of Stenness and the Skerry of Eshaness, separated by a narrow channel called Whilse Sound. In front of them, Dore Holm with its amazing natural arch that looks like a flying buttress. Closer to Hillswick Ness and dominating the view is a series of spectacular sea stacks known as The Drongs – gravity-defying, sea-worn pillars of rock rising improbably from a grey, lumpy sea. In 1832, Charlton took a rowing boat around them on his way to spend the night with friends who lived at the mansion house of Tangwick Haa on the peninsula of Eshaness. The day was one of strong winds and rough seas and he was startled by the vision of several fishing boats, looking for all the world like small Viking longships, suddenly appearing through the mist. They were making their way to the '*haaf* fishing'. *Haaf*, like the modern Norwegian word *hav*, comes from an Old Norse word meaning 'the deep sea'. The fishing grounds these 18th-century decedents of the Vikings were making for lay up to 40 nautical miles west of Shetland.

Tangwick Haa, where Charlton spent time with his friends the Cheynes, is nowadays a museum, telling the story of Northmavine. Among the pictures and artefacts are models of the traditional boats that went to the *haaf* fishing. There

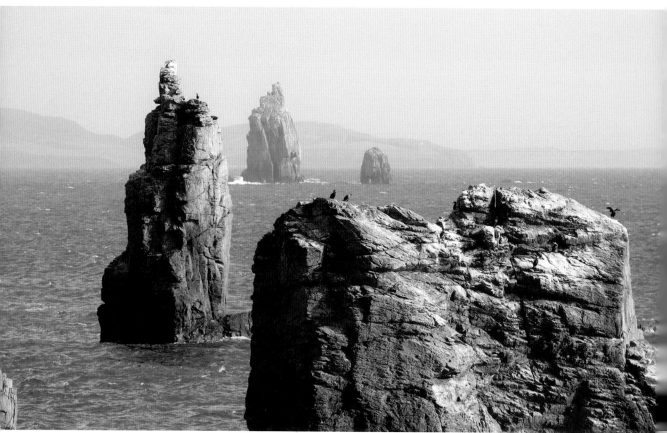

The spectacular sea stacks – The Drongs – near Hillswick Ness.

is also a display of the replica knitted garments worn by Gunnister Man.

From Tangwick, I followed the road inland to explore more of Eshaness. Close to the car park at the lighthouse, there's a cliff-top walk which takes in some of the wildest scenery in the whole of Shetland. The coast here is exposed to the full might of Atlantic storms, which drive mountainous waves against the cliffs. Over the course of millennia, the rocks have been battered, torn and eroded into contorted sea stacks, geos (inlets or deep coves in the cliffs), collapsed sea caves, tunnels and cavernous spaces deep inside the earth. In 2014, geologist Jonathan Swale made an astonishing discovery. At the back of Calder's Geo, a deep inlet in the cliffs to the north of the lighthouse, is a large sea cave. Jonathan paddled his kayak into its dark maw. Exploring the enormous space inside, he used a borrowed laser rangefinder to measure the dimensions of the cave, which turned out to be a massive 5,600 square metres. This is nearly twice the size of the famous Cheddar Gorge cave in Somerset, making Calder's Geo by far the biggest cave in Britain.

Ronas Voe looking towards Ronas Hill.

RONAS VOE

Ronas Voe is a deep fjord north of Eshaness. It almost cuts through to Quey Firth on the east coast of Mainland. The voe gets its name from the high granite summit of Ronas Hill to the north, which plunges steeply into the narrow sheltered waters below. The name Ronas derives either from *rauðr*, the Old Norse word for 'red', which could refer to the pink granite rocks that protrude through the thin soils, or from the Old Norse *røn* which describes the stony ground or scree on the summit. Either way, the single-track road that leads down to the voe and skirts the southern shore makes a picturesque approach to a sparsely populated corner of Northmavine. But a hundred years ago, the scene was altogether different – one of industrialised slaughter.

In 1903, two whaling stations were built in the Ronas Voe, bringing the total number in Shetland to four. The money and the impetus for these developments came primarily from Norway, where new legislation had banned similar whale processing factories on the Norwegian coast. With the blessing of the British government, the Norwe-

gians looked west and set their sights on Shetland where they invested heavily at Ronas Voe, Collafirth and in Olna Firth.

The whaling stations at Ronas Voe, which have almost completely disappeared except for a few low brick walls, were run by two rival outfits. In April 1903, the Shetland Whaling Company began operations with a single whale catcher – a boat called the *Frithjof*. A few months later, a second operator, the Norrona Company, took up the hunt with its whale catcher, *Norrona*. By the end of the first season, which finished in September 1903, between them, these two whale catchers had landed and killed over 120 whales. The whale carcasses were winched ashore at the whaling station where a mostly Norwegian workforce stripped off the animals' thick blubber in a process known as flensing. The blubber was then boiled to extract the valuable whale oil which was used in a huge range of industrial and chemical processes from lubricants, automatic transmission fluid, industrial cleansers and cosmetics to photographic printing materials. After flensing, the whale body, or *crang*, was further processed at the factory. The meat was cut into manageable lumps. A conveyor belt then transported it to huge boilers where it was rendered and ground into meal. This was then dried in kilns and packed into 200-kilogram bags and exported for use as fertiliser or animal feed – an absolutely tragic end for such noble and magnificent creatures.

Over the following decades, thousands of Atlantic whales met the same brutal fate at the two factories on the shores of Ronas Voe. All the profits went to the Norwegian-owned companies that ran the operations and, with the exception of a few low-skilled jobs offered to locals, Shetland derived very little benefit from the slaughter of

its mighty creatures. At Tangwick Haa Museum, there is an exhibit detailing some of the whaling activity from that time. One young employee tells of how he either walked or cycled three miles every morning to work. His shifts were long – from six in the morning to six at night, for which he received the princely sum of £1 per day. Not that he complained – this was considered good money, added to which were opportunities for overtime. However, the Norwegians, who occupied all the specialist positions at Ronas Voe, remained the best-remunerated employees on the payroll.

That young worker might have been happy enough with his wage of £1 a day but other folk were growing increasingly angry. The whaling stations, with their belching chimneys, the stench of boiling blubber and rotting whale carcasses, were polluting the beaches and creating environmental havoc. The local fishing community also complained that blood and offal dumped into the sea were attracting sharks that frightened away the shoals of herring they depended on. Earlier, in Norway, this had been precisely the same complaint made by Norwegian fishing communities when they forced the whaling companies to move to Shetland in the first place.

Eventually the authorities began to listen to the many complaints about the whaling stations in the voe. Restrictions were put in place. Whales had to be processed within 60 hours of slaughter. Harpooning could only take place beyond a three-mile offshore limit and a ban was imposed on whaling between the months of November and March. By 1920, both whaling stations in Ronas Voe had closed down.

Although Shetlanders might have objected to the Norwegian whaling presence in Ronas Voe,

they had been taking part in whaling for many years. For decades, Shetland men had crewed ships heading into the wild North Atlantic where they hunted for whales and seals in the icy waters around Greenland. And, nearer to home, there was the tradition of hunting pilot whales by driving them ashore. This practice was known in the dialect of the islands as 'caain' whales' – to *caa* means 'to drive a herd of animals'. The whales were rounded up and forced to beach in shallow water where they were killed for their blubber. In 1741, a huge pod of 360 caain' whales was driven ashore at Hillswick. In the bloody aftermath that ensued, hundreds of barrels of oil were produced from the blubber flensed from the corpses of these unfortunate creatures. Happily, attitudes have changed enormously since then. When 40 pilot whales came ashore in a mass stranding in 1983, local people fought for hours to refloat and save them. Sadly, only eight survived. In 2013, another large pod of pilot whales was spotted close inshore and appeared to be in danger of stranding in Firths Voe. Again local people came to the rescue. A boat from the oil terminal at Sullom Voe was called out to assist and managed to drive the pod offshore and into deeper water.

In Norway today, whale meat is considered by many a heritage food and eating it is far from taboo – some might even say that it's a patriotic act to eat it. My father used to buy *hvalbiff* (whale steak) regularly from the fishmonger in Bergen. He'd cover the thick steaks of the deeply dark red meat in cling film and then wrap them in a paper parcel, which I remember would leak blood on the journey home. I never really acquired a taste for *hvalbiff*, although, when stewed, it was more like real beef than anything else I'd ever tasted from the sea.

Although the custom of eating whale meat is undoubtedly an ancient one in Norway, by the 20th century, modern hunting methods had made it a cheap and readily available source of protein. Industrial-scale whaling was pioneered in Norway by Svend Foyn. In the 1860s, he developed a new type of harpoon gun and built a large steam-powered whaling ship which brought him success and wealth. His argument for hunting these amazing creatures was a simple one: 'God had let the whale inhabit [these waters] for the benefit and blessing of mankind, and consequently I considered it my vocation to promote these fisheries.'

Now, in the 21st century, Norway is one of only three nations that continue to hunt whales – the others being Japan and Iceland. Every year, the Norwegian government grants licences for up to a thousand minke whales to be culled annually. However, in recent years the whaling fleet has declined and there are fewer than 20 boats that continue to hunt in Norwegian coastal waters. This decline is surely set to continue – and hopefully not just because there are no whales left. In time, I fully expect Norway to finally realise that hunting whales totally undermines the country's environmental credentials – and its claim to be the greenest country in Europe, if not the world.

Unless you have a boat to ferry you over to the north shore of the Voe, which was once home to Shetland's whaling industry, the usual route to the summit of Ronas Hill is by taking the road east to Collafirth and then climbing Collafirth Hill, easily identified by the two radio masts adorning its summit. According to Edward Charlton, writing in 1832 about his travels in Shetland, 'Roeness Hill', as he called it, was one of the last refuges of the rare 'skua gull or bonxie'. Charlton was aware of the bird's endangered status and

wrote that 'Foulah and Roeness Hill in Shetland are the only British locations in which it breeds, and if not carefully protected, it will soon be totally banished from there'. However, this sentiment didn't prevent the young student from grabbing his gun, and rushing off to 'wage war on the Skua Gulls in order to obtain specimens'. Fortunately, there are many more bonxies today than there were in 1832 when Charlton aimed his gun at the few that were left. In fact, you can now expect to be dive-bombed by these fearless birds as you make your way across the high, trackless moorland from Collafirth Hill, west towards the distant summit of Ronas Hill.

Scrambling over rocks in a boulder-filled landscape that reminded me of the tundra of northern Norway, I came to the first summit of Mid Field, which is marked by a cairn. From here, the route dropped west to a small lochan which marks the saddle of Shurgie Scord. As I made the final pull up to the summit of Ronas Hill, the views really began to open up. From the cairn which marks the highest point in all Shetland, the panorama included all of Northmavine, the lochan-studded desolation of North Roe, the islands of Foula, Unst and Yell and, in the far distance, the rocks of Muckle Flugga. And beyond that is nothing but the sea and the wide blue horizon until the ice floes of the Arctic.

About 40 metres to the south-east of the summit is a much bigger cairn. What at first just seems to be a pile of rocks is in fact a Neolithic chambered cairn. At 450 metres above sea level, it is amongst the highest Neolithic structures to be found in Britain. Beneath a stone lintel, a narrow, dark passageway leads to the heart of the cairn – a coffin-sized chamber with a metre-high ceiling made of stone slabs. This is not a place for the faint-hearted, claustrophobic – or superstitious. Suffering from all three conditions, I contented myself with just poking my head inside the dark interior.

ISBISTER

The tarmacked road to the northern tip of the Mainland ends at the crofting township of Isbister. From here a rough Land Rover track continues for three kilometres over the hill and moor to a narrow isthmus where a double-sided shingle beach separates the Isle of Fethaland from the croft lands to the south. Facing the sea on both sides of the isthmus are the ruins of up to thirty drystone buildings. These once made up the old fishing station of Fethaland, which archaeologists believe was established in the 15th century. In its heyday, Fethaland was said to be one of the busiest *haaf* fishing stations in Shetland, until it was finally abandoned in 1906.

Local man Douglas Murray moved with his parents into a nearby croft in 1944 when he was just a two-week-old baby. He told me that, back in the late 19th century, boats and crews arrived every spring for the short *haaf* fishing season which lasted from May to August. 'The boats were usually anchored in the East Wick. They were big, open, wooden boats with a crew of six men. They were clinker-built and, for many years, were imported from Norway. Shetlanders called them *sixareen* because they were equipped with six oars – which they needed if the wind wasn't blowing or, more usually, blowing in the wrong direction. The *haaf* fishing grounds were in deep water a long way offshore. The boats would sail and row up to 40 miles out before the men dropped their baited lines, which could be seven miles long.

The abandoned fishermen's huts at Fethaland, Isbister.

Mostly they caught cod and ling.'

We looked at the roofless stone buildings above the beach which once provided accommodation for the crew. 'We ca' them *böds* – booths or huts,' said Douglas. 'Each boat had a *böd* where the men would stay when the boat wasn't at sea. Every year at the start of the fishing, they'd have to put a turf-and-straw thatch on the roofs.'

He went on to paint a picture of the activity that once made the shingle beach a hive of industry. 'The fish were washed and put on a table where they were split so they would lie flat. They were then salted and left to dry on the stones of the beach. In the old days, the fish were traded with German Hanseatic merchants for the things fishermen needed but couldn't get on Shetland.'

This marks the northern entrance to Yell Sound, which leads in turn to Shetland's longest voe, Sullom Voe. This was a sleepy place until the Second World War, when RAF coastal command stationed seaplanes here. To protect these U-boat hunters, a runway was built at Scatsta, where RAF

fighter escort planes were based. After the war, these facilities were abandoned and Sullom Voe reverted to its quiet and remote old self – until oil was discovered in the North Sea in the late 1960s. Since then, Sullom Voe has become synonymous with the all-important oil industry in Shetland.

In 1973, work started on the 1,000-acre site on the north-eastern shore of the voe to build one of the largest oil terminals in Europe. Given the remote location, this was a major civil engineering and logistical achievement. Everything had to come in by sea and a huge jetty was built for this purpose. When the terminal was under construction, an army of 6,000 workers was employed on site. Many were accommodated on board the converted New Zealand ferry, *Rangatira*, which was moored just offshore.

The Sullom Voe terminal took until 1981 to complete although the first oil to come ashore arrived in November 1978. But it isn't a refinery – Sullom Voe is a storage facility and shipment hub. The deep waters of the voe can accommodate the biggest oil tankers in the world. They take on the oil, which is piped from the Brent and Ninian oilfields. These are located far out in the North Sea, midway between Shetland and Norway. Once full, the tankers transport the oil to destinations around the world for refining and processing. At the height of North Sea oil production, Sullom Voe handled a quarter of the total oil extracted from British waters, an astonishing 7 billion barrels annually. In more recent years, the terminal has a begun handling natural gas and oil from discoveries west of Shetland. The gas is burned at an onsite gas turbine power plant, which produces over 40 per cent of the islands' electricity needs.

Today, Sullom Voe and the reopened airfield at Scatsta are busy places, employing over 500 people. To some, these industrial developments might seem something of a blot on the landscape, with gas flares illuminating the night sky, and frequent helicopter and aeroplane take-offs and landings disturbing the quiet and solitude normally associated with the Shetland Islands – but the oil-related developments here and elsewhere in Shetland have brought the islands considerable wealth. Perhaps unusually, this financial success was achieved by a far-sighted local government initiative. When oil was discovered in the North Sea in the 1960s, it quickly became obvious that the Shetland Islands would play an important part in the exploitation of this newfound resource. Cannily, the council secured special powers from parliament to protect the interests of the islands and their 22,000 inhabitants. A bill was passed in 1974 which gave the Shetland Islands Council unique powers ahead of big oil companies and the government. One of the first things the council did was to set up an oil fund. Under the terms of a 'Disturbance Agreement', oil companies had to pay compensation for the disturbance oil-related activity caused traditional ways of life. Over the course of the next 30 years, millions of pounds were paid into the fund. This money was then used to pay for such things as leisure centres and care homes. The oil revenues also allowed the council to reduce local taxes and to improve the general infrastructure of the islands. This perhaps is why the roads in Shetland seem to be the best kept in Scotland.

WHALSAY

Whalsay lies about five nautical miles east of the Mainland ferry terminal at Laxo on the Derry Voe. The island gets its name from the language of the

Sullom Voe oil terminal.

Vikings – *hvals øy* means 'whale island' in Old Norse. The principal settlement and port is Symbister, which nestles around a sheltered bay on the western end of the island. Getting to Whalsay today is easy enough. In addition to the regular service from Laxo, another ferry service connects the island to Vidlin on the Mainland. The crossing takes just over half an hour but, in the past, the journey was less straightforward. Up until the middle of the last century, there was no pier big enough to take the steamer from Lerwick. In those days, passengers had to disembark using small craft known as 'flit boats'. Some more important passengers were even carried ashore in the strong arms of Whalsay fishermen in order to keep their feet and footwear dry. Rather disappointingly, perhaps, there was no one to carry me ashore when I arrived. Of course, these days landing on Whalsay is a straightforward affair. A walk down the ramp of the roll-on roll-off ferry ensures dry feet when stepping ashore.

Once on dry land, the first thing that struck me about Whalsay was how busy the place seemed. There were numerous fishing boats crowding the quay – from the smallest creel boats, to mighty pelagic boats weighing thousands of tonnes. Unlike some of the other outlying islands in Shetland, Whalsay has a growing population of over a thousand and nearly everyone here depends in some way on the sea and its riches. 'Whalsay is

known locally as "the bonny isle",' I was told by an islander on the ferry over from Laxo.

'It's got more millionaires than the city of London as a percentage of the population. And when you get ashore, you'll see some big, fine houses.'

'Where does all this wealth come from?' I wanted to know.

'Pelagic fishing – fishing right out on the open sea as opposed to fishing close to the shore. The big boats you'll see cost at least £15 million. Each crew member owns a share in the boat, plus a share of the fishing quota, which in itself is worth a fortune. And they only fish for three months of the year.'

'Nice work if you can get it,' I said.

'Aye, right enough, but for a lot of the men it's been a long haul getting to where they are today.'

The boats I surveyed in Symbister harbour represented the collective wealth of the island – and its dependence on the sea in all its fickle moods. But the apparent affluence and independence of the fishermen today is in stark contrast with the lives of their forebears.

Until quite recent times, pretty much until the turn of the last century, every aspect of life on Whalsay was controlled by the laird up at 'The Haa', as the big house is called. Today, The Haa still looks down on the harbour from its lofty position on the hill above Symbister.

At one time, a single family owned the entire island. The Bruce family arrived on Whalsay in the 16th century and immediately dominated the lives of everyone – almost, it's said, to the point of tyranny. Tenants were bound to them in an almost feudal way. Fishermen were forced to sell their fish to the laird, who fixed the price in his favour. He also owned the only shop, where

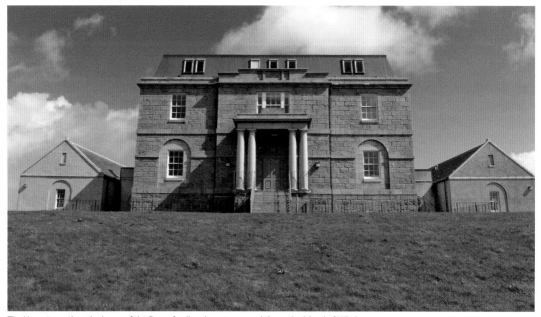

The Haa, at one time the home of the Bruce family, who once owned the entire island of Whalsay.

islanders were driven into debt slavery by the high prices charged to their accounts. Things became worse in lean years when the harvest or the fishing was poor. Failure to settle debts created an excuse for the laird to force his tenants from the island. The laird's hard-heartedness made life unbearable for ordinary people – so much so that, according to a local legend, a curse was put on the entire family.

The curse was made in the mid 19th century after two brothers had defied the laird and signed aboard a Greenland whaling ship. Instead of being forced to fish for their landlord for a pittance, they made good money. The laird was furious and refused absolutely to ever allow the brothers to set foot on Whalsay again. The news of their exile broke their mother's heart. She begged the laird to relent but he turned his back on her and she, in turn, cursed him, saying, 'It will come to pass that no Bruce will ever live on Whalsay. Your proud mansion will stand empty and village children will play freely in the grounds.'

This was a powerful curse, which some local people believe came true. The last Bruce laird died without an heir in 1944. The Bruce family left The Haa, which then began to deteriorate in the wild climate. For years it was battered by the weather but eventually it was saved from ruin in the 1960s when it was converted into the island school, where children 'play freely in the grounds'. The Bruce family's grip on Whalsay had come to an end – perhaps hastened by the brave woman who spoke out against authority with a curse for their cruelty.

Behind the old Haa, which resounded with the clamour of busy classrooms as I passed by, is a long, low building. This was formerly an outhouse of the Bruce family home. Now, it's the island's heritage centre, stuffed full of all kinds of historical artefacts – many which belonged to the Bruce lairds. When I visited, there were two permanent exhibitions – one dedicated to the history of fishing on Whalsay and the other examining the influence of the Bruce lairds on the island. In an adjoining room I met with Joan Poulson and several other local women who had come to introduce me to the famous Whalsay fare of bannocks and mutton.

As I tucked into my hearty meal, Joan explained that, traditionally, bannocks and mutton were served at Whalsay wedding feasts when they would have been presented as a hot dish. Before the wedding, the men folk cooked the mutton in a big iron pot suspended over an open fire. The women, who made the bannocks on a 'girdle' or griddle, also prepared the venue for the wedding feast. The bannocks were dunked into the mutton juices or 'brewy' to soak them up.

'It was very traditional and very delicious,' said Joan as I helped myself to a second bannock. She watched me out of the corner of her eye and then said pointedly, 'I got up very early this morning to make them. I'm very busy lambing at the moment and don't have much free time.'

'Lambing?' I said jauntily. 'And here we are eating mutton.'

Joan laughed. 'I know. I kind of go off it at this time of the year!'

In the past, feasts were few and far between on Whalsay so mutton and bannocks must have been a rare treat during the long years of poverty that continually gripped the island. But despite the hardships endured by fishermen, either at sea or inflicted on land by their rapacious lairds, there remained a spirit of independence which was expressed in the humour and intelligence of Whal-

say folk. Perhaps it's some quality of the air in these northern islands that encourages such an attitude to life – and perhaps, too, it was this same clear air that encouraged an unlikely visitor to the island to make his mark on Scottish literature. In 1933, the radical, contrary, irascible poet Christopher Murray Grieve, known by his pen name Hugh MacDiarmid, moved to Whalsay with his wife Valda and their baby son Michael.

Outside Symbister, at a place worryingly called Sodom, I met up with Jacqueline Irvine who led me under grey skies to the house where MacDiarmid spent the best part of a decade living in poverty and obscurity. Jacqueline reminded me that the poet's real name was Christopher Murray Grieve. However, on Whalsay, locals called him by another name – 'Alt' Grieve or Old Grieve, on account of his aged appearance and unsociable ways. But, in fact, Alt Grieve was much younger than he looked in photographs taken at the time. When he moved to Whalsay, he was only 41 years old but alcoholism had taken a toll on his health, which explains why he came to Whalsay in the first place. At the time, the god-fearing islanders were alcohol-free. Whalsay was a 'dry' island and it was well nigh impossible to get a drink, making it the perfect place for an alcoholic to recover and dry out.

I asked Jacqueline why the place where she was taking me to had such an unfortunate name. Why Sodom? Apparently in the Shetlandic dialect it's called *Sudheim* or 'south home'. But perhaps the poet might have taken some perverse, wry pleasure in his address – Sodom sounding like an appropriate place to be for a man whose moral reputation had frequently been called into question.

Today, the property the poet rented has been converted into a cosy walkers' bunkhouse called the Sodom Böd but, during the 1930s, life here must have been a bleak experience. There was no electricity and no running water, which would have been hard for a couple more used to the hustle and bustle of city life. According to their neighbours, the family was so poor that Valda and the boy Michael were often seen scavenging for potatoes in nearby fields. Perhaps this grim existence explains MacDiarmid's description of their adopted island as 'Wind-blasted Whalsay, sodden with the peat of forgotten centuries . . . a bucket or two of earth in the chilled lapping bitterness of the North Sea.'

The hardships endured by the family also fed into MacDiarmid's political thinking, which was informed by the ideas of Marx, Lenin and international socialism, so I was surprised to learn that this communist-inspired poet liked to make social calls on the island's gentry.

'He used to go to dinner with the laird and they would play bridge,' said Jacqueline as we warmed ourselves in front of the fire inside MacDiarmid's former home. 'He would also socialise with the doctor and they were often invited to the manse to visit the minister.'

'Isn't that odd that an avowed socialist should prefer the company of his class enemies to mingling with the poor?' I remarked.

'Well, he was a writer and an intellectual and craved intellectual stimulation. Perhaps he could only get that from educated folks like the laird.'

MacDiarmid it seems didn't mix much with the locals, unlike his vivacious wife Valda, who was well liked and better able to integrate with the wider community. She learned to knit and took part in 'finishing' parties where groups of women gathered to complete a knitting order.

She also had an outlet for her work in England – and she made this merchandising opportunity available to other women knitters on the island.

Despite his social remoteness – one might even say aloofness – MacDiarmid did venture, at least once, out on a local fishing boat. He was keen to research the lives and language of the men who went in search of herring. Apparently, he spent most of his time on board writing in his bunk but was always excited to hear a new Shetland word. Now the fishermen saw this as an opportunity to teach the poet a lesson or two about the Shetland sense of humour.

'There was one man on board who played a joke on Alt Grieve. He shouted out "Skarramadoo!" a few times. Alt Grieve leapt out of his bunk and rushed on deck. "What was that? What's skarra-madoo?" he demanded. But it was a nonsense word. Entirely made up!' Jacqueline told me, chuckling.

How wonderful it would have been, I thought, if this nonsense word had made its way into one of MacDiarmid's dialect poems – 'The Muckle Skarramadoo of Sodom' perhaps! Yet, despite having his leg pulled, MacDiarmid did, in fact, draw on the experience of Whalsay life in his poetry – especially the famous and critically acclaimed 'On a Raised Beach' and 'With the Herring Fishers'.

> I see herrin', I hear the glad cry
> And 'gainst the moon see ilka blue jowl
> In turn as the fishermen haul on the nets
> And sing: 'Come, shove in your heids
> and growl.'

Looking at the number of boats in the harbour at Symbister, it was pretty clear to me that fishing remains a big part of the local economy, just as it was back in MacDiarmid's day. It's what makes the island tick and always has done. In fact, the trade in fish once connected all the Shetland islands with countries across the North Sea and beyond in a special 'piscatorial' relationship – an early sort of EU, presided over by the merchants of the exotically named Hanseatic League. Down on the waterfront is a unique and rather wonderful relic of those days – the restored Hanseatic *böd*, which is now proudly regarded by Whalsay islanders as something of a jewel in the island's historic crown.

The two-storey building stands on its own jetty above the grey waters of the harbour. Built of local stone, it dates from the 15th century and is now a museum to the golden age of the German Hanseatic traders who once played a key role in shaping Shetland's economy. These merchants were mostly German-speaking and had a trading network across northern Europe and the Baltic – right up to the Arctic outposts of Norway and down to London, which was a key centre for the League.

In the refurbished store room, local man Robbie Irvine explained that, from the 13th century onwards, Hansa ships from Bremen, Lübeck and Hamburg arrived every summer to exploit Shetland's rich resource of fish. Loaded with salt, fishing tackle, iron tools, seeds and luxury goods the ships used the *böd* as an onshore base, from where they traded for salted cod and herring.

On the second floor of the *böd*, Robbie showed me the old windlass hoist which hangs over the water beneath a slated dormer. This was the business end of the trading operation. From here goods were hauled into the *böd* or winched down to waiting boats for transportation to the big

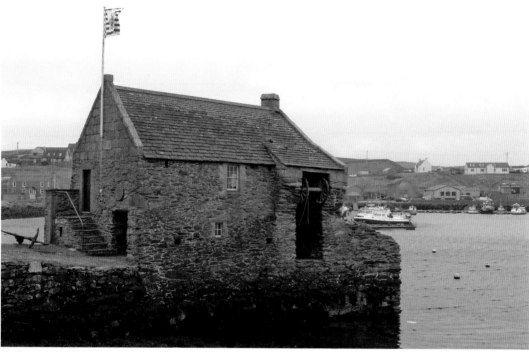

The Hanseatic *böd* in Whalsay, originally used as an onshore base for ships trading goods.

merchant ships, which once anchored in the harbour. It was an arrangement that was familiar to me and reminded me strongly of the sea houses along the waterfront in Bergen, Norway. As a boy, I'd often played in the *sjöboden* ('boathouse') at Sandviken where my father kept his boats. I explained this to my guide Robbie and pulled on the rope to turn the gearing mechanism of the hoist. As I did so, an old bird's nest scattered detritus over my head.

'That's not been used for a while, Robbie!' I said, brushing off feathers and rubbish.

'Could have been worse, Paul. There were no eggs in it!'

As we left the old *böd*, I wondered what had happened to the lucrative trade in salted fish. It had flourished for over four centuries but is now a fading memory in the islands. Robbie told me that after the 1707 Act of Union, which brought together the English and Scottish parliaments, a new tax was imposed on imported salt. This effectively killed off the Hanseatic trade in Shetland.

Leaving Robbie to contemplate the role of fish and salt in the history of international relations, I headed across to the main fishing harbour where I'd been invited aboard one of Whalsay's biggest and most up-to-date fishing boats – the deep-sea trawler *Charisma*, owned and skippered by Jimmy John Tulloch. As we steamed away, Jimmy cheerfully told me that we were consuming about a tonne of fuel oil every hour. But *Charisma* weighs in at 2,500 tonnes and is over 70 metres long. That's

a sizeble boat to push through the stormy waters around Shetland so perhaps it isn't so surprising that she's such a gas-guzzler. And she's not the only big boat operating from Whalsay. When I visited, there were six more like her, in addition to a fleet of smaller craft, making fishing the backbone of the island's economy.

'Fishing is the heart of our community,' said Jimmy John. 'The boats here employ over 150 men so, out of a population of a thousand, fishing represents a big proportion of the workforce.

Charisma goes after pelagic fish and sails out into the stormy Atlantic west of St Kilda and off the Norwegian sector of the North Atlantic looking for herring and mackerel. To find these fish, the crew use an amazing array of high-tech equipment. Jimmy John showed me the sonar screens up on the bridge.

'This is where you can see the shape of the shoal and, from that, if it's a big lump or a small lump of fish.'

'How big a lump of fish is a large shoal?' I asked.

'Sometimes they can be as big as five or six miles. When they get to that size, there's a danger they will break the nets – especially if it's rough weather.'

Once she's chased the shoals and filled her holds full of fish, the *Charisma* races to market, looking for the highest prices. Sometimes she will land her catch in Scotland but quite often she offloads directly to the Norwegians at the coastal port of Ålesund.

I wanted to know more about the history of the *Charisma*, which Jimmy John said had been built in a Norwegian yard. He told me that he has owned three similar boats all bearing the same name. The first *Charisma* was bought in the 1990s. At the time, Jimmy John and a group of family

The deep-sea trawler *Charisma*.

and friends got together to buy a boat. 'I had no money so had nothing to lose,' he claimed. But, for another member of the syndicate, the stakes were much higher. His steady job as the captain of the Whalsay ferry allowed him to support his wife and young family. The money for their venture came from a Norwegian bank, which loaned them the capital to commission a Norwegian boatyard to build the first *Charisma*. Later, this loan was picked up by the Shetland Islands Council, who paid off their debt. After that, they were all in business.

Jimmy John treated me to lunch on board in the elegant saloon. The cook, also a share fisherman, served up fresh grilled herring and smoked mackerel, washed down with a crisp dry wine. This luxury seemed a far cry from the experiences of their grandfathers who would have gone to the *haaf* fishing in boats open to the elements.

'Unlike our ancestors, we have a very short

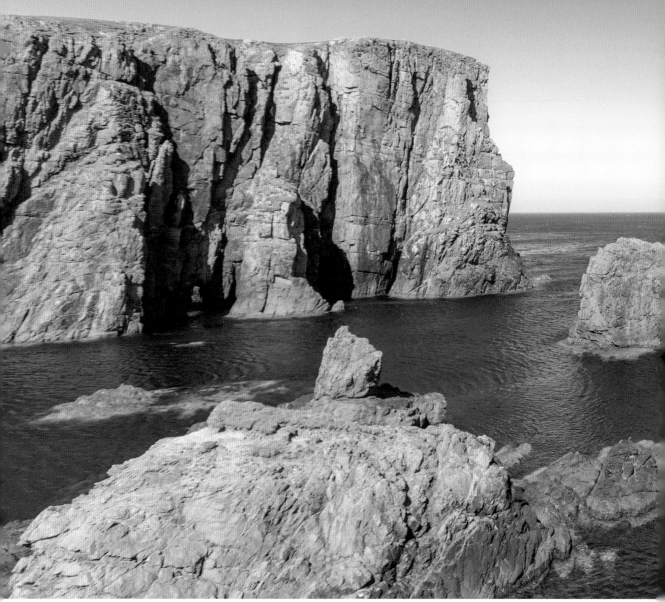

Muckle Roe.

season. Our time at sea is regulated, along with the amount of fish we can catch – our quota is controlled by legislation,' Jimmy John explained. 'This is why we only fish for a few weeks a year.'

'What do you do for the rest of the time?' I wanted to know.

'Holidays mostly . . . I love golf so I take my clubs to Spain and enjoy a few rounds there. Have you seen the course on Whalsay? It's the most northerly in the UK.'

I had to confess that I hadn't had this pleasure so, when we returned to Symbister harbour, I followed the road north for five kilometres in order to at least claim I'd been to Britain's most northerly golf course. On the way there, I photographed an old stone shed with a roof made from an upturned boat. Judging by its double-ended, clinker-built design, it must have been an old fishing boat – a *sixareen* perhaps. The light was fading by the time I reached the golf course. The

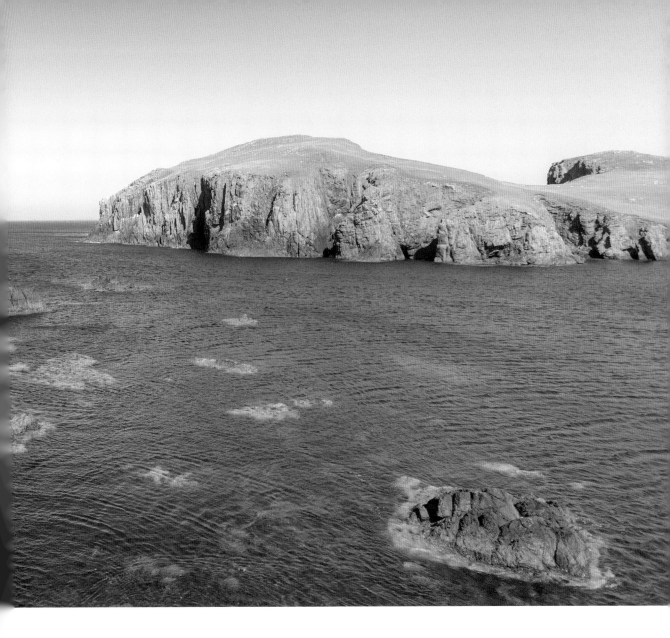

clubhouse stood beside an airstrip – handy for the jet-setting golfers of this world, I thought, as I walked out towards a yellow flag marking a distant green. Being a non-golfer, I'm not qualified to comment on the course layout but, from what I could see, at least one fairway ended at a cliff edge and I wondered how many golf balls had ended up in the briny. There were no golfers playing when I reached the green. The wind had picked up and the sea below had a decidedly angry look.

On the horizon, just a few miles to the north-east, were the rocks and wave-washed reefs of Out Skerries, known to locals as 'Da Skerries'. As I turned to walk away, I saw the beam of the lighthouse on Bound Skerry flash in the gathering gloom.

MUCKLE ROE

The name 'Muckle Roe' comes from a combination of Scots and Old Norse words – *muckle* being the

Scots word for 'big' and rød-øy, meaning 'red island' in the language of the Vikings. Put them all together and you get 'Big Red Island', which makes sense because Muckle Roe is composed of red granite. This is most obvious in the colour of the spectacular high cliffs along the fractured west coast of this roughly circular island, which has a diameter of about five kilometres.

If you apply the strict definition of what constitutes an island, Muckle Roe fails to meet the criteria and can no longer claim island status, having been connected to Mainland by a bridge since 1905. At its narrowest, Roe Sound, which separates the island from Mainland, is only a few metres across – close enough, I'd have thought, to throw a stone from shore to shore. But this narrow stretch of water was all that it took to make Muckle Roe feel remote and life for the inhabitants difficult. When the medical student Edward Charlton passed though narrow Roe Sound in the mid 19th century, he noted that 'Muckle Roe is a dark, desolate and thinly inhabited island, contrasting strongly with the brilliant green hills of [the Mainland]'. The hardships endured by the people on this 'dark' island drove many of them away. Over the course of the 19th century, the population of crofter-fishermen and their families declined sharply from a high point of nearly 300 but, after the bridge was built at the turn of the 20th century, the population slowly began to increase again and now stands at over 130.

Among Shetland's outdoor community, the circular walk around the south-eastern coast is one of the finest anywhere in the islands. It takes in the wild cliffs of the west and includes two 'Hams' – North Ham and South Ham – 'ham' being derived from the Old Norse word for 'a harbour'. There are no roads to the now-abandoned settlements of the Hams but, in the 19th century, remote South Ham had a reputation for smuggling. Apparently, Shetland fishing boats returning from the cod-fishing grounds around the Faeroe Islands would call in at South Ham – not to land their catch but to drop off contraband.

My visit to Muckle Roe was not to take the air or to enjoy the fine views but to tread lightly and learn the steps of a famous dance – the Papa Stour Sword Dance. Sadly, there are too few men left on Papa Stour to keep the tradition alive on its native turf. It was rescued from extinction by a former teacher and Papa Stour man, George Peterson, and has now found a new home among the good folk of Muckle Roe. At the village hall, I met up with George Peterson's grandson, Danny Peterson, and six other male dancers, plus two fiddlers. Today, they are the custodians of the ancient Papa Stour dancing tradition, complete with its own fancy moves. Among folk-dancing connoisseurs, it's considered a classic of the genre and quite unique. It's also deeply symbolic and represents the victory of the goddess Venus over Mars, the god of war.

Standing on the sidelines, I watched as the fiddlers struck up a tune and Danny and his pals took to the floor. To me they looked more like Italian waiters than sword dancers. They wore black trousers and white shirts. Coloured sashes added a sartorial flourish. Each man carried a sword and circled in a slow, sombre manner, then changed direction from clockwise to anticlockwise in time with the music. I have to admit the spectacle wasn't what I had expected. It looked more like a slow-motion Morris dance than a sabre-rattling sword dance.

During a break, Danny told me that the sword dance was first mentioned in the 18th century by

Learning the Papa Stour sword dance with Danny Peterson.

Sir Walter Scott, when he came on a visit to the Shetland Islands but, even then, he noted that the tradition had almost died out. No one it seems knows exactly where the dance comes from. With its characters of St George, Venus and Mars, it doesn't seem to have a Viking pedigree. Some people believe it was brought to Papa Stour long ago by guests of the laird, who encouraged the islanders to take it up, which seems a likely explanation.

Danny was keen that I join in and learn the steps of this ancient and mysterious dance. Rather hesitantly, I did my best to keep in step but I soon discovered that sword dancing is much harder than it looks. If anything, it was a bit like playing an elaborate form of Twister, with dangerous weapons and a ceilidh band backing. The climax of the whole piece is when the swords are interlocked to form a five-pointed star. Rather gratifyingly, I was given the honour of holding it aloft to mark the end of this remarkable dance.

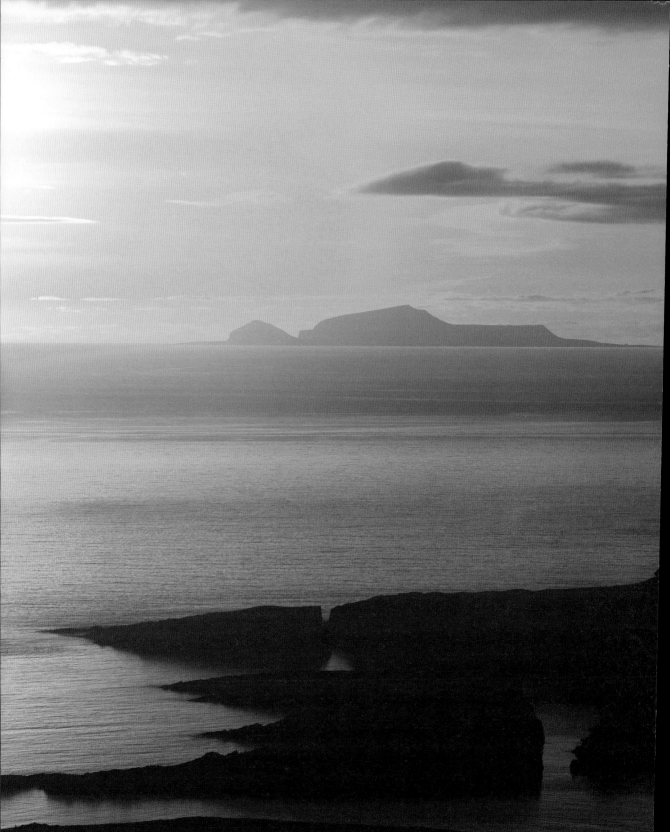

CHAPTER 3
ISLAND OUTLIERS

Foula, Fair Isle, Papa Stour, Out Skerries

FOULA

The island of Foula lies some 16 nautical miles west of Shetland's Mainland. It's roughly diamond-shaped, being about five kilometres north to south, and four kilometres east to west. The 30 people who live there today make up the second remotest island community in Britain – after Fair Isle. The isolation and loneliness of life on of Foula is legendary. Even the Romans recognised how remote it was. It's said that they named this far-flung outpost *Ultima Thule* – 'the very edge of the world', beyond which there was only the infinite restless ocean. As you'd expect this far north, the name Foula is Norse in origin, coming from *fugl-øy*, 'the island of the fowls' or 'bird island'. The birds that gave the island its name continue to nest on its spectacular cliffs and hills, which rise to Da Sneug at 418 metres, making Foula, when seen from some angles, resemble a giant wedge-shaped piece of land adrift on the sea. The other high hills have similarly evocative, Nordic-sounding names – Da Noup, Hamnafield, Tounafield and Da Kame. At Da Kame, perpendicular cliffs plunge 376 metres into the Atlantic below. These dizzy heights are unequalled anywhere else in the

Opposite. Foula in midsummer.

UK for their dramatic impact. They are also the second-highest sea cliffs in Britain after St Kilda's Conachair.

According to an archaeological survey published in 2010, standing stones and the recently discovered remains of a stone circle provide evidence of human habitation on Foula going back 5,000 years. However, it's the Norse influence on the island which has had the most lasting impact. The Vikings occupied Foula early on in the 9th century and the islanders kept their Norse language and traditions for longer here than anywhere else in Shetland. An English visitor in 1832 wrote about a man on the island whose knowledge of the old Viking language enabled him to recite in Old Norse a 'ballad of strife between the King of Norway and the Earl of Orkney'.

It seems that Foula initially avoided annexation by the Scottish crown, unlike the rest of the Shetland Islands which were pawned to raise money for the dowry of Margaret of Denmark when she married James III in 1469. Until the 1490s, Foula was owned by a Norwegian family called Ciske, when a man called Alv Knutsson acquired it. At this time, udal law – the old law of the Viking era – still held sway locally. Under this ancient legal

system, the islanders of Foula had possession of property in often unwritten freehold, effectively giving them absolute ownership of the land on which they had been settled for generations. These independent freeholders had no 'feudal superiors' as elsewhere in Scotland and had no obligation except a duty to pay tax or *skat* to the king. According to legend, there was no king on Foula in the late 17th century but there was a queen – Kathcrinc Asmunnder. She is remembered today in the name of a grassy knowe near the settlement of Hametoon. It's called *Krukaitrin* which apparently means 'Katherine's shelter'. The state of legal independence on Foula was soon to change with the arrival of man from the south. The story goes that he was a doctor and, having gained the trust of the locals, he persuaded them to hand over their old Norse title deeds so that he could have them properly registered in Edinburgh. But this was a ruse to cheat the islanders of their birthright. The deeds were never seen again and, instead of being independent freeholders, the islanders became tenants with no rights of tenure over the lands of their Viking ancestors.

I'd always wanted to visit Foula, ever since I'd read director Michael Powell's account of filming on the island in the 1930s. Powell had been fascinated by the story of St Kilda and the evacuation of its population and wanted to make a feature film about island life. Just weeks before he and his crew were due to sail for St Kilda, the owner denied him permission to land. Quickly rethinking his plans, Powell scoured a map of the British Isles looking for an alternative island and discovered Foula, whose inhabitants were still living remote lives not dissimilar to those experienced by the people who'd recently left St Kilda. Having secured permission from the island's laird and adapted his script to accommodate an entirely new location, Powell landed on Foula with an invasion force of actors and technical crew. They spent the summer of 1936 shooting Powell's first feature *The Edge of the World*, which starred, among others, John Laurie (who went on to become Frazer in *Dad's Army*). Powell used the innovative approach of casting Foula folk in the film and weaving documentary elements of Foula life into the narrative but perhaps the most memorable character to appear in *The Edge of the World* was the dramatic landscape of Foula itself. When it was released, Powell's film was a moderate box office success and paved the way for his later classic works, which included: *The Red Shoes, I Know Where I'm Going!, The Life and Death of Colonel Blimp, One of Our Aircraft Is Missing* and *Black Narcissus*. He wrote about his experience as a young and hopeful filmmaker on Foula in his book *200,000 Feet on Foula* which, of course, has nothing to do with the height of the cliffs but refers to the amount of film footage he shot on the island.

It wasn't until 2004 that I first made landfall on Foula. Like Powell, I, too, was in the company of a film crew but a much smaller one – where he had dozens, we were just five. After circumnavigating the island to take shots of the stupendous cliffs and the extraordinary hollowed-out sea stacks with their arches and windows, the mailboat berthed alongside the quay at the small settlement of Ham. Here, we were met by a man driving a quad bike with a trailer. The red quad had been pimped to look like a mock-up of the Red Baron's WW1 fighter plane, complete with wings and a propeller. 'It keeps us amused,' said the young driver behind his aviator's goggles. 'We see how fast we can fly between the island's gateposts.'

'What happens if you get it wrong?' I asked.

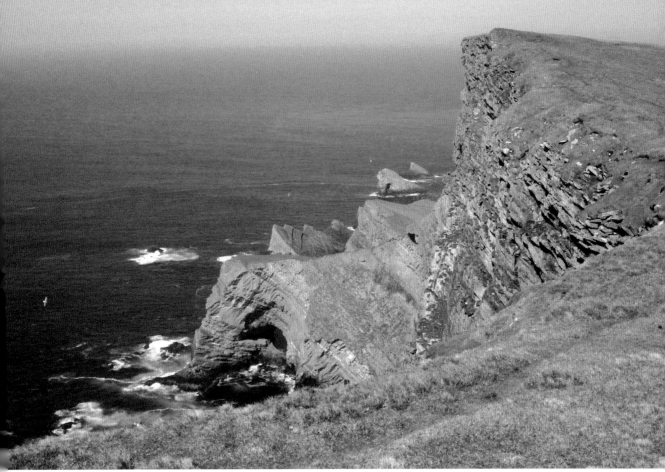

The 376-metre cliffs at Da Kame, Foula.

'Not good! You lose your wings if you're lucky. Crash and burn if you're not!'

It took a couple of trips, fortunately free of aeronautical mishaps, to get us and the film equipment up to our accommodation at The Haa – the laird's house. Although this modest building with its crenellated porch looked like something from the 1930s, it is actually a much older house dating from the 18th century.

After a lively night of home entertainment and home brew, we were up with the lark the following morning to start filming. Our focus was Da Kame and its mighty cliffs, where we would film the aerial acrobatics of the many nesting seabirds. At some point during the day we also hoped to test the reputation and defences of the ferocious great skua, the infamous bonxie.

In our birding endeavours, we were following in the footsteps of an earlier traveller. Over 150 years earlier, Edward Charlton had spent three nights as a guest in a Foula home. Like us, he too was fixated on the birds of the island. Unlike us, his shots were of deadly lead and made with a gun, while ours were made on videotape with a camera. The birds he saw, he recorded by shooting, we simply made photographic records. In his journal, Charlton gives his specimens the names local people still call them – tammy norries (puffins), brongies (young cormorants), tysties (black guillemots) and mooties (storm petrels) – not forgetting the bonxies. When Charlton spotted the noble skua gull, 'the Eagle of his tribe, he said he 'fired

hastily at him with buckshot'. Fortunately for the descendants of those bonxies, the species is now legally protected. Globally great skuas are very rare – a fact it's easy to forget in Shetland where their numbers have greatly increased over the years. Probably because they are ground-nesting birds, they have acquired a reputation for aggressive behaviour. Their vulnerable nest sites are scattered all over the high moorland on Foula. Here, they keep a steely watch, maintaining an exclusion zone over the whole area, which they defend ferociously. So, approach at your peril! We soon learned the truth of this as we made our way across the turf and short grass towards the heights of Da Kame. Several of their number took to the air and set about dive-bombing us. For some reason, these angry and implacable birds picked out the sound recordist for special treatment but he soon discovered a new use for his boom microphone. It made a useful decoy, which the bonxies attacked instead of his head.

The view from close to Da Kame was truly impressive. Towering above the blue Atlantic, its sheer cliffs resounded with the bewildering noise of thousands upon thousands of nesting seabirds. These must have been the sights and sounds that had impressed the Vikings when they named Foula 'bird island'. But, to me, more impressive than the cliffs themselves was the thought that generations of men and boys had climbed these vertical, guano-splattered rock walls to plunder the nests for eggs and to take the adult birds for their meat and feathers. Crawling forward on my stomach, I peered over the cliff edge and into the abyss. My stomach churned just thinking about the bravery of those early fowlers. They must have had nerves of steel. Witnessing their legendary exploits, a 19th-century visitor was amazed by the fearless men of Foula.

He wrote admiringly how, '[w]ith a rope of hemp and hog's bristles, coiled over his shoulders, he proceeded to the cliff . . . [T]he dexterity and bravery with which he threw himself from one aperture to another was truly grand. The tumbling roar of the Atlantic was foaming many of hundreds of feet beneath.'

My old *Black's Guide to Scotland* also mentions the skill and bravery of Foula's cragsmen. 'Their fatalism was as remarkable as their daring. When reproached for their recklessness, the common reply was: "My gutcher [grandfather] gaed afore; my faither gaed afore, an' ower da Sneug I'll ging too.'

Edward Charlton wrote about the fatalism of the men who went on to the great cliffs. Their lives depended on the strength of their hemp and bristle ropes. According to one story recorded by Charlton, a father and two sons were suspended from the same homemade lifeline, when the younger of the sons Magnus, who was the last on the rope, noticed it was starting to fray dangerously. He urged his brother Robbie to save their lives by sacrificing their father who was dangling below. This Robbie would not do. So Magnus took his own knife and severed the rope and climbed to safety as his father and brother plunged to their deaths. On another occasion, a man and his wife were out collecting birds' eggs, when the wife slipped and fell. Her full weight came on the rope, threatening to pull her husband off the cliff with her. Acting swiftly to save himself, the man cut the bond between them and his wife fell screaming towards the waves, hundreds of feet below. When the grief-wracked husband returned home, his neighbours gathered around and tried to console him. Suddenly the door burst open and in walked the man's wife, 'dripping from sea salt and giving

convincing proof by means of her fists and tongue that she was no disembodied sprite, but true flesh and blood'. Her miraculous deliverance from certain death was down to the voluminous petticoats she was wearing when she fell. These opened out like a parachute and allowed the wind to catch her 'til she sank gracefully into the ocean's bosom, where by good chance a passing boat picked her up'. I'm not sure that Charlton was necessarily convinced of this parachuting tale but he did mention that the islanders had lively imaginations and loved to tell old stories around a peat fire during the long dark nights of winter.

It took Charlton eight hours to reach Foula from Mainland when he visited in 1832. At that time, the population was well over 200 souls who were accommodated in 38 houses. All were dependent on the sea and the land for a living. On their crofts, the Foula folk grew oats, barley, potatoes and kale. They kept chickens, cows and an ancient breed of sheep unique to Foula. They fished the seas for cod and combed the rocky shores for whatever fate and serendipity might have brought on the incoming tide, which often included unexpected bounty from shipwrecks. Charlton admired the ingenuity and intelligence of the people he met and would no doubt have agreed with an earlier visitor, the mapmaking soldier James Vetch who came to survey the island in 1821. He wrote that in 'every case the inhabitants seem to be much at their ease, are decently clothed and are of a cheerful inquisitive character ... Their frank, free disposition, simple primitive manners, render them a very amiable people.' Despite having been cheated three hundred years earlier of their rights as freeholders under udal law, much of the free spirit and independence of the islanders' Viking ancestors were apparently still evident.

On the plane to Foula.

I visited Foula for a second time in 2013. Instead of taking the mailboat, this time I flew, landing on the airstrip, which had been built by the community after an earlier mailboat, *Island Lass*, sank in a terrible storm in 1962. Thankfully, the crew survived but the loss of this vital lifeline added further impetus to those who wanted to leave the island permanently. There was even talk of evacuating the island. But the loss of their link to the outside world also galvanised the core of the community to secure an alternative to sea travel and so the airstrip was built to enable flights to land from the airport at Tingwall. Today, tiny Islander aircraft give travellers the option of flying to Foula, instead of taking the much slower and weather-dependent mailboat, which still operates a ferry service from Walls. However, that's not to say that these flights are not also subject to the vagaries of the weather. When I flew from Tingwall, we were delayed for an hour because of fog. Only when it cleared could we take off.

Foula airstrip.

That day I was lucky enough to have a seat beside the pilot in the tiny plane, which carried just five passengers. Almost as soon as we climbed above the runway, Foula came into view on the horizon. A cap of cloud on Da Sneug made the island look like a smoking volcano. As we closed in, I could see a scattering of houses along the eastern coastal strip. Many of them seemed to be roofless – others just ruined shells. We banked low over the steep, grassy slopes of Hamnafield and made our approach. As we skimmed over the houses of Ham, I could see the runway ahead. The pilot adjusted the throttle. Flaps down, we bumped over the dirt airstrip and then taxied to a halt. Waiting for us was a reception committee of islanders who watched our approach from the shelter of their cars. They hadn't come to meet me but to collect vital supplies from the aeroplane. Supermarkets run a subsidised airlift for the islanders these days. A phone call or email secures the order from Lerwick, which is then packed

aboard the plane bound for Foula. As I disembarked, I noticed boxes of groceries, cases of beer and bottles of wine and whisky being offloaded into the hands of grateful islanders. It must be hard, I thought, just getting the bare necessities of life out here on this rock in the Atlantic. The Foula shop closed years ago and there is no pub, no doctor, no chemist, no police station – in fact, very few of the amenities of modern civil society. Added to that, the self-sufficient ways of the old crofting and fishing community have largely died out, making the island utterly dependent on the air and ferry links to Mainland. Foula felt vulnerable but then it has always been on the edge – quite literally.

After the plane took off for its return flight to Tingwall, the islanders drove home with their supplies. Left alone, I followed the single-track road north, heading for my B&B. Taking in my new surroundings, I thought about the claim often made by experienced travellers that the journey from airport to hotel tells you everything you need to know about the place you are visiting. What's true of New York, Tokyo or Dubai must surely be true of Foula and walking the route just fuelled my expectations of what was to come. There didn't seem to be a soul about as I passed a hand-painted road sign pointing back to the airstrip. It indicated that there was a payphone and toilet in that direction – if I felt the need for either. Another sign showed the route to the nurse and the post office, neither of which were obvious to me. A few yards further along, I saw a few small sheep nibbling the short grass beside several rusting old tractors whose carcasses were being slowly absorbed into the thin soil. As I neared my destination, I couldn't help but notice lines of decaying vehicles. Apparently, there is no MOT requirement on Foula, so

all sorts of old wrecks are imported by islanders, who run them into the ground. The problem is how to dispose of them. At one time they were thrown over the cliffs. But this is no longer allowed. Instead, they stand like industrial tombstones in a car graveyard.

The struggles of the present-day islanders were fairly obvious to see from the road. This is a community where resources and people are scarce but, put into the context of history, this is nothing new. Over the centuries, Foula has had its fair share of real hardship. The population peaked in 1881 at 267 souls but, since then, numbers have declined steeply. People moved away to find an easier life and, alarmingly, disease once took a heavy toll. At the turn of the 17th century, an epidemic struck. It was called the 'muckle fever' but we know it as smallpox. It wiped out 90 per cent of the island's 200 inhabitants. Although the island survived as a community, the legacy of the muckle fever left an understandable fear of infection. Even today, there's a 24-hour quarantine period before an outsider is allowed to meet elderly islanders.

At the B&B, my host Brian didn't seem too worried about quarantine and disease transmission vectors. He was outside in the spring sunshine feeding cat food to his pet bonxie, Bob. Brian was pleased to see me and said that I'd be sharing his humble abode with a freelance photographer called Walter from the Netherlands. Inside his rambling bungalow, Brian chatted while he prepared an evening meal. He told me that he'd lived on Foula for 35 years. He'd once run a motorcycle shop in Edinburgh but was attracted by the remoteness of life on Foula.

'It was like the last frontier when we arrived,' he said, 'and there was an opportunity to build something from scratch. Back then, there was no electricity or running water. We used diesel generators for electricity and water from a well. Even ten years ago, it was really difficult to get things on to the island but the flights have made it easier to live here now.'

Like most islanders, Brian had more than one job to make ends meet. On top of running the B&B, he kept some sheep, skippered the Foula ferry and worked as the island's road maintenance man. He was also the lighthouse keeper and gravedigger. 'Fortunately, there's not much call for that one,' he chuckled.

Walter, the young Dutch photographer, joined us for dinner. He told me that he'd come to Foula to document life in communities that had unfairly been given bad reputations. 'A lot of people in Lerwick on the Mainland think Foula is just full of scroungers living off benefits of some kind. The ferry and air service cost a fortune and they resent that. But it's not true and I want to show that in my photographs.'

Later, Brian showed us an old documentary film shot on Foula in the 1960s. 'What this film doesn't tell you,' he said mischievously, 'is that the laird's 16-year-old son married a 46-year-old local woman, whose nickname was "the Fisherman's Friend", aka "the Training Ship". They never had any children but I always thought the marriage was one of convenience anyway – just to get hold of the Training Ship's land.'

The following day dawned beautifully – brilliant sunshine but cold. Breakfast was marred slightly by Brian's fury at his cat. 'The effing thing has just killed a rare migrating Siberian wren!'

Walter was off to photograph one of the oldest residents on the island while I had a rendezvous with two local women, Penny and Fran, who

Opposite. Da Sneck o' Da Smaallie.

Above. Fran with Shetland ponies.

wanted to show me their secret lair in Da Sneck o' Da Smaallie. Who could turn down such an intriguing invitation? Penny explained the meaning of this fabulous name as we walked over the moors. 'These are all Old Norse words. *Da* is the definite article. *Sneck* is "a notch" or "a gap". *Smaal* is "small" and *lie* is "a slope" so you've got "a small gap in the slope".'

The walk to Da Sneck o' Da Smaallie took us through a small glen known as 'Da Daal' where Shetland ponies grazed the hillside. But this was really bonxie territory. Fortunately, they hadn't laid their eggs yet and we got off lightly. Eventually, we came in sight of the sea and an impressively deep cleft in the ground – Da Sneck – which looked like a mini version of the Grand Canyon. Penny and Fran disappeared down a pothole in the rock face. This gave access to Da Lum – a narrow chimney which dropped precariously down to the bottom of Da Sneck. I followed nervously. Wrig-

gling and squirming, I lowered myself inside the confined passage, pressing uncomfortably against its damp and slimy walls. When I rejoined the Penny and Fran at the bottom of Da Lum, we picked our way over the boulder-strewn floor and then entered an eerie, dripping, moss-covered world. Alarmingly, balanced 30 metres above us were enormous chock stones wedged between the sheer walls of Da Sneck – hundreds of tonnes of rock just waiting to fall on our heads. Penny told me that Da Sneck is one of Foula's secret places and that folk who've left the island sometimes return to enjoy its dangerous and daunting delights. At last, we emerged on to the shore where the Atlantic surf pounded the cliffs. Penny and Fran said they loved it here. It was certainly an awe-inspiring place and I could appreciate how such wild beauty could get under your skin.

In the evening, I made my way to the south-east of the island. I'd been prompted to go by

Walter the Dutch photographer who told me excitedly that he'd met one of the 'last true Foula folk'. Outside an old whitewashed croft with a rainbow-coloured wooden fence, I met 70-year-old Eric Isbister. As the sun slowly sank behind the hills to the west, he told me that he could trace his ancestry back to 1813 on one side of the family. The other side, he said, went back into pre-history, making him 'Foula through and through'. The house he lived in had been built by his grandfather and great-great-uncle. But Eric was still waiting for electricity and mains water to be connected – not that he regarded this as any great hardship. He was used to it and to the old crofting way of life. 'It was quite a tough life. Every croft had to produce enough to eat. It was all done by hand. There was no machinery then. Every family had five or six cows and a good number of sheep and grew all their own vegetables. We were still doing that right up until the 1970s and 80s.'

Eric's father was something of a Foula celebrity. In his youth, he had served aboard a sailing ship in the 1930s, before settling back into crofting life. He had been an accomplished boatbuilder, fiddle-maker and songsmith, having written several folk ballads and fiddle tunes which have since become part of the Shetland repertoire. Eric told me quite proudly that he had only been off Foula twice in his life. The first time was to go on the only holiday he'd ever taken, travelling all the way to Shetland with his old dad. I wanted to know what he thought of the place when he got there. 'Well, it's not a patch on Foula scenery wise. They don't have cliffs like we do. But it was OK I suppose. A bit crowded.'

It would be a mistake to think a man like Eric, who has spent his entire life on tiny Foula, must be insular in his outlook. The reverse is true. Eric is extremely well-read and curious about the outside world, especially northern communities, with which he feels a connection. He taught himself Icelandic and has been taking Icelandic newspapers for over 20 years although he regrets that they always arrive a couple of days late.

FAIR ISLE

This lovely island competes with Foula for the title of remotest inhabited island in the British Isles and, if distance is the arbiter, then Fair Isle wins because it's further from any other land. Lying almost midway between Orkney and Shetland it is approximately 24 nautical miles from Shetland to the north and 27 nautical miles from North Ronaldsay in Orkney to the south-west. Yet, despite the greater distances involved, Fair Isle seems somehow better connected than Foula and, therefore, feels less remote. Comparing the two islands, the contrasts are great. Although Fair Isle has impressive cliffs and sea stacks, it's a much lower island than Foula. It's also greener, more cultivated and has a bigger population. Unlike Foula, there is a shop, which is an obvious focal point for the community of about 60 permanent inhabitants, many of whom come from different backgrounds, giving the island a cosmopolitan feel. Like Foula, Fair Isle has a strongly Norse heritage and features as a location in the ancient Norse sagas. The name Fair Isle is said to come from the Viking word *Friða-rey* or *Frid-øy* which translates as 'island of peace'. However, the history of human occupation long predates the 9th-century Norse occupation. There is archaeological evidence of settlement from Neolithic times 6,000 years ago and also Bronze Age burnt mounds and the remains of an Iron Age fort.

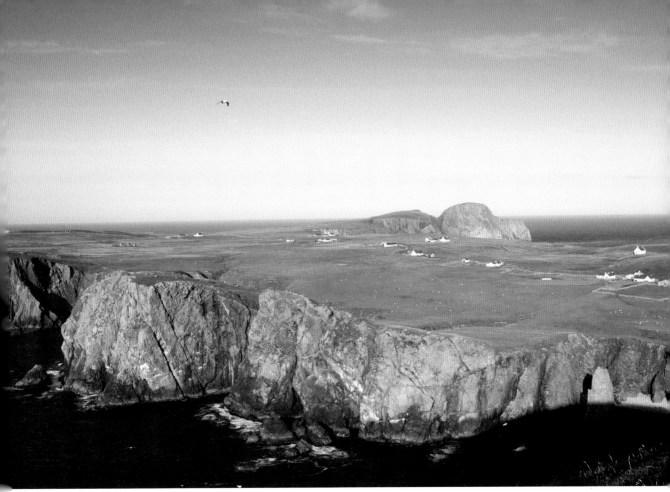

Fair Isle.

To get to Fair Isle, it's possible to fly from Ting-wall in a tiny Islander aeroplane or to catch the ferry *Good Shepherd* from Grutness near Sumburgh Head. This can be a wild and dangerous crossing, rough enough to make even veteran mariners go green around the gills. Fortunately for me, the weather was perfect when I sailed – blue skies and just a hint of ocean swell gently rocked the passengers and crew as we steamed south towards distant Fair Isle. 'This is flat calm for me,' said skipper Neil Thompson up on the bridge, 'but it can be really hellish in winter. The biggest wave I've taken this boat o'er was 11 metres high.' Neil went on to tell me that Fair Isle has a long history as a graveyard for ships.

In 1588, the notorious tides and rocks wrought havoc on a galleon from the Spanish Amada. Fleeing the English fleet, the 38-gun *El Gran Grifón* tried to escape by sailing north but was wrecked on the cliffs of Stroms Heelor on the east coast of the island. Over 200 men survived and managed to struggle ashore. 'Someone on board kept a diary, and I learned Spanish so I could read it,' said Neil. The diarist described being wrecked as 'this day of our great peril' and went on to give an account of his first impression of Fair Isle. 'We found 17 houses, more hovels than houses, and a population of scarce 70, neither Christian or heretic, serviced by a priest who came once a year in which they hold little store.'

This sudden increase in population posed problems for the survival of everyone on the

island. Resources were limited but, for seven weeks, the people of Fair Isle did what they could for the castaways. Eventually, there was no more food to go round. About 50 Spaniards succumbed to starvation and disease. They were buried in the island's cemetery, where an iron cross was erected in 1984 by a delegation from Spain in remembrance of the men who died so far away from home.

As the outline of Fair Isle grew larger on the horizon, Neil showed me some photographs he'd taken of an underwater archaeological investigation that was carried out on the wreck of the *El Gran Grifón* in 1970. Several guns and metal artefacts were discovered on the seabed where they had lain for nearly four centuries. But what of the men who had been wrecked, I wanted to know? Neil explained that they were eventually evacuated after a stay of two months. They were sent first to Orkney and then on to Leith. Scotland at the time was an independent realm and was not at war with Spain. The Scottish authorities were happy to help the shipwrecked crew on their way to the Netherlands, which was then ruled by the Spanish crown.

The stormy seas around Fair Isle have not only accounted for many shipwrecks – they also mean the island can be cut off for weeks at a time. When wind speeds increase, *Good Shepherd* can't put to sea and aeroplanes can't fly – a fact that was hard for me to imagine on the day we sailed into the tiny harbour of North Haven. The island was doing its best to live up to its Old Norse name. Fair Isle seemed a peaceful, cliff-girt haven in the sea. Basking in the spring sunshine, it looked idyllic. The Vikings must have been on to something when they named it, I thought.

When we docked, there was a flurry of activity on the pier as all manner of essentials were offloaded. The island is only five kilometres long by two kilometres wide, so it doesn't take long for the packages and goods to arrive at their final destinations. Despite its diminutive size, Fair Isle punches far above its weight in terms of brand recognition. The name is broadcast four times a day in the Shipping Forecast because Fair Isle is also a meteorological sea area. But perhaps the biggest reason that most people have heard of Fair Isle is because of the knitting patterns that made this tiny island world famous.

From the 1920s right through to the 1960s, Fair Isle knitwear was highly fashionable. Up at the island museum, which has many fine examples of Fair Isle knitwear, Stewart Thompson gave me a potted history of these beautiful woollen garments. He said that we can't be sure exactly when knitting started on Fair Isle. There are references made towards the end of 17th century but it probably dates from much earlier. The patterns that are typical of Fair Isle are also similar to those found in Norway, the rest of Scandinavia and all around the northern periphery. Whether or not the Fair Isle style arrived with the Vikings or it represents a wider, shared northern culture isn't clear but one thing is certain – Fair Isle was, at one time, at the crossroads of a lot of trade. In the days of sail, the island was in the middle of an international shipping route and islanders were able to exchange knitwear for goods or cash. 'People here were living very much hand to mouth. They had to grow virtually everything they ate. The winters could be very severe and there was virtually no money so anything extra was a huge benefit,' Stewart said.

Trading with foreign ships spread the work of Fair Isle knitters across the seas. In 1902, the

garments got a marketing boost when the crew of the *Scotia* Antarctic expedition chose the jerseys to keep out the cold. But real popularity came when young Edward, Prince of Wales, the future Edward VIII, was painted by John St Helier Lander in 1925 wearing a V-neck Fair Isle pullover and carrying his favourite pooch. This wasn't just a royal endorsement – it was a major fashion statement and Fair Isle patterns were quickly copied by factories around the world. Unfortunately, the Fair Isle style was never protected by a patent so the island failed to really benefit from the popularity of its knitwear. Despite this, the tradition of knitting is alive and well and selling genuine Fair Isle garments made on Fair Isle is still something that brings in good money for the island's knitters.

Up at Stewart's home, his wife Katrina and her neighbour Holly were busy knitting. A cruise ship was due to arrive in two days and they were rushing to finish as much as possible to sell the tourists. Watching them, it looked painstaking and highly skilled work. I wanted to know why there had never been a big push to capitalise on the Fair Isle name and produce more of the world-famous knitwear on Fair Isle. Katrina quickly poured scorn on this idea. 'What we are doing is a skill – an art. What you are suggesting is mass production using machines. Where's the skill in that? I think, if we ever went down that road, knitting as a real craft would die out and that would be terrible. No, we are quite happy with the way things are. There's more than enough work for us as it is with these cruise ships coming in.'

Buying myself a beautiful woollen Fair Isle hat, complete with an impressive tassel, I left the knitters hard at work and set off to explore the rest of the island. Fair Isle's strategic location in

With my new Fair Isle knitted hat.

the northern seas may have helped the spread of its knitwear but the location became a liability during the Second World War. Just before Christmas 1941, the Luftwaffe attacked the most southerly of the island's two lighthouses. The bombs that fell that day killed the assistant keeper's

wife and badly injured their daughter. And then just a couple of days after New Year, the Germans returned with deadlier force. This time, the bombs killed the keeper's wife and their daughter, along with a young gunner who was attempting to defend the lighthouse. They are commemorated by a plaque on the old perimeter wall.

In Memory of
Mrs Catherine Sutherland,
Mrs Margaret Smith
Margaret (Greta) Smith
Gunner William G Morris RA

Looking at their names, it was terrifying to think that, even in a remote place like Fair Isle, no one was safe from the ravages of war.

But this mini Blitz in the Battle of Britain wasn't all a one-sided affair. In January 1941, a German Heinkel 111 came down after a dogfight with the

Fair Isle wren.

RAF. The remains of the aircraft, including its two engines and fragments of the wings and fuselage, can still be seen in a field close to the road at Vaasetter. Miraculously, three of the five-man crew survived the crash. The pilot, Karl Heinz Thurz, who was just 20 years old at the time, and the two other survivors were arrested by a local crofter, Jimmy Stout, who held them for two days until they were taken as prisoners of war to the Shetland mainland. The day of their departure was the 19th of January 1941 – a date that coincided with Karl Thurz's 21st birthday. It's said that when the islanders realised this, they took pity on the young pilot and gave him a party. Thurz returned to the scene of the crash in the 1980s and met the man who had made the citizen's arrest four decades earlier. Apparently Jimmy and Karl Heinz got on rather well!

After the war, when there was no longer any military threat to the island from the sky, Fair Isle became the target for a different kind of aerial interest – twitching or birdwatching to be precise. The island is an important breeding colony for a host of seabirds. It is also a vital stopping-off point for hundreds of thousands of migrating birds, all grateful to find a place to rest on this scrap of land far out to sea. Ornithologists will tell you that there are more sightings of rare bird species on Fair Isle than anywhere else in Britain – making the island a twitchers' paradise. Tramping around the island with their binoculars poised for action, birdwatchers are a common sight. I met at least a dozen during my brief stay. They came from all over – Germany, New Zealand, Australia, England and the USA. The ones I chatted to were excited to have seen several rare birds including the iconic Fair Isle wren, Blyth's reed warbler, the thrush nightingale, ospreys – and of course the less than

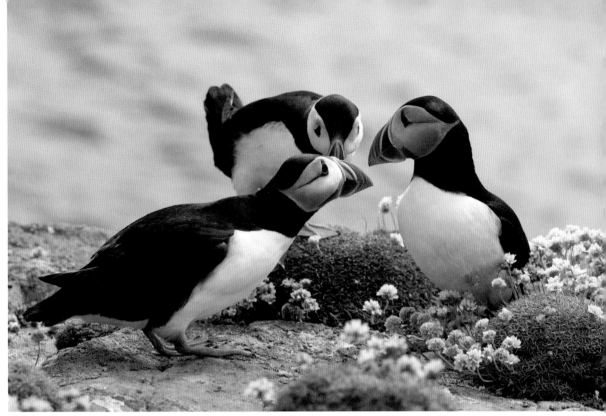

Fair Isle puffins.

rare but ever entertaining puffin.

The unique status of Fair Isle as a place to study and understand bird migration was first recognised back in the 1930s, when the island was bought by the Scottish ornithologist George Waterston who developed the now world-famous bird observatory. In 1954, he sold the island to the National Trust for Scotland, which carried out improvements to encourage visitors to appreciate the wonderfully rich birdlife. Today, the new bird observatory is situated not far from the harbour at North Haven. Built in 2010, it provides accommodation for visitors of an ornithological persuasion and houses a team of wardens and the island's ranger. From the observatory, I followed the bird warden David Parnaby and a group of twitchers as they did the rounds of several Heligoland bird traps – large netted enclosures used by ornithologists to identify, ring and weigh passing birds. David was in a sombre mood. He said he'd witnessed a terrifying decline in the number of seabirds in recent years. There used to be 60,000 puffins on the cliffs. Numbers were now down to 12,000. Kittiwakes were once very common – 18,000 of these elegant gulls used to crowd the ledges but now their numbers had dropped to just 1,200. The arctic skua – the sleek relative of the bonxie – had recently been reported extinct on Fair Isle. The previous year, RSPB volunteers had been distressed to find thousands of dead and abandoned chicks on the cliffs.

'What had gone wrong?' I asked.

'In the past, the rich seas around Fair Isle meant that adult birds only needed to search for food five or six miles from the coast. Now we find Fair Isle puffins off Aberdeen – one hundred-and-fifty miles away. It just isn't sustainable,' he explained. 'The food just isn't there anymore. Probably due to a combination of factors – over-fishing and climate change have both had a catastrophic

impact on the health of the bird colonies here.'

'No wonder he looked at a low ebb,' I thought.

In a reflective mood, I watched the sun go down from the high vantage point of Malcolm's Head, where fulmars glided around the cliffs and the silhouetted sea stacks of the island's rugged west coat. In the thickening twilight, I made my way to my accommodation at the Old Haa, which was then run as a B&B by a couple from New York State. By a quirk of fate, they had entered and won a competition organised by the National Trust for Scotland to encourage young families to put down roots on Fair Isle. They and their son had been on the island for seven years. They loved it but were now at a crossroads. Their son was due to enter secondary school on Mainland Shetland after the summer holidays. He would board there and come home irregularly. They felt a vacuum opening up in their lives and were uncertain about their future commitment to the island. As we chatted over the dinner table, the lights suddenly went out.

'A power cut?' I asked.

'No. It's just the island generator. It's switched off every night to save fuel.'

We continued our conversation about life on Britain's remotest inhabited island by candlelight.

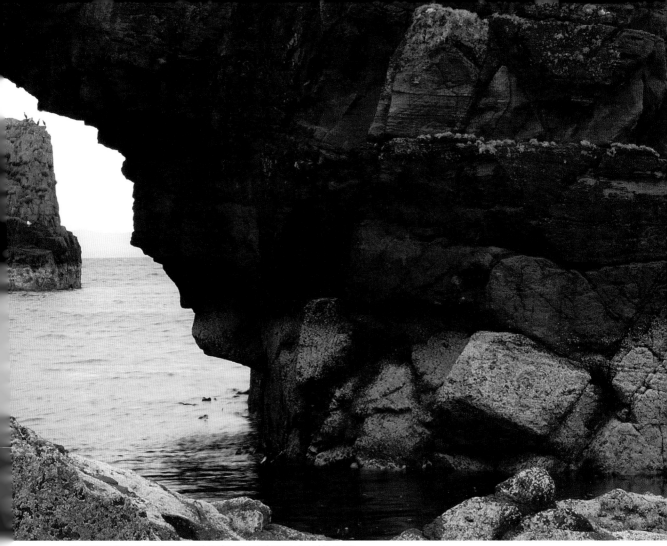

Papa Stour. Sea erosion has created stacks, geos and caves around its coast.

PAPA STOUR

Measuring just 3.5 kilometres by 3 kilometres, Papa Stour is a small island with an unbroken history of habitation going back at least 3,000 years. It lies less than a nautical mile from the coast of Mainland Shetland but the strong currents and dangerous waters that surround Papa Stour make it feel more remote and inaccessible than it really is.

Although it's a cliff-girt island, Papa Stour is fairly low lying, rising to Virda Field at 87 metres in the north-west. The rocks here are composed of ancient volcanic material from the Devonian geological period about 360 million years ago when ash and lava were deposited over the sands of a vast desert. Being soft, the rocks that were laid down at this time are easily eroded by the sea, which over the millennia has carved stacks, and geos – and created marvellous caves and tunnels through the cliffs. The headland at Virda Field is cut through by a 360-metre-long passage called the Hole of Bordie – the fourth-largest sea cave in the world. Other features of the west coast include passages through Fogla Skerry and Lyra Skerry. At Kirstan Hol, there is a deep cleft (or geo) in the cliffs, with sea tunnels leading to a massive collapsed cavern. The coast of Papa Stour is

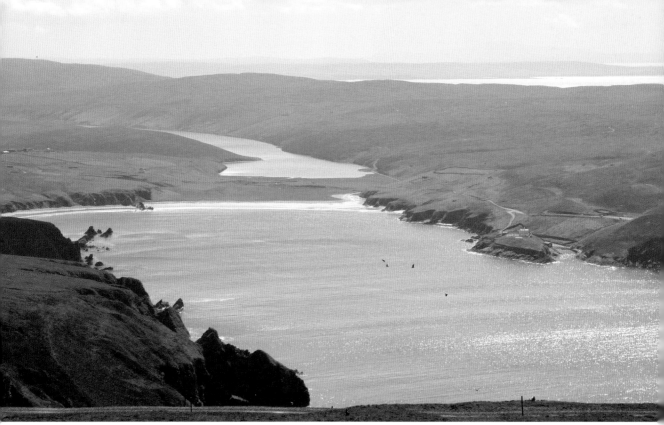

Burrafirth – 'the big islands of the priests'.

paradise for kayakers and a wonderfully exciting destination for seaborne exploration, which was first written about by early visitors like Edward Charlton. He sailed over from Foula with his friends in 1832 and was taken on a sightseeing trip by their host Mr Henderson of The Haa. Entering one of the sea caves in a boat, Charlton wrote:

> For a few minutes, we were enveloped in darkness, and then all of a sudden a bright luminous ray broke upon us from a perforation in the rock and revealed a variegated corraline and tangled seaweed which clothed the rocky bottom a fathom or two beneath our boat. To the right and left branched off various *helyers* – or caves – some totally dark, others partially illuminated at some distances from above but too narrow for our boat to enter. No

wonder that the Papa men are considered to be the most superstitious of all the Shetlanders, for who could traverse these marine abodes without a hope of coming at every turn upon some merman old and grey?

Legends abound on Papa Stour – it's a place where once the inhabitants believed in giants and trolls or *trows*. When I caught the ferry from West Burrafirth on a cold day in early May, I thought about the meaning of the island's name. It comes from the Old Norse *papar* for 'priests' or 'monks' and *stor* meaning 'big'. Papa Stour therefore means 'the big island of the priests'. There is actually a Papa Little just to the east of Papa Stour, which suggests that there must have been quite a lot of churchmen about in the past. They would have been monks and anchorites of the old Celtic church – men who sought out lonely places to

The eighth-century Monks' Stone, found on West Burra in 1943.

pray or to base themselves for missionary work among the pagan Pictish people of Shetland.

At the Shetland Museum in Lerwick, there is a fascinating stone relief known as the Monks' Stone. Found to the south-east of Papa Stour at Papil on the island of West Burra in 1943, it is thought to be part of an 8th-century box shrine. It depicts five hooded figures, one behind the other, on top of stylised waves. The first three are on foot and carrying crosiers. They are followed by one on horseback and bringing up the rear is another walking figure who, as well as carrying a crosier, has a bag or satchel with him. The five men are clearly Christian clergy making their way over the waves towards a cross – a scene which is thought to represent the arrival of Christianity on Shetland. By the time the pagan Vikings arrived in Shetland around AD 800, Christianity on the islands had been established for two centuries but

the Vikings had no need for priests. They had their own religion and a fierce reputation for murdering churchmen and plundering their monasteries so the monks either fled or were killed. For the next two centuries, Shetland reverted to paganism, in thrall to the Norse gods of Asgard, where Odin held sway, until the Norwegian king, Olaf Tryggvason, converted to Christianity in 994. He insisted that Sigurd, Jarl of Orkney, whose rule extended to Shetland, follow his example. And so Shetland returned to the Christian fold.

The Vikings made a big impression on Papa Stour. Nearly all the place names have a Norse origin and many features of the dramatic coastline are woven into the Viking folklore of the island. Frau Stack or Maiden Stack is one such example. As the ferry entered Housa Voe and headed towards the pier, it passed a high pillar of rock standing close to the island's red cliffs. According

to local legend, the Maiden Stack got its name because of the actions of a real historical character – the Viking Thorvald. Worried that his daughter might run away with a lowly fisherman she'd fallen in love with, he imprisoned her on the sea stack. He built a stone cottage on its summit and, as we sailed by, I could just make out the ruins of a small building still perched on top of the rock tower. But, despite all of Thorvald's efforts to protect his daughter's valuable virginity, his plan came to nothing. Under cover of darkness, the young man scaled the sea stack and rescued the girl. It's said they lived happily ever after.

During the reign of the Vikings, the little island of Papa Stour became an important outpost for a man who would one day become Norway's King Håkon IV. To discover more about this royal connection, I walked the island's only tarmacked road, a single-track right of way that stretches inland for just one and a half kilometres from the ferry pier. Halfway along, I stopped at a place sign-posted as 'The Stofa'. This is a partial reconstruction of an important building from the days when Papa Stour was at the heart of Shetland's Viking world. In medieval times, most Norse farming settlements had a public gathering place – a great hall – where the affairs of the estate were discussed and issues resolved. The building allocated for this sort activity was known as the *stofa*. Back in the 13th century, the *stofa* on Papa Stour belonged to Duke Håkon Magnusson, who would later become king of Norway. Håkon employed a factor called Thorvald to run his estates, which stretched as far and wide as the Faeroe Islands. Incidentally, Thorvald is the same character who is mentioned in the legend of the Maiden Stack. We know all of this because Thorvald, Håkon and the *stofa* are featured in Shetland's oldest surviving document,

which details a legal dispute that took place in 1299. The document describes how a remarkably brave local woman, Ragnhild Simunsdatter, stood up to the factor Thorvald at a meeting in the *stofa*. She accused him of fiddling the books and stealing rent, which should have gone to his employer, the landlord Håkon Magnusson.

Before setting out for Papa Stour, I had spoken to Barbara Crawford, an archaeologist from St Andrews University. During the 1970s, Barbara had been inspired by the account of Ragnhild's bold confrontation with Thorvald to look for the location of the *stofa*, where the argument had raged. In 1977, she began her investigation by trying to identify the most likely site for a high-status dwelling, which she thought would have been on the best land in the centre of the island. She was lucky and, although the site was difficult to work because it was covered by the ruins of an 18th-century farm building, she found the evidence she had hoped for. Over several years, she and her team uncovered the wooden walls and floor of a building, which was carbon dated to a period that matched the historical record.

The wooden construction indicated that the building was indeed of high status. Only the wealthy could afford to import timber from Norway to the treeless Shetland Islands. Moreover, a wooden house would have been an exceptional sight in medieval Shetland, when most poor people lived in huts made of stone and turf. The *stofa* was undoubtedly a building that was designed to impress. Today, it has been partially rebuilt on the archaeological site using timbers from western Norway where the original wood probably came from.

The *stofa* vividly demonstrates the importance of Papa Stour to the Vikings but, after Norse rule

ended in the 15th century, the islanders continued to work the land and harvest the seas as they had always done. The fertility of the rich basalt soils made the land more productive than most and, when commercial fishing began, the potential rewards were considerable. At the height of the herring boom in the 19th century, thousands of fishermen, fish curers and fishwives crowded the island during the summer months. This hive of industry created an unprecedented demand for fuel and the land was scraped clean in the desperate search for peat to burn. When Edward Charlton arrived in 1832, he described the housing on Papa Stour as 'wretched hovels, worse here than in any other part of Shetland'. By the turn of the 20th century, the fortunes of the whole island began to decline.

George Peterson was brought up on Papa Stour. His grandson Danny gave me a lift in his pick-up and drove me the last kilometre to the family croft – a smartly painted single-storey building overlooking bright green fields with views across the sound to the Mainland. A collie dog was barking as Danny's grandfather came out to greet us. George was in his early eighties and was a retired schoolteacher. Although lambing kept him busy, he no longer lives on the island. This is a common story. Despite the number of houses dotting the landscape, Papa Stour had a population of just a handful of permanent residents at the time of my last visit in 2016. 'A lot of the properties have become holiday homes these days or are for occasional use by people who still have crofting rights. Like me, they come over when there's work to do,' George explained.

We leant on a drystone dyke and watched the newborn lambs playing in the sunshine.

'This is what we call *da vaar*,' said George. 'I

George Peterson outside the family croft on Papa Stour.

think it's a Scandinavian word – the old Viking word for "the spring".'

George told me that his mother came from Papa Stour. She loved it so much that she persuaded her husband to move back to the island from Lerwick when George was a baby. The community was still vibrant then. George remembers a population of over 90 – nearly all crofter-fishermen and their families. There was a church, a post office and a school. It was an idyllic island to be brought up on. But the community suffered a terrible blow after the school was closed in the 1960s and children were forced to move to the mainland of Shetland for their education. 'It broke the back of the community,' says George. There are just eight – maybe ten people living here now. No shop or pub. No hotel or post office. And no children. Not any more.'

George puts the decline down to economics.

Jane Puckley, who has been crofting on Papa Stour for over 20 years.

'The income from a traditional croft is never likely to be enough to satisfy the expectations of a modern lifestyle.' But there was a time in the 1970s when it looked as if this decline were going to be reversed. An advertisement appeared in *Exchange and Mart* offering free houses on Papa Stour, each with a piece of land and sheep to go with it. There was a sudden influx of New Age couples, many with children, who brought a new way of life to the old. Papa Stour became a hippy island and, for a few years, life improved for everyone. But, gradually, people moved away again, perhaps having had enough of 'the good life' or once the reality of

living on a remote island began to sink in.

On the other side of Housa Voe, I shared lunch with Andy and Sabrina, who had been living on Papa Stour since 1973. They had originally met at a Christian community on the shores of Loch Ness but, as Andy explained, 'We were thrown out because we became an item.' Hearing about the opportunities on Papa Stour they set up home and lived for a while in a shed that they built in the middle of a roofless croft house. 'We had no money and were reduced to eating daffodils and wild cabbage,' said Sabrina. By a 'miracle', they were now living in a large house and croft, which they had previously run as a drug rehabilitation centre until the local authority funding they depended on ran out.

Outside in the sunshine, I was feeling a little dispirited by the unhappy recent history of Papa Stour. Then I met Jane Puckey, originally from Gloucester. She had been crofting on the island for the last 23 years but, like George, she was no longer a permanent resident although she still regarded herself as an islander. She seemed practical and unsentimental in her approach to life. 'I never thought that when I was living in England that I'd end up, in my sixties, lambing on Papa!' She was busy in the old byre of a croft overlooking the sea. I watched as she delivered twins from a panting Shetland ewe – a breed which, she explained, had originally been brought to the islands by the Vikings. 'Spring is a wonderful time of year for me,' she said. 'I never tire of it – bringing new life into the world. It's renewal going on all over the island – all over the country.'

Later, I stood on the cliffs not far from the croft. Overhead, the sound of a distant helicopter competed with the shrill cry of gulls. A few miles offshore, an enormous oil-production platform

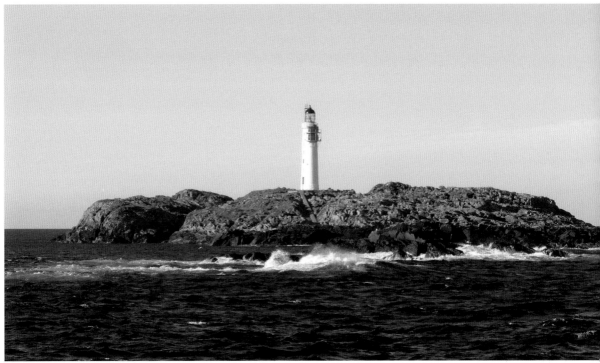

Bound Skerry.

was slowly being pulled by tugs to new oilfields west of Shetland. Between the rig and the cliffs was the Maiden Stack. Closer still was Brei Holm, a tiny island which was apparently once used as a leper colony. According to tradition, the disease died out in 1742, when a day of thanksgiving was held. I thought about the fate of Papa Stour which has been inhabited for at least three millennia. 'What,' I wondered, 'would secure the future of the island into the 21st century?'

OUT SKERRIES

Known to all Shetlanders as 'Da Skerries', Out Skerries is a beautiful group of low-lying islands, wave-washed rocks and sea stacks four nautical miles north-east of Whalsay. Bound Skerry, with its distinctive lighthouse, marks the eastern extremity of Scotland. There is no land east of here until the Norwegian coast 200 nautical miles to the east. The name Out Skerries also serves as a reminder of the proximity of Scandinavia – geographically, historically and culturally. The 'out' in Out Skerries derives from the language of the Vikings and has one of two possible meanings – *út* for 'outer' or *austr* for 'eastern', making Out Skerries either the eastern or the outer skerries. The people on Da Skerries live on two islands connected by a narrow bridge which spans the 20-metre tidal channel separating the island of Housay in the west, from the island of Bruray in the east. The other large island in the group is

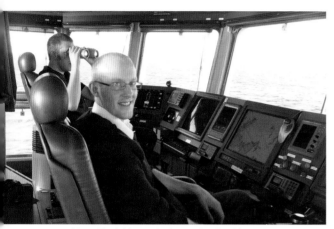

Above. The bridge on the ferry to Out Skerries.

Opposite top. Harbour, Out Skerries.

Opposite bottom. The now abandoned coastguard lookout, Out Skerries.

Grunay, which lies just to the south-east. Now uninhabited, it was used as a shore station for the keepers on Bound Skerry until the lighthouse was automated in 1972.

Until 2015, it was possible to fly to Da Skerries from Tingwall on Mainland Shetland. This air service, combined with frequent ferry sailings from Lerwick and Vidlin, made the archipelago one of the most accessible island destinations in Shetland. However, getting to Da Skerries in recent years has become harder. The air link no longer exists and the ferry service has been cut back to just four sailings a week, giving Da Skerries more of a 'final frontier' feel than they'd previously had.

It was the last day in April when I travelled to Out Skerries from the mainland ferry terminal at Vidlin. I was surprised by the appearance of the ferry *Filla* as she steamed up the voe. She looked more like an oil supply ship than a passenger ferry. But, then, the seas around Shetland are notoriously rough and, if you are going to Da Skerries, which

lie a long way offshore, I suppose it makes good sense to have a boat capable of withstanding the worst of Shetland's weather. Not that this was going to be an issue today – the sun was shining and the sea sparkling as we headed east under a canopy of blue.

Up on the bridge, I chatted to the skipper and his mate. They were both Whalsay men and, for them, the seas around Da Skerries are home waters. Very kindly, they said that, because there was no particular hurry that day, they'd take the ferry on a detour so I could appreciate the rocky coast of the archipelago better. Heading around the outside of the islands, the skipper pointed out North and South Benelip, islands where it's thought Celtic monks may have once had a chapel before the Vikings swept in from Norway in the 9th century. On we sailed, passing around the outside of Grunay. Until the 1970s, this is where the shore station was for the lighthouse on Bound Skerry. During the Second World War, the German Luftwaffe targeted the lighthouse on two occasions. In 1941, the shore station was machine-gunned. Fortunately, there were no casualties. The following year, it was again attacked. This time a bomber destroyed the lighthouse keepers' accommodation. The boatman's house was also destroyed when it sustained a direct hit that killed the boatman's mother. Later, in 1942, a Blenheim IV bomber of the Royal Canadian Air Force crash-landed on the island. It had been on patrol close to the Norwegian coast but had suffered damage from enemy fire. Unable to make it back to base at Sumburgh on Mainland Shetland, it attempted to land on Grunay. Tragically, it bust into flames when it hit the ground, killing the three airmen on board.

Rounding Bound Skerry, *Filla* headed west to

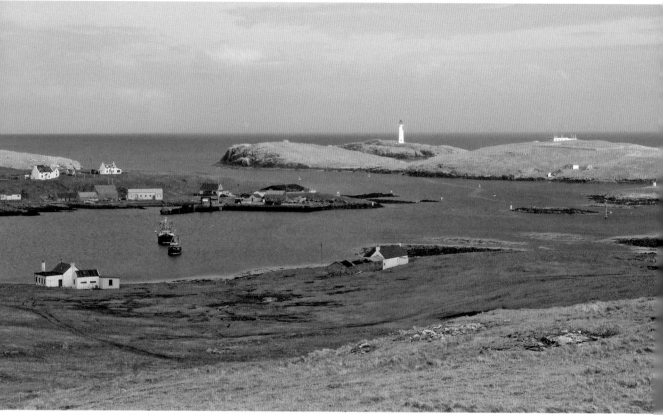

Southmouth, Out Skerries.

come inside the islands, giving me a good view of the lighthouse, which was built by the engineers David and Thomas Stevenson. Thomas was the father of Scotland's literary giant, Robert Louis Stevenson. As a boy, he'd visited this rocky skerry when the lighthouse was under construction. Stevenson's boyhood experiences of all the islands he had travelled to undoubtedly helped him find his voice as a writer. Da Skerries are an inspirational place and I'm certain that they would have made a big impression on the imagination of such a creative and sensitive mind.

With Bound Skerry and Grunay now to port,

Filla entered the sheltered waters of a channel called the North-East Mouth, which leads into the heart of Da Skerries, which cover not much more than four square kilometres of land and, from *Filla*, they looked almost too small to be habitable but the hardy breed of folk who live here have a great reputation for hospitality. Ahead of me now, I could clearly see some the houses on Housay and Bruray overlooking the natural harbour of Böd Voe, and on the pier I could make out the figures of people waiting for the ferry – the islands' only lifeline. According to the skipper, until the 1970s, ferries were unable to get into the harbour.

Passengers wishing to go ashore had to transfer into open flit boats for the final short leg of their journey. Not anymore. Stepping ashore from *Filla*, I made my way along the island's only road and was reminded of a royal visit made in 1960 when the young Queen Elizabeth and Prince Philip came on a visit to the islands. Back then the population was 150. That number has fallen dramatically since then and it now stands at around 70.

Alice Arthur is a Skerries woman 'through and through' and can trace her ancestry on the islands back for hundreds of years. I met her at her house on Housay, which her husband had built a few years earlier. Over a cup of tea and a huge slice of cake, Alice told me she had been taken to see the Queen when she came on her royal visit. Unfortunately, she has no memories of the islands' biggest day because she was just four months old at the time. But, since then, she'd met the Queen on two other occasions – most recently in 2006 when she was awarded the MBE at Buckingham Palace. Just six years earlier, her father had been honoured with the same award. Alice's MBE was given in recognition of her services to the local fire brigade and to the community on Out Skerries. But that wasn't all she had been doing at the time. Alice also worked in the fish factory, at school as an art teacher and on the family croft. That's a lot of different hats to wear but, very sadly, things changed in the years following her MBE. After her visit to the palace, the community suffered a succession of blows that impacted the economic viability of the island. Alice reeled off a list of closures – a litany of decline. 'It happened very suddenly – really just in the last two years that it's gone downhill fast. We've lost the secondary department of the school; we've lost the salmon farm; we've lost the fish factory; we've lost the

flights coming into the island; we've lost the fire brigade. We're really struggling to be honest.'

All this adversity did not seem to have diminished Alice's love for her home. 'It's a place to treasure – quite literally,' she said. To demonstrate what she meant, she produced some gold and silver coins from a drawer – doubloons and ducats lay on the table in front of us, collected over the years by family members from the rocky shore. For as long as anyone on the islands can remember, sunken treasure has been continually washed ashore from ships wrecked on the harsh coast. The coins in Alice's family collection came from a Dutch East Indiaman wrecked in 1711. A large silver coin, found in a rock crevice by her father, had an inscription in Latin around the rim. It read, '*Concordia Res Parvae Crescunt*'. With the aid of some quick internet research, I was able to tell Alice that this translated as 'In harmony small things flourish'. She was delighted. 'That could be a motto for us here on Da Skerries. We're not giving up yet!'

Leaving Alice, I headed outside and walked up to an old coastguard's lookout hut where a wind turbine lay like a felled giant. Its buckled blades seemed to gesture to a promise betrayed. The wind was blowing strongly now. There were expansive views across the white-capped waves to all the rocky islets that make up Da Skerries. Further off on the horizon to the south-west was Whalsay and its fishing boats and wealth. Beyond that, distant Mainland Shetland where Alice's husband now worked. Like so many of the island's men, he had been forced to leave in the last couple of years to earn money for his family and, now that the school was closing, the community seemed to have shrunk to a handful of women, waiting for their loved ones to come home.

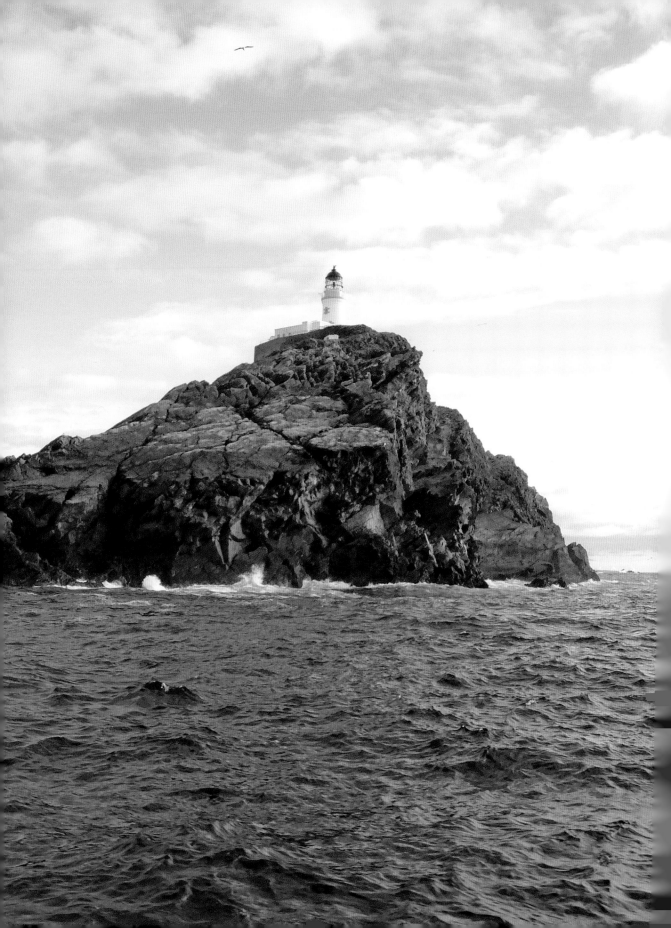

CHAPTER 4
THE NORTH ISLES

Yell, Fetlar, Unst

YELL

Lying to the north of the mainland of Shetland are three islands with distinctive names: Fetlar, Unst and Yell. Together they are known as the North Isles. For anyone travelling from the south, the first of these is Yell – an island with a name that sounds as if it's a place that wants to be heard – which indeed it may do. This is the second-largest island in Shetland. At 27 kilometres long by 10 kilometres broad, it is almost the same size as Arran but has a population of just under a thousand. Perhaps because the charms of Yell are not obvious or immediate at first, the people who live there are inclined to feel overlooked. Some visitors in the past were indeed unkind in their accounts. One 16th century traveller wrote that Yell was 'so uncouth a place that no creature can live therein, except such that are born there'. This, I can happily report, is entirely untrue. The people I met on my travels were always models of hospitality and politeness. However, the landscape of Yell can be challenging. The most striking feature of the island is the peat, which in places can be up to three metres deep. It covers the interior in a great blanket of wild and featureless moorland, known as 'Da

Opposite. Muckle Flugga lighthouse.

Wilds o' Yell'. This great, uninhabited tract of land is a haven for birdlife – a place where hen harriers and merlins hunt over the heather, where the thrum of snipe reverberates over the moor and where the lonely call of red-throated divers carries over wind-ruffled lochans. As I made my way across the island, I saw numerous peat workings close to the single-track road – signs that Yell folk continue the ancient tradition of digging, stacking and drying this wonderful but soggy material for use as fuel.

Most travellers to Yell from the south arrive by ferry at the small settlement of Ulsta, also known as 'Flukes Hole'. For visitors unused to Shetland place names, Flukes Hole is mild by comparison with many other places signposted across the island. There's Gutcher, Lumbister, Hamnavoe, Grimister, Effstigarth, Sound and Gloup, to name but a few. All of these are Norse in origin, but the name Yell remains something of a mystery. Historians are uncertain of its origin. Some claim that it pre-dates the Norse settlement, which would make Yell a Pictish name. Whatever the truth, I've found Yell to be appropriate. This is a windy island and, to make yourself heard in a gale, it's only natural to yell!

Despite being the last day of May, it was grey,

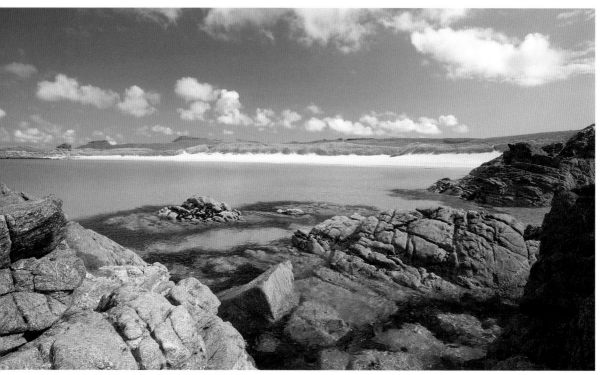

Turquoise waters at the Sands of Breckon, Yell.

windy and a rather chilly nine degrees when I arrived at Flukes Hole. Heading east along the single-track road, I made for the sheltered natural harbour of Burravoe, which was once the main ferry port for goods and passengers travelling from Lerwick. Burravoe gets its name from an ancient Iron Age broch, which today is in such a ruinous state that there is little left to see except for a pile of stones close to the rocky shore below the Old Haa. Now a museum, the Old Haa was originally built by a merchant in 1672, making it the oldest surviving building on the island. Inside is a marvellous collection of artefacts, documents and images telling the story of life on Yell throughout the centuries. Having satiated my historical curiosity, I needed to assuage my hunger pangs so I visited

the museum tea room where I was served a gigantic slice of lemon drizzle cake – one of the 'fancies' baked by local women. As I enjoyed this guilty pleasure, I delighted in the Shetland dialect being spoken by a group of ladies nearby. Its lilting cadences, unique words and pronunciations sounded like another language to the casual listener. I hope they weren't speaking about me!

As I left the Old Haa to brave the elements again, I noticed a plinth supporting a propeller blade from an aircraft. In January 1942 an RAF Catalina flying boat was on a mission to the Norwegian coast to try and locate the German battleship *Tirpitz*. Flying across the North Sea, the Catalina developed engine problems and the crew were forced to return to base. Unable to make the

'Da Wooden Wife', once the figurehead of a sailing ship, at Queyon.

distance, the pilot tried to land at Sullom Voe, but crashed in the darkness on the hills above Burravoe. Seven of the crew died. Miraculously, three survived. The names of all the men are recorded on the base of the memorial.

Thinking of memorials, I was keen to see the White Wife – or 'Da Wooden Wife', as she is also known locally – which I'd been told I could find somewhere on the coast near Otterswick. In fact, she stands overlooking the grey sea at a place called Queyon and was once the figurehead of a sailing ship. Painted white, she holds a black Bible in her hand and makes a dramatic and slightly surreal spectacle in the surrounding landscape. No longer at sea, she commemorates the loss of a German sail-training ship called the *Bohus*, which sank in

a storm on the rocks of the Ness of Queyon in 1924. The *Bohus* was originally called *Bertha* and was built in Grangemouth in 1892. After a varied career she was renamed *Bohus*. In 1924, she set sail from Sweden to Chile with a crew of 34, many of whom were young cadets. Unfortunately, the captain miscalculated the position of his ship. During a storm, he mistook the lighthouse on Out Skerries for the light on Fair Isle and hit the rocky coast of Yell. Those who could swam ashore as the ship broke up. The remaining crew clung to the wreckage. Their plight was seen by a group of Yell men who came to the rescue. In the teeth of the storm, they somehow managed to throw a rope to the stricken vessel and bring most of the remaining crew to safety. Miraculously, only four men

lost their lives that night. Then, five months after the *Bohus* disappeared beneath the waves, her figurehead was washed ashore. She was in remarkably good condition and was erected close to where she was found, making a fitting memorial to the *Bohus* and her crew.

Following the excellent single-track road north, which winds over high moorland, I enjoyed wonderful panoramas of the islands of Fetlar and Unst. Continuing through a landscape of heather-clad hills and broken peat hags, I descended to the village of Mid Yell, which is the largest centre of population on the island. When the Vikings settled in Yell during the 9th century, they called Mid Yell Voe *Reydarfjordur*. This gradually mutated first into *Refurd* and then, by the 16th century, into *Reafirthand*. It was only much later that the settlement on the southern shore of the voe acquired the prosaic and unromantic-sounding name of Mid Yell.

Reaching the village, I went in search of sustenance and found the Hilltop Bar, which declared itself to be the most northerly public house in the UK. This may have been true at one time but, apparently, a bar on Unst usurped the Hilltop for this honour. Since my visit, the Hilltop Bar closed permanently in August 2017 so there's no longer any rivalry for this claim to fame. The Mid Yell drinking establishment certainly had a frontier feel about it and to say Hilltop's service provision was basic would be an understatement. It was a pretty rough place and, while standing at the bar, I overheard a female tourist ask for wine. 'No problem. We've got two varieties – red and white. But we've got no wine glasses, I'm afraid,' said the helpful barman, offering her a half-pint mug instead.

I sat for a while nursing my drink until a group of cheerful men of a certain age began to arrive for some refreshment. We got chatting and I learned that they belong to a local male choir who called themselves 'The Shanty Yell Men'. At 83, Andy Gear was the oldest member and came from Foula. Mike was a retired doctor and another singer was formerly a policeman in Kent. The prime mover and shaker of The Shanty Yell Men appeared to be a big moustachioed Dutchman called Pieter. Once the full compliment of 10 shanty men had assembled, they began to sing a traditional song in a language that the Vikings would have understood – the Old Norwegian dialect Norn. For the most part, Norn died out several generations ago but The Shanty Yell Men were helping to keep it alive in song. As I listened, the words seemed uncannily familiar. My smattering of modern Norwegian was enough to allow me to get the gist of 'The Unst Boat Song':

Starka virna vestilie
Obadeea, obadeea
Starka, virna, vestilie
Obadeea, monye.

Stala, stoita, stonga raer
O, whit says du da bunshka baer?
O, whit says du da bunshka baer?
Litra mae vee drengie.

Andy Gear was moderately impressed when I told him that I understood some of the song. '*Starka virna vestilie* – "*Sterke vindene vestilige*" is how it would go in Norwegian, or "The strong west winds" in English. That's right, isn't it?' I asked.

Andy smiled and explained 'The Unst Boat Song' tells of the dangers of the weather and the

Opposite. Peat workings on Yell.

Windhouse – the most haunted building in Shetland.

need for a sturdy boat and a good crew. Being a Foula man, he knew the truth of this first hand. He went on to claim, somewhat ominously I thought, that he was descended from the Viking Thorfinn the Skull-splitter! I wasn't sure if this was a proud boast or perhaps a threat.

Only a narrow neck of land, just a kilometre wide, separates Mid Yell Voe from Whale Firth in the west. These long arms of the sea nearly cut Yell in half, almost making Yell two islands. I wondered if boats had been dragged across from shore to shore in the past, creating a short cut similar to the one at Mavis Grind on Mainland Shetland.

Above the road that crosses the isthmus, I saw a conspicuous ruined house on the hillside. For some reason I felt compelled to take a photograph of it. Perhaps it was the location or the dramatic light but there was definitely something about its gaunt appearance that seemed peculiarly atmospheric in this treeless landscape. I later discovered that the ruin is called Windhouse and is said to be the most haunted house in all Shetland. The

first supernatural tale connected to Windhouse dates back to the early 18th century, when it was home to the laird, who had built himself a mansion using stones taken from an earlier house which had stood a little further up the hill. As with many old stories it began, 'It was a dark and stormy night . . .' It was also Christmas Eve and the occupants of the laird's house were disturbed by the unexpected arrival of a visitor at the door. The stranger turned out to be a shipwrecked sailor who was looking for shelter. To his surprise, he found everyone packing up and ready to leave because of a deadly curse that said, every Christmas, someone would die in the house. The sailor was urged to leave with the family but, for some reason, he decided to stay on. Alone now, he sat and waited. As midnight approached, he heard a terrific noise coming from outside. A hideous creature – a *trow* – was attacking the house. Unperturbed, the sailor did battle with it and killed the monster with an axe. The *trow* fell to the ground – a shapeless mass. When the family returned the next day, the sailor was waiting for them. He had survived the night

– but the body of the *trow* had disappeared. There was no evidence of the fight except for at the place the body had fallen where the grass and heather had turned an unseasonal bright green.

Later tales of mystery and imagination involve ghostly sightings, including a lady dressed in silk, a tall man, a servant girl and a mysterious spectral collie dog. Curiously, there have been several reports over the years of human remains being discovered. A female skeleton was found beneath the old staircase close to where the ghostly woman with her rustling silk dress is alleged to appear. Another account from 1887 claims that the body of a six-foot-tall man was unearthed by workmen removing debris from the back of the house. The body was lying in a shallow grave. This led to the suspicion that the man might have been murdered, which could explain why his restless ghost still haunts the place. Then, at the turn of the last century, workmen replacing a window discovered the body of a child wrapped in sheepskin inside the wall.

Windhouse was abandoned in the 1920s and has changed hands several times. When planning permission was requested recently to turn the ruin into a house again, a survey was carried out. Two bodies were discovered in shallow graves near the front door. Archaeologists now believe that the house was built on an ancient graveyard, which may account for its long association in the minds of local people with the supernatural and the forces of darkness.

Although I didn't see any ghosts at Windhouse, I did witness a surreal spectacle in a field nearby as I made my way to the ominous-sounding settlement of Grimister. Not far from the road junction were two headless human forms, which seemed to be taunting each other across the open space

between them. When I got closer, I realised they were scarecrows made from two old boiler suits, hung on frames and billowing in the wind. And what a curiously unsettling sight they made as they danced like tormented wraiths in the wind.

The narrow fjord-like Whale Firth presumably got its name from the whales which once sported in its waters and which are still are occasionally spotted. Sadly, there have been reports of several standings in recent history. In the 1990s, a dolphin was washed ashore on the beach at Grimister. Submersibles of another kind were also once active in the Firth. According to the German Navy, U-boats once sheltered in its loneliest reaches during the First World War. Because the coastline here is almost completely deserted, the U-boats went undetected.

On the southern shore of the firth, where it bends to face the north, is the tiny settlement of Grimister. It was a shadow of its former self. It used to have a shop and a school and there was also a significant herring curing station on the shore but that closed shortly after the Second World War. Reaching the end of the road that leads to Grimister, I could see several ruined crofts on the grazing land overlooking the beach – a forlorn reminder of livelier times.

Heading north again, I made my way to Gutcher – the ferry port for all traffic making for Unst. For such a significant centre of inter-island communication, I was surprised by the size of Gutcher. It was tiny and had a real 'end of the road' feeling about it. A couple of houses, a weather-beaten cafe and the Old Post Office, where I had booked a couple of night's bed and breakfast, were all there was to it. The Old Post Office was a fine building which had obviously been a place of some importance in the past. It was now home to Adrian

and Jane – a couple who'd moved from the English West Country a couple of years earlier. Adrian was a composer and played me a tape of his music over dinner in the wood-panelled dining room. 'We moved here to have an adventure and to create a place of peace and renewal,' Jane explained as she patted the head of a large dog. The place was full of her pets – dogs and cats lounged indolently in the most comfortable chairs and, to complete the domestic menagerie, some very large and intimidating geese patrolled the premises outside.

The following morning, as I was gazing at the empty ferry terminal though the dining-room window, Adrian interrupted my reverie by brandishing a dangerous-looking weapon in my direction. This turned out to be a bread knife, which he brushed against the whiskers of his grey beard as he asked me what fillings I'd like in the sandwiches for my packed lunch. When I told him, he kissed the knife and returned to the kitchen, where I could hear him humming a tune – perhaps he was composing another fugue or sonata, I thought.

Having negotiated the aggressive geese outside, I made my way along the coast road around Bluemull Sound to Cullivoe, a name which comes from the Old Norse *Kollavágr* – meaning 'Kolli's Bay'. This used to be where the ferries for Unst came and went until its role was usurped by Gutcher. But, unlike Gutcher, Cullivoe is still an active fishing harbour. Down at the pier, I met up with three fishermen, Michael, Ian and Richard, who were taking me out on their fishing boat through Bluemull Sound to the north end of Yell. At first, I found it almost impossible to tune into the Shetland dialect on board. It sounded like a foreign language but, when the skipper was talking to me about how they caught cod and ling using long baited lines, I found I could follow him with

no difficulty. When I pointed this out, he explained that he was *knapping*. To make themselves more easily understood when speaking to non-Shetlanders, it's common for Shetlanders to modify their language.

'So you're knapping now – speaking posh?' I asked.

'Yes, I am,' he said with a grin. 'It's sometimes a bit embarrassing when there are other Shetlanders nearby and they can overhear you knapping away because they know that's not the way you usually speak.'

As we rounded the headland of Gloup, we could see the stacks and skerries of Gloup Holm, the Whilkie Stack and the Clapper. According to local legend, this coastline was known to one of the most famous Vikings to have ever lived – Leif Erikson, who some believe visited Yell on his way to discover America in the 11th century. It's interesting to speculate that this area may have been where Leif Erikson came before he embarked on his long voyage west but, as with most 'local' legends, there's no hard evidence to support the claim.

As the fishing boat rose to meet the Atlantic swell, I asked how far they take their boat looking for fish. The skipper Michael said that they were fishing pretty much as their grandfathers had done when they went to the *haaf* fishery – heading up to 40 miles into the deep sea. The furthest he'd taken his own boat to drop was west of Rockall, some 300 nautical miles further out into the Atlantic.

'I'll never go there again,' he said grimly. 'The seas are enormous and the winds regularly blowing at 60 knots. It's not pretty. There's no shelter and nowhere to run to.'

There's a reminder of the perils of the sea situ-

Yell Sound.

ated not far from the settlement of Gloup, at the northern extremity of Yell. In the 19th century, Gloup was an important *haaf* fishing station, until 1881 when one of the worst fishing disasters in Shetland history devastated the community. For several days, the fishing fleet had been unable to sail because of stormy conditions and the men were getting desperate to return to work. Then unexpectedly, the weather broke. Taking advantage of the fine conditions, dozens of small boats set sail on 20 July and headed out to fishing grounds some 40 miles offshore. But suddenly, out of nowhere, a terrible storm drove down from Iceland and overwhelmed the fleet with hurricane-force winds and mountainous waves. Ten boats never returned and 58 men lost their lives. The disaster left 34 widows and 85 children fatherless. To commemorate this awful tragedy, a simple and

poignant memorial has been erected overlooking Gloup Voe where many of the boats had left from. The name of every man that drowned is listed, along with the boats that were lost and the communities that were left to grieve.

FETLAR

The island of Fetlar lies a half-hour ferry journey south-east from Gutcher. Its name apparently derives from Old Norse and means 'fat land'. That's not because people in the past tended to be on the large side but because, by Shetland standards, Fetlar is very fertile and the inhabitants could live off the 'fat of the land', which is also why it's sometimes known as 'the Garden of Shetland'. The island is the fourth largest of the Shetland Isles and measures about 9.5 kilometres east to west by

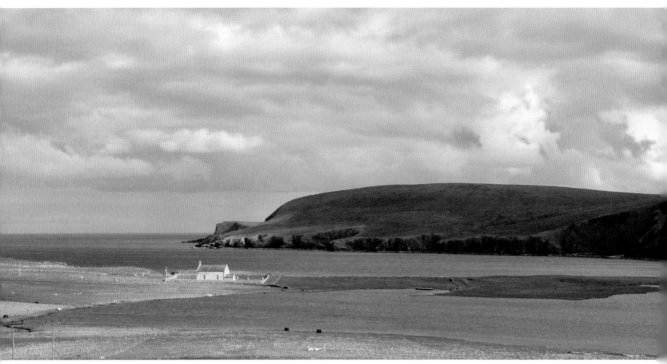

View across Fetlar, 'the garden of Shetland'.

5 kilometres north to south. It is also a pretty flat and featureless place, with a small population of about 50 full-time residents.

When the Vikings arrived on the island in the early 800s, Fetlar had already been inhabited for thousands of years and is littered with ancient remains. There are stone circles, Neolithic cairns, Iron Age brochs and a feature that's unique to Fetlar – an ancient wall that crosses the island, dividing it in two, with the peculiar name of 'Finnigert Dyke', and it's just as puzzling as it sounds. Having read about its existence, I was keen to discover the dyke for myself. Legend says it was built by Finns – *trows* that lived beneath the sea and had magical powers. Unfortunately, there was not a lot of this ancient monument left to see – it is about 3,000 years old and, throughout the

ages, many of its stones have been plundered and put to other uses. Today, most of Finnigert Dyke, also known as 'Funzie Girt', is just a heather-clad, low rise that's especially visible to the west of the high ground of Vord Hill. Walking beside it, I realised that its existence was evidence of a pretty sophisticated society, which must once have flourished on ancient Fetlar – one that could organise communal effort on an imposing scale. When the Vikings arrived, they too must have been similarly impressed by the achievement of their predecessors as it led them to regard Fetlar as two distinct islands, divided by the dyke. As a consequence, *Est Isle* and *Wast Isle* is how the two separate areas of Fetlar appear in early Norse records.

The fertile soils of Fetlar made agriculture a mainstay of island life and its population flour-

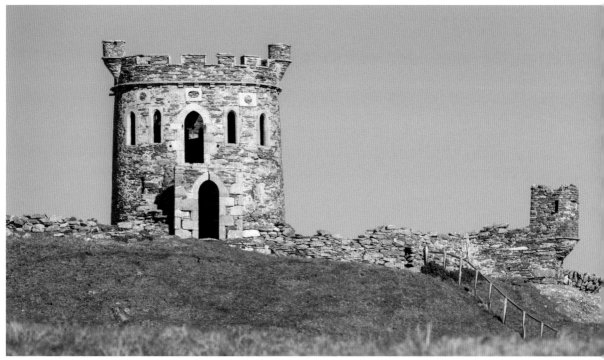

The folly at Brough Lodge, Fetlar.

ished. By the beginning of the 19th century, nearly 900 people lived off the land, supplementing what they grew with what they could catch from the sea. But things changed for the worse when Fetlar was bought by a rich Lerwick merchant with aristocratic pretentions. After acquiring the island, Arthur Nicholson went on a Grand Tour of Europe and returned with big plans. Inspired by the architecture of the continent, he set about constructing a palatial house. Brough Lodge was finished in 1825 and boasts a brick Italian-style chapel and a folly, which was erected on the site of an Iron Age broch. In order to derive an income substantial enough to fund his lavish lifestyle, Nicholson set about improving the efficiency of his new estate. First, he enclosed much of the island's productive land for sheep grazing. The tenants who had previ-

ously farmed there became surplus to requirements and were given notice to quit. Over the course of the next few decades, the population went into steep decline. The departure of so many of its people and traditions had a devastating impact on those who were left.

Many of the people cleared from Fetlar were replaced by sheep. These had been crossbred and improved by Nicolson from the ancient native stock, which probably arrived with the Vikings. The descendants of these woolly beasts still roam the island, which has seen something of a revival in old crofting traditions. However, many of the modern crofters were not born on Fetlar and have moved from elsewhere. Joanne and Les Bell came originally from County Durham but wanted to escape the hustle and bustle of modern life. Far

With Joanne and Les Bell before Jo showed me how to *roo* her sheep.

from the madding crowd, they were now crofting land near Houbie. When I met the couple, Joanne was very enthusiastic about embracing the old ways. She wanted to demonstrate the traditional method of harvesting wool from her flock of Shetland sheep. Instead of shearing, she likes to *roo* her sheep. This involves getting very intimate with the beasts. With a ewe clamped between her thighs, Joanne explained the *rooing* process.

'You start from the neck and work your way down, using your fingers like a comb, and pulling. The fleece will come away – hopefully in one piece.'

In the past, this was how all Shetland sheep were shorn. The fine and soft fibres of their wool quickly became renowned for quality and warmth and an important part of the island economy. At one time, every woman of Fetlar would have been adept at spinning wheel and knitting. Joanne proudly showed me her own spinning wheel and how she produces her own yarn. She might not have been a native of Fetlar but she had a natural flair for island traditions.

'I love it here,' she said. 'I knew the first time I got off the ferry that I belonged to Fetlar.'

Her husband Les seemed a bit more cautious. 'To be honest, the winters can give you the blues. I had no idea what it would be like without streetlights. I'm from Newcastle and it was just so black outside the house. And sometimes the winds are so strong, it is simply too dangerous to go outside – even to walk the dogs!'

There is really only one road on Fetlar. It crosses the island from the ferry terminal at Hamars Ness to the happy-sounding place of Funzie in the east where, tradition has it, the less-than-fun-loving maritime *trows* have an association. Making my way from one end of the road to the other, I encountered lots of Shetland ponies which seemed to have been given a licence to wander freely across the island. Some of these creatures took a perverse delight in making a stubborn stance in the middle of the road, refusing to move unless possibly coaxed by nibbles.

Down at the lovely Tresta Sands is a wide crescent of beach, which backs on to a loch called Papil Water – a holy place even in Viking times. Here, the plain but beautiful 18th-century Fetlar Kirk stands surrounded by a graveyard, which includes the bodies of three sailors who were washed up after their ship the SS *Hop* was torpedoed by a German U-boat in 1940. Other members of the crew whose bodies were recovered from the seas lie in burial grounds at Baliasta, Easting and Lunna. Away from the bay, there were plenty of signs of

Brydon Thomason, who took me on an otter hunt.

an island struggling for survival. Ruined and derelict houses were dotted across the landscape, evoking a weird, post-apocalyptic feel where you half-expected the survivors of some catastrophe to emerge looking dazed and shell-shocked. But these haunting ruins are mostly the result of the clearances and subsequent economic decline over two centuries. Adding to this otherworldly feeling were strange stone-walled enclosures that dotted the landscape. I was reminded of the cleats of St Kilda – except these structures were roofless. It wasn't until I met local boy Brydon Thomason that I learned their true purpose. According to Brydon, they were built by crofters as places to grow crops and vegetables. The stone walls gave protection from the winds and grazing animals.

Brydon, who runs wildlife safaris around Shet-land, took me on an otter hunt. Shetland is considered to be the otter capital of the UK because of they occur in such numbers across the islands, especially in the north, making Shetland the best place in the world to catch sight of this elusive creature. Brydon was quick to explain that these are not sea otters, which are a different species altogether. Although their habitat is coastal and they hunt in the sea, they are European otters – or *Lutra lutra* to give them their Latin binomial name. And, despite seeming to be perfectly adapted to seawater, they need fresh water close by in order to clean their thick, protective layer of fur. Why, I wanted to know, is Shetland such a great place for otters?

'It's the pristine waters here and abundant food supply and access to plenty of streams and burns

A Shetland otter.

where they can have their daily shower,' said Brydon.

Down on the wet grassland above the shore we got our first clue that otters were about – a thin track, worn in an area of damp moss and grass, was a sign that otters had been passing. Just moments later, their presence was confirmed by the discovery of a 'spraint' or pile of otter dung, complete with the undigested bones of its prey – 'Fish and crabs mostly,' Brydon told me after picking it up for closer examination. Heading into the wind and keeping a low profile, we stealthily made our way along the rocky shore. Brydon confessed that he's had a passion for otters since he was a wee boy growing up on Fetlar. 'I'd follow their runs and try to find their holts – anything to do with otters just fascinated me.' Now crouching below a gravel bank our patience paid off. Brydon pointed out a mother and two cubs swimming a few yards away. Then the thrill of the chase as the mother dived and brought ashore an octopus, tentacles waving desperately. But this was just for starters. Next came an equally difficult dish to

tackle – a velvet crab with alarmingly active and vicious claws. I'd seen otters in the wild before but never this close. It was thanks to Brydon's tracking skills that I had the privilege to observe these wonderful animals in their natural habitat from such close quarters.

UNST

Having been goosed by a goose at Gutcher, I left my B&B at the Old Post Office and caught the ferry across Bluemull Sound to Unst – a place that sounds more like a grunt than an island but which is, in fact, Yell's northern neighbour. At 19 kilometres long by 8 kilometres wide, Unst is Shetland's third-largest island – after Mainland and Yell – and has a population of somewhere in the region of 650 souls who are mostly scattered in small communities along the east coast. The origins of the monosyllabic name Unst are obscure and are thought to belong to the period before the Vikings arrived in the 9th century. There is a considerable amount of archaeological evidence for these earlier

Uyeasound pier.

inhabitants – the ruins of Iron Age brochs and homesteads, chambered cairns and standing stones. The massive three-metre-high Bordastubble standing stone is thought to be the largest in Shetland and the legendary Uyea Breck standing stone is said locally to mark the place where one of the sons of the Viking king, Harald Hårfager (Harald Fairhair), was killed. Despite several thousand years of human occupation, the Vikings' influence on Unst is evident. The island is less than 200 nautical miles from the west coast of Norway – London is 600 miles away – and it is claimed that Unst was the first Atlantic landfall the Vikings made on their early voyages of discovery. In recent years, over 60 Viking longhouse sites have been discovered on the island. There are Viking burials, the ruins of Viking chapels and, of course, a host of place names and legends associ-

The ferry to Unst.

ated with language and culture of the Vikings.

Landing on Unst, I took the road from the ferry pier at Belmont and headed east towards Uyeasound – an almost unpronounceable place with a picturesque old pier and harbour overlooking a narrow channel to the island of Uyea – an Old Norse name which possibly comes from *ve-øy*, meaning 'home island'. The island is now uninhabited but an old story tells of how two girls who once lived there went off in an open boat one day to milk the cows on the neighbouring island Haaf Gruney. A storm blew up unexpectedly and the girls were carried out to sea, where they spent several days clinging on for dear life, praying for salvation and bailing water when waves broke over the boat. Eventually, they reached the coast of Norway where they were given food and shelter on the island of Karmøy. At this time, women were in short supply on Karmøy, which made the girls very popular – so popular that they never returned to Shetland but, instead, married local men and lived happily ever after.

The road east from Uyeasound towards Muness runs past the Uyea Breck standing stone, which supposedly marks the place where King Harald Fairhair's son was slain. Harald Fairhair appears in the Viking sagas, which claim that, in the 9th century, he became the first king to rule over all of Norway. The unification of the Viking lands started as a love story. Harald's proposal of marriage to Gyda the daughter of the king of Hordaland was only accepted on condition that he became king of the whole country. Harald promised to do this and further vowed never to cut his hair until he had won his bride. After years of fighting, his hair grew long and matted until the day of final victory. Thereafter, he cut his hair and indulged in some early male grooming – thus

becoming Harald Fairhair, King of all Norway. But he had lots of enemies, many of whom fled his rule and headed west to Iceland, Orkney and Shetland. These rebel Vikings represented a threat to Harald and he duly set sail with a large fleet to hunt them down and destroy them. He landed in Shetland and killed and burned his way to peace, although victory cost him the life of his son.

From one man to another. At the village of Muness an impressive Z-plan tower house commands the landscape. This is Muness Castle, built in 1598 by the sheriff of Shetland, Laurence Bruce, who was the half-brother of Robert Stewart, Earl of Orkney, the bastard son of James V. At this time the Scottish crown and its representatives were actively stamping their mark on the recently acquired Shetland Islands. Their reign was characterised by oppression, cruelty and corruption. On Unst, Laurence Bruce raised taxes and grew as wealthy as a robber baron on the proceeds. However, when his half-brother Earl Robert of Orkney died and was succeeded by his son Earl Patrick Stewart, Lawrence Bruce felt threatened. The Northern Isles weren't big enough for two powerful and ruthless egos – especially when they were related. Preparing to resist his nephew, Laurence set about building the castle at Muness. An inscription above the doorway of the southern facade reads:

> List ye to knaw
> This building quha began
> Laurence the Bruce he was that worthy man
> Quha earnestly his airis and offspring prayis
> To help and not to hurt this wark aluayis
> The yeir of God 1598.

Opposite. Uyea Breck standing stone, Unst.

114

Earl Patrick, now operating from his new castle at Scalloway, took a very dim view of his half-uncle's new castle. It was an obvious challenge to his own position of power over the Shetland Islands. In 1608, he set out to meet that challenge, landing on Unst with a force of 38 men and several pieces of artillery, intent on destroying Muness and vanquishing his rival in the north. But his siege failed and he was forced to withdraw. However, fate played another hand when pirates, or privateers, from Dunkirk sailed to Unst in 1627 and attacked Muness. Unlike Earl Patrick, they succeeded and caused substantial damage by setting the castle alight. Although it was reoccupied afterwards, by the end of the 18th century, Muness Castle had fallen into ruin after which many of its stones were removed by local people for use in nearby buildings.

The five kilometres of coastline that separate Muness from Baltasound to the east of Unst are uninhabited. But, in centuries past, there were several townships along this beautiful stretch of shoreline, each with its own now largely forgotten history of human habitation. The great arc of sand at Sandwick – Old Norse for 'sandy bay' – can be reached after a 15-minute tramp over the fields from the car park at the Hannigarth road end. The stunning white sands and blue seas of Sandwick make this a glorious location – yet there's a poignancy to the view. All around the bay and up on the green sward above the beach are the ruins of people's homes. There are Iron Age houses here, a Viking longhouse, its low walls protruding from the sandy soil, and about 16 long-abandoned and roofless croft houses. At the north end of the beach at Framgord is an ancient enclosed cemetery, which includes some unusual Viking keelstone grave slabs – so called because they resemble the

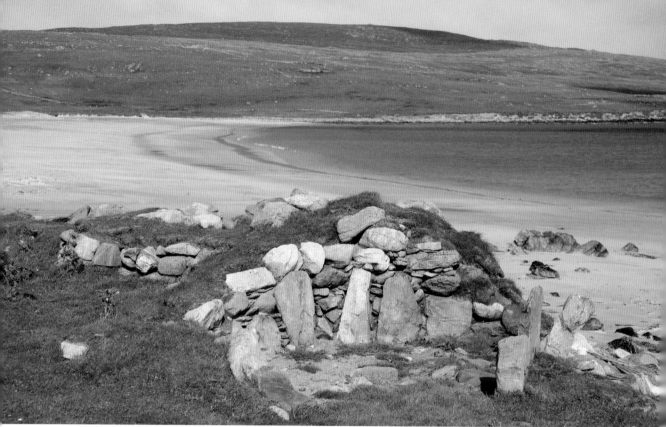

The Viking longhouse at Sandwick Bay, Unst.

underside of a longboat's keel – and small crosses. In the centre of the graveyard are the tumbled stone walls of a medieval chapel. Thought to be dedicated to Our Lady, the chapel is contemporaneous with the later Viking era on Unst. Close by is a gravestone with a greatly weatherworn coat of arms. According to local tradition, this is where the ruthless Laurence Bruce of Muness Castle was laid to rest.

A kilometre further north of Framgord is another area of green pasture. It too is peppered with ruined houses and outbuildings – all that remains of the township of Colvadale, which was apparently occupied until the 1950s. In amongst the derelict houses are more ancient remains, which include another Viking longhouse. Looking at the tumbled walls and broken houses, I was forcibly reminded of the long history of depopulation which, for the last 200 years, has ravaged

the North Isles. There had once been vibrant communities at Sandwick and Colvadale. Soon the last living person able to remember them will be gone. A census taken in 1831 recorded 2,730 people living on Unst. Today the figure stands at less than a quarter of that figure.

From the empty beauty of the east coast and its abandoned communities, I headed north over the Hill of Caldback, passing several chambered cairns, until I came in sight of the sea and Baltasound. The capital of Unst, it was one of the busiest fishing ports in Scotland. A century ago, thousands of men and women flocked here to chase the silver darlings – the shoals of herring. Up until the First World War, the fishing grounds around Shetland were amongst the richest in the world. Every year, huge shoals of migrating herring appeared around the coast. The catches were enormous – hundreds of thousands of tonnes of fish, an annual harvest

of the sea that kept Baltasound's fleet of 700 boats very busy.

When the fish were landed, teams of women gutted and packed the herring into barrels on the quayside. These women were known as 'the gutter girls'. Rhoda Hughson's aunts were amongst the many gutter girls from Shetland who followed the herring fleet all over the country. Walking with Rhoda beside the ruins of a once-busy fishing station, she painted a word picture of what life was like a century ago.

'These low walls are the footprint, if you like, of the herring fishing industry here on Unst. They are all that is left of the accommodation blocks used by the gutter girls during the fishing season. Each block comprised four huts, each with a stove. There were four girls to a hut, making 16 in each block, all living and working in close proximity to each other. All along the waterfront were dozens and dozens of similar huts. The workforce was huge and the population of Baltasound soared each summer to 12,000, turning the village into a city.'

Rhoda went on to explain how the gutter girls worked in teams – one gutted while the others packed the fish. They had to be incredibly fast and efficient because they were paid by the barrel-load. The most skilled ones were able to gut 60 herrings in a minute. That's one a second! To give an idea of how fast and efficient they could be, in just a single week in 1904, seven steamers left Baltasound with 3,000 tonnes of cured herring on board. Now, that's a lot of gutting. The knives the gutter girls wielded so dexterously were extremely sharp, which presented their own dangers because protective gloves were not available in those days. Rhoda once met a former gutter girl who showed her how they bound their fingers with cotton bandages to protect them from cuts, which could go septic. If they were injured in this way, they would not have been able to work, which would mean they would not get paid. So it made sense to be careful.

Many of the gutter girls came from Shetland. But a great many more came from coastal communities all over the country – from as far afield as Ireland, the Hebrides, the coasts of Moray, Aberdeenshire and the Western Isles – following the herring fleets as they in turned chased the shoals from north to south. But gutting was a filthy, smelly job. The girls worked from 6 a.m. to 6 p.m., with their hands immersed in brine for much of the time. Despite this, the *craic* was good and the work relatively well paid. Gutter girls could earn more during the herring season than a domestic servant could earn in a whole year. This allowed the girls to enjoy a degree of independence that was unusual for most young women at the time. But, of course, those days of relative financial well-being were entirely dependent on the annual migration of the herring shoals. When they failed to appear, the consequences for the fishing industry were catastrophic. By beginning of the 20th century, over-fishing was beginning to take its toll, and the First World War marked the beginning of the end. Fish stocks were decimated and, today, hardly any herring is caught close to the coast of Shetland.

Before I left Baltasound, Rhoda suggested that I visit the Boat Haven at nearby Haroldswick – a delightful little museum dedicated to preserving the memory of the maritime folk culture of Unst. To get there I thought I'd catch a bus, which would give me the chance to see for myself the now world-famous Bobby's Bus Shelter, which is not only the most unusual but also the most northerly bus stop in the whole of the UK.

Bobby's Bus Shelter, the most northerly bus stop in Britain.

The legend of this icon of rural transport started when the council wanted to scrap the bus shelter but a campaign by a local schoolboy called Bobby gained huge local support. Not only was the shelter saved, it became famous and is now a tourist attraction in its own right, affording the weary traveller all the comforts of home. Thanks to Bobby, islanders can enjoy the long wait for a bus in luxury. There's a couch, a television set, pictures on the walls, a window box full of blooming flowers and even a library. Which is just as well. According to the timetable, the next bus wasn't for hours – just enough time to finish a novel perhaps.

The Boat Haven at Haroldswick is a delightful museum. It houses a range of different types of boat from an era, not so long ago, when the men of Unst sailed and rowed to the fishing grounds around the coast. The smells of the wood, the Stockholm tar and Danish oil in the museum were powerfully evocative and reminded me of the old sea house my father used in Bergen to store his old boats, which looked almost identical to the ones undercover in the Boat Haven. Like my father's *færings*, the boats at the museum were open boats, with up to six oars and a small mast for hoisting a lugsail when the wind was blowing in the right direction. The double-ended bow and stern of all the boats reminded me of Viking ships in miniature, which I suppose is what they are. And like my father's Norwegian boats, their origins date back to the Norse period. The problem for the Shetlanders was always a lack of wood for building boats – and houses for that matter – so timber was regularly exported from Norway to satisfy this demand. Later, Shetlanders imported complete boats, particularly from a place called Tysnes, south of Bergen, which specialised in building the *Hjaltebåt* or 'Shetland boat'. These were sent over in kit form ready for assembly once they arrived.

If you want to see a real belter of a Viking ship, then Haroldswick has just the thing to impress. Not far from the Boat Haven, at the Viking Unst Project, Brookpoint, is the *Skidbladner* – a full-size replica of the Gokstad ship which was discovered in a burial mound in Norway in the 19th century. The Gokstad ship is thought to have been built during the reign of Harald the Fairhair, who came to Unst to vanquish his enemies after he became king of Norway. Local people have claimed that he made his first landfall on Shetland in the bay that was named after him – Haroldswick. Whatever the truth, the *Skidbladner* is the sort of craft that Harald may well have used to cross the North Sea and it serves as a powerful reminder of the golden age of the Vikings. Made almost entirely of oak, it's 24 metres long and 5 metres wide and is held together with iron rivets. But, I have to say,

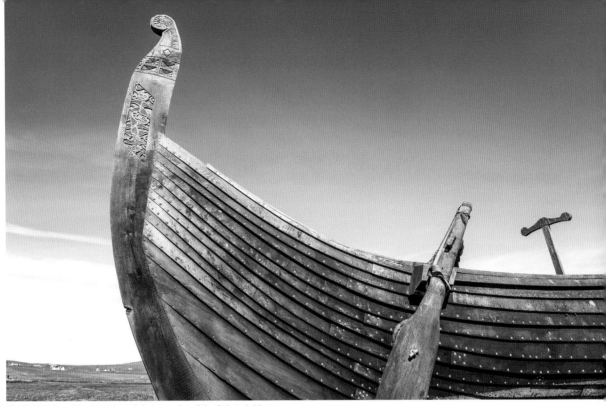

The *Skidbladner*, Haroldswick – a full-size replica of the Gokstad ship.

it looks a little forlorn stranded on dry land where is sits beside another fascinating relic of the Viking age – the reconstruction of a longhouse. This represents a typical dwelling from the period and was built using evidence obtained from archaeological excavations at several Norse-period sites across Unst. Traditional Viking building techniques had to be relearned in the construction of the longhouse. All the wooden timbers were cut and jointed to fit together without nail, and the turf roof was laid over wooden planking, which was then covered with a membrane of birch bark to keep out the rain. I did exactly the same thing as a student working with my father in Norway. At the time, he was restoring an old wooden farmhouse in the mountains above Norheimsund, east of Bergen. He showed me how to lay large pieces of birch bark on the sarking boards before cutting and placing sods of turf on top to create an eco-friendly and very green roof.

At 250 metres, Saxa Vord is the highest hill on Unst and it gave its name to RAF Saxa Vord which, for nearly 50 years, played a vital role in the defence of the United Kingdom. During the long years of the Cold War, the radar installations on the summit of Saxa Vord monitored Soviet air and sea activity across a huge area of the North Sea and far out into in the North Atlantic and the strategically vital Norway–Iceland gap. When it closed as part of the so-called 'peace dividend' in 2006, over a hundred jobs were lost. The impact was dramatic for the whole community, affecting not just employment but schooling, housing and many other island services, including the island's airport.

Not far from the old RAF base was the pier where I was meeting the skipper who had agreed to take me to Muckle Flugga. For the past ten years, Glaswegian Kenny has been running trips for sea anglers. They catch mostly cod and ling but, apparently, the great flatfish turbot are enormous in these northern waters – real record breakers, including one that weighed 13.6 kilograms.

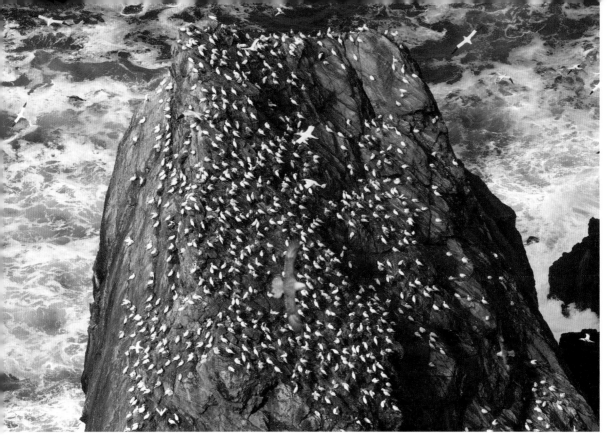
Residents of Hermaness, Unst.

'That was the biggest to have ever been caught in Scottish waters,' said Kenny. 'It took 20 minutes to haul it aboard.'

Instead of going directly to Muckle Flugga, we motored around the bird reserve of Hermaness, where the cliffs rise 130 metres above the sea. The sky was full of wheeling birds – fulmars, gannets, guillemots and razorbills, the full gamut, including ruthless and piratical bonxies.

'What a brilliant place for wildlife!' I observed, stating the obvious.

Kenny nodded. 'It's a pity you weren't here last week. I counted 14 killer whales in a single pod – mothers with their calves swam right past the boat.'

Beyond Hermaness, the heights of Saxa Vord came back into view – instantly identifiable because of the 'golf ball' radar dome that adorns the summit.

'The highest wind speed ever recorded in the UK was measured up there,' said Kenny. 'Hogmanay 1991–2. They say it got up to 197 miles per hour before the instruments blew away.'

Ahead of us now was the jagged, rocky island of Muckle Flugga. The name apparently comes

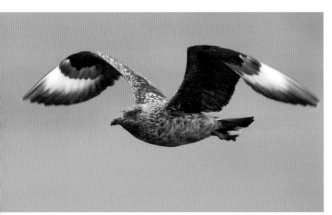
The Great Skua, or bonxie.

Out Stack, the most notherly point of the British Isles.

from the Old Norse *mikla flugey* meaning 'big, steep-sided island'. Its cliffs gleamed white with the feathery bodies and guano of 40,000 pairs of breeding gannets. Even at a distance of a mile, you could smell the pungent aroma of this gigantic bird colony. Today, birds are the only occupants of this northern outpost but, until the lighthouse was automated in 1995, the keepers could proudly boast that they were the most northerly residents in the British Isles. Here they spent one month on and one month off, perched on an improbable rock, where the weather can be unbelievably violent. Just after the lighthouse was opened in 1858, it was subjected to an onslaught of breath-taking power. For 21 hours, mountainous seas broke over the whole island, engulfing the tower and moving massive blocks of stone around as if they were bits of driftwood.

As we cruised past on a calm day in June, it was hard to imagine the ferocity of the seas in winter but, despite its reputation for wild weather, Muckle Flugga isn't actually the most northerly point of the British Isles. That title belongs to the appropriately named Out Stack – or 'Ootsta' as it's called in Shetlandic. It lies 600 metres north of Muckle Flugga, making it the very last point of the British Isles. No one has ever lived on Ootsta. It's just a wave-battered hump of rock in the sea, which is almost impossible to land on because of the ceaseless Atlantic swell that washes over it even on a calm day. Beyond Ootsta there is nothing further north for thousands of miles – just cold ocean until the polar ice of Svalbard and the North Pole. As Kenny's boat rose to meet the long sluggish waves coming from the north, I realised there was nowhere else to go. I'd reached the end of the road. Perhaps this is why Ootsta has been called the full stop at the end of Britain.

PART TWO ORKNEY

North Ronaldsay

North Ronaldsay Firth

Papa Westray

Noup Head

Pierowall ○

Westray

△
Fitty Hill

The North Sound

Sanday

The Wart
△
□ Quoyness

Westray Firth

Bay of Stove

Rousay

Eynhallow

Egilsay

△
Blotchnie Fiord

Papa Stronsay

○ Whitehall

Stronsay

Burgh Hill △

Brough of Birsay

Birsay ○

Broch of Gurness □

Marwick Head

Tingwall ○

Wyre

Gairsay

Stronsay Firth

Skara Brae ○ □

Yesnaby

Ring of Brodgar □
Maeshowe ○ □
Standing Stones □
of Stenness

Mainland

○ Kirkwall

Tankerness ○

Brough of Deerness

Shapinsay

Auskerry

Wide Firth

Stromness ○

Ward Hill
○ Moaness
△

Old Man of Hoy

Rackwick ○

Hoy

Scapa Flow

Fara

Lyness ○

Flotta

Churchill Barriers

Lamb Holm

Burray

○ St Margaret's Hope

South Walls

Stanger Head

South Ronaldsay

□ Tomb of the Eagles

Pentland Firth

The Gloup △ *Cairn Hill*

Stroma

Pentland Skerries

John o' Groats ○

0 2 4 6 8 10 Miles

0 2 4 6 8 10 Kilometres

INTRODUCTION

The Orkney Islands lie six nautical miles across the Pentland Firth from the Caithness coast of mainland Scotland. The archipelago consists of over 70 islands, of which 20 are inhabited, with innumerable offshore skerries and sea stacks. The total population is just over 22,000 permanent residents. The name Orkney is thought to be very old and was known to the ancient Greeks and Romans. The Greek historian Diodorus Siculus referred to the islands as 'Orcades', quoting from Pytheas, the Greek geographer writing about 320 BC. Later, the Roman author Pliny the Elder also mentioned the Orcades and went on to write about small whales there, which he called orca. Today, of course, the orca, or killer whale, is frequently seen: on a recent trip I made across the Pentland Firth, the ferry stopped halfway across to allow passengers to thrill at the sight of a pod of orca swimming mid channel.

Like Shetland, Orkney's history is heavily influenced by its Norse heritage – even the its flag looks Scandinavian, being based on the flag of Norway with a yellow-fimbriated blue Nordic cross on a red background. But, unlike Shetland, Orkney seems a gentler, more benign place. Where Shetland is wild and rugged, Orkney is greener and has softer contours. I sometimes think that the whole archipelago resembles a drowned landscape where low sunken hills and flooded valleys have become distinct islands separated by a shallow sea. Recent geological and archaeological

Chapter opening: Looking towards Hoy across Scapa Flow.

research seems to bear this out. About 20,000 years ago, Orkney was part of a land mass that joined Scotland to the continent of Europe – until the land disappeared under rising sea levels caused by melting ice sheets. The bones of ancient creatures, including woolly mammoth, have been discovered in the mud on the seabed.

Geology accounts for the relative richness of Orkney's agriculture when compared to that of Shetland, which suffers from thin, sour soils. Orkney is composed primarily of Old Red Sandstone, which is seen to dramatic effect in the cliffs and sea stacks of Hoy, including the famous 137-metre Old Man of Hoy. Old Red Sandstone is associated with fertile soils, which make for happy farmers. There is a saying in the Northern Isles about how the quality of land can shape the character of a people: 'An Orcadian is a farmer with a boat but a Shetlander is a fisherman with a croft.' For thousands of years, the fertile soils of Orkney made the islands a desirable place to settle and farm, and the visible evidence of these former inhabitants is scattered everywhere. There are Neolithic burial chambers, Stone Age settlements, standing stones, stone circles and cairns in greater density here than anywhere else in Europe, making Orkney an archaeological paradise.

Although Orkney can boast a better climate than Shetland, this is only relative. Orkney lies at latitude 59 degrees north. Head west and you'll hit the southern tip of Greenland, all of which makes for fairly chilly weather. My old *Black's Guide to Scotland* warns the Victorian tourist not to expect

too much: 'Spring does not commence until April and there is little warmth until June. Summer terminates for the most part in August and winter commences in October and occupies the remaining five months of the year.'

Oh dear . . .

Despite the warnings of less than balmy conditions, I had long been inspired to visit the islands by the poems, short stories and novels of the Orcadian writer George Mackay Brown but the islands always seemed very far off. As a student at Aberdeen University, I'd often toyed with the idea of taking the ferry from the city direct to Orkney but the price of a return ticket was beyond my means. It wasn't until I got a job in television that I finally had the chance to visit. I remember travelling with the comedian and presenter Craig Ferguson. We were filming a series about archaeology in Scotland and were scheduled to interview a forensic archaeologist on Orkney who had analysed some ancient bones for one of the programmes. We took off from Glasgow Airport on a day of dangerous meteorological activity. Having been thrown around in the air for about an hour, we made our approach into Kirkwall Airport. Actually, we made two or three approaches because of problems with visibility. Sea fog had blown in and the ground was invisible. Eventually, the pilot committed us to a descent. I glanced at Craig. He was looking anxious. Then I saw the flight hostess, who was sitting alongside us. She was visibly clenching every muscle in her body as we dropped though cloud and fog, to hit the ground with a resounding thump. Engines roared into reverse thrust and we rattled to a halt. It felt more like being on a rutted field than on a tarmacked runway. As it turned out, this was exactly what had happened. We had overshot in

poor visibility and were now taxiing over the grass on the runway apron. Inside the terminal building we picked up our bags and I heard one aircraft handler say to another, 'Did you see the Glasgow flight come in? He came off the runway. There's mud and grass all over the plane!' Indeed – as I could see with my own eyes.

Craig and I were understandably both a bit rattled as we drove in a hire car to Kirkwall. Approaching the town, a policeman stepped out of the fog and waved us down beside a sign saying, 'Welcome to Kirkwall'.

'What's wrong?' I muttered.

For some reason the policeman wanted to know how fast I thought I'd been going.

'I don't know,' I said. '40 miles an hour?'

'No,' came his stern response. 'You were driving at 38 and this is a 30-miles-per-hour zone.'

I thought he was kidding. There was nothing but fields and drystone dykes as far as the eye could see which, admittedly, wasn't very far because of the fog. But there was definitely nothing to suggest we were in a built-up area. I tried to find something to say. I cast Craig a sideways look, hoping that his comic genius would come to my rescue but it seemed to have failed him – either that or he preferred to keep a low profile. I sighed and said I was sorry and tried to blame the fog, a bumpy landing and shattered nerves – all of which was a hopeless defence. For this motoring indiscretion, I received a heavy fine and three points on my licence. However, I'm happy to say that, since then, my relations with Orkney's boys in blue have vastly improved!

Opposite. The green, soft landscape of Orkney.

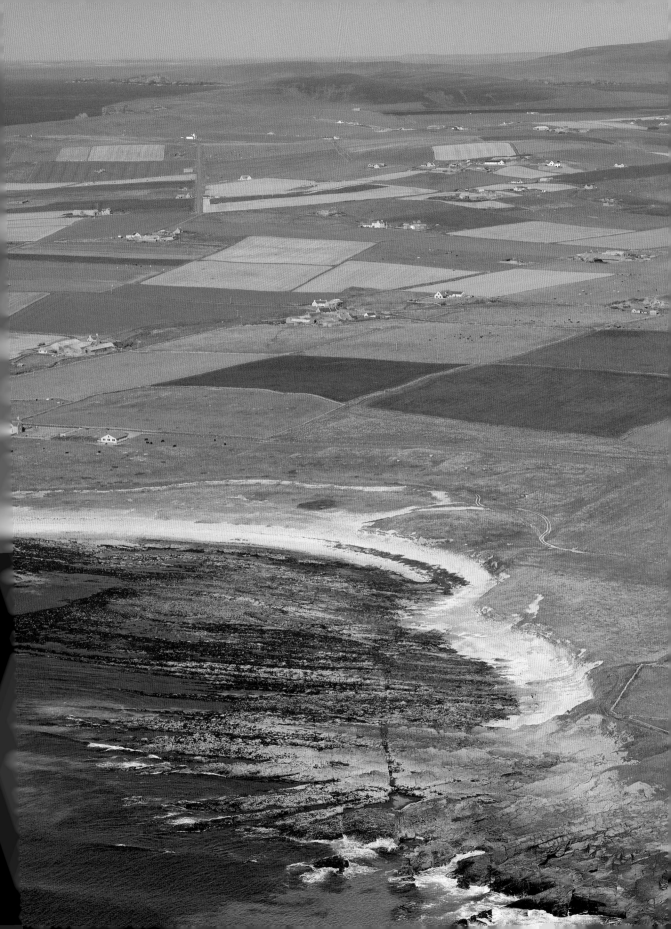

CHAPTER 5
MAINLAND

Deerness, Kirkwall, West Mainland, Stromness

DEERNESS

Mainland is the name of the principal island of the archipelago. However, on some old maps, it appears as Pomonia. Apparently, this arose because George Buchanan, the tutor to the young James VI, had mistranslated a passage of Latin text by the Roman writer Solinus. Mainland's mistaken identity also appears when an elusive scholar, known only by his soubriquet Jo Ben, paints a colourful picture of 16th-century life on Orkney:

> The island Pomonia, otherwise the Mainland, so called as it meant the middle of the apple, because it lieth between the North and South Isles. The warlike men in Pomonia are about 5,000 and just as many in the islands. There is abundance of barley and oats. All the men are very drunken and wanton, and fight among themselves. For an example of their friendship, if one neighbour invites another, if the guest, before his departure, has not vomited, he assails his host and there is much strife so long as the drunkard delays in the house.
> They use in their common way of talk-

ing peculiar expressions, as when we say 'Guid day, guid man', they say 'Goand da, boundae'.

Interestingly, Mainland has never been called Pomonia by locals. However, the Vikings named the island *Hrossey*, meaning 'horse island', apparently because of its shape, although I like to think the name has a more romantic and mythological origin. In his poem 'The Horses', the Orcadian poet Edwin Muir alludes to this when he writes about a post-apocalyptic Orkney and the return of mysterious equine beasts:

> Late in the summer the strange horses came.
> We heard a distant tapping on the road,
> A deepening drumming; it stopped, went on again
> And at the corner changed to hollow thunder.
> We saw the heads
> Like a wild wave charging and were afraid.

The eastern extremity of Mainland Orkney is called the Brough of Deerness – a wild headland almost

Opposite. St Magnus Cathedral, Kirkwall.

The Brough of Deerness

surrounded by the sea. It's an ideal site for a forti-fication and, from the ruins that occupy the promontory, it seems that it was used as defensive refuge for a least 2,000 years. In amongst the tangle of long grass on the cliff top are the remains of a series of structures which archaeologists believe represent different epochs of occupation, from the Iron Age Picts, to Celtic monks and Vikings. The ruins include a medieval chapel and the outlines of about 30 other buildings, surrounded by an earth bank and wall. An archaeological dig in the 1970s peeled back layers of history and uncovered a coin in the foundations of the chapel. It dated from the reign of the 10th-century Anglo-Saxon king, Edgar. But the function of the Brough of Deerness remains a mystery. According to local tradition, it was a monastery and a place of pilgrimage for many centuries. The existence of the chapel gives the site an obvious religious func-tion but other factors led archaeologists to conclude that the site primarily had a defensive role – a fortified stronghold for a Viking chief perhaps and, before that, an Iron Age fort.

Across the wide and shallow expanse of Deer Sound, which forms a bay between Deerness and Tankerness, I was excited to see the name Murton marked on my OS map of Orkney. My name was positioned intriguingly over the rocky coast about a kilometre north of a headland called Gumpick. Sadly, after a tramp across the fields on the other side of the Sound, I was a little disappointed to discover that Murton amounted to nothing after all – just a couple of wave-washed rocks below the cliffs where fulmars soared and glided.

Passing the Loch of Tankerness, a favourite spot for birdwatchers who come in search of ornithological rarities, I made my way to Kirkwall, passing the distillery of my all-time favourite tipple Highland Park whisky. Before I knew about these things, I had always assumed Highland Park to be a whisky of the Scottish Highlands. It wasn't until I learned that the Orcadian writer George Mackay Brown also favoured its amber hues that the penny dropped. Highland Park is a noble Orcadian tradition. The distillery was founded in 1798 by Magnus Eunson and took its name from the ground on which it was built – the High Park (as opposed to the nearby field called Low Park). Over the years, it gradually became known as Highland Park. Half a mile down the road is Orkney's other distillery. Scapa takes its name from the nearby Scapa Bay. It was built in 1885 but was mothballed and threatened with closure in 1994. Fortunately, it was saved from destruction and reopened in 2004, producing a delightfully smooth dram with honey notes.

KIRKWALL

Kirkwall is the undisputed capital of Orkney and has a population of about 9,000. The name comes from the Old Norse *Kirkjuvágr*, meaning 'Church Bay'. The church in question is not the magnificent St Magnus Cathedral but the earlier St Olaf's Kirk, founded around 1035 to honour the Norwegian king, Olaf II Haraldsson, who is credited with helping to convert the pagan Vikings to Christianity. There isn't much to see of this venerable building today – merely a stone archway of cut sandstone up a lane in the heart of old Kirkwall, not far from the harbour.

Arriving in Kirkwall on a recent trip, I turned for help to *Black's Guide* which described the town

in rather unpromising terms: 'Kirkwall is the capital of the Orkney Islands and is a clean and tidy, if not very lively, town.' That was in 1862. The day I arrived, it was a noisy, bustling place.

As I walked the narrow streets around the cathedral, I was aware of drumming and the sound of whistles being blown. A flatbed pick-up drove past decked in carnival bunting. A group of young women dressed in old boiler suits were responsible for all the noise. They were sitting in the back drinking cans of beer and holding a placard with the name 'Celia' scrawled across it. The pick-up drove past and then parked in the precincts of St Magnus Cathedral where an ancient and sticky ceremony took place. The women dragged an almost-willing victim towards an old sycamore tree, where they smeared treacle over her face and bound her to the trunk with a roll of cling film. I felt I had to intervene and discovered that the poor lassie in treacle was the same Celia whose name had been paraded around town.

'What's she done to deserve this treatment?' I asked a cheery young woman who was wielding the treacle.

'Celia is getting married soon – so she deserves it!'

Orcadian grooms- and brides-to-be have long endured public ridicule at the hands of their best friends. However, it seemed a good-natured, if rather sticky, business. With a covering of treacle to keep her sweet, Celia was left to contemplate her forthcoming nuptials as the rest of the gang drove off, waving farewell from the back of the pick-up.

The precincts of St Magnus Cathedral have been witness to many tarrings and featherings over the centuries. Founded by the Viking Earl of Orkney, Rognvald Kali Kolsson, in 1137, this 'stately

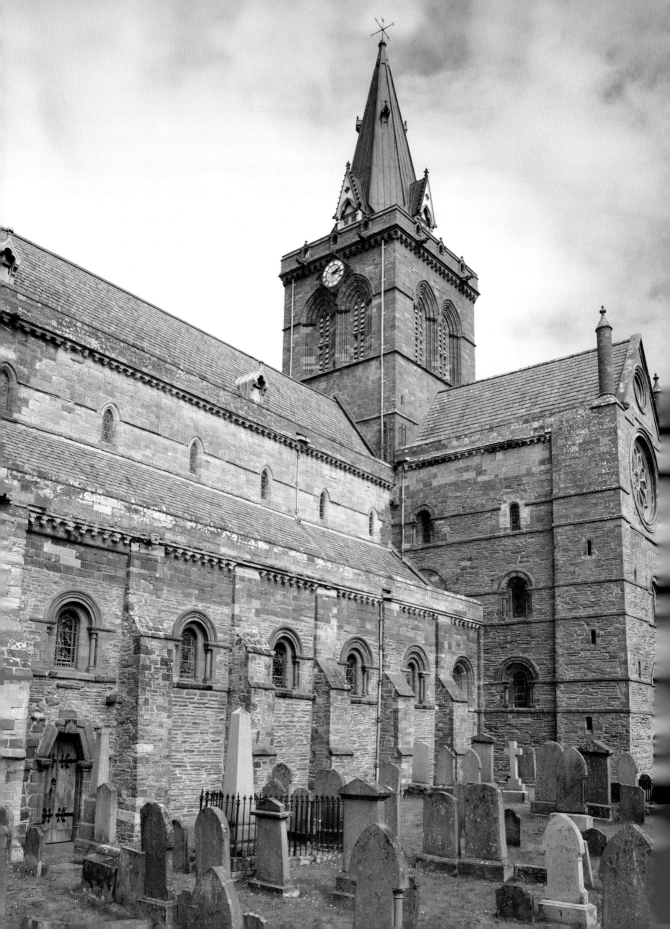

and venerable pile, as *Black's Guide* describes it, is dedicated to Orkney's very own Viking saint, St Magnus.

At the beginning of the 12th century, a power vacuum in the Viking north saw two cousins rule Orkney – Earl Haakon and Earl Magnus. Haakon was ruthless and warlike while his cousin Magnus was pious and meek. At first, they ruled well together but evil men stirred up trouble between them and war threatened to engulf the islands. In an attempt to establish a peaceful future, a meeting was arranged on holy ground on the island of Egilsay. But Magnus was betrayed and killed. Later, this pious Christian man's memory was associated with miracles and wonders and he was canonised, becoming St Magnus. His bones were enshrined in the cathedral at Kirkwall, which was built to house them and to honour his name. During the reformation, which took a dim view of the veneration of saints, the relics disappeared until 1919, when workmen discovered a wooden box beneath a pillar in the cathedral. Inside were human remains: a skull and bones. Because the skull showed signs of an injury that seemed to be consistent with the story of Magnus's betrayal and death, it was thought that the bones must be those of the saint. They were re-interred in the cathedral, where they remain today.

In the nave of the cathedral is an effigy of a sleeping man carved in white marble. He wears what seems to be a jacket made of skins and lies beneath a thick blanket, a gun at his side. This is the Orkney man and Arctic explorer Dr John Rae – an unsung hero of the Northwest Passage and a genius at using traditional survival techniques to

reach previously unmapped parts of Arctic Canada. John Rae was born in 1813. At the age of 20, like many Orkney men before him, he joined the Hudson's Bay Company and sailed for James Bay at the southern end of Hudson Bay. He remained there at the company's base called Moose Factory, working as a surgeon and relishing the 'wild sort of life' he experienced in the frozen north. He became an expert on the culture and language of the indigenous people, adopting their customs, clothing and, more importantly, their techniques for surviving in Arctic conditions. After he walked 1,200 miles on snowshoes in two months, they gave him the nickname *Aglooka*, 'he who takes long strides'.

In the 1850s, Rae was asked to help locate a missing Royal Navy expedition. In 1845, the explorer Sir John Franklin had set sail to try to find the Northwest Passage – a sea route from the Atlantic, through the islands and frozen seas of Arctic Canada, to the Pacific. He, his two ships and a crew of 134 men went missing. After a long search, Rae eventually located the remains of the last survivors and, in so doing, also discovered the final link in the Northwest Passage. But, because he reported that Franklin's men had resorted to cannibalism in their final struggle to survive against cold and starvation, he offended Victorian sensibilities and was discredited. As a consequence, he never received the recognition that he deserved.

St Magnus Cathedral isn't just a place where the dead are memorialised – it is very much the cultural centre of Orkney. Since the 1970s, it has been the principal venue for the St Magnus Festival, an international event that attracts musicians, composers and audiences from around the world. Founded in 1977 by Orkney's distinguished composer Sir Peter Maxwell Davies, the festival

Opposite. St Magnus Cathedral, Kirkwall, founded in 1137 and dedicated to Orkney's Viking saint.

is a highly regarded celebration of modern classical music. Fortunately for me, the festival was in full swing during my stay on Orkney. After enjoying a stunning concert of Bach cantatas at the cathedral, I met up with an old friend, the composer Sally Beamish, in the bar of the festival club. Sally introduced me to the great man himself – Sir Peter Maxwell 'everyone calls me Max' Davies. I knew that Max had a reputation for writing some pretty challenging avant-garde music but I had always loved his elegantly simple and immediately accessible piece for piano, 'Farewell to Stromness'.

Over a glass of wine, he told me that he wrote the melody as a protest against a proposed uranium mine near Stromness. 'During the 1970s, a geological survey revealed a vein of uranium ore called "yellow cake" between the town of Stromness and the cliffs on the coast. The Scottish Electricity Board made a few test bores and had plans to mine the stuff. Orkney was in the shadow of a radioactive nightmare. But, fortunately, opposition was too great and we stopped it.'

The heart of Kirkwall is still dominated by the medieval bulk of St Magnus Cathedral, which tends to overshadow the remains of an equally ancient and distinguished building – the Bishop's Palace. Its ruins stand across the street to the south where its round Moosie Tooer is a landmark on a corner of the old town street plan. Like the cathedral, the Bishop's Palace has been at the centre of Orkney's dramatic history for the past nine centuries.

It was built in the mid 12th century to accommodate Bishop William the Old – a friend and important political ally of Earl Rognvald Kali Kolsson who founded the cathedral to house the bones of St Magnus. Until that time, William the Old had presided over the relics of the saint at his previous religious and ecclesiastic base at Birsay.

When religion and politics coincided in Rognvald Kali Kolsson's bid to secure the earldom of Orkney for himself, the bishop lent his support in a plot that involved promoting the cult of St Magnus and kidnapping the incumbent earl, Paul Hakonsson. According to an account in the *Orkneyinga Saga*, Earl Paul was blinded and incarcerated in a dungeon before finally being murdered. Hardly a Christian way to get to the top, I'd have thought. But then expectations of faith and religion were different in the 12th century, which is perhaps why Rognvald Kali Kolsson was eventually elevated to sainthood himself. After his death, his bones were placed in a pillar in the cathedral he'd erected to the memory of the other Orkney saint – St Magnus. Forgiveness is, of course, one of the greatest Christian virtues.

Just yards away from the ruins of the Bishop's Palace is another imposing ruin – the Earl's Palace – a memorial to the vanity and cruelty of a despotic dynasty. In the late 16th century, Robert Stewart, the bastard son of King James V, became Earl of Orkney and began to create a northern power base in both Orkney and Shetland. In 1600, Robert's son Patrick planned a residence of such grandeur it would rival any of the royal palaces in Scotland. His vision was ambitious – a stately complex that would incorporate the neighbouring Bishop's Palace. Hundreds of Orcadian men were drafted in and forced to work unpaid, quarrying stone and labouring on the vainglorious project, which eventually emptied the coffers of the Stewarts. Despite this, the first phase of the palace was completed in 1607. But Earl Patrick Stewart didn't

Opposite top. The memorial to John Rae in St Magnus Cathedral, Kirkwall.

Opposite below. The Earl's Palace, Kirkwall.

JOHN RAE M.D. LLD FRS FRGS
ARCTIC EXPLORER
INTREPID DISCOVERER OF THE FATE OF SIR JOHN FRANKLIN'S LAST EXPEDITION
BORN 1813 DIED 1893
EXPEDITIONS 1846 1847 1848 1849 1851 1853 1854

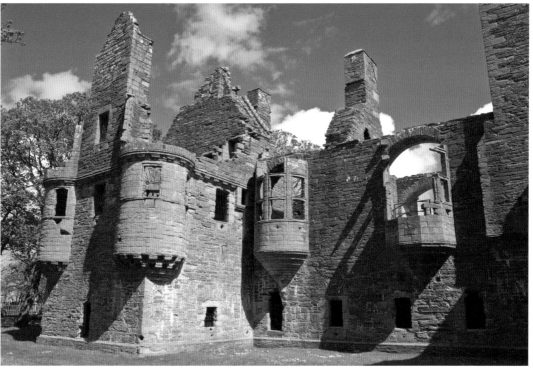

have long to enjoy the delights of his new home. A couple of years later, he was arrested and tried for his crimes and misrule. While he languished in a prison cell in Dumbarton Castle, his son Robert staged a rebellion. In 1614, his troops captured the Earl's Palace, the Cathedral and Kirkwall Castle. The king responded with deadly force. After a siege, which badly damaged the palace and completely destroyed the old castle, Robert was captured and taken to Edinburgh where he was executed prior to the beheading of his father.

The ruins of the Bishop's Palace and the Earl's Palace are relatively recent additions to the hundreds of historic monuments that are scattered across the landscape of Orkney. By far the majority of them are much, much older and exude a sense of improbable antiquity. There is hardly a contour on the map of Orkney that doesn't have some story associated with it – some relic of the past or a standing stone or burial place. For anyone who wants to get in touch with the mysteries of the deep past, this is the northern equivalent of ancient Egypt and the Valley of the Kings. In fact, there are some sites on Orkney that are significantly older than the era of the Pharaohs.

WEST MAINLAND

On the north-east coast of Mainland, on the promontory of Aikerness and overlooking Eynhallow Sound, is the wonderful Broch of Gurness. Unlike other brochs I've seen, which tend to be situated alone in the landscape, the Broch of Gurness is part of a complex of buildings making up a settlement. Surrounding the remains of the ancient stone tower, which is thought to date from the 2nd century BC, is a ruined Iron Age village. Until 1929, the entire site was hidden beneath a massive mound of grass. Then one summer's day, while the Orcadian poet and antiquarian Robert Rendall was sketching the view, the leg of his artist's stool sank unexpectedly into the ground, revealing a subterranean passage. The secrets of the Knowe o' Aikerness, as the broch site was previously known, were about to be revealed. Today, it is acknowledged as one of the finest prehistoric settlement sites to have survived.

Archaeologist believe that the broch tower was only ever about eight metres tall, which is pretty low for most brochs. Unusually, it is over 20 metres wide. Below this squat tower were dwellings for about 40 families, which would have made a sizable community living in a fairly confined space, hemmed in between the sea on one side and three defensive ramparts and three ditches on the other.

The Broch of Gurness is undoubtedly an impressive relic from the distant past but, compared to some of the other antiquarian sites on Orkney, it is almost modern. There are archaeological remains on the island that can compete with the oldest human structures anywhere in Europe.

On a day of unspeakable dreariness, I set off for Maeshowe, a chambered cairn built over five thousand years ago – so old and that it's thought to have been in use before the Great Pyramid of Giza in Egypt was built. It lies at the heart of Orkney's ancient monumental landscape, where some of the most spectacular and significant Neolithic sites in Europe are to be found. Known to the Vikings as *Orkhaugr*, 'the mound of the Orks', Maeshowe is a green hillock surrounded by a circular ditch, situated in the middle of a field of cows. As I approached through mist and driving rain, there was nothing about its unremarkable

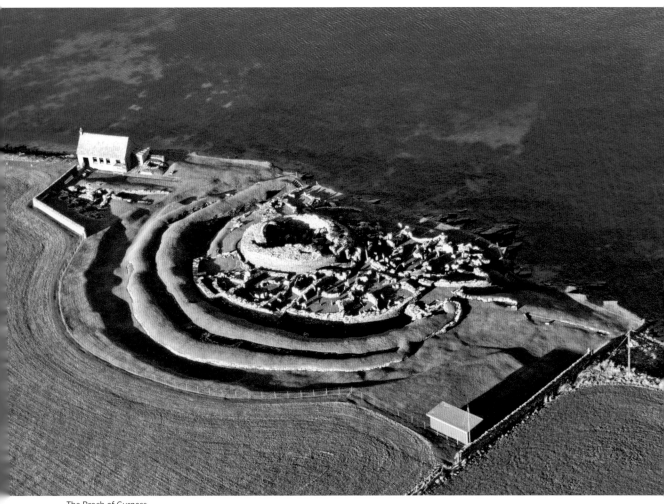

The Broch of Gurness.

appearance that suggested an archaeologically important and unique structure lay hidden beneath the grass. Waiting for me under a dripping umbrella was tour guide Sheena Wenham. She told me that, for centuries, Maeshowe had been a mystery. Local people once believed it to have been inhabited by malevolent trolls and it wasn't until the 19th century that archaeologists opened it up to reveal a structure older than the pyramids of Egypt. Using torches in the darkness, Sheena led me inside – an uncomfortable walk bent double along a very low, narrow passage for several metres until we reached the central corbelled chamber. Sheena flashed her torch up at the stone-built ceiling four metres above. It was amazing to think that five thousand years ago, the people of Orkney had had the skill and technology to cut, fit and lock together stones in such a precisely engineered

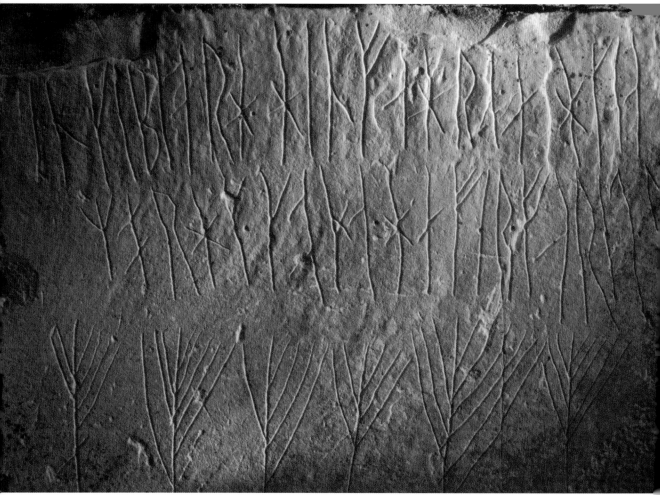

Runes inside the Neolithic Maeshowe burial chamber.

way and without the use of metal tools. Sheena explained that the people who had built Maeshowe were Stone Age farmers, who kept livestock and grew crops. When someone in this society died, it's thought that the body was left to be picked clean by scavenging birds and animals. Reduced to bare bones, it was brought inside the tomb and placed in small side chambers. However, when archaeologists opened up Maeshowe, they found

no bones or grave goods, something which has remained a mystery and given rise to other theories about its use and purpose.

Sheena reminded me that Maeshowe, like many other Neolithic sites and structures, is aligned astronomically to the sun. 'It's quite extraordinary. If you stand in here in pitch darkness on the shortest day of the year, on the winter solstice, about 3 p.m. in the afternoon, the rays of

the setting sun shine down the entrance passage and splash the wall at the back of the tomb lighting the place in a rosy glow.' While she said this, the hairs on the back of my neck began to rise as I imagined the symbolism of the scene she was describing. In the depths of winter, the life-giving sun penetrates the dark earth and lights up the tombs of the dead. To me, the religious significance was obvious and unavoidable.

But this sacred space had been desecrated – not in recent times but centuries ago when a group of Vikings broke in and scrawled graffiti on the walls. However, the marks they left have become hugely significant and represent some of the best-preserved runes from the Viking world. They also confirm two separate episodes mentioned in the Viking *Orkneyinga Saga*, which describes how, on one occasion, a party of warriors sought refuge in the tomb during a snowstorm. According to the saga, two of the men were driven mad by the oppressive atmosphere inside. On the second occasion, the saga states that the Vikings were returning crusaders. Some of the marks they made are less than pious and were written in the kind of language you might expect to see on a bus shelter or in a public lavatory:

Thorni f*cked. Helgi carved
Ingigerth is the most beautiful of all
 women (this is carved beside a
 rough drawing of a slavering dog)
Ingebjork the fair widow – many a
 woman has walked stooping in
 here a very showy person signed
 by 'Erlingr'

Most of the inscriptions are, however, of the 'Kilroy was here' variety:

Ofram the son of Sigurd carved these runes
Haermund Hardaxe carved these runes
These runes were carved by the man most
 skilled in runes in the western ocean
Tholfir Kolbeinsson carved these runes
 high up

Looking at the runic graffiti in the beam of Sheena's torch, it suddenly struck me that the 9th-century Vikings who'd made them must have had a high degree of literacy, despite the sentiments expressed by their words. They may have been a wild and warlike bunch but Vikings could certainly read and write.

A narrow finger of land almost bridges the largest enclosed body of water on Mainland Orkney, dividing it into two halves. To the west is the Loch of Stenness; to the east is the Loch of Harray. The road that crossed this land bridge passes the Standing Stones of Stenness on the south-eastern shores of the loch. From archaeological carbon dating, these four massive, six-metre upright slabs were once part of a much bigger stone circle, erected about 3,100 BC, making it amongst the oldest stone circles in Britain. Nearby are other standing stones. These solitary outliers include the Watch Stone and the Barnhouse Stone. Until the 19th century, the massive Odin Stone also stood nearby. It had a hole through its base about two metres from the ground and was the focus of much folklore and legend. My *Black's Guide* says this about it:

So long as it stood, it was regarded with much reverence by the peasantry, none of whom visited it without leaving some offering. Lovers were accustomed to plight their troth by joining hands through the

hole and repeating a time-hallowed form of words.

Unfortunately, the Odin Stone and several other uprights from the Stones of Stenness were deliberately destroyed in 1814 by an incomer or 'ferry louper', as non-Orcadians were called at the time. The landowner, Captain W. MacKay, was angered by local people visiting the stones for various superstitious rituals. He considered their presence on his land to be damaging trespass and their old beliefs an affront to reason. He, therefore, decided to put an end to both by toppling the stones. According to local tradition, MacKay used the fragments of the smashed stones in the construction of a byre. This wanton destruction was stopped by a local antiquarian who managed to get a court order to prevent MacKay from wreaking more havoc.

Guarding the small bridge that carries the road over to the peninsula of the Ness of Brodgar is the towering 5.6-metre Watchman megalith. On the other side, the road leads to the Ring of Brodgar – the jewel in Orkney's prehistoric crown. With a diameter of 103.6 metres, this is the third-largest stone circle in Britain. Built between 4,000 and 4,500 years ago it is thought to have originally comprised up to 60 standing stones. Although only 27 remain erect today, the Ring of Brodgar is an impressive sight.

A few years ago, my wife Nicky and I were lucky enough to stay at a traditional hotel overlooking the waters of the Loch of Harray close to these standing stones. It was a rather old-school establishment, geared up for the huntin', shootin' and fishin' brigade but an ideal place from which to explore the antiquities close at hand. We arrived on the evening of 21 June and we planned to visit

the Ring of Brodgar at midnight to see how the solstice was celebrated in these northern parts, wondering how they might compare with the revels at Stonehenge and other ancient sites of solar worship. As we talked about our trip over dinner, we overheard a very posh, tweed-clad but frightfully nice chap of a certain age order drinks from a nervous young waitress.

'If the barman does a damn fine Bloody Mary, I'll have that,' he boomed.

'Ah dinnae think he'll know what that is,' came the timid response.

'Well, why don't you ask him if he can mix a Bloody Mary? If he says, yes, I'll have one. If he seems unsure, I won't bother.'

Now that's the way to order drinks and make an impression, I thought.

The sky was partly overcast as we set off for the Ring of Brodgar. It was already past 11.30 a.m. but, of course, the darkest hour in summer isn't until 1 a.m. – the real midnight – so we had plenty of time to soak up the atmosphere. In these latitudes, at this time of year, it never gets fully dark. Light streaks the northern sky between dusk and dawn creating a magical state where it's easy to comprehend Lady Macbeth's observation that 'light thickens'. In this eerie gloaming we approached the stone circle, where a few silhouetted figures moved around on the skyline. When they stopped still, it was difficult to distinguish the human forms from the shapes of the monoliths they had come to see. But rather disappointingly, this was no New Age festival. There were just half a dozen folk there – some elderly French tourists, some London city-types and one sad soul who went around hugging the standing stones and muttering strange imprecations.

The following morning, we returned to the

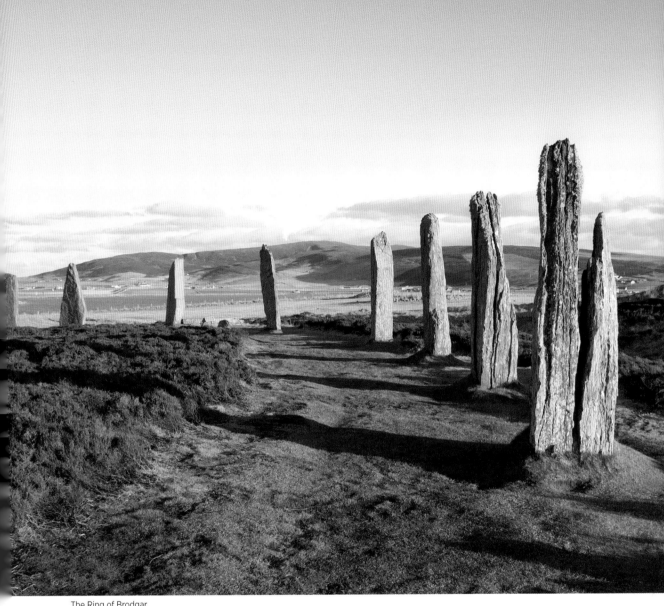

The Ring of Brodgar.

Ness of Brodgar to have a look at the work being carried out at a new archaeological site. Just below the Ring of Brodgar astonishing discoveries have recently been made. In 2003 excavations revealed a large complex of Neolithic buildings and structures, along with decorated stones, stone tools and fragments of a unique style of pottery. They dated from as long ago as 3,000 BC. One of the structures is considered by experts to be the remains of a huge building – perhaps a temple at the heart of a ceremonial landscape that also included the Ring of Brodgar, the Stones of Stenness and Maeshowe, all of which were clearly visible from the six-acre site. The finds that have so far been excavated indicate that this was once a place of worship and pilgrimage. Looking at the outlines of so many buildings, I was struck by the complexity and sophistication of the people who

had built them – people who, 5,000 years ago, had made Orkney their home.

To get a glimpse into everyday Neolithic life on Orkney, we headed to Sandwick and the extraordinary remains of an intact Neolithic village called Skara Brae. In the winter of 1850, a terrific storm battered Orkney. At a large mound known locally as *Skerrabra*, the winds and high tides worked together to drive off the surface of the mound and the remains of a village were exposed. The site was excavated and was thought to be an Iron Age settlement of Pictish origin. The ruins were again damaged by another storm in 1925 and, when workmen were making repairs and constructing a coastal defensive wall, they discovered evidence of more ancient dwellings. Subsequent archaeological excavations revealed the full extent of Skara Brae as it's now called. There are eight houses, built to the same plan, each with a central hearth, a stone dresser and bed spaces in the walls. All the houses, which would have had roofs of turf or thatch, are linked by narrow, low passages. The whole complex was sunk into the ground to provide draught-proof insulation and keep out the worst of the Orkney weather. Carbon dating of the organic material discovered during the excavations has shown that Skara Brae was occupied for a period of some 600 years between 3,200 and 2,200 BC. But why was it abandoned?

During the archaeological dig of the 1920s, the discovery of a great many Neolithic domestic artefacts prompted the chief archaeologist Professor V. Gordon Childe to compare Skara Brae to classical Pompeii and he believed its abandonment was just as hasty and dramatic. I remember as a schoolboy watching a dramatised television reconstruction of the last days of Skara Brae. During a terrible storm, the people fled in a panic – one woman

breaking and losing her beaded necklace in the rush to evacuate her home before it was overwhelmed by the tempest. Despite the fiction, the beads were real. Their discovery by archaeologists in the 1920s prompted Childe to conclude that Skara Brae's demise had been sudden and unexpected. More recently, however, other theories have emerged to explain why the people left after 600 years of habitation – a combination of diminishing resources, climate change and a new social order led to a drift away from the village to newer ways of living.

As we were leaving Skara Brae, a group of American tourists from a visiting cruise ship made their way slowly and painfully down the path to the ruined village. I smiled to myself when I overheard one portly fellow complain breathlessly, 'Why on earth did they build this place so far from the car park?' Indeed. Those Neolithic people were a thoughtless and inconsiderate lot. No wonder their culture died out!

From the ruins of Skara Brae, we headed north along the coast, where some routes led to a place signposted as Twatt. This rang a bell in my mind. I'm sure I'd seen a Twatt in Shetland and wondered if the two Twatts might be related – as in 'Welcome to Twatt Orkney, twinned with Twatt, Shetland'. Later inquiries confirmed the both Twatts are indeed related through the Old Norse word *þveit*, which apparently means 'a bit of land'. The relationship goes further. The word *þveit* has the same linguistic origins as the Old English *thwaite*, which also means 'a bit of land'. It was a relief to discover that Twatts are not just confined to the Northern Isles.

Beyond the realm of Twatt, we passed another Earl's Palace at Birsay. Like the one in Kirkwall, it too is a ruin – another monument to the reviled

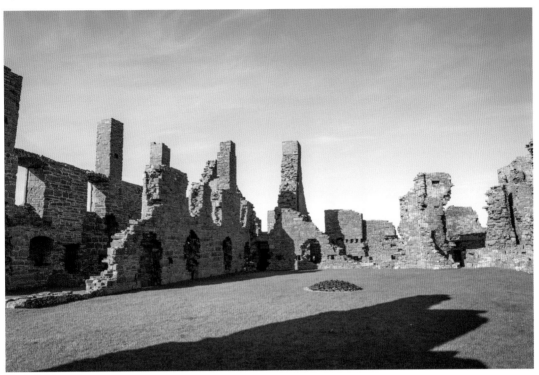

The Earl's Palace, Birsay.

Earl Robert Stewart. It was built over a period of ten years from 1569. Today, it's difficult to imagine the impression the palace would have made on the neighbouring population, whose lands had only relatively recently been transferred into the possession of Scots-speaking aristocrats like Robert Stewart. A contemporary account gives a rare insight into the magnificence of the palace, describing it as a 'sumptuous and stately building'. Two generations later, it was still being described in grand terms by Reverend John Brand, who published a description of Orkney in 1701: '[It] hath been prettily decorated, the ceiling being all painted, and that for the most part with schems holding forth scripture histories of Noah's flood, Christ's riding to Jerusalem etc.'

Just inland from the Earl's Palace, on the Burn of Boardhouse that flows from the Loch of Boardhouse, is a magnificent relic from Orkney's agricultural past – the Barony Mill of Birsay. The present two-storey building dates from 1873 but there have been mills on the site since Viking times, if not earlier. Like its predecessors, the mill is water-powered and produces flour in the traditional way. The huge four-metre diameter water wheel turns about 12 times a minute to grind an ancient type of barley called 'bere'. This is dried first on a kiln floor inside the mill building before being fed between the grindstones. The mill is run today by the Birsay Heritage Trust and is open to

Overleaf. The Neolithic village of Skara Brae.

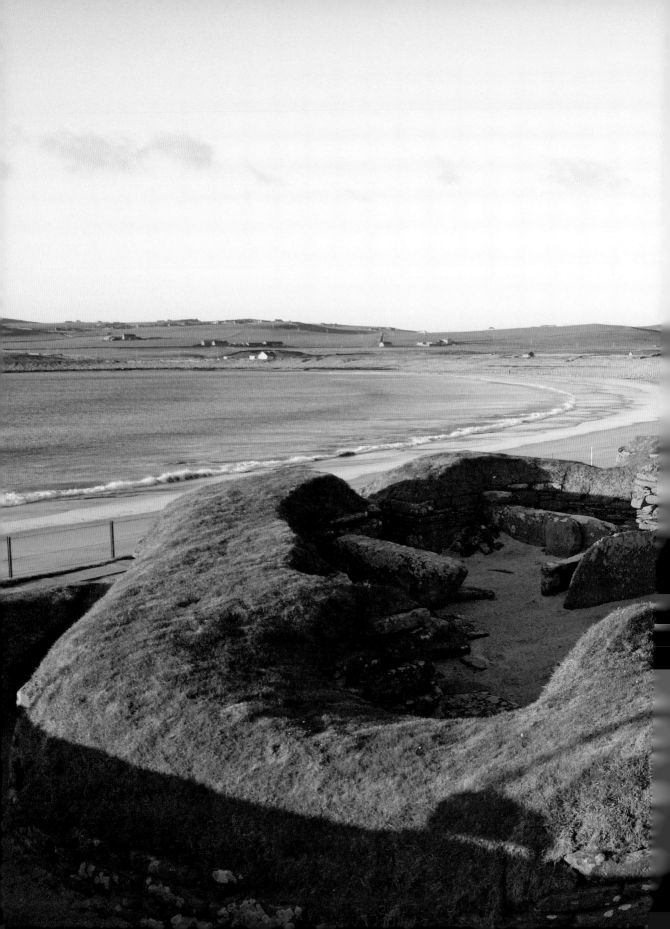

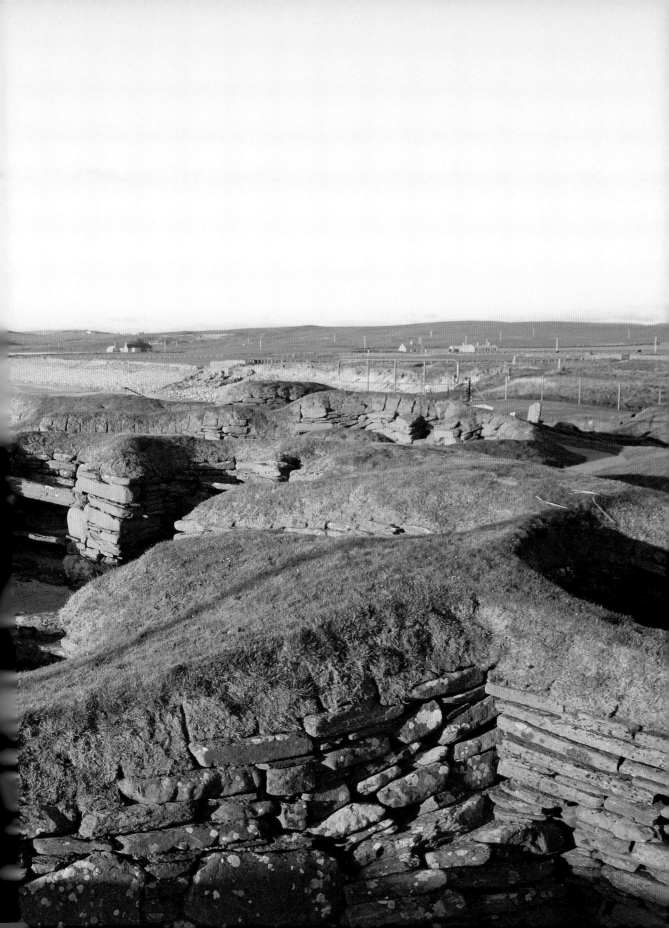

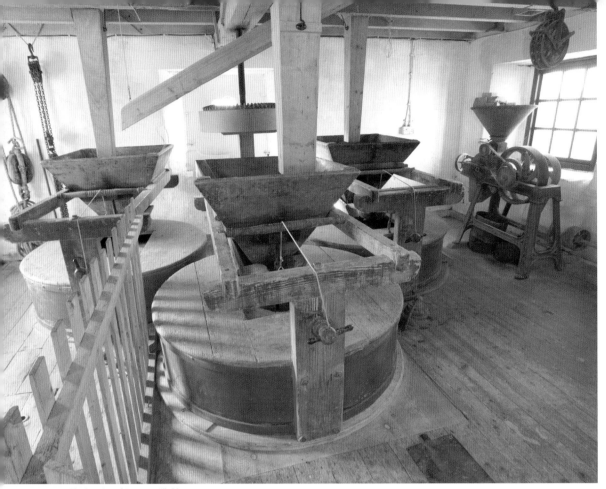

The interior of Barony Mill, Birsay.

the public. Standing beside the clanking wheels and gears is an unforgettable experience and transports you to an earlier time when milling was at the heart of the local community. As a souvenir of my visit, I bought some Orkney bannocks made by artisan bakers from the flour produced by the mill. The flour is available to buy from their online shop (baronymill.com) and in certain stores (the website gives details of where to find them).

About a kilometre north of Birsay, the road ends at a place called the Point of Buckquoy. Beyond this dead end and just a short distance from the shore is one of the most interesting and historic locations on Mainland Orkney. The Brough of Birsay is a low green tidal island, which can be reached on foot over a slippery, seaweed-covered causeway. But, to enjoy its treasures, timing is everything. If you don't want to get wet feet or worse, remember to leave enough time to cross over, see the sights and return before the tide cuts you off.

The Brough of Birsay was, at one time, connected to the mainland but coastal erosion over millennia created an island, which has seen layers of human activity since the earliest times. It seems likely that, by the 5th century AD, Birsay was a holy island, occupied by Celtic Christian missionaries. By the 7th century, it had become a significant Pictish stronghold and several Pictish carved stones discovered there testify to its importance. However, the cultural legacy of the Picts was displaced when the Vikings arrived and the

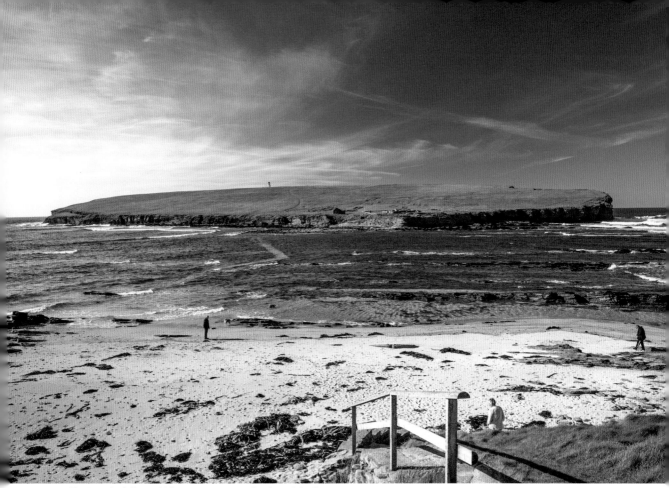

The Brough of Birsay, which was once connected to the mainland.

majority of the archaeology on view today dates from the Norse period after they began to settle the island during the early 800s.

The most prominent ruined building on the Brough is the little church of St Peter's Kirk, which is thought to date from the 12th century. It's surrounded now by a somewhat confusing array of ruins – no more than outlines in stone of the buildings that once stood there. These include several Viking longhouses and the remains of what some people believe to be the palace of the Viking earl, Thorfinn the Mighty, complete with a very chic palatial accessory – its own sauna. If there was ever any doubt about the sophistication of the Vikings, the medieval acme of hygiene must surely be proof beyond measure.

Beating the incoming tide (just), we made it to the mainland with dry feet and headed south to an unusual memorial to a giant figure in the history of the British Empire – Lord Kitchener of Khartoum. Standing on a cliff top, where views of the restless Atlantic extend to the wide horizon, is a 15-metre-high stone tower. Although its battlements give the appearance of a medieval castle, it was erected almost a century ago, by public subscription, to the memory of the man many Britons felt was the only one capable of saving the country and delivering victory in the First World War.

Kitchener is a character who has intrigued me for many years. When I was a teenager, his moustachioed image adorned my bedroom wall, striking

the memorable pose he had assumed in the famous recruiting poster that had impressed many young men in WW1. The slogan in bold ran 'Your Country Needs You'. Kitchener's eyes and his insistently pointing finger were designed to appear to be directed at the viewer from any angle – making escape from his hawk-like gaze impossible.

Kitchener was a hero of the conquest of East Africa. He had risen to fame during the failed attempt to rescue General Gordon from Khartoum and then later after the defeat of the native armies of Sudan. These exceptional victories against the odds accorded with the public's idea of Britain's imperial greatness and gave Kitchener an almost cult status at home. When the First World War broke out in 1914, Kitchener became Secretary of State for War. The destiny of Britain seemed to lie in his hands. But fighting a European war was much harder than defeating an army of mostly spear-waving Sudanese troops commanded by the Mahdi. As British soldiers got bogged down in Flanders, eyes turned to the sea. Britons hoped for victory in the expected clash of two titanic navies, which eventually happened at the Battle of Jutland when the Royal Navy Grand Fleet met the Imperial German Navy's High Seas Fleet. The battle was inconclusive and Britain's pride was severely damaged. Then, just days later, Kitchener was dispatched on a mission to Russia to have talks with Britain's ally Tsarist Russia. In early June 1916, he embarked on the battle cruiser HMS *Hampshire* and sailed from Scapa Flow into the teeth of a storm, heading to the Arctic Circle and the town of Archangel. As the ship battled around Marwick Head, a sudden explosion ripped through the ship when it struck a mine. HMS *Hampshire* went down in 20 minutes. Only 12 of the nearly 700 crew survived. Kitchener wasn't one of them.

From the Kitchener Memorial, Nicky and I headed south again. When we clambered down a steep path to the glorious Waulkmill Bay, the tide was out and the wet sands were shimmering and sparkling in the sun. The water looked refreshingly inviting after all the history we had consumed but, after a paddle in the numbingly cold waves, it was time for more antiquities. Just along the coast from Waulkmill Bay and overlooking the vast watery expanse of Scapa Flow are the peaceful ruins of St Nicholas's Church. Also known as Orphir Round Kirk, it's unusual in that its remains are the only surviving example of a circular medieval church in Scotland. It was built in the late 11th century to glorify God and, perhaps more importantly, to atone for the sins of the man who'd commissioned it, Earl Håkon Paulsson – a man with a lot on his conscience.

When Orkney was a shared Viking earldom, Håkon murdered his cousin Magnus to secure his dominance over the islands and then went on a crusading pilgrimage to Jerusalem to cleanse his soul. But it seems this wasn't enough. When he returned to Orkney, Håkon discovered that his murdered cousin was fast becoming a saint in the minds of the islanders. Indeed, he was eventually to become St Magnus in whose honour the cathedral in Kirkwall was erected. Perhaps wracked by feelings of guilt and to atone further for the sin of murdering his cousin, Håkon built the circular church of St Nicholas which is based on the Church of the Holy Sepulchre in Jerusalem, which Håkon had seen on his crusade. But was this enough to save Håkon's soul, I wondered. Probably not because, as my mother-in-law always likes to remind me, 'The way to hell, Paul, is paved with good intentions.' This being so, I reckoned that Håkon was already a fair way down the road to

The circular church of St Nicholas, Orphir.

damnation when he died at the ripe old age of 55 – not violently, as you might have expected of a murderous, crusading Viking, but quietly in bed.

STROMNESS

Orkney's second town Stromness – from the Old Norse *Straumsnes*, meaning 'the headland in the tidal stream' – grew up on the shores of the bay known to the Vikings as a safe haven and which they called Hamnavoe. Today, Stromness has a population of just over 2,000 and is a linear settlement which stretches along the entire western shore of Hamnavoe, a sheltered bay that was once crowded with all manner of boats. Stromness was

also the home town of the Orcadian author George Mackay Brown, who set many of his stories and poems in the place he liked to call Hamnavoe.

My father passed with his penny letters
Through closes opening and shutting like
 legends
When barbarous with gulls
Hamnavoe's morning broke
On the salt and tar steps. Herring boats
Puffing red sails, the tillers
Of cold horizons leaned
down the gull-gaunt tide
And threw dark nets on sudden silver
 harvests.

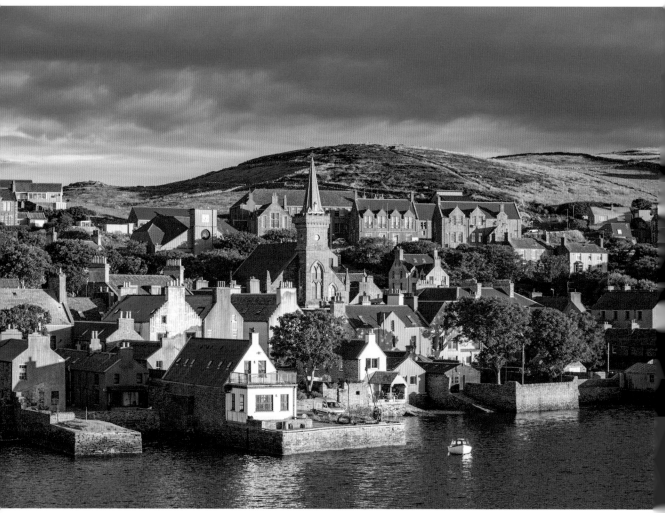

Stromness,Orkney's second town.

The history of Stromness is inextricably bound up with the sea and the lives of those who wrestled a living from its cold depths. The town grew rapidly during the 17th and 18th centuries when wars between France and Britain made the English Channel a hazardous place for trade and shipping. Preferring an alternative northern route to avoid hostilities, ships began calling in at Stromness where they took on water and other supplies before continuing on their various routes out into the Atlantic and beyond. By the end of the 17th century, the famous trading corporation, the Hudson's Bay Company had established an important base in Stromness where it began recruiting local men for service in Canada and the Arctic. Apparently Orcadians were more likely to be sober

than the Irish and were cheaper than the English. Men who signed up were paid handsomely. The company offered labourers £15 a year and £25 annually for tradesmen working at their settlements in Canada – excellent money when you consider that a schoolmaster at the time earned about £10 in a year. Incentives like these led large numbers of men to leave Orkney for Hudson Bay. By the end of the 18th century, almost three-quarters of company men in Canada were Orcadians.

If it wasn't the Hudson's Bay Company that depleted Orkney of all its vigorous and ambitious young men, then the whalers took the rest. The Davis Strait whaling fleet established a supply base at Stromness and, for generations, men who had learned how to handle small boats around Orkney were much sought after. Signing up, their native skills were deployed hunting whales in the Atlantic and Arctic.

Men who go down to the sea in ships are famously superstitious and one 18th-century local woman had a reputation for cashing in on their fears and credulity. According to my old *Black's Guide to Scotland*, Bessie Millie did brisk business by selling winds to credulous skippers. She lived on Brinkies Brae in 'a wretched cabin' and lived to be 'upwards of ninety years of age'. She was visited by the novelist Sir Walter Scott, who used her as inspiration for the witch Norna in his novel *The Pirate*.

While he was in Stromness, Scott was also inspired by the villainous deeds of John Gow, a Caithness man who'd opted for a life of crime and piracy. In 1724, at the age of 26, John Gow took part in a mutiny on board the merchant ship *Caroline*. After murdering the captain and principal officers on board, the international crew elected Gow as their leader and renamed the vessel

Revenge, after which they set sail on a voyage of piracy in the seas around Spain, France and Portugal. Eventually, the *Revenge* was driven north by fear of capture and sailed incognito to John Gow's home town of Stromness, where he assumed the unimaginative alias of John Smith, captain of the merchant ship *George*. He was soon unmasked and, when his true identity was revealed, he set sail again, embarking on a spree of piracy in the Orkney Islands, robbing the big houses of the local gentry and abducting two young women. He was eventually captured and sent to London where he was tried and executed – twice. Hoping to die swiftly, he asked the hangman to pull on his legs after he'd dropped from the scaffold. Unfortunately, the hangman pulled too hard and broke the rope. But Gow survived this ordeal and was forced to climb the scaffold for a second time, where he was successfully dispatched. Afterwards, his body was left to be washed in the river for the customary three tides. The bedraggled corpse was then painted in tar, bound in chains and hung from a gibbet on the banks of the Thames as a warning to other would-be mutineers and pirates – a grisly end to an otherwise colourful character.

Seafaring traditions continue in Stromness, which is still busy with fishing boats, yachts and the regular arrival and departure of the ferry to the Scottish mainland. On a cold and blustery day in late April, I met a man for whom the old traditions are something of a passion. Willie Tulloch is a prime mover and shaker of the Orkney Yole Association, a group of enthusiasts dedicated to sailing and preserving the little boats that kept island communities connected in the days before fast and reliable road transport. Willie and the octogenarian club commodore were both keen to take me sailing in their recently built 18-foot

The 18-foot yole, *Lily*, moored at Stromness.

yole, *Lily*, which was bobbing up and down in the choppy waters alongside a pontoon down at the marina. She looked like a thoroughbred straining at the leash. Orkney yoles are traditional craft. They resemble the double-ended, clinker-built boats that are such a feature of Shetland's coastal culture and they share the same Viking heritage. After hoisting sail, *Lily* was soon skimming across the waters of Hamnavoe, driven by an icy blast which seemed to be coming straight from the Arctic. Despite the deep chill, Willie seemed relentlessly cheerful.

'I just love these little boats. They are very kindly to sail and are very seaworthy,' he said in a sing-song Orcadian accent. Watching the wind on the water, he tightened the main sheet. 'These were the workhorses of the islands in the olden days. They were like Ford Transit vans before there were proper roads. Anything that needed carrying was carried by an Orkney yole, which has evolved over the generations – each one making a tweak here and a tweak there so now we have these absolutely fantastic little boats.'

'What are they like to sail?' I asked.

'Oh just fantastic – like driving an E-Type Jag!'

Unfortunately, at that moment, we were hit by a gust of wind. As we leaned over on the starboard tack, the port stay broke. Luckily, the mast didn't go overboard and we managed to limp back to the pontoon – just.

Before I said farewell to a sheepish-looking Willie, he told me that the yole *Lily* had been built locally by Richardson's boatyard. If I wanted more information about boatbuilding traditions, I should go there and speak to the master boat-builder himself, Ian Richardson. Following Willie's directions, I came to a very workaday, inconspicuous-looking building on an industrial estate at the edge of town. The sound of hammering drew me inside. There, I discovered the proprietor Ian Richardson busy caulking the seams of a wooden boat. The boat I was told, was 'a South Isles yole, 18-foot long and 7 foot 6 inches in the beam, copper fastened and very traditional to the islands'. It had taken Ian just over five months to build, working alone for the most part and only needing a hand to help with the steam-bent timbers because his 'arms aren't long enough to go around the whole boat'.

Ian had learned the boatbuilding trade in Stromness as an apprentice. Back then, in the 1970s, there were two boatyards in town and five in total across Orkney. 'Now there's just me,' he said ruefully.

'How does that make you feel?' I asked.

'Quite sad, really. There's no one else to take over after I've hung up my saw for the last time. I've got daughters and they're not interested in boats.'

Master boatbuilder Ian Richardson, Stromness.

Looking around the big shed where Ian plied his trade, I counted four large wooden boats in for repair and one under construction. 'There's more to these boats than just wood isn't there? There's a lifetime of experience here.'

'Yeah, well. It's not something you pick up in a year or so!' he said modestly.

Ian is something of a legend amongst people who know about these things. Over the years, he has built dozens of boats, mostly working craft used by fishermen, and I had actually sailed on one or two of them before realising it, often being told by a proud skipper that his boat was a 'Richardson's of Orkney'. Now that is quite an endorsement.

CHAPTER 6
NORTHERN ARCHIPELAGO

Shapinsay, Egilsay, Wyre, Rousay, Stronsay, Auskerry, Papa Stronsay, Sanday, North Ronaldsay, Eday, Westray, Papa Westray

SHAPINSAY

The island of Shapinsay lies close to Kirkwall and the crossing takes just 30 minutes on the ferry which runs regularly from the harbour to the village of Balfour. Shapinsay covers an area of approximately 29 square kilometres and is home to just over 300 people, some of whom take advantage of the proximity of Kirkwall and commute by ferry to town. The origins of the name Shapinsay are obscure but probably derive from the old language of the Vikings. The earliest written record dates from 1375 when the island is referred to as *Scalpandisay*. There is a local legend which claims that the Roman general Agricola paid a visit in AD 84. According to the general's son-in-law, the historian Tacitus, Agricola sailed north, discovered the Orkney Islands and subjugated the people. However, there is no evidence to back up this claim. Although some Roman artefacts and goods have been discovered by archaeologists at Iron Age sites throughout the islands, this does not provide sufficient evidence of a Roman conquest – merely that the people of Orkney traded with people who were part of the Roman world. Despite this, the Agricola legend continues, perhaps given

Opposite. Midhowe Broch, the Iron Age stronghold on Rousay.

substance by the occurrence of the Roman general's name on the Ordnance Survey map. Along the west coast of Shapinsay, Agricola appears three times – there's a small lochan called Agricola, a section of the stony shoreline is called the Furrow of Agricola and up the beach is the Noust of Agricola, suggesting this was where the Roman general hauled his boats ashore. However, historians have dismissed this idea, arguing that the name Agricola is a corruption of the original place name Grukalty. This is a shame if true, as I'd always liked the idea of the imperial fleet of ancient Rome sailing north to Orkney and landing on these green and fertile islands but sadly facts do sometimes get in the way of a good story.

My wife Nicky and I hired a couple of bikes in Kirkwall before catching the ferry for the short crossing to Shapinsay. I have to say that, even before we set foot on the island, we formed the impression that the place was somewhat 'whiffy' due to the very strong aroma of cow dung which was being blown offshore. After the ferry berthed in Balfour, the main village on Shapinsay, the source of the bovine pong soon became apparent. There seemed to be more cows per acre of land than I think I've ever seen before on a small island. Shapinsay obviously boasts very fertile soils to

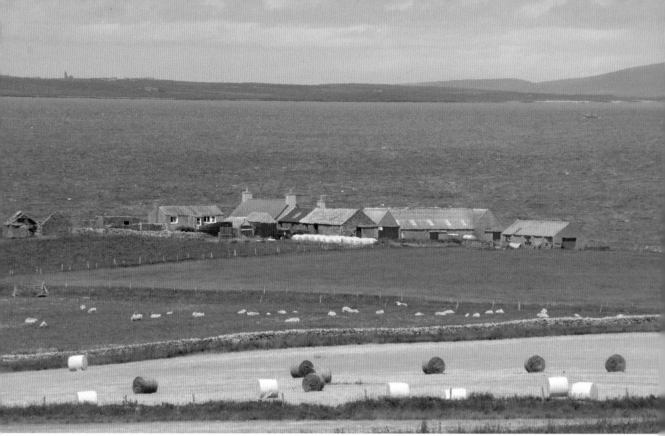

A Shapinsay croft with one of the 10-square-acre walled fields.

support cows in such large numbers – and much of this fertility must in no small measure be down to the huge quantities cow dung we saw piled up against farm buildings, ready to be mechanically spread on the lush green pastures.

The malodorous welcome was soon forgotten, however, as we set out to explore the island. The village of Balfour, where the ferry came in, was named after the Balfour family who dominated Shapinsay for most of the 18th and 19th centuries. Their ancestral pile, Balfour Castle, was for a time an exclusive hotel but now, according to the castle's website, 'Balfour Castle is a private house'. When the Balfours lived there, it was the centrepiece of their island estate, which at one time generated a sizable income from harvesting kelp. This seaweed was burnt on the shore to produce an ash rich in sodium alginate – an essential ingredient in several industrial processes. The trade flourished during

the 18th century and reached its height during the Napoleonic Wars. At that time, Shapinsay exported up to 3,000 tonnes of kelp ash, with an annual value of £20,000. Today that would be worth a staggering £1.7 million.

But, when the war with France came to an end, other cheaper sources of sodium alginate became available and the price of kelp collapsed as a consequence. Many landowners across the Northern Isles and the Hebrides struggled financially in the wake of peace and used the failure of the kelp industry as a reason to evict their tenants. But, on Shapinsay, the people fared better because their landlord, David Balfour, decided to reform agriculture on the island instead of clearing the people. He drained the land, divided it up into 10-square-acre fields on a grid pattern. Each portion of land was enclosed and the resulting drystone dykes remain a prominent feature of the island

Mor Stein, Shapinsay.

today. He also created a millpond and built a water mill and a fine castle for his family, which he rather immodestly named after himself. He laid out a village – again named after himself – and erected a strange tower with doocot at the top of it. It's called 'The Douch' because it also served as a salt-water shower to keep folk clean and next to godliness. Balfour must have been somewhat ahead of his time when he created a gas works for lighting and heating both the castle and the village. The gasometer is still standing. Built in 1854, it is a mock-medieval red-brick tower near the village school and was formerly used to store gas produced by heating coal. When I saw the tower, I wondered if, instead of coal gas, it could now be converted to use methane. The island's cows seemed capable of producing an endless supply of the gas – enough to light and heat any number of homes.

Leaving the village, we cycled along the road that heads out towards the Ness of Ork at the northern tip of the island. Who were these 'orks', I wondered. The 'ork' prefix seemed to be fairly common in Orkney. Were they the killer whales seen around the coast as I'd previously supposed – or were they perhaps the pre-Norse native Celts whose language has almost entirely disappeared from the place names of Orkney?

On our slowly wobbling two-wheeled route, we passed several reminders of these and other ancient peoples – the 3.2-metre Mor Stein mono-lith standing alone in a field and looking suitably mythic, various Neolithic cairns and a farm named after an Odin Stone. Like the other Odin Stone on Mainland, this one is also no longer standing. Its broken remains can apparently be seen just above the tide line on the beach of Veantrow Bay. At the north end of the island, just a couple of kilometres from the Ness of Ork, is the Burrough-

ston Broch. Unlike most other brochs we had seen, the remains at Burroughston were unusual – only the central parts of the structure had been excavated, giving the impression that it was half-buried. Standing on the grassy mound that surrounds the double outer walls, we looked down on to the ancient floor plan. I wondered why the broch had been buried in this way. Had a storm blown sand and soil over the ruined walls or had the earth been piled up deliberately for some long-forgotten reason?

Near the Ness of Ork we passed some very old and now-abandoned stone-built crofts. The roofs were amazing. Instead of being slated, they were covered in huge slabs of sandstone, which must have been quarried locally. It would certainly take a terrific gust of wind to lift one of those off the roof, I thought. And also some mighty strong roof timbers to hold them up. Down on the shore at the Ness of Ork, we ate our picnic and looked across to the islands lying north and west of us –

Egilsay ferry.

Stronsay, Eday, Egilsay, Rousay and Wyre clustered together on the wide horizon. How amazing it would be if the Roman general, Agricola, really had visited this northern archipelago. What would he have made of it? And what would the early Orcadians have thought of him, an emissary from the richest, greatest and most materially advanced empire on earth?

EGILSAY

Egilsay is one of the small islands connected by the ferry from Tingwall on Mainland Orkney. The island is named after the church that was, for many years, the focus of the entire island. Interestingly, it is one of the few Orcadian place names to have an obvious Gaelic connection – *eaglais*, which is Gaelic for 'church', morphed into *egil* in Old Norse and then *Egils-øy* – 'church island'.

It was an exceptionally grey and chilly May morning when I caught the *Eynhallow* – a rather aesthetically challenged roll-on roll-off ferry that looked like a landing craft from the Second World War. But then functionality is key in the islands. The *Eynhallow* was no beauty. She was more important than that – a modern workhorse that connects the inner north isles of Wyre, Egilsay and Rousay. Most of the deck space was taken up with vehicles but there was a small area behind the ship's bridge where some degree of shelter could be had to watch the passing scene. Sipping a cup of instant coffee I'd purchased from a vending machine located in the dreary lounge, I started chatting to the only other foot passenger on board. She was a recently retired schoolteacher from London who was looking to escape the big city and move to Orkney – she wasn't sure where exactly. As we headed out across the choppy grey

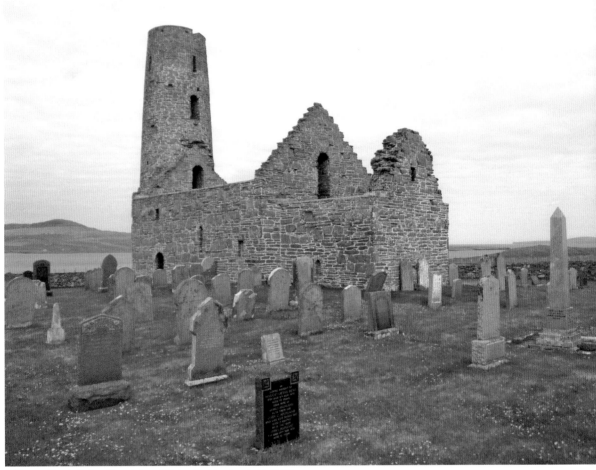

St Magnus Church, Egilsay. The saint was killed on the island, probably in 1117.

waters of the Sound of Rousay, she pointed out a pair of great northern divers. She was excited, remembering the rare bird from Arthur Ransome's children's novel *Great Northern*. 'I thought they were very rare and had never nested in Britain – which is the basis for Ransome's exciting tale of violent egg collectors,' she said. 'I know they visit in winter but what are they doing here now?'

'Well, it feels like winter. It's certainly cold enough,' I said.

The teacher from London looked again at the birds. 'They can't be. They must be black-throated divers. They look pretty much the same – smaller and not quite so heavy.'

At that moment a bonxie – a great skua – attacked the birds and drove them off.

'Well, if they were great northerns, I don't fancy their chances trying to raise chicks with those pirates around,' I said.

When we landed on Egilsay, I made straight

for the famous ruined church, which is only a kilometre from the jetty at Skail. The present structure, with its distinctive round steeple dates from the 12th century and stands on the site of a much older place of worship that may have had a Celtic origin. Despite the tiny size of Egilsay – the island is only five kilometres north to south by a kilometre broad – the history of the island and its church has played a hugely significant role in forging the wider identity of all the diverse islands that make up Orkney. What happened here 900 years ago is eloquently described in the Viking epic the *Orkneyinga Saga*, one of the most celebrated pieces of medieval Scandinavian literature ever written. According to the saga, this is where Earl Magnus, whose remains were later interred in St Magnus Cathedral, met a martyr's brutal death.

At the beginning of the 12th century, Orkney was ruled by two cousins – the Earl Håkon, who later went on a crusade to Jerusalem and built the church of St Nicholas on Mainland, and the Earl Magnus. Both earls had to answer to an overlord – Sigurd, the bastard son of the mighty Norwegian king Magnus Barelegs. Sigurd called on the loyalty of the two cousins to take part in various Viking expeditions, including the invasion of Anglesey. The *Orkneyinga Saga* tells of how Earl Håkon was a fearless warrior, while Earl Magnus preferred to stay on his ship and pray.

Returning to Orkney the two earls ruled well together at first but Håkon later grew jealous of Magnus, whose intelligence and virtue had made him very popular with the people. Stirred up by evil men, the two cousins became deadly rivals, and war threatened to engulf the islands. In an attempt to avoid bloodshed, a peace conference was called for Easter Day. It was to be held at the church on Egilsay.

The rival earls agreed to attend with no more than two boats and a handful of men each. Magnus arrived first and, being a saintly soul, began to pray. But when his bellicose cousin Håkon turned up, he brought with him a small fleet of ships and several hundred men. Seeing them, Magnus felt utterly betrayed. He realised that death was near.

Håkon's followers urged their leader to seize the moment and finally unify Orkney by killing Magnus. But Håkon couldn't bring himself to do it. Instead, he called for a volunteer but none of the noble warriors had the stomach to kill Magnus who, eyes cast aloft to heaven, was busy praying. Exasperated, Håkon ordered his cook Lifolf to dispatch his cousin with an axe. The *Orkneyinga Saga* tells how Magnus remained calm to the end. When Magnus saw the tearful Lifolf approaching with the axe, he told Lifolf to calm himself and not to worry. God would forgive him. 'Be not afraid, for you do this against your will and he who forces you sins more than you do.'

Kneeling on the ground, Magnus asked to be struck hard on the head, rather than beheaded like a common criminal. 'Stand thou before me, and hew on my head a great wound, for it is not seemly to behead chiefs like thieves. Take heart, poor wretch, for I have prayed to God for thee, that He be merciful unto thee.'

Lifolf struck the blow and cleaved the earl's skull in two.

So Magnus got the chop and, very soon afterwards, all kinds of miracles began to be associated with his name. Within a generation, Earl Magnus had become Saint Magnus. And, ever since, Egilsay has been holy ground. Orcadians came to regard Magnus as a martyr. While he lived, the islands were divided. His sacrifice held the islands together

for the good of all. Today, Magnus continues to link Orcadians to their Scandinavian past and helps unify the islands and give them a distinct identity.

After leaving the ruined church, I had some time to wander around the island before the ferry returned. There was some quality of the light and an atmosphere about the place which I couldn't put my finger on. Superficially, the island looked run down, with the usual tangle of barbed wire fencing, bits of shredded black plastic blowing in the wind and rusting agricultural machinery abandoned in the corner of the fields. Yet, despite all this, the island seemed to emanate peace and tranquillity.

At some point along the only tarmacked road on the island, I met a man outside the community centre. He introduced himself as Dave and invited me inside for a cup of tea. Dave was from England. He'd fallen in love with Egilsay years ago and had retired to the island where he now lived with his wife and their 15-year-old grandson on a nearby croft. Dave told me that the population on Egilsay at one time numbered several hundred – many had arrived as 'refugees' in the 19th century from neighbouring island of Rousay when it was cleared by their landlord. Since then, the population of Egilsay had slowly declined.

'We're down to 26 now,' said Dave. "We buried the last true islander last year. Everyone else is an incomer, including one family with 13 kids – that's half the population!'

'That must be a good thing,' I said. 'New blood coming to the island.'

'Yeah but she home educates so, ever since our grandson went to secondary school in Kirkwall, the island's primary school has been closed. Another vital community asset lost.'

WYRE

Wyre is one of the smallest inhabited islands in Orkney. It covers an area of approximately 2.5 square kilometres and has a population of about 19 who are mostly engaged in crofting and agriculture. The island is thought to have been named by the Vikings because of its shape – Wyre comes from the Old Norse *vigr*, meaning 'a spearhead'.

The ferry *Eynhallow* calls regularly at the slipway at on the west side of Wyre facing the heather-clad hills of neighbouring Rousay. From here I set off on foot, following the island's only tarmacked road to a turnoff that leads down to an enclosed burial ground and the ruins of a 12th century Viking chapel. It is currently referred to as St Mary's Chapel but earlier chroniclers claimed that the whole island of Wyre was dedicated to St Peter so there is some uncertainty about the pre-Reformation affiliation of this place of worship.

The chapel is thought to have been built by Bishop Bjarni, the son of the famous Viking warrior Kolbein Hruga, who is known locally as Cubbie Roo. Cubbie Roo appears in the *Orkneyinga Saga* as 'the most outstanding of all men'. He was born on the west coast of Norway and settled on Wyre around 1145. Here he built a defensive tower which is also mentioned in the saga: 'At that time there was a very able man called Kolbein Hruga farming on Wyre in Orkney. He had a fine stone fort built, a really solid stronghold.' The ruins of this fort have survived the centuries and stand in the middle of the island on Wyre's highest hill, which lies just 150 metres across the fields from the chapel. The castle is said to be the oldest stone keep castle in Scotland. The remains of the stone keep are surrounded by defensive ditches and earthworks, which support the claim of the sagas that Kolbein Hruga's fort was a difficult place to attack.

Welcome to Wyre.

To appear in the sagas, Kolbein Hruga must have been an important figure of considerable influence in the Viking world. By all accounts, he was a big man and physically powerful. Apparently *hruga* in the language of the Vikings means 'heap', perhaps making him the 'Giant Haystacks' of his day. His exploits became legendary and, after his death, he entered Orcadian folklore as the giant Cubbie Roo whose monstrous size enabled him to travel across Orkney using individual islands as stepping stones. He is also said to have created many of the rocks and skerries around the coast and several standing stones across the islands. In folklore, it seems that Cubbie Roo had an obsession with building causeways and bridges.

However, his engineering efforts were always thwarted and he continually dropped stones into the sea, which became rocky islands. Sometimes, in a rage, he would throw stones in anger. If these came to earth on land, they became standing stones.

Below the castle is a farm called The Bu. In Old Norse, *bú* means 'great hall' and this could well have been where Kolbein lived when he wasn't fending off his enemies up at the castle. The Bu could also be the place where his son Bjarni grew up. As well as becoming a bishop, Bjarni was an important poet, writing the skaldic verse poem *'Jómsvikingadrápa'* which commemorates the fallen Jómsviking warriors at the Battle of Hjörungavágr. Given that the Jómsvikings were a ruthless bunch of pagan mercenaries, they make an odd subject for a pious priest to celebrate in verse.

Centuries later, the poet Edwin Muir also spent his childhood growing up at The Bu. His father was a tenant farmer who had taken the on the lease, having moved with his family from Mainland Orkney. The young Edwin Muir spent an idyllic childhood on Wyre, where he roamed the island under wide skies. But these happy days weren't to last. In 1901, the family were forced to leave the island. High rents and poor harvests had made life on Wyre impossible. After five unsuccessful years back on the Mainland, the Muirs tried to make a new life for themselves in Glasgow. At the age of 14, Edwin found his world transformed by the move from the tranquillity of Orkney, to the grime, noise and chaos of an industrial city. Years later, Muir described this dislocation as being like a strange form of time travel. Life on Wyre had been pre-industrial. Arriving in Glasgow at the turn of the 20th century had fast-forwarded him 150 years:

I was really born in 1737, and till I was fourteen no time-accidents happened to me. Then in 1751 I set out from Orkney for Glasgow. When I arrived I found that it was not 1751, but 1901, and that a hundred and fifty years had been burned up in my two days' journey. But I myself was still in 1751, and remained there for a long time. All my life since I have been trying to overhaul that invisible leeway.

As I continued to the western tip of the spear-shaped island of Wyre, nesting Arctic terns performed their aerial dance. On the stony headland, seals were laboriously hauling themselves out of the water. With the sea on either side of me and the land of this flat island fanning out behind me, Wyre seemed in my mind to resemble a ship underway – and me its figurehead. Leaning a little into the westerly wind, I thought of Edwin Muir's time travel. I felt as if I had experienced it in reverse and had returned to a point where time stood still.

ROUSAY

The island of Rousay, from the Old Norse *Hrolf-øy*, meaning 'Rolf's Island', is a five-minute ferry ride on the *Eynhallow* across the sound from Wyre. The fifth largest of all the islands of Orkney, it covers 48 square kilometres. Its high, heather-clad hills rise to the summit of Blotchnie Fild at 250 metres, the highest hill in Orkney outside the island of Hoy. The people of Rousay, who numbered almost 1,000 in the 19th century, were once known by other Orcadians by their *teu neem*, or nickname, as 'Mares'. Just why is unclear but perhaps it was because the name Rousay is similar to the Old Norse word *hryssa*, meaning 'a mare'.

Today, after years of emigration and eviction, the population of 'Mares' on Rousay is down to about 230. Since the dark days of depopulation, the island has embraced incomers and has branded itself as the Egypt of the North not because of sand dunes and camels – of which there are none – but because of the extraordinary number of prehistoric relics that litter the landscape. There are at least 160 known sites including Neolithic chambered cairns, a Stone Age settlement, standing stones, crannogs and an impressive Iron Age broch.

Just up the road from the cluster of houses around the ferry pier is Trumland House. But for missing a 'p', Trumland sounds like the residence of a US president but it is, in fact, the former residence of Lt-General F. W. Traill-Burroughs, who inherited Rousay from his uncle, George William Traill. Traill-Burroughs was a military man. He had served with distinction in the Crimean War, taking part in the action celebrated by Robert Gibb's famous painting *The Thin Red Line* (1881), which depicts a scene during the Battle of Balaclava when 500 Scottish Highlanders stood their ground against 2,500 charging Russian cavalry. Traill-Burroughs, like his uncle George before him, ruthlessly evicted his tenants, especially in the west of Rousay, earning the reputation as the worst landlord in Orkney. For this, and because of his diminutive stature, he was given the ironic nickname 'the Little General'.

Heading along the coast, I made my way past Westness House – where the lairds of Rousay had traditionally lived before the Little General established his mansion at Trumland. Following the Westness Heritage Walk, which billed itself as the most important archaeological mile in Scotland, I came to Midhowe Cairn, protected from the elements by a huge, purpose-built stone shed.

When the site was excavated in the 1930s, a Neolithic burial chamber dating back to 3,500 BC was revealed beneath a grass-covered earth mound. Inside, archaeologists discovered a 23-metre-long chamber divided into 12 stalls, each containing a shelf on which bodies were laid. The bones of 25 people were removed, including 17 adults, six children and two infants. Not a lot, perhaps, for such a significant structure – and very few indeed when you consider that the burial cairn was used for hundreds of years. However, Neolithic burial cairns were not like modern mausoleums or graveyards, where the dead are left and eventually forgotten. It is now thought that places like the Midhowe Cairn formed an integral part of the living community, which celebrated the dead who were amongst them with regular visits and festivals at the burial chambers.

Further along the walk and past another chambered cairn, I came to the remains of the Midhowe Broch, the best-preserved broch in Orkney, which dates from around 200 BC. Like the broch on Shapinsay, artefacts with a Roman origin were found here, showing the extent and influence of the Roman Empire on people and cultures far distant from the imperial centre in Rome.

A kilometre across the narrow sound that separates Rousay from Mainland lies the tiny island of Eynhallow, which for centuries has been veiled behind myth and legend, being one of the 'vanishing islands' of Orkney and home to the fearsome supernatural beings known as the Finfolk. Finfolk were infamous for their sorcery and their habit of kidnapping men and women and whisking them away to their enchanted realm. In Orcadian folklore, the victims of the Finfolk were taken to the vanishing islands of Hildaland and Hether, which appear mysteriously from the waves and then vanish again. Hildaland, which today is known as Eynhallow lost its enchanted status as a haven for the Finfolk when it was taken from them by a mortal man, the Goodman of Thorodale, whose wife had been stolen from him by a Finman. Bent on revenge, Thorodale sought the assistance of a witch on Hoy. Following her advice, he first visited the Odin Stone on Mainland and stared through its circular hole until he gained the power to see the vanishing island of Hildaland. Next he and his sons braved whales and mermaids in Eynhallow Sound and landed on the island where they defeated a monster. Then, as instructed, Thorodale circled Eynhallow nine times spreading salt as he went. He then cut nine Christian crosses into the turf, causing all the Finfolk to flee into the sea. Empty of its evil former inhabitants and visible now to man and God, the island was cleansed. A church was built and the name changed to Eynhallow – holy island.

Tuning away from my view of Eynhallow and its ancient ruined church, I continued north along the track, reaching a desolate moorland called Quendale where my map showed a number of ancient sites – the remains of more brochs, cairns and burnt mounds. Amongst the wind-blown grass were more recent ruins. These scattered stones and field outlines are all that is left of the community that was cleared by George Traill when he evicted 215 people after they had struggled to bring in the harvest of 1845. Traill destroyed their farmsteads so they couldn't return and put sheep on the land where they had previously grown bere barley. His nephew, the Little General Traill-Burroughs, completed the job. He needed to improve the productivity of his island estate to pay for the mansion he was building at Trumland. To do this he raised the rents to such an extent

Trumland House, Rousay.

that many of his tenants couldn't pay them. Those who fell into arrears were quickly evicted.

The Napier Commission was a royal commission set up in 1883 to report on the condition of crofting in the wake of crofters' complaints about increased rents and forced evictions. When the commission came to Kirkwall, James Leonard, living at Digro, a small hillside croft on Rousay, was the voice of island's crofting community. He testified against their laird, the Little General, and, for his trouble, he and his family lost the tenancy to their croft and were evicted. A century and a half later, his two great-granddaughters attended a ceremony to unveil a stone memorial in his honour. It stands by the roadside at Digro as a reminder of Rousay's dark days and carries James's own words:

> I will not be cowed down by landlordism . . .
> We are telling only the truth.

To climb Blotchnie Field I retraced my steps towards the ferry pier and then headed past a strange double-decker chambered cairn at Taversoe Tuick. Apparently, it had been discovered by in 1898 workmen who were labouring for Traill-Burroughs to build his wife a seat on top of a grassy knoll so that she could enjoy the view across the sound to the neighbouring islands. From the cairn, I headed up hill across some fields and then picked up the route, which was marked by white painted wooden posts. After about an hour, I reached the summit where I enjoyed some fine views across the island and over to Mainland, Wyre, Egilsay, Gairsay and the rest of Orkney's north islands. As I returned across the heather and deer grass, I remembered that the hill I'd climbed, Blotchnie Field, is mentioned in another old tale about the islands where it is called Bloodfield.

Like many of the tales from Orkney folklore, this one involves a giant. The story begins with

The double-decker chambered cairn at Taversoe Tuick.

the queen of Rousay who has fallen on hard times. Things get worse when her daughter, the princess, is carried off by a giant to his hall. The giant gives her various tasks to perform. One is to milk the cows on Bloodfield hill and then to spin cloth. He will release her if she completes them all. The princess does all the chores asked of her but can't spin. Luckily the work is done for her by a little man with yellow hair who lives in a knowe – presumably one of the old burial cairns on the island. All he asks by way of payment is for her to guess his name. If not, she won't get the cloth and the wicked giant will do what he will with her. By a stroke of luck, an old woman, who has been treated kindly by the princess, discovers by chance the yellow-haired little man spinning by a mysterious light in his underground home. He sings to himself:

Tease, Teasers, Tease
Card, Carders, Card

Spin, Spinners, Spin,
For Peerie-fool,
Peerie-fool is my name.

The old woman returns to the giant's hall and tells the girl what she has heard. The delighted princess knows now that she is safe. When the little yellow-haired man reappears with the cloth the giant has demanded, he asks the princess if she can guess his name, which of course she can. When the giant returns to his hall, the princess gives him the cloth. She has now completed all the tasks he had given her and is released.

Of course, the giant comes to a sticky end – as happens in most folk tales. Just below Blotchnie Fiold is a standing stone called the Yetnasteen. The sinister-sounding name of this two-metre-tall monolith comes from the old language of the Vikings – *Jotunna-steinn*, which means 'Giant Stone'. The giant in question is bound by magic, having been turned to stone by the rays of the sun but

The island of Stronsay.

every year at Hogmanay he comes alive again and makes the short trip to the nearby Loch of Scockness, where he takes a drink. I suppose that's his way of celebrating the chimes of New Year.

STRONSAY

Stronsay is a very low-lying island and can be reached by a two-hour ferry crossing from Kirkwall. There seems to be some disagreement about the Norse origin of the name Stronsay. Some sources suggest that the it comes from *strjóns-øy* meaning 'good fishing and farming island'. Others are inclined to think that the name comes from *stjarna-øy* because of the star-like shape of the island, which is certainly all arms and legs when seen on a map. It's 12 kilometres long and would be square but for the three great interlocking bays. St Catherine's Bay, Mill Bay and Bay of Holland bite deep into the island creating three slender peninsulas, which, at their narrowest, are just a couple of hundred

metres across. The highest point on the island is Burgh Hill, which rises to a modest 46 metres. Slightly lower but more accessible is the 43-metre St John's Hill, marked by a trig point, which is just a few metres from the road that leads to the airfield. From this viewpoint, pretty much all of Stronsay can be seen, along with many neighbouring islands lying on the broad horizon. Overall, the island has a well-kept, cultivated feeling to it. Agriculture and fishing are the main economic activities of the population which numbers around 350 people and whose nickname or *teu neem* amongst locals is 'Limpets'. I have no idea why they are called limpets and neither did any of the locals I met – although one non-native did suggest two possible reasons. Stronsay folk may have been very poor in the past and were forced to eat limpets to survive during times of hardship. Alternatively, the name is an insult – Stronsay fishermen were reluctant seafarers and more inclined 'stick to the pier like limpets' than leave port in bad weather. But I like to consider

a kinder interpretation. Perhaps the name 'limpet' describes the general tenacity of the islanders' character.

The main village is Whitehall – which sounds more English than Orcadian. Apparently, it was named by a notorious 17th-century pirate called Patrick Fea who made a small fortune raiding passing ships. With his ill-gotten gains he built a grand house and painted it white – hence Whitehall. By all accounts Patrick Fea was a warlike man who liked nothing better than a good fight, who seems to have found excuses to punch almost everyone on this otherwise peaceful island. Unsurprisingly his appalling behaviour made him very unpopular. In fact, he was so disliked that he caused a riot, which ended when he and his family were chased off the island for good.

Today, there are several white houses in picturesque Whitehall, though I couldn't spot the one which might have belonged to Patrick Fea. Making my way from the ferry terminal along the waterfront I dropped in at the Fish Mart Café – the fish mart is sadly no longer open – where I had lunch and perused several wall displays and photographs describing Whitehall when it was the centre of the herring fishing industry in Orkney. From the early 17th century up until the First World War, thousands of migrant workers came to work here during the fishing season, swelling the population of 1,200 to over 5,000. During these boom years, the bay was filled with over 300 boats while, onshore, there were 15 fish-curing stations, 10 shops, 3 bakeries, 5 butchers, 5 ice-cream parlours and 40 pubs! There was even a cinema on the island. But Whitehall is a very quiet place now. From the window of the Fish Mart Café, I could see a couple of fishing boats moored alongside the pier – otherwise there was

no activity and it was hard to imagine the hive of industry that must have been a regular sight along the waterfront a century ago.

Because Stronsay is so flat, it makes it an ideal island to explore on a bicycle. However, I decided to forgo the pleasures of two wheels and opted instead to take a four-wheeled taxi to start me off on my round trip. Don Peace, the only taxi driver on the island, is a local man. Apparently, the name Peace is common in this part of Orkney, making Stronsay a peaceable place I suppose. Don agreed. 'It's a beautiful island and I'm very happy here,' he said. By way of confirmation, he told me that there was no police station on the island. 'There's no need,' he said. 'Not since the days when the pirate Patrick Fea was on the rampage.'

As we drove along a narrow road heading for Mill Bay, I asked Don if he minded being called a 'Limpet'.

'Oh, no. I'd say I was a proud Limpet.'

'What does it mean, though?'

'Oh, I don't rightly know. But we are all Limpets here.'

A few moments later we passed a semi-derelict, three-storey water mill – a wonderful relic from a more self-sufficient past. Don told me that he had worked there as a boy in the 1950s when the mill produced bere barley and oats for the local community.

I asked Don to drop me off at Mill Bay, where I hoped to find the legendary and mysterious Mermaid's Chair, which was clearly marked on my OS map. Don had heard of the Mermaid's Chair but was vague about its exact location.

'Were mermaids a big thing on the island at one time?' I asked him.

'Well, maybe. Maybe they were. But I've not seen one – although I live in hope.'

Don left me at the southern end of Mill Bay, where the beach swept north in a beautiful arc of golden sand for almost two kilometres. My map indicated that the Mermaid's Chair was halfway along the bay on what appeared to be an outcrop of sandstone, a seemingly ideal spot for such a creature of myth and legend. In Orkney, the sea and the creatures that inhabit its depths form a central part of island folklore which blends fact and fantasy. However, mermaids are amongst the deadliest in the pantheon of enchanted beings. Exquisitely beautiful, they have a single goal – to find a mortal husband and become human. If they fail, they lose their gorgeous looks and become hideous sea hags. Desperate to keep young and beautiful, a mermaid will deploy everything in her sexual armoury to get her man. She will sing, display her nakedness and call suggestively to passing sailors – before dragging them into the deep where she will keep them as her mate. In days gone by, Orcadians blamed mermaids for the disappearance of many young men lost at sea. On reflection, I thought, perhaps this was not the worst way to go.

In the Northern Isles, a common variation of the mermaid myth is the legend of the selkie. These seductive creatures appear at first sight to be seals but then shed their skin to reveal a beautiful human form hidden beneath. Selkies can be either male or female and stories abound about how islanders fall desperately in love with these alluring creatures. But, of course, relations with such beings only brings pain. To keep a selkie bride, a man must hide her seal skin in order to stop her returning to her own folk beneath the sea. But this usually ends in tragedy. The selkie will eventually pine for home and want to escape. Using her superior intelligence, she will discover where the seal skin has been hidden, put it on and then return to her realm beneath the waves, leaving broken hearts and grief in her wake.

I eventually found what I thought must be the Mermaid's Chair located in the shadow of a low sandstone cliff. This is where mermaids of legend would have sat combing their hair and calling out to passing ships. The chair is also said to confer on young island women who rested on its cold stone, the power to see into the future. But, in local legend, the chair has less peaceful associations. This is where Scota Bess sat. She was no mermaid – she was a storm witch who had the power to call up thick sea fogs and a phantom ship to lure sailors to their doom.

But things didn't go too well for Scota Bess. She got a brutal comeuppance when a mob of angry islanders beat her to death with sticks conveniently washed in holy water – just to keep God on their side. Behind the backdrop of myth and superstition is a true story. Scota Bess was a real woman, whose murder in 1630 was well documented at the time, although no one seems to have been charged with killing her. As in many other real cases of so-called witchcraft, here was a woman who didn't conform and was punished for being different in a way her community found unacceptable.

At the north end of Mill Bay is the intriguingly named Well o' Kildinguie – a place once famous in the Middle Ages as a healing spa. Apparently people flocked from as far afield as Norway and Denmark to take its curative waters. According to an old proverb:

The Well o' Kildinguie, and the dulse
 o' Guiyidn,
can cure all maladies but black death

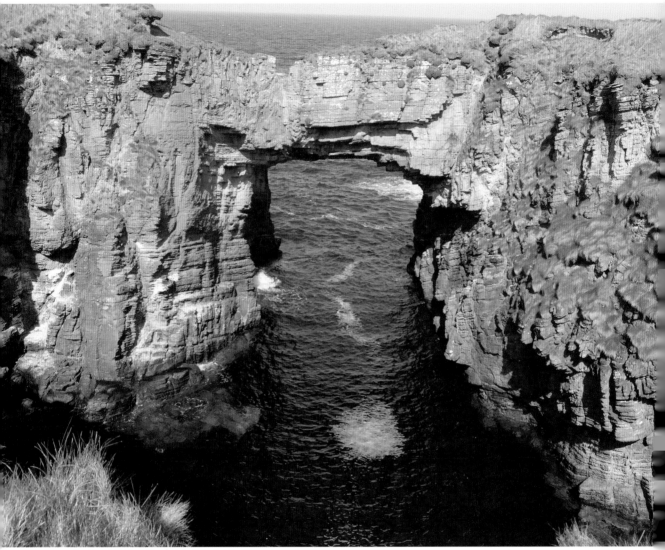

The Vat of Kirbister. The arch is all that's left of the entrance to a huge sea cave.

Writing in the *Old Statistical Account of Scotland* in 1795, the local minister said that the waters from the well were particularly effective when taken with seaweed – dulse – harvested from Guiyidn, a cleft in the cliffs otherwise known as Geo Odin.

Finding the Well o' Kildinguie was almost impossible. I'd been told to look out for a one-metre square rock down on the shore with inscriptions and ancient graffiti carved on it – not an easy task because there were stones of this size everywhere I looked. As for the curative waters of the well, there was neither sight nor sign. Appar-

ently, they'd stopped flowing in the 19th century after a farmer blocked up their source. Eventually, just as I was at the point of giving up my search, I saw the first inscription – the letters JL. Could this unlikely spot be the former place of pilgrimage? It was hard to believe because there was nothing to see but apparently a location on the shore between high and low water was once considered especially sacred. After its popularity as a spa resort waned, the Well o' Kildinguie apparently became a place for lovers to meet. During their liaisons, they left their names and initials, carved in stone for posterity. I looked at the letters JL again and wondered if true love had blossomed here – or was it a cryptic message of hope, only comprehensible to the carver? Unrequited love, perhaps?

Before I left the western side of the island, I decided to walk the cliffs above Odin Bay. Wondering who had named it after the Norse god, I came to a spectacular natural arch which spans a cauldron of surf-swirling sea in the cliffs. Known as the Vat of Kirbister, the arch is all that's left of the entrance to giant sea cave which collapsed thousands of years ago. Drawn irresistibly to its elegant span, I couldn't resist crossing over – a narrow and exposed route involving some scrambling in a spectacular situation 33 metres above the churning waters of the Vat.

At the south end of the island I met a man who was in touch with another Stronsay sea mystery – not a witch or a mermaid this time but a genuine monster of the deep, the Stronsay Beast, which was washed ashore in September 1808 at Rothiesholm. Standing on the edge of the spectacular cliffs, fisherman John Stevenson pointed to a rocky tidal reef immediately below us.

'That's where it was lying when John Peace found it. He was a crofter-fisherman and had seen

With fisherman John Stevenson, Stronsay.

all the seabirds circling around it and he went over to investigate. As a wee boy, I remember John Peace's grandson telling me about how his granddad had found it.'

At first, John Peace thought the carcass on the rocks was a whale but, as he drew closer, he realised that he had found something altogether different and strange.

'It was a great long thing,' he said, 'with a neck 15 feet, a heid like a sheep and a tail like a lizard. It measured 55 feet altogether.'

Crude sketches were made of the beast and news of its discovery soon spread far and wide. Before long, details of the incredible find reached the ears of a Natural History Society in Edinburgh. They declared the beast to be a new species and gave it an official Latin name, *Halsydrus pontoppidani*, 'Pontoppidan's snake of the sea', in honour of Erik Pontoppidan, a Norwegian–Danish author

and clergyman who, in his *Natural History of Norway* (two volumes, 1752 and 1753), argued for the existence of sea serpents, mermaids and krakens.

But the naturalist Sir Everard Home was sceptical. When he viewed what was left of the evidence, he was convinced that the Stronsay Beast was nothing more than the remains of a basking shark. He argued that when a basking shark dies and decomposes its huge lower jaw drops off and the lower parts of the tail rot away. What's left resembles the remains of a long-necked, serpentine creature with a small head. But not everyone was convinced by this dismissive explanation. Crucially, for believers in the beast, the longest basking shark ever recorded was a mere 40 feet long – 15 feet shorter than the monster washed up at Rothiesholm.

'At fifty-five-feet long from tip to tail, there is no way it was a shark!' said John, as he demonstrated the sheer size of the beast by pacing out its length on the short grass above the cliffs.

And we may not have heard the last of the Stronsay Beast. Incredibly, some fragments of the creature's vertebrae still exist at the National Museum in Edinburgh. With modern DNA-testing techniques, perhaps the mystery will be solved once and for all.

'What do you think it was?' I asked John.

'Oh, I think it was a sea serpent that was washed up here all those years ago.'

'Do you think there are such things as sea serpents?'

'Oh, I think maybe there are, aye. The sea is a deep and mysterious place,' he said, looking at the wide blue horizon.

Being something of a sucker for stories of 'here be monsters', I felt inclined to agree.

AUSKERRY

Auskerry, from the Old Norse *østr sker*, meaning 'east skerry', lies about three nautical miles to the south-east of the cliffs of Rothiesholm on Stronsay. Auskerry is a low-lying flat island, measuring 1.6 kilometres long by just over a kilometre wide. The most obvious feature is the lighthouse at the southern end of the island. It was built in 1866 by the engineers David and Thomas Stevenson. Despite the surrounding reefs and the turbulent waters of Auskerry Sound, Auskerry has a long history of habitation. Several ancient sites, settlements and standing stones are evidence of this, including a three-metre monolith close to the middle of the island. Later, monks of the Celtic church established a religious community and built a chapel but nothing precise is known of these holy men or their mission. The chapel has been reduced over the centuries to a pile of windswept rubble close to the south-eastern shore.

For many decades, there were no permanent residents on Auskerry. Occasional seal hunters came to cull the grey seals that continue to congregate and breed on the nearby rocks below the lighthouse; the inlet called Hunter's Geo recalls those times. Sheep were regularly grazed by crofters from Stronsay who also harvested kelp and extracted peat as a fuel source. After the lighthouse was built in the 19th century, two keepers and their families came to live on the island. During the First World War, the keepers were joined by navy personnel who established a signalling and radio surveillance station. Like several other Scottish lighthouses, Auskerry was attacked by the German Luftwaffe during the Second World War. In 1942 anti-aircraft guns were installed to protect it. When the lighthouse was automated in the early 1960s, the keepers left and

the island became uninhabited until it was bought by a rock-music promoter, Simon Brogan. Since 1975, he and his family have lived on Auskerry full-time and have created a sustainable farm business based on their large flock of seaweed-eating North Ronaldsay sheep, producing yarn, fleeces, sheep-skins, felt and woven goods and items made of horn.

When I was on Stronsay and talking to fisherman John Stevenson about the mysterious Stronsay Beast, we could clearly see the island of Auskerry on the horizon. When I asked him if it was uninhabited, he told me about the family who lived there. The owner, Simon Brogan, had worked with some of the biggest names in rock music during the 1960s and '70s, including the Rolling Stones, The Who and Jethro Tull. But, after a successful and frenetic decade, he wanted to escape the music industry. After buying Auskerry, he and his wife Teresa Probert rebuilt an old ruined croft and reared a family of three sons. The boys were home educated and later went on to university – an impressive story of survival and commitment to an alternative ideal, I thought. Looking at their island home from the cliffs of Stronsay, Auskerry looked very remote. John said that, despite being cut off by bad weather and having no mains electricity, life on the island was very civilised. 'For a start, they benefit from the services of the mailboat. I know. I run it and they get regular deliveries – fourteen times a year!'

PAPA STRONSAY

Papa Stronsay is a tiny island covering an area of less than a square kilometre that lies a few hundred metres north of Whitehall, the main village on Stronsay. The prefix *papa* indicates that when the Vikings arrived sometime in the 9th century they probably encountered priests or monks on the island. It seems that Papa Stronsay remained a religious centre until the Reformation. The island also gets a mention in the *Orkneyinga Saga*, which describes how two 11th-century Viking rivals, the fair-haired Earl Rognvald and Earl Thorfinn, ravaged the Western Isles from their Orkney base until they fell out with each other. When they met in war, Rognvald lost a sea battle but escaped to burn down Thorfinn's house. Luckily, Thorfinn managed to get away, carrying his wife on his back. Thinking he'd seen the last of his enemy, the victorious Rognvald then sailed to Papa Stronsay to buy some of its famous malt barley in order to make a celebratory batch of Christmas ale. But he was surprised on the islands by Thorfinn, who encircled him in a ring of fire. Rognvald managed to escape through the flames, but his dog gave him away as he tried to hide. He was discovered and slaughtered on the shore.

When I travelled to Papa Stronsay, I was in the company of a small film crew. We had taken the early morning ferry from Kirkwall, sailing through grey light and rising seas to Whitehall on Stronsay, where we had arranged to meet the leader of the island's present residents – Fr Michael Mary. Fr Michael is a monk of the holy order Transalpine Redemptorists, a tiny unorthodox community of old-fashioned Catholics who are dedicated to the sacred cause of keeping the Latin language at the heart of their devotions. There was no mistaking our hosts when we stepped ashore. Two imposing figures dressed in billowing black cassocks approached us along the pier. Instead of immediately taking us across to Papa Stronsay, they first invited us to their guesthouse on the harbour

The monks' ferry, Papa Stronsay.

front – a small grey-harled building with a niche in the gable, from where a statue of the Holy Mother peered out watchfully. It was cold and dark inside. Fr Michael Mary, who hails from Christchurch, New Zealand, beamed across the table at us and began a gentle interrogation. I think he wanted reassurance about our intentions before spending a day filming with us.

When it was time to make our way over to their island home, Fr Michael led us along the quay, where we carefully climbed down an iron ladder to board their ferry – probably the least seaworthy craft I think I've ever seen. It was a dreadfully leaky old hulk and seemed to be kept

afloat by little more than the power of prayer. The wind had risen and the waves were looking threatening as we made a clumsy departure from the harbour and headed across the sound.

'Are you used to this sort of weather?' I asked nervously.

'Oh, yes. We have been out in worse,' Fr Michael said, trying to sound reassuring but, at that moment, he was hit in the face by a splash of cold seawater. 'Well, perhaps not much worse – but we'll be OK. Brother Martin is at the helm. He's a good sailor.'

The tall, bearded and enigmatic Brother Martin looked gravely over his shoulder and gave a reas-

The old farm house, Papa Stronsay, home now to Transalpine Redemptorist monks.

suring nod. 'It won't take more than 15 minutes and we'll soon find the sheltered lee shore of Papa Stronsay.'

Fr Michael tapped me on the shoulder and pointed at our helmsman. 'He used to be a drummer in a band. Gave it all up. Left a comfortable life in Oxford to come here to join our community of prayer.'

It was with some relief that we made it to the ramshackle pier on Papa Stronsay. The area around the harbour seemed to be full of large sheds, old farm buildings and several Italianate shrines from where moulded concrete saints gazed balefully at our approach.

'The religious roots of this island go way back,' said Fr Michael Mary. 'Since the time of St Columba, monks have been saying the Latin mass and reading holy scripture right here, under these same grey skies.'

The original monastery was abandoned in the 16th century. The island then became a farm and later shared some of neighbouring Whitehall's brief success during the herring boom of the 19th century. When the Transalpine Redemptorist monks bought the place in 1999, they converted the old farm and its outbuildings into a refectory and a chapel. The ornate interior fixtures and fittings, including the impressive altar, came orig-

inally from a convent in Belgium.

'We hired a big van to pick it up. Drove all the way there and back. The nuns were so grateful. They knew it was going to a good home,' Fr Michael explained as he lit a candle. 'There's something about a monastic vocation in the solitudes that has an inexplicable appeal to something deep in our souls. We need somewhere we can escape the noise of the world. That's why laypeople come here on retreat. It's a bit like a secular holiday perhaps. Just think, instead of going to Las Vegas, you could come to Papa Stronsay!' He grinned at the thought and then led me to one side and asked earnestly, 'Are you a Catholic?'

'Well, no,' I said. 'But my mother is.'

'Well, that will do. Come and I'll show you something amazing!'

Wondering what this invitation could mean, I followed Fr Michael into an antechamber where he rummaged around in some boxes for a while before turning to face me holding a rosary in his hands.

'This is our holiest relic. It's an authenticated fragment of the true cross and once belonged to Mary, Queen of Scots and was worn by her on the night before she was executed. Touch it and you are touching history!' There was a conspiratorial note to his voice. I felt as if I were enjoying an illicit pleasure when I held the beads in my hand.

'Amazing!' I said.

Stepping outside into the chilly embrace of an Orcadian spring, Fr Michael Mary and Brother Martin led me over rough ground to show me evidence of the island's sacred lineage. Along the coast were the ruins of a sixth-century Celtic monastery.

'There isn't an older Christian place of worship in all Scotland,' said Brother Martin. 'This is the oldest and most northerly monastery ever found in the UK.'

'It makes me feel great,' said Fr Michael. 'Just think, there have been monks here for three millennia – before the Vikings, before the year 1000, after the year 1000 and now into the 2000s. We might have been absent for a while but we are back again!'

SANDAY

Sanday is just a half-hour ferry crossing to the north of Stronsay. A low-lying, narrow 'winged' island, it looks like a dragon taking off when viewed on a map. It measures 20 kilometres from west to east and nowhere on the island is much more than a kilometre from the sea. The highest point is The Wart, which reaches the less-than-majestic height of 65 metres. From just a few miles out to sea, Sanday appears to be almost invisible, which explains the long history of shipwrecks along its coast. A lighthouse was built in 1806 at Start Point on the eastern extremity of the island, both as an aid to navigation and to warn shipping of the dangerous and unseen coast lurking below the horizon. In 1915, Start Point Lighthouse was painted with black and white vertical stripes, making it highly distinctive and unique in Scotland.

For anyone walking the many beautiful, sweeping beaches of Sanday, such as the spectacular one at Bay of Stove, the meaning of the island's name is abundantly clear. This is a very sandy place and was called Sand-øy, meaning 'sand island', by the Vikings when they settled sometime in the

Opposite. Start Point Lighthouse with its distinctive vertical stripes, Sanday.

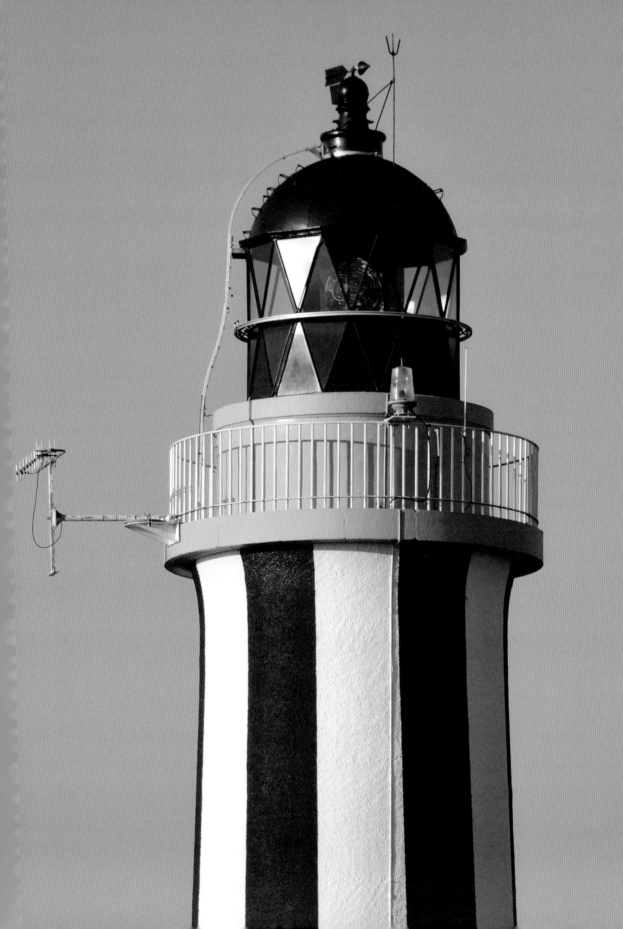

The beautiful Bay of Stove, Sanday.

9th century. Back then, they would have found a land covered in Bronze Age cairns and the remains of the Iron Age Broch of Wasso at Tres Ness. When it came to burying their own dead, the Vikings reserved the Ness of Brough on the west coast as a special place for internment. In the 1990s, at Scar to the north of the island, an amazing discovery was made – a Viking boat burial. It was unusual because it included the bodies of a man of about 30 years of age, a child of about 10 and a woman who was probably in her seventies when she died – a truly venerable age in Viking times when the average life expectancy was several decades less than it is now. The bodies were buried with treasured personal possessions. The man had his sheathed sword next to him, a quiver with eight arrows and a bone comb. The old woman had her spindle whorls to spin yarn, a little sickle, a pair of shears, a gilded bronze brooch and one of the most beautiful whalebone plaques ever found, decorated with dragons' heads.

Although nearly all the place names on Sanday are Old Norse in origin, little is known about the island's earlier inhabitants. There is scant evidence

of the Neolithic culture that flourished millennia ago – with one spectacular exception. On the shore towards the southern point of Quoyness is a chambered cairn believed to have been built around 5,000 years ago, making it older than the great pyramids of Egypt. But, like the pyramids, this extraordinary monument was designed to house the dead and, when it was excavated in the 19th century, the bones of several adults and children were discovered inside.

Looking at the cairn on a cold, grey, blustery day, I was impressed by its construction. Made of loose stone, it had been put together without the use of mortar or cement. The only thing holding it up was the force of gravity. The weight of the stones pushing downwards locked the whole structure together. The best place to view the ancient stonemason's craft was to enter the tomb, which, I have to admit, was a rather unpleasant experience. On hands and knees, I entered a tiny stone passageway and crawled for nine dark, claustrophobic metres until I reached the central chamber. It was a relief to stand up and I was impressed by the scale of the structure which seemed a much bigger space inside than I'd imagined when I'd viewed it from outside. The stonework was exquisite, rising to a vaulted ceiling four or five metres above the clay floor. Every stone had been carefully placed by the Neolithic builders to create an eerily peaceful, silent space shut off from the outside world. It felt very much like the last resting place of the dead. On either side of the central chamber, low door lintels opened out into small side chambers, making the architectural layout of the tomb similar to other Neolithic buildings found across Orkney. From this, archaeologists have concluded that a complex, interrelated society of different island communities once existed on the islands thousands of years ago. Standing in the prehistoric tomb, I imagined for a moment that I was in a time machine and that, outside, the Neolithic world still existed. A moment of craziness perhaps but sometimes the past can be felt very strongly in Orkney where the continuity of human settlement stretches so very far back through the centuries.

The cairn at Quoyness is a striking monument to a people whose past is forgotten. But, just down the road at Lady Village, I met up with a couple who have gone to great lengths to ensure that more recent Sanday traditions are remembered by future generations. A few years ago, Jim and Rona Towrie led a band of enthusiasts from the Sanday Heritage Group to create a window on to a lost domestic world. The Croft is the result – a traditional 'but and ben' Orkney dwelling that was restored over several winter months to demonstrate how ordinary Sanday folk lived a hundred years ago.

Rona welcomed me in. 'This is the "but" end of the "but and ben". It's the main room of the house – the kitchen and living area. They did everything in here – cooking, washing and they slept in a box bed beside the wall. Often there were up to 13 children in a family and sometimes a shelf was put inside to make a bunk bed. The children would have been stacked up inside. All the cooking was done on a "girdle" hanging over the open fire. There was no oven.'

'How did they make bread?' I asked.

'They didnae have bread. They made bannocks on the girdle, which they'd eat with fresh fish, crabs, maybe lobster. They ate salt fish all winter. They'd hae a coo for milk and cheese. Chickens for eggs. They were self-sufficient and had a healthy diet.'

The cairn at Quoyness.

Rona and Jim next took me through to the other room.

'Come away ben,' Rona said, ducking under the low door lintel.

The 'ben' of the croft was the best room in the house. 'This is where you'd entertain the minister when he came calling,' Jim explained. 'It was where you had all your finest possessions on display.'

At The Croft, Jim and Rona have recreated the feeling of a real home from the past. Much of their knowledge of this earlier way of life came from their own experience. They were both Sanday folk

through and through and called themselves 'Gruelly Belkies' – the Orkney nickname for anyone one from the island. As with other *teu neems,* its origin and meaning is obscure. Gruelly Belkies is sometimes thought to mean 'porridge bellies' – perhaps on account of the abundance of oats that were once grown on Sanday.

Rona remembered living in a house like The Croft. She used to help her mother do the washing – a task that involved lighting a fire outside to heat well water and then treading the clothes in a bucket to loosen the dirt. They had no electricity

or running water in those days. Water was transported in buckets from a well with the aid of a square-framed yoke which Rona would carry across her shoulders, looking like the image of an archetypal milkmaid.

'A lot's changed since then, Rona,' I said. 'And it wasn't that long ago.'

She looked thoughtful for a moment, casting her mind back over the years. 'It was just after the war. Hard to imagine now but that's why I want to keep the memory of these old ways alive for the future.'

Saying my goodbyes to Jim and Rona, I headed towards the coast and the village of Kettletoft. I had booked a room at the hotel, where the bar was unexpectedly busy with a crush of young men and boys. They were celebrating the victory of the island football team over rivals from a neighbouring island – a result that ensured much drinking and hilarity that night.

Over the decades, the population of Sanday has fluctuated considerably. In the late 1880s it reached a high of over 2,000. When I considered Rona's claim that some families had thirteen children, this seemed entirely possible – and a credible number without adding to the total number of island households. Today, the population is much smaller and stands at around 500 but, unlike previous generations who lived simple crofting and fishing lives, Sanday folk today are no longer self-sufficient.

For centuries, the islanders were drawn to the bays and stunning beaches along the coast, perhaps not to admire their beauty – although I'm sure that didn't go unnoticed – but to eke out a living from the shore. Great quantities of seaweed, especially kelp, are regularly washed ashore. In the past, it was harvested by crofters and spread

With Rona and Jim Towie at The Croft, a restored traditional Orkney dwelling.

on their fields as a fertiliser. In the 1800s landlords paid their tenants to gather and burn the kelp – though how they ever managed to light the sodden stuff defies comprehension. The ash – called potash – was collected and sold for use in the manufacture of soap and glass.

Sanday's beaches also provided an important source of protein. All kinds of shellfish were caught to supplement an often meagre diet, including razor clams, known locally as 'spoots'. Spooting for razor clams is still a popular thing to do on the sandy beaches of Sanday so, to learn how, I met up with the island's wildlife ranger Emma Webb. As we walked over the wet sand at low tide, Emma explained that spooting gets its name from the habit of razor clams to spout water when the tide is out. This is usually the first sign that your quarry is close at hand. In days gone by, entire communities would head for the beaches at low tide, armed with long sharp knives to hook out the spoots from the sand and carrying buckets to collect them in.

Spoots have very a distinctive shape. Their long tubular brown shells divide in two. Each half looks a little like an old-fashioned cut-throat razor. Catching them is an art and involves a lot of walking backwards over the sand. The clam can feel the pressure of the spooter's footfalls above and reacts by using its big anchor muscle to bury itself deeper, leaving a telltale hollow in the sand. To catch the spoot, the spooter has to move quickly, using a knife to howk out it out before it gets too deep.

'Once you've got the knife in position and got the spoot trapped, then you can take your time bringing it up. But your free hand soon gets numb with cold from guddling around in freezing sand to feel for the shell,' Emma explained.

'And is it worth all the effort?' I wanted to know.

'Oh, definitely. They're delicious!'

Before I left Sanday, I wanted to visit the Holms of Ire – two rocky islands with an angry-sounding name and a fearsome reputation, lying off the northern tip of Burness. Over the centuries, these small tidal islands have wreaked havoc on shipping. As I hurried over the seaweed-draped rocks to the first of them, I saw the remains of a rusting old steam boiler. Barnacle-encrusted, it had been thrown up on the shore when the fishing boat it had once powered was wrecked in 1939 – just one of dozens of boats that have come to grief here. But there was a more peaceful side of the Holms that I had come to see – the ruins of an ancient chapel dedicated to St Columba. But it wasn't easy to find. Dotted about were the remains of several *planticrubs* – circular walled enclosures where

Oposite top. Hotel and pier, Sanday.

Oposite bottom. The Holms of Ire, Sanday.

people had once grown kale. To confuse things even further, there were other unidentified piles of rubble lying in the grass but using my GPS, I think I found what I was looking for – the remains of a stone-built structure where a chapel was marked on my OS map. Disappointingly, there was little to see of the oratory that had been dedicated to the man known as 'the dove' of the Celtic Church but then it is very old, dating from a time before the Vikings arrived on Sanday. Unfortunately, despite the sunshine and bracing sea air, I didn't have much time for further exploration. The tide was coming in fast – so fast in fact that I got very wet feet trying to outpace it before I was cut off. I really didn't want to be stranded for hours until the next low water.

NORTH RONALDSAY

North Ronaldsay is a long way from South Ronaldsay – also in Orkney – making this an awkward island pairing separated by 43 nautical miles. Whereas South Ronaldsay is connected by causeways to the Orkney Mainland, North Ronaldsay is an isolated community with just four ferries a month in winter. An air service does something to plug the gap but, like the ferry, it too is subject to interruption and delays by the weather. Today, just fewer than 70 people live on this low-lying island, which is only five kilometres long by a kilometre wide.

The Vikings knew North Ronaldsay as *Rinansøy*, the meaning of which is unclear. To get there, I caught a scheduled flight from Kirkwall airport and was lucky enough to sit up-front with the pilot, Colin McAllister, in the tiny eight-seater Islander aeroplane operated by Loganair. Founded in 1962, the company's website proclaims 'Loganair,

the UK's longest established airline'. As the green, sand-fringed islands of Orkney's northern archipelago slipped below us at just a thousand feet, Colin told me that he once flew similar aircraft in Botswana but had always wanted to return to the north. He'd been living in Orkney for a decade now and loved the challenge of flying to the six tiny islands served by Loganair – North Ronaldsay, Westray, Papa Westray, Stronsay, Sanday and Eday all have characters of their own. He told me he thought that without the air service, life on some of the remoter islands would not be viable in the 21st century. 'In summertime, North Ronaldsay gets just one ferry a week. They are totally dependent on the air link.' He then went on to tell me how the potential of air travel in Orkney had been recognised as long ago as 1934 when the pioneering aviator Captain Ted Fresson began flying people to the islands. Nine decades later, Fresson's legacy is an inter-island air service that enables people to live on North Ronaldsay and commute to work in Kirkwall.

'We are better connected in Orkney that most people are on the west coast of Scotland,' Colin said. You can be in London in four hours.'

It was a beautiful but cold evening when we landed. A couple of part-time ground staff came out and helped unload the Islander before it took off again, circling above the airstrip prior to flying back to the Mainland. As I made my way south, the sun began to sink low on the horizon. In a field about halfway between the airport and the North Ronaldsay Bird Observatory, I passed the Stan Stane – a four-metre-tall monolith with a small hole, like a bullet wound in its side, about two metres from the ground. It's thought that the Stan Stane could be an outlier of a long-lost stone circle that may have stood somewhere close by.

In local tradition, the Stan Stane was the focal point for New Year celebrations. Writing in the *Statistical Account of Orkney*, 1795–98, a minister from Sanday described how island folk would congregate around the stone and how he had seen 'fifty of the inhabitants assembled there on the first day of the year, and dancing with moonlight, with no other music than their own singing'.

The bird observatory, which overlooks the pier at the south end of the island, was built in 1987 to study and record the migrant birds stopping over on Orkney's most northerly island. Visitors can stay a night or more in the observatory's hostel or guest house. A well-stocked shop offers supplies and souvenirs and, more importantly from my point of view, there's a restaurant with a bar. Over a meal, I chatted to a couple of guests. They hadn't come to look for the island's famous rare birds but were using the observatory as a base while undertaking maintenance work on Orkney's lighthouses. They obviously seemed to love the job. 'We get helicoptered out to some pretty remote places,' said one of them enthusiastically. 'We've been out to North Rona, Auskerry and Sule Skerry. That's an amazing place. It's over 60 kilometres west of the Orkney Mainland. Before it was automated in the 1960s, it was the remotest manned lighthouse in Britain. They must have been hardy buggers, those old keepers!'

The evening conversation seemed entirely appropriate as my accommodation for the night wasn't at the bird observatory but in the old keeper's cottage at the lighthouse overlooking Seal Skerry at the northern end of the North Ronaldsay. The sun was setting by the time I left for the five-

Opposite. The Stan Stane, North Ronaldsay. The small hole in the centre is clearly visible.

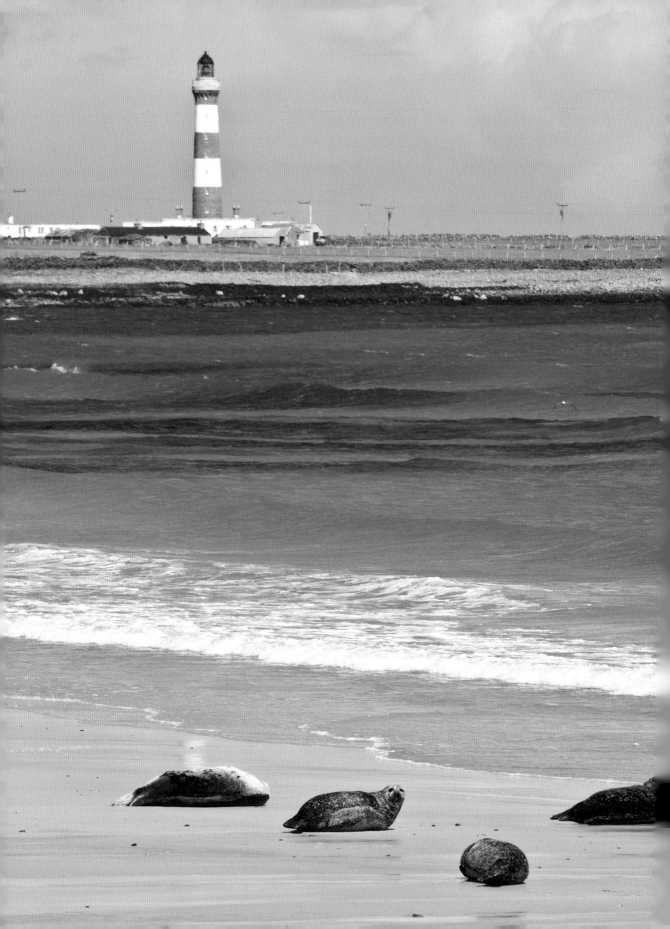

kilometre walk to get there, passing the old war memorial with a distressingly long list of the fallen for such a small island. When I arrived at the lighthouse, I was greeted by my host, Billy Muir, who was once the keeper when it was a manned station. He showed me the newly refurbished and luxurious accommodation where I was to spend the night. 'We get a lot of holidaymakers staying here during the season. They like to get away from it all,' said Billy. 'But it's very different from the old days when the keepers lived here – very swanky now!'

It was dark when Billy left. As I watched him walk away, the lighthouse towered above, its beam creating a giant spoke of light that slowly turned against the brilliant stars in the ink-black sky. Unfortunately, despite my comfortable bed, I slept fitfully and dreamt that I could hear footsteps walking in the corridor outside. When Billy returned next morning, resplendent in his old Northern Lighthouse Board uniform, I asked him if the place was haunted.

'Oh, no. Why would you think that?'

I told him of my nocturnal disturbances and that I had been at another lighthouse, years ago, where I had experienced something similar. On hearing this, Billy considered for a moment and then made an admission.

'Well, there was a keeper here once – many years ago – who committed suicide. It was a terrible tragedy. And well, I sometimes I used to wonder if I'd meet his ghost one day.'

'And have you?'

Billy grinned. 'No, of course not. There's no such things as ghosts. You should know that now!'

Having laughed off the threat of the supernatural, Billy took me on a tour of the light – all the way to the top, where I found myself scaling some-

Above. Billy Muir, once keeper of the lighthouse, North Ronaldsay.

Opposite. Seals basking on the beach, North Ronaldsay, with the lighthouse in the background.

thing rather like a stairway to heaven. There are 176 steps to take you there and each one has a religious significance. The lighthouse was designed by Alan Stevenson in the 1850s and, according to Billy, the number of steps corresponds to the number of verses in the longest of all the psalms – Psalm 119 – which includes these fitting words:

Your word is a lamp for my steps
It lights the path before me.

'Climbing the steps not only keeps you fit, it's good for the soul,' said Billy as we finally emerged on to the balcony of Scotland's second tallest lighthouse, from where we could see the whole of North Ronaldsay. On the horizon, I recognised the shape of Fair Isle 44 kilometres away to the north-east, marking the halfway point between Orkney and Shetland.

'I've spent all my life here – was born in the house on the other side of the bay there,' said Billy, pointing, 'and I moved into that one there when I was married. I've lived there ever since.'

'What's the social mix like here, Billy?' I asked.

'Well, it's an aging population, one has to say, and a declining one. There were about 200 folk living here when I was a boy and 30 children in the school. Now there are just three in the school and the population is way down. We don't want it to drop to 60 but it's heading in that direction.'

'And what's the ratio of incomers to locals?' I wanted to know.

'About 50–50. And we call them New Islanders.' Billy laughed and then became serious. 'But we really need the New Islanders. They keep the school open and the services going. Without them, the island wouldn't exist at all.'

He gazed out across the island of his birth thoughtfully. 'And, if I had my life over, I'd live exactly the way I have done. Here on North Ronaldsay.'

Down on the rocky shore below the lighthouse, I came across the island's most famous residents – a primitive breed of sheep, which takes its name from the island and which also seems to exist on a diet of seaweed. Close to the sheep, I encountered North Ronaldsay's equally famous drystone dyke, which some excitable and impressionable souls have claimed to be Scotland's equivalent of the Great Wall of China. The dyke encircles the entire island in a 19-kilometre girdle of stone, some three metres high, forming a structure which has been described by an august Scottish historical institution as 'probably the largest drystone construction conceived of as a single entity in the world'. Impressive stuff! And both sheep and dyke are inextricably connected in a symbiotic relationship.

The dyke owes its existence to the sheep. It was built in the 19th century to exclude North Ronaldsay sheep from agricultural land. Shut out by the dyke, the sheep became feral and were forced to develop new dietary habits. As seaweed eaters, they are thought to be unique in the ruminate world. The flock, which numbers up to about 4,000 head, is communally owned and run by a 'sheep court'. The court is responsible for managing the grazing, allocating sheep to island households and for maintaining the dyke. Wool is spun at North Ronaldsay's mill and sold around the world as yarn or knitwear. And island mutton, famous for its strong flavour, has become a popular delicacy and has even been presented to Her Majesty the Queen.

I was keen to sample some of this regal delicacy for myself. Fortunately, North Ronaldsay mutton pies were available at the community cafe at the lighthouse. Here, I met up with Mark Holbrook from Essex who was busy rolling pastry and making pie fillings. Mark told me that he'd lived on the island for three years. He was obviously something of an entrepreneurial type and claimed to be doing 15 jobs, from running the cafe to being a first responder. He also told me that it was quite true that mutton produced on North Ronaldsay was highly sought after. Apparently, posh hotels and eateries in London and Paris serve it to discerning diners. In addition to his *spécialité de la maison*, Mark also produces artisan mutton sausages. As I chomped through my pie, he brought me a glass of fine Côtes du Rhône as an accompaniment. Sipping it, I watched the sheep feeding on seaweed down on the shore and felt quite the sophisticated gourmet.

Opposite. One of North Ronaldsay's famous seaweed-eating sheep.

Above. Carrick Houuse, Eday, where the notorious pirate John Gow was captured in 1725.

Opposite. The Stone o' Setter, said to resemble a giant's hand sticking out of the ground.

EDAY

Eday is the ninth largest of the Orkney Islands and lies in the middle of the northern archipelago between Stronsay and Westray. It is 14 kilometres long and at its narrowest is just 500 metres wide, giving rise to its name in Old Norse, *Eið-øy*, meaning 'isthmus island' on account of its nipped waist. The highest point of land is Ward Hill, rising to 102 metres. There are many Ward Hills across Orkney. The name derives from the Old Norse for highest point. The gentle hills that occupy much of the centre of Eday are covered in blanket bog. Most of the 150 islanders live in scattered crofting communities around the coast. As with elsewhere in Orkney, the history of human habitation goes back thousands of years to at least Neolithic times. There are several Bronze Age sites and the remains of an Iron Age roundhouse testify to the continuity of settlement over the millennia.

One of Orkney's biggest standing stones can be encountered on the route of a heritage walk at the north end of Eday. The Stone o' Setter is a gigantic 4.5-metre monolith made of eroded red sandstone. Its weathered form is said to resemble a giant's hand sticking out of the ground. Occupying a prominent position overlooking several Neolithic chambered cairns, The Stone o' Setter appears to have been deliberately erected as a focal point in the landscape, where it probably had a ceremonial and religious function. However, the local legend says it has nothing to do with giants. Apparently, a laird ordered islanders to raise the stone by digging a pit and sliding it over the edge. The stone got stuck halfway and balanced see-saw like over the hole. The laird then ordered his wife to jump on the suspended end of the stone. It rocked once. The laird then commanded his wife to keep jumping. She did so and the stone toppled, dropping her into the hole and then followed her, crushing her beneath its weight. However, this was no tragedy for the laird who was happy enough with the outcome. It satisfied two desires of his – to raise a monument and to rid himself of a troublesome wife!

In the 17th century, John Stewart, the newly created Earl of Carrick, was granted the island of Eday and built himself Carrick House, a mansion on the Bay of Carrick. This is where the pirate John Gow was captured in 1725. Gow had successfully raided similar houses on other islands and planned a surprise robbery on Carrick House but his ship got into difficulties and ran aground. Undeterred, Gow pressed on but had obviously lost the element of surprise. When he landed, he was arrested and sent into captivity, and was later tried and hanged in London.

The community on Eday is involved in a pioneering renewable energy project. Called Surf

'n' Turf, it uses excess electricity generated from both its own wind turbine on Eday and electricity from an experimental tidal turbine project, centred in the nearby Fall of Warness tidal race, to produce hydrogen. The gas is then transported to Kirkwall where it can be used as a power source in a variety of new technology initiatives.

Sailing past Eday on the Kirkwall ferry, I fell in with another passenger – a primary school-teacher who was travelling from another of the islands. He told me he was originally from Edinburgh but had fallen in love with Orkney when he had travelled to Eday to discover his ancestors. 'I found them – lots buried around the old kirk and plenty more alive and well. I even found my long-lost cousins and spent four months living with them, helping out on the farm. It was a brilliant experience.' But my companion was worried about the future of islands like Eday. 'Their communities are small and fragile. When the school roll drops, it can be a death knell. And once a school closes, it's almost impossible to get the council to reopen it, making it unrealistic for young families to ever consider moving on to the island and making a life there.'

WESTRAY

The sixth-largest island in Orkney, Westray has a population of around 600, mostly concentrated along the east coast and around the village of Pierowall. As the name suggests, Westray – or *vestrøy* in Old Norse, meaning the 'Western Island' – is the furthest west of Orkney's North Isles. The island covers an area of 47 kilometres square, being almost 17 kilometres from the Sands of Woo in the south-east to Noup Head in the north-west. The highest land is in the west, rising 169 metres

above sea level to Fitty Hill. The locals are known to other Orcadians as 'Auks' – which is their *tue neem*. These Auks like to boast that Westray is the Queen o' the Isles but, as you'd expect, this is a somewhat biased opinion.

There are several sites of great archaeological significance on the island, especially at the Links of Noltland towards the north where a large expanse of sand covers one of Scotland's most important prehistoric landscapes. The first settlers built stone houses and structures on the land at Noltland about 5,000 years ago. A thousand years later, the same site appears to have been used by Bronze Age people. Over 30 buildings have been discovered on the site by archaeologists in recent years. Several extraordinary artefacts have also been uncovered, including the so-called 'Westray Wife' – also known as 'the Orkney Venus' – a four-centimetre sandstone figurine which is thought by experts to be the earliest representation of the human form ever discovered in Scotland. Having seen the 5,000-year-old Westray Wife for myself, her lack of arms and legs made me think she looked more like a ginger biscuit than a woman. Her face wasn't easy to distinguish as human either but apparently other schematic and symbolic representations of humans have been uncovered at Stone Age sites across northern Europe. What they were used for is impossible to say. They could have had a ceremonial or religious purpose but I like to think that perhaps the Westray Wife was a toy – a doll once played with by a Neolithic child before she lost it five millennia ago.

About a kilometre west of the village of Pierowall is the impressive ruined castle of Noltland. It was built between 1560 and 1572 by Gilbert Balfour, a Scotsman from Fife, who was married to Margaret, a sister of Adam Bothwell, the last

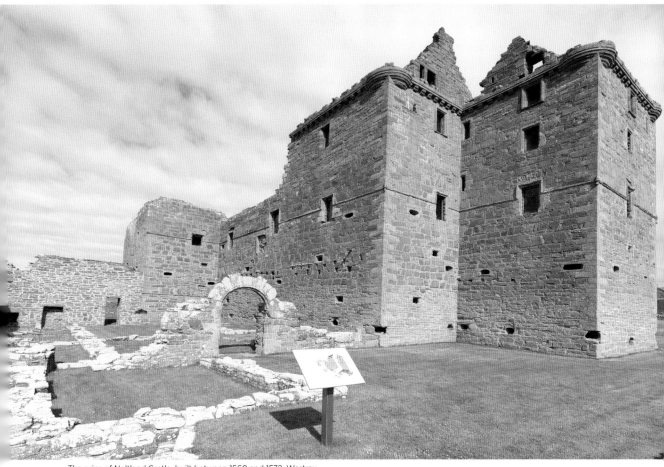

The ruins of Noltland Castle, built between 1560 and 1572, Westray.

Bishop of Orkney. During the Reformation in the 16th century, the bishop had grabbed former church lands and given them to members of his own family and this is how Margaret came to be in possession of a part of Westray. Her husband immediately started building Noltland Castle but Gilbert was a man embroiled in religious conspiracy and political intrigue. Earlier, in 1546, he and his two brothers had been implicated in the brutal murder of the Bishop of St Andrews. They then took part in the siege of St Andrews Castle where they supported the Protestant cause. But, when the castle fell to Catholic forces, the brothers were captured and sentenced to a period of confinement on board a French prison galley in the Mediterranean. Among the other Protestants sharing a bench with them and sweating as they pulled on heavy oars was the leader of the Reformation in Scotland, John Knox. The fire-and-brimstone preacher was not impressed with Gilbert or his brothers, describing them as 'men without God' who had 'neither fear of God nor love of virtue'.

When Gilbert was eventually released, he became entangled in the successful plot to kill Darnley, the husband of Mary, Queen of Scots. She quickly married James Hepburn, 4th Earl of Bothwell, but the Scottish nobles and public opinion turned against Mary and Bothwell, forcing her to abdicate. Bothwell fled the scene and, when he turned up in Orkney looking for sanctuary, Gilbert refused and sent him on his way. The exiled Bothwell died in a Danish prison.

However, Gilbert was soon on the run himself, seeking refuge in Sweden, where his compulsion for political violence once again got him into trouble. He was arrested and executed for plotting against the Swedish king. The castle at Noltland then passed into other hands. Interestingly, beside the stone arch that leads to the courtyard and barely decipherable are words from the Book of Exodus in the *Old Testament*:

> When I see the blood, I will pass over you
> in the night.

This faint inscription is part of God's promise that, during the tenth plague to afflict the Egyptians, the Israelites would be spared the loss of their firstborn if they marked their doors with lamb's blood. Looking at the ruins of the castle today, I wasn't convinced that the biblical reference had provided the protection hoped for by the whoever commissioned it. The whole edifice seemed to exude misfortune. Indeed, the castle has many gloomy associations, including ghosts and even a spectral dog known as 'the Boky Hound' whose blood-curdling howls precede a death in the Balfour family.

Superstition and a belief in the supernatural have played a large part in Westray folklore and legend. Sometimes the two overlap with tragic consequences, as demonstrated by a case of witchcraft brought against a local woman, Janet Forsyth, in 1629. Janet was a sensitive young woman given to dreams. One night, she dreamt that her lover, Ben Garrioch, a local fisherman, had drowned at sea. The next day, she warned him not to go fishing with the rest of the crew but he laughed off her fears and went out in his boat anyway, never to be seen again. Janet was broken-hearted and became reclusive. Despite her solitary existence, local people began to blame her for bad weather and misfortune at sea. Then 'one dark and stormy night', as they say, a big sailing ship appeared off the coast and was clearly in danger of being wrecked. Standing on the shore in the wind and rain, the islanders of Westray watched and waited for the ship to founder on the rocks, hoping to gather all the good things that might be washed ashore as a result. But Janet wasn't among them. Instead, she took it upon herself to save the stricken vessel. Launching her own small boat, she braved high winds and terrifying waves to row into the storm and guide the ship to safety in the sheltered waters of Pierowall Bay. This act of selfless bravery was her undoing. Having saved the ship and crew, superstitious and spiteful islanders said she must have used some dark magic to defy the storm – and rob them of their salvage rights. After all, she was only a weak and feeble woman. The Devil must have been her helper. Janet was arrested and sent to Kirkwall where she was tried as a storm witch and sentenced to a horrible death. The record of her trial in 1629 ends with the verdict that she must be 'taine be the lockman and conveyit to a place of execution wi her hands bund behind her back and worried at ane staik and brunt in assis' (*The Pirate Queen*,

Barbara Sjoholm, Seal Press, 2004). But, before the sentence of hanging and burning could be carried out, Janet mysteriously disappeared from her prison cell. But how? Was this more evidence of sorcery? Some say that her lover Ben had come to the rescue. He had never drowned as Janet thought but had been press-ganged into the navy. He eventually returned to Orkney, arriving during Janet's trial and was there to witness her terrible sentence. But, somehow, overnight, Ben managed to spring Janet from gaol. The lovers were reunited at last and escaped to a new life together. This must surely be one of the few witch-hunt stories to have a happy ending.

A walk along the cliffs to the lighthouse at Noup Head passes through some spectacular coastal scenery and a famous sea cave. Starting at Backarass Farm, a grassy track leads down to the cliffs where there is a good view of a couple of fine natural sea arches. The land ahead rises quite steeply at the burn bearing the evocative name the Grip of Monivey, which tumbles over the cliff into the sea. The rock here is stratified sandstone which forms a succession of ledges, making ideal nest sites for a multitude of seabirds, including many fulmars, gannets and guillemots. Below the highest point of the cliff is a huge sea cave. Known as 'the Gentlemen's Cave', this was used as a hiding place for several gentlemen of a Jacobite persuasion after the defeat of Bonnie Prince Charlie at the battle of Culloden in 1746. One of these gentlemen was a Westray Balfour – William Balfour of Trenabie in the north-east of the island. After the defeat of the Jacobites, he and several of his friends became outlaws and were forced to hide in caves to evade capture by government soldiers. In a game of cat and mouse that almost mirrored the wanderings of Bonnie Prince Charlie who was a

fugitive in the Western Isles at the same time, the 'gentlemen' spent much of the winter of 1746 in the giant sea cave at the base of the 70-metre-high cliffs just south of Noup Head. Happily, William Balfour survived his ordeal in the Gentlemen's Cave and lived to see more peaceful times. However, his support for the Jacobites cost him his mansion, which was burnt down by government troops while he was hiding. Standing on the cliff top looking at the cave, I wondered how on earth they got down to it. Apparently there is a route involving a scramble along a series of broken ledges, a rock-ramp and a 'bad step' where the unprotected climber risks a 30-metre fall into the sea. I couldn't find the route down the cliff face which is perhaps just as well – it wasn't for the faint-hearted.

In the main village of Pierowall, I met up with a local man with a passion for the language of the islands and its connection with the once culturally dominant Vikings. Sam Harcus was involved in a survey of Westray place names, charting the difference between how they are said and remembered by local people and how they appear on modern maps.

'There is a lot of history in the way folk pronounce a place name,' he explained. 'The community project gets younger folk to record older folk speaking the place names of the island. Take Noltland Castle where I know you've been. No one on Westray calls it that. We call it Noutland. And *nout* in the language of the Vikings were cattle. So *Noutland* was where there were cattle – grazing land probably. But for some reason, the letter "l" crept into the way it was written down by the map-maker, who wouldn't have been a local and who would have been unused to the dialect. There are plenty of other examples. The Old Norse word

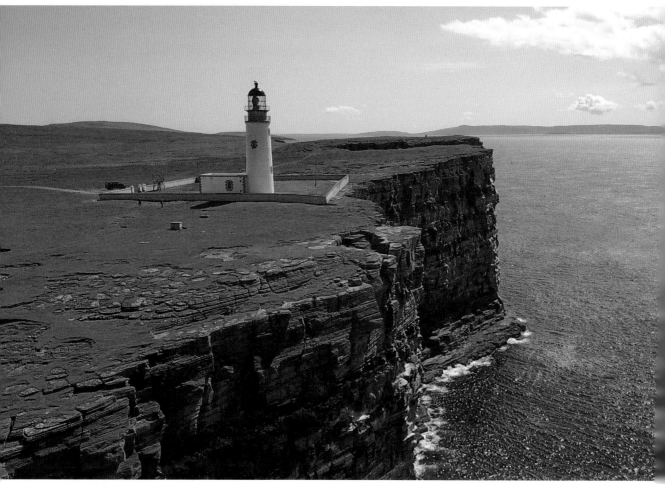

The lighthouse and sheer cliffs at Noup Head, Westray.

wa' meaning "a bay", was written down as wall. Think of Kirkwall or Pierowall. And then the word *bu*, often mistakenly written as "bull", is from the old word for the main house in the community – "the hall of the laird".'

Sam told me that he hoped his project would preserve the old names and pronunciations for future generations and help new islanders understand the Viking heritage of Westray. 'Not far from the Gentlemen's Cave, which you chickened out of exploring, is a cleft in the cliff face known as "Ramni Geo". *Ramni* comes from the Old Norse for "raven". So Ramni Geo is "the raven's geo". What's wonderful is the fact that ravens still live there – a direct link to the Vikings who saw them over a thousand years ago and named the geo after them. Brilliant!'

With my head full of Old Norse names I headed to another one – Aikerness, which is the location of Westray's airfield. I had booked a flight on the

world's shortest scheduled air route – from Westray to the island of Papa Westray, which lies a less-than-wearisome 1.9 kilometres across the tidal races of Papa Sound. When the eight-seater Islander aircraft landed from Kirkwall, I squeezed in beside a couple of supply teachers who were hopping from island to island and school to school. 'Oh we're used to it. Just another day's work!' one said cheerily as we bumped out way over the runway to begin our stomach-churning short flight to Papa Westray, where I arrived a couple of minutes later feeling as if I'd been fired over the water from the barrel of a gun.

PAPA WESTRAY

Papa Westray – known to everyone in Orkney as 'Papay' – is a tiny island with a growing population of about 90 souls. From north to south, the distance is 7 kilometres and, from east to west, it's just 1.7 kilometres at its widest, making it easy for me to explore on foot – once I'd recovered from the flight, that is. But, despite its diminutive size, Papay is an island with a deep history, stretching back 5,500 years. Accordingly, there are over 60 archaeological sites on the island. The most famous of these is an extraordinary Neolithic site at the Knap of Howar. Older than the more famous Skara Brae, its two oblong buildings were excavated in the 1930s and 1970s and are considered by archaeologists to be the earliest known dwellings in Northern Europe, dating from sometime around 3,800 BC. The bones of sheep, cattle, pigs and fish were extracted from material in the ancient middens which once surrounded the houses. From this evidence, archaeologists believe the houses at the Knap of Howar were once a farmstead where the people kept animals and fished.

The name Papay comes from Old Norse and means 'priests' island' and is first mentioned in the *Orkneyinga Saga* as *Papey in Meiri*, the bigger of two Orkney islands called Papay. The other Papay mentioned by the saga is *Papey Minni* – or Papa Stronsay. As you'd expect with such an ecclesiastical history, there are at least two sites of ancient Christian significance on the island. About a kilometre up the road from the airfield is the now restored St Boniface's Kirk, which dates originally from the 8th century. St Boniface, who was born Wynfrid, was an Anglo-Saxon Christian missionary who was martyred while on a mission to convert the pagan Germans. At about that time, the Pictish king, Nechtan, invited a group of missionaries from Northumberland to bring the new religion of Christianity to Orkney. They established a church on Papay and dedicated it to St Boniface. In the burial ground surrounding the church are some of the earliest Christian graves to be found in Orkney, including early cross slabs and Viking graves.

In the south-east corner of Papay is the Loch of St Tredwell, named after another Christian martyr – this time a woman. According to the legend, St Tredwell was born with the name Triduana and was among those who'd been invited by King Nechtan to help evangelise and spread the word of the Lord to the Pictish people of Orkney. By all accounts, Triduana was a beautiful woman with alluring eyes. But she had taken a vow of chastity and was unavailable to King Nechtan who longed to embrace her and gaze through the windows of her soul. Hoping to sway her, Nechtan sent a messenger to Triduana to tell her how much he loved her eyes. Triduana responded by plucking out her eyes and sending them to the king, impaled on a branch – which was a very effective turn-off.

Papa Westray.

As a reward for maintaining her virginity in such a drastic fashion, Triduana became St Tredwell and, for centuries, was associated with the miraculous cure of various eye conditions.

The ruins of the 12th-century chapel dedicated to St Tredwell occupy a small peninsula in the loch which bears her name. Interestingly, the chapel was built on top of more ancient remains. Archaeologists in the 19th century discovered an underground passageway beneath the ruins, lead-

ing to what is thought to be the remains of an Iron Age broch. It was common practice for early Christians to erect their places of worship on older pagan places of importance and strength and St Tredwell's Chapel seems to be an example of this custom.

Because of its holy associations, the waters of the Loch of St Tredwell became a place of pilgrimage for many centuries. The afflicted from all over the north came in the hope of a cure. After walking around the loch in complete silence, they would bathe in the waters and leave an offering of a coin or some other token. According to the *Orkneyinga Saga*, the waters restored the eyesight of the Bishop of Caithness after the Viking Earl Harald had blinded him.

Before I reached the pier at Moclett at the south of the island – where I planned to catch the ferry back to Kirkwall – I was overtaken by an ancient blue tractor, driven by 83-year-old crofter Maggie Harcus. She stopped to give me a lift to her croft where she invited me in for a cup of tea with her friend Elisabeth. Listening to the two ladies chatting, I was fascinated by their dialect and was reminded of the conversation I'd had with Sam on Westray about the Viking influence on the speech of people here. According to Sam, the folk on Papay have their own words and phrases and the way they speak retains many of the sounds and cadences of the language of the Vikings. I asked Maggie about this and she agreed that Papay folk did have their own way of speaking – especially about the weather and work activities. She gave me an example of what she meant.

'Wi the weather we say sometimes that it's *mugger o' fou.*'

'What's that?' I asked.

'Well, now, that'll be when it's clammy, drizzly weather. And then we've got *gamfur for snaw* – that's what we say when it might be threatening snow.'

'Tell me,' I said mischievously, 'do you have many words for bright weather?'

Maggie and Elisabeth both looked puzzled and then looked at each other.

'Well, now, we don't have many I can think of right away. We'd be so surprised.'

'It would be so rare, you'd have no special word?' I suggested.

'Oh, no. We'd say, "It's a grand day the day!"' And both elderly ladies chuckled at the thought of such a meteorological wonder.

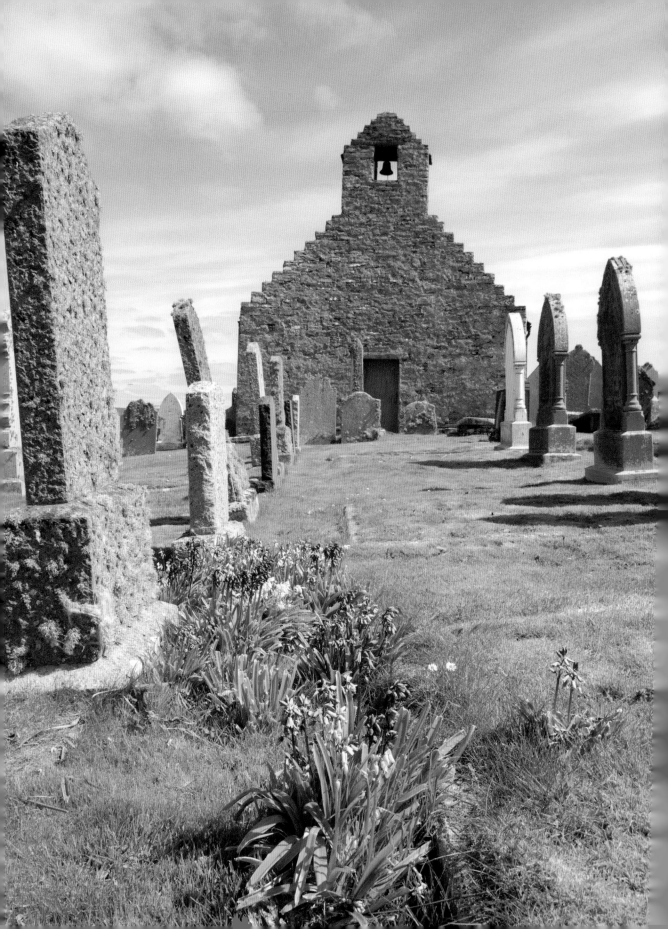

CHAPTER 7
AROUND SCAPA FLOW

South Ronaldsay, Lamb Holm, Hoy, Flotta, Stroma

SOUTH RONALDSAY

The name comes from the Old Norse *Rognvalds-øy*, 'Ronald's island'. Strictly speaking, South Ronaldsay is no longer an island in its own right because it is connected to Mainland by a series of causeways. These are part of the Second World War Churchill Barriers, which were constructed to protect the British Home Fleet, anchored in Scapa Flow, from attack by German U-boats. South Ronaldsay measures about 12.5 kilometres from north to south and at its widest is 9 kilometres from east to west. The population has declined in recent years but has stabilised at just under a thousand, with almost half of them living in the third-largest village in Orkney, St Margaret's Hope.

St Margaret's Hope is an ancient and very picturesque village at the southern end of a bay that shares its rather strange name. However, the 'Hope' in St Margaret's has nothing to do with aspiration or wishful thinking. When I visited, I was told that 'hope' is a corruption of the Old Norse word *hjop* – another word for 'a bay'.

The fact that St Margaret's Hope is named after a saint has led to conflicting accounts of who the

Opposite. Old St Mary's Church, Burwick, South Ronaldsay, which marks the place where, reputedly, the first Christian missionaries arrived in Orkney.

saint in question might be. There are records of a medieval chapel close to the site of the present village. It was dedicated to St Margaret, the Anglo-Saxon wife of the 11th-century King Malcolm Canmore, the man who slew Macbeth in a revenge killing for the murder of his father King Duncan. Some historians believe that it's this Margaret who is remembered by the name of the village. Alternatively, it could be 'the Maid of Norway'. In 1286 King Alexander III was killed when he was thrown off his horse, leaving a power vacuum in Scotland. His sons were already dead and his nearest living relative was his granddaughter Margaret of Norway. This three-year-old princess was the daughter of Alexander's own daughter Margaret, who had died giving birth to her, and her husband, King Eric II of Norway. During Princess Margaret's minority, while she was a child in Norway, Scotland was riven with competing claimants to the throne, among them Robert the Bruce and John Balliol. Eric of Norway was naturally anxious about sending his young daughter to Scotland to take up this unstable and violent inheritance and asked Margaret's great-uncle Edward I of England for protection. Edward, who later became the infamous 'Hammer of the Scots', proposed a marriage between Margaret and his own son, the Prince of

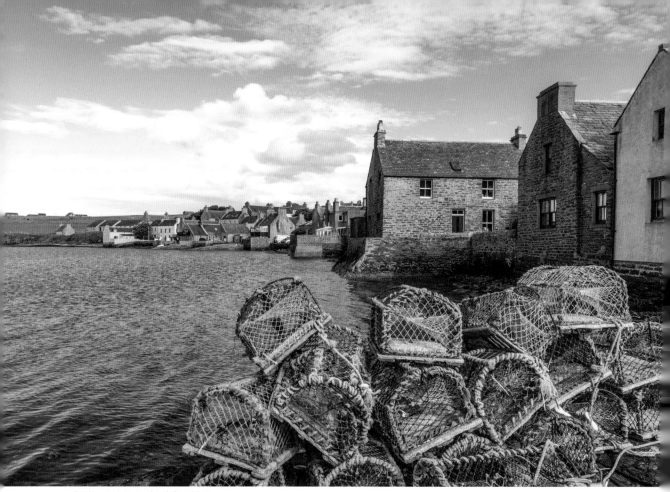

St Margaret's Hope, South Ronaldsay.

Wales, thereby placing Scotland under English control in a union of crowns. But the match and this union of crowns never happened. When the English king sent a ship to Bergen to collect Margaret, fate intervened. As she sailed across he North Sea to become Queen of Scots, her ship was battered by terrible autumnal storms. This was too much for the young girl. She fell ill and was taken ashore at St Margaret's Hope. There she died. Her body was later returned to Bergen, Norway where she was buried beside her mother. For a time, the Norwegians regarded her tragic death as a martyrdom and Margaret became an unofficial saint. But in Scotland her untimely death led directly to the Wars of Scottish Independence with England. It's fascinating to spec-

ulate what might have happened if Margaret had married Edward I's son. The union of crowns of Britain would have taken place three hundred years earlier than it did, which might have saved a good deal of bloodshed over the centuries. Of course, there would have been no Bannockburn and history would have had very different accounts of William Wallace and Robert the Bruce. Just imagine, no *Braveheart* or Mel Gibson crying, 'Freedom!'

When I arrived in St Margaret's Hope, having disembarked from the ferry which runs from Gills Bay in Caithness, I dropped in at the Smiddy Museum which offers a fascinating look at the fiery art of blacksmithing. Originally built in the 1880s, the Hourston family toiled for generations

Relics of yesteryear, South Ronaldsay.

over burning coals, hammering and shaping red-hot iron into all manner of tools and artefacts, shoeing horses and mending broken agricultural machinery.

Recalling the days of horsepower, St Margaret's Hope plays host to a strange and unique tradition celebrating the partnership of beast and man. Every August, the Boys' Ploughing Match and the Festival of the Horse take place. Children dress up in elaborate horse costumes and some of the boys become ploughmen for the day. The 'horses' and 'ploughmen' parade through the town before heading off to the nearby Sands o' Wright for the ploughing contest. Using miniature ploughs, which are often family heirlooms, the boys are judged on the straightness and depth consistency

of their furrows. The 'horses' wear large decorated collars and harnesses and embroidered jackets, trousers and hoods. Most have fringes at their ankles and wrists to represent the feathering on the legs of draft horses. They compete for prizes awarded for the best outfits.

Just a few miles from St Margaret's Hope, at the south end of South Ronaldsay, is one of the most remarkable and romantic-sounding archae-ological locations in Western Europe – the Tomb of the Eagles, a family-run archaeological site where the main focus of interest is a 5,000-year-old Neolithic burial cairn. On a day of cloudless blue skies and sparkling seas, I joined sisters Freda and Kathleen Simison who have lived and farmed on South Ronaldsay all their lives. In addition to

Tomb of the Eagles, South Ronaldsay.

looking after sheep and chickens, they are also custodians of the remarkable Tomb of the Eagles, which their father, Ronnie Simison, had discovered in 1958 while mending a fence on his farm.

'He was looking for stones to make corner posts in the field. There was a mound above the shore, which the wind and the rain had eroded away and that's where Dad discovered the stones that turned out to be the wall of the tomb,' Freda explained.

After making this discovery, Ronnie then waited patiently for almost two decades before he began his own excavations, spending the intervening years learning the skills of archaeology from professionals, whose respect he earned with his meticulous and careful approach to unearthing the secrets of the tomb. Inside, he found the bones

of the ancient people who had been laid to rest there, along with a host of Stone Age artefacts, which are now on display at the visitor centre.

Getting inside the Tomb of the Eagles involves a claustrophobic ride on a trolley through a very dark and narrow passageway that is only 85 centimetres high. Lying face down, I pulled hand-over-hand on a rope, slowly propelling the trolley forward through the darkness to enter the inner sanctum. Once inside, I was able to stand up and view the tomb, which was lit by daylight from a glass panel in the roof.

'Why was it called the Tomb of the Eagles?' I wanted to know.

'That's because of all the eagle bones and talons that were found here,' said Freda. 'Many of the excavated tombs on Orkney are associated with

the bones of different animals. Inside some tombs, deer bones have been discovered. Inside others, dog skulls have been found along with human bones.'

'But why would the ancient people have done that?' I asked.

'We obviously don't know for certain but it might be that different groups of people – different tribes, if you like – identified with specific creatures and were buried with their totemic animals. The people here might have called themselves "the eagle folk" and accordingly were buried with the eagles they identified with,' Kathleen said.

Archaeologists believe that the first known settlers on Orkney were Mesolithic people who moved in after the last ice age some 6,000 years ago. About 5,000 years ago, these people began building cairn tombs to accommodate their dead. Like many of the ancient structures I'd seen on Orkney, the Tomb of the Eagles was older than the pyramids of Egypt.

On the two-kilometre walk back to the visitor centre, my eye was drawn to a large and imposing standing stone overlooking the path. But this was no ancient monolith. It was a memorial to Kathleen and Freda's parents. 'From there, Mum and Dad can see their old home and the tomb they looked after for such a long time. They can also keep an eye on things and keep us straight,' they explained. How ironic, I thought, that the man who had devoted so much of his life to an ancient monument should himself have become a monument in the landscape peopled by the ancestors.

Leaving Freda and Kathleen with the dead from 5,000 years ago, I took the road north, grateful for some fresh air and the warmth of the sun to dispel the mortuary chill of the Tomb of the Eagles.

I soon reached the shores of the great natural harbour of Scapa Flow that lies encircled by islands at the heart of Orkney. During the two world wars of the 20th century, this huge area of sheltered water was an important base for the Royal Navy. Today, the tiny islands of Burray and Lamb Holm at the eastern end of Scapa Flow are connected by a causeway that carries the road to the mainland of Orkney. The causeway was built during the Second World War after the disastrous loss of the battleship HMS *Royal Oak*. On the night of 14 October 1939, just a few weeks after Britain had declared war on Nazi Germany, submarine *U-47*, commanded by Kapitänleutnant Günther Prien, crept between the islands and into the very heart of Britain's most important northern naval base. Günther Prien was looking for a trophy. Surrounded by British warships, there were several targets to choose from. Selecting the silhouette of HMS *Royal Oak*, Prien fired three salvos of torpedoes at the battleship. The last salvo scored a direct hit. There was an enormous explosion as the *Royal Oak*'s ammunition magazine caught fire. Within fifteen minutes, she had sunk to the bottom of Scapa Flow – quite a prize for the German captain of *U-47*. There were 1,234 men on board the *Royal Oak* when she disappeared beneath the waves of Scapa Flow and 833 of them drowned that night. A week later, Adolf Hitler decorated Prien with the Iron Cross and Oak Leaves at a special ceremony in Berlin. The Nazi newspapers were triumphant in their praise.

The loss of HMS *Royal Oak* was a terrible blow to the Royal Navy and to the morale of the whole country. In response, Prime Minister Winston Churchill ordered the construction of antisubmarine barriers to seal the entrances to Scapa Flow and to make similar attacks impossible. During the First World War, there had been an attempt

These British vessels called block ships were sunk at the entrance to Scapa Flow during the First World War.

Opposite. The interior and exterior of the chapel built by Italian POWs during the Second World War.

to plug the gap between the islands by sinking old ships. Their gaunt, rusting remains, bent ribs and buckled, seaweed-clad plates can still be seen beside the causeway that was built later, using massive concrete blocks. Today the four Churchill Barriers form important road links between the islands of the south and the capital, Kirkwall.

LAMB HOLM

This tiny island was the last to be linked by the Churchill Barriers – to Mainland by Barrier 1 and to Glimps Holm by Barrier 2. It is now uninhabited but, during the Second World War it was populated by Italian prisoners of war, most of whom had

been captured by the British Army in North Africa. On Lamb Holm, 550 of these men were accommodated in a prisoner-of-war camp called Camp 60, where they were put to work building the Churchill Barriers. At the southern end of Lamb Holm, which is just over a kilometre long and 600 metres broad, is a flooded quarry, now occupied by a fish farm. During the war years, this quarry produced the rock and rubble for the construction of the barriers. The concrete blocks were cast at a yard on the Mainland at St Mary's village and were laid on top of a rubble base. Over 66,000 gigantic blocks weighing between five and ten tonnes each were produced there.

When viewed from the air Lamb Holm appears

to have a religious significance as there's a gigantic cross right in the middle of it. However, the cross has more to do with war than peace. The cross is formed by two intersecting runways of an old military airfield, which almost covers the entire island. Beyond the airfield, which is still used by private light aircraft, the remaining space on Lamb Holm is scarred by the old foundations of prison huts, air-raid shelters and the fading outlines of many buildings associated with the construction of the Churchill Barriers. The most complete structure from the war years is the extraordinary and rather wonderful Italian Chapel. In 1943, the camp's British commander agreed to the Italian priest's request for a place of worship for the prisoners. Two Nissen huts were joined together. Then, under the leadership of a prisoner called Domenico Chiocchetti, the prisoners transformed the corrugated iron Nissen hut into a beautiful catholic church with an ornate facade, bell tower, altar, frescos and an elaborately painted ceiling – a little piece of faraway Italy in Orkney. When Domenico Chiocchetti returned to Lamb Holm in 1960 to help restore the chapel, he wrote a letter to the people of Orkney:

> The chapel is yours – for you to love and preserve. I take with me to Italy the remembrance of your kindness and wonderful hospitality . . .
>
> I thank the authorities of Kirkwall, the courteous preservation committee, and all those who directly or indirectly have collaborated for the success of this work and for having given me the joy of seeing again the little chapel of Lamb Holm where I, in leaving, leave a part of my heart.
>
> Domenico Chiocchetti, 11 April 1960

HOY

Hoy is the second largest of all the islands that make up the Orkney archipelago. It is approximately 19 kilometres long by 9.5 kilometres wide and covers an area of 143 square kilometres. The name comes from the Old Norse *há-øy* meaning 'high island' and, as the name implies, Hoy has the highest land in Orkney, Ward Hill in the north rising to 479 metres. Much of the island is covered in mountainous moorland cut by deep glaciated valleys. The feeling here is more Highland than elsewhere in Orkney. The population a century ago was about 1,300. Today it has declined to just over 400, with most of the island's residents living in the south and east around the two main settlements of Lyness and Longhope.

Hoy is an impressive sight. My very first glimpse of Orkney was of the island's red sandstone cliffs. It was a winter's afternoon and I was standing on Dunnet Head in Caithness. Across the Pentland Firth, dark snow clouds were piling up above the island and the setting December sun illuminated the great sandstone cliffs of Hoy, which seemed to glow a lustrous orange colour in the gathering darkness. A few months later, I sailed to Stromness from Scrabster. The ferry passed close to the dramatic west coast of Hoy, coming within a couple of nautical miles of the Old Man of Hoy – perhaps the most famous and precarious sea stack in Britain. Like the other passengers on board, I stood at the rail and gazed in wonder at the extraordinary cliffs which rise to over 335 metres at St John's Head – one of the highest vertical sea cliffs in the UK.

From Stromness, I caught the ferry to Moaness

Opposite. The Old Man of Hoy, the most precarious sea stack in Britain.

on Hoy and made my way along a single-track road west towards the steep rounded hills that characterise much of the north of the island. Wisps of cloud drifted in the still, heavy air and hung like a veil across the dark crags of the Dwarfie Hamars. My first destination was immediately below these cliffs. A wooden walkway led across the moor and bog, through patches of purple heather and rushes to the Dwarfie Stane – a remarkable boulder lying by itself on the remote moor. Measuring 8.5 metres long by 4.3 metres wide, this massive block of sandstone was probably carried to its present position by an ancient glacier that melted away over ten thousand years ago. But it's not just the spectacle of the stone in its isolated location that makes the Dwarfie Stane a landmark. It also bears the marks of human hands, having been hollowed out and sculpted by Stone Age tools 5,000 years ago. An opening one metre square in the side of the stone leads to a chamber with two bunk-like platforms on either side. In the past, these were thought to be beds with sculpted pillows for the incumbents. The traveller Martin Martin, who visited in the 17th century, said that local people believed the Dwarfie Stane was the home of a giant and his wife – although, having seen for myself the space inside, these giants must have been on the small side. The supernatural associations of the Dwarfie Stane continued to be reported over the centuries. According to my old copy of *Black's Picturesque Guide*, 'It was believed to have been the residence of a troll or a dwarf.'

When Sir Walter Scott wrote his novel *The Pirate*, which is set in the Northern Isles, the Dwarfie Stane makes an appearance and is described as 'This extraordinary dwelling which Trolld, a dwarf famous in the northern sagas, is said to have framed for his favourite residence.'

Later, another explanation became current – the Dwarfie Stane was the home of a hermit or holy man seeking solitude and perfect isolation. This theory seemed to be supported by the now-forgotten custom of leaving offerings at the stone. However, modern archaeologists tend to think that the stone was used by Neolithic or perhaps Bronze Age people as a tomb and the large block lying outside the entrance is thought to have been used to seal its contents from the outside world. If this theory is correct, then the Dwarfie Stane would be the only example of a rock-cut chamber tomb in northern Europe – a type of ritualistic burial place normally associated with the Mediterranean.

From the Dwarfie Stane and its unsolved mysteries, I made my way west and down to the Atlantic coast. Huddled beneath 200-metre towering cliffs and heather-clad hills, I came to the old settlement of Rackwick, which the poet George Mackay Brown once described as the 'last enchantment':

Let no tongue idly whisper here
Between those strong red cliffs,
Under that great mild sky
Lies Orkney's last enchantment,
The hidden valley of light
Sweetness from the clouds pouring
Songs from the surging sea
Fenceless fields, fishermen with ploughs
And old heroes, endlessly sleeping in
Rackwick's compassionate hills.

At one time, Rackwick was a thriving community of fisher-farmers who worked the land above the crescent of sand and boulders that make up the

The Dwarfie Stane, Hoy – perhaps the home of a hermit or a tomb.

bay. When the men took to their open boats to brave the Pentland Firth, they were known as the finest fishermen in Orkney. In 1900, there were over 80 homes at Rackwick. But the school closed in the 1950s and today only a handful of houses are occupied – and those seem to be holiday homes. One of the old places has been turned into a self-catering hostel-cum-bunkhouse. Another group of turf-roofed buildings has been transformed into a museum called 'the Cra'as Nest' (the Crows' Nest), where you can get a flavour of what life must have been like back in the early 18th century for the people living in this remote location on the wild west coast of Hoy.

A path leaves Rackwick and climbs around the base of a hill called Moor Fea and then heads north-west and inland for about 1.5 kilometres towards the pinnacle of the Old Man, which gradually reveals itself as you get closer to the cliff edge. This is a spectacular location and one where care should be taken. The mighty Old Man is just 150 metres away and looks hugely unstable. Formed by the process of erosion, he seems to be composed of layers of brick-like sandstone blocks piled on top of each other like some sort of giant Jenga stacking game. Over the centuries, the cliffs have receded leaving the Old Man stranded – a process which continues. An old etching made in 1814 depicts the Old Man with two legs and a much broader base. Over two centuries, he's lost a leg

and is now looking painfully thin. For me, seeing the Old Man of Hoy for the first time was a real thrill. The mighty 137-metre sea stack had entered my consciousness at an early age – ever since I had watched *The Great Climb*, the famous 1967 BBC outside television broadcast, when Chris Bonington and his team of climbers recreated their first ascent from the previous year, for the benefit of couch potatoes and wannabe boy climbers. The television spectacle inspired me to head upwards and has stayed with me ever since – even if I haven't always reached the top.

From the Old Man, it's possible to continue north for another couple of kilometres to the awesome heights of St John's Head and the biggest vertical drop of any British sea cliff. Amazingly, in 1970 two climbers found a route up this seemingly impossible great rock face. The route they forged is called the Long Hope and it took Ed Drummond and Oliver Hill seven days to climb, sleeping on ledges and in hammocks as they made their painfully slow ascent in horribly damp and difficult conditions. Incredibly, in 2011 the Scottish climber Dave MacLeod scaled the route as a solo free climb in a single day, with an even more difficult variation on the desperately hard headwall. This one is definitely for the brave only.

Heading back through the glen and past the Dwarfie Hamars, with the vast expanse of Scapa Flow shining like a polished silver disk below me, I returned to the east coast to visit Betty Corrigall's grave, which is situated at the southern end of the tiny Water of Hoy. This is a lonely spot. In bleak, uninhabited country, a wooden walkway leads across peaty ground to a brilliant white headstone encircled by a white painted wooden fence. The inscription is simple and to the point – 'Here lies Betty Corrigall' – but these words give no indication of the tragic circumstances surrounding the death of the woman whose remains lie beneath.

In the 1770s, Betty Corrigall lived at a place called Greengairs Cottage on Hoy. She was a young woman in her twenties whose lover deserted her and ran away to sea when she fell pregnant. In those days, for a woman to have a child outside of marriage was a sin and brought great shame on the whole family. Together with the local community, Betty's family turned against her. Disgraced and abandoned by those she loved, Betty attempted to take her life. First, she tried drowning herself in the sea but she was rescued and brought back to the shore. A few days later, she tried again – this time by hanging herself – and she succeeded. But her suicide was considered by the pious to be a further sin, which meant that she could not be given a Christian burial in consecrated ground. Instead, her body was placed in a wooden coffin and put in an unmarked grave. There she lay forgotten for 160 years, until 1933 when two men digging for peat unearthed her coffin. Opening it, they saw Betty's body. It had been preserved by the peat and Betty's long dark hair still curled about her shoulders. After a police inquiry, she was reburied and forgotten again until the Second World War. In 1941, a party of soldiers was digging on the moor when they came across Betty's unmarked grave. She was exhumed and placed in a new grave about 50 metres from the original spot and concrete slab placed over her to prevent her from being disturbed again. There she lay in peace until an American minister, sensitive to the injustice that had been done to her, erected a wooden cross over her grave. The headstone with its inscription was added later in the 1970s. Ironically today, Betty now rests in one of the most frequently visited graves in Orkney, having been

forgotten for generations. It can only be a good thing that her pain and suffering have finally been acknowledged.

The main village on Hoy is Lyness. Here, there is access to Scapa Flow through narrow channels between the neighbouring islands of Flotta and Fara. During both world wars in the 20th century, Lyness was a major base for the British fleet in Orkney with HMS *Proserpine* acting as the base there while the Second World War was being fought. In 1940, over 12,000 military and civilian personnel were stationed around the village. The many scattered and desolate buildings are reminders of those days of war. However, some old structures have found new uses and have been converted into sheds and workshops or put to agricultural use. A couple of kilometres outside Lyness, I came across a curious building with dramatic black-and-white art-deco styling. It dates from 1942 and was formerly the front of the Garrison Theatre. Behind the elegant facade, Nissen-type huts housed a cinema, a dance hall and a stage where many famous acts entertained thousands of personnel stationed in the nearby military camp which was demolished years ago. Most of the Garrison met the same fate but the impressive front survived and is now a rather unique private home.

Down at the old fuel pumping station near the pier, I dropped into the Scapa Flow Visitor Centre and Museum where there's a fascinating collection of photographs, documents and artefacts detailing Scapa Flow's role in the two world wars.

During the First World War, the British government decided that naval operations against the new enemy Germany would be more effective if there was a substantial presence in the north of Britain to guard the seaways leading from the North Atlantic to the German Baltic ports. The huge sheltered natural harbour of Scapa Flow, which covers about 310 square kilometres of water, was selected to be the base for the Grand Fleet. Thousands of men and millions of tonnes of resources and equipment poured into Orkney to supply, arm and defend the Royal Navy.

With the Armistice and the end of hostilities, the German battle fleet was forced to surrender to the British. The entire German fleet of 74 battleships and cruisers was then held in Scapa Flow but, in a final act of defiance, Rear Admiral Ludwig von Reuter gave a secret order to scuttle the ships. On 21 June 1919, German flags were raised on mastheads for the final time. Seacocks and hatches were then opened and the sea allowed to flood in as crews took to their lifeboats. Men from British ships on guard managed to stop some of the German ships from sinking by beaching them or sailing them into shallower water. Violence flared when they tried to force the German crews back on to their vessels. Nine German sailors were killed and 16 injured – among the very last casualties of the war. In total, 52 German ships were sunk. Most of those that were still visible above the water were later salvaged or broken up for scrap. The rest still lie where they settled at the bottom of Scapa Flow.

With the outbreak of war in 1939, the Royal Navy returned to Scapa Flow which became the base for the British Home Fleet. Some of the most significant naval action of the war began in Scapa Flow, including the hunt for the German battleship *Bismarck* and the aircraft-carrier raids against the *Tirpitz*. Convoy escort ships were also based in Scapa Flow, joining merchant ships sailing north into the Arctic with vital supplies for the Soviet Union.

Continuing around the South Bay, I crossed a causeway that links Hoy to the tidal island of South Walls or 'Sooth Waas' in the dialect – in Old Norse *vágr* means 'bay'. The principal settlement on the island is Longhope, a village forever associated in my mind with its ill-fated lifeboat and the tragedy that befell its crew. At 8 p.m. on 17 March 1969, the lifeboat *T.G.B.* was launched into the teeth of a storm to go to the aid of the Liberian-registered cargo ship *Irene*, which was in danger of being driven ashore on South Ronaldsay. In complete darkness, the *T.G.B.* battled ferocious winds and turbulent seas. As it fought its way towards the *Irene*, the lifeboat was caught in a dangerous tidal race and struck by a monstrous wave. Being unable to right itself the *T.G.B.* capsized. The crew of eight were swept into the sea and were all lost, including the coxswain and his two sons, and the mechanic and his two sons. In the burial ground at Kirkhope, a bronze statue of a lifeboat crewman commemorates the men who died. A museum dedicated to the history of the Longhope Lifeboat Station is housed in the old lifeboat slipway overlooking Aith Hope and is well worth a visit.

Before I left Hoy and as an antidote to tales of war and loss at sea, I made my way to Melsetter House, which lies on the southern tip of the island, back across the Ayre causeway from Longhope.

Melsetter House is an extraordinary building – a monument to an ideal and the dream of a better way of life. The original house dates from 1738, it was transformed by the wealth of the English industrialist Thomas Middlemore whose wife Theodosia Mackay was a disciple of William Morris and his Arts and Crafts movement. When they bought Melsetter in 1898, they commissioned the famous architect William Lethaby to transform the old place into a house that expressed their social philosophy – one that valued traditional skills and crafts and espoused any form of egalitarianism. Today, the house is one of the finest examples of an Arts and Crafts house in Scotland. It also seems to have found favour with the daughter of the man whose ideas inspired it. May Morris – daughter of the revered William Morris himself – visited in the early years of the 20th century and was suitably impressed. She described Melsetter as:

> A sort of fairy palace on the edge of the northern sea, a wonderful place, remotely and romantically situated, with its tapestries and its silken hangings and its carpets; for all its fineness and dignity it was a place full of homeliness and the spirit of welcome, a very loveable place. And surely that is the test of an architect's genius; he built for home life as well as dignity.

FLOTTA

Flotta is a small hook-shaped island measuring about five kilometres by four kilometres. The name comes from the Old Norse *flott-øy*, meaning 'flat island'. As the name suggests, there are no hills on Flotta, which is a grassy, agricultural island, rising to a modest 58 metres. The resident population is down to about 60 these days. However, during the day, the number increases dramatically with the arrival of workers at the huge oil terminal, which was built in the 1970s to bring the oil ashore from the North Sea.

To get to Flotta, I met up with tour guide Kinlay Francis – a real giant of a man. Together, we took the ferry from Houton on Mainland, Orkney, and crossed the glassy calm of Scapa Flow. There was no mistaking our destination, which could be seen

Kinlay Francis, my tour guide to Flotta, in front of one of the many abandoned military structures on the island.

for miles around by the brilliant orange gas flare that burns day and night above the vast oil terminal on the island.

Leaning on the rail in the morning sunshine, Kinlay confessed that he had once been in finance in Edinburgh but had given it all up to run a tour-guide company. He'd moved to Orkney when his parents returned to the islands.

'I have absolutely no regrets,' he told me. 'I love it here.'

Having set up a successful business, Kinlay became something of an expert on the wartime history of Orkney. As we approached the northern shores of Flotta, he pointed towards a buoy. 'Some-

Wartime ruins on Flotta.

where near here, one of the worst maritime tragedies to afflict the Royal Navy happened during the First World War. The battleship HMS *Vanguard* exploded one night in July 1917 with the loss of over 800 men on board,' he said.

'Was a German U-boat responsible?' I wanted to know.

'Apparently it was a dreadful accident. An investigation in the 1970s confirmed the cause as a spontaneous explosion of faulty cordite in the

munitions on board. It must have been a massive explosion. Every ounce of cordite went up almost at once. Only three men survived – although one of them died later from his injuries. The wreck of the *Vanguard* is now a protected war grave.'

I shuddered momentarily as the ferry slipped past the site of the tragedy. HMS *Vanguard* and the bones of the men who'd served aboard were very close, lying in just 35 metres of water.

The ferry dropped us close to the oil terminal,

which covers 395 acres of the island and employs over 300 workers. Heading round the coast to Stanger Head, Kinlay told me about a time when Flotta experienced an influx of even greater numbers of people.

'Stanger Head was pivotal in the First World War, especially because it guarded the southern approaches to Scapa Flow. Back then, 20,000 personnel maintained the fleet based in Scapa Flow – effectively doubling the population of Orkney.'

Down on the shore, Kinlay showed me evidence of how important Flotta was to the war effort. King George V visited the island in 1915. To commemorate the occasion, a large stone was inscribed and set above a specially prepared royal landing stage, where Kinlay pointed out the still-legible and unforgettable words – 'King's Hard'. What a way to salute a monarch, I thought.

As we walked towards the coast, we passed the ruins of many military structures – watchtowers, gun emplacements, ammunition magazines and the foundations of old barracks. Royal Marines were stationed on the headland of Stanger Head. Many wrote home about the terrible accommo-dation in their leaky huts.

'It must have been pretty grim for a lot of the men,' said Kinlay. 'It was cold, dark and bleak in winter. There was absolutely nothing here before they came so entertainment was all home-grown. To keep up morale, sporting events were organised – including a boxing match in 1917. Ten thousand men surrounded the arena on Flotta. Amazing. Almost like a rock concert.'

Flotta eventually boasted its own cinema and there were visits from a range of popular enter-tainers of the day to help improve morale. Flotta became the place to go for some relaxation although, at first, there was just a canteen selling tea and biscuits – perhaps not exactly what a thirsty young sailor had in mind. By all accounts, the locals also did a lot to make their new guests feel welcome, from cooking hearty meals to darning their socks, and many homesick recruits wrote home testifying to the kind-heartedness of the Flotta folk.

The defences on Flotta proved effective on two occasions during the First World War when German U-boats were detected and sunk while attempting to enter Scapa Flow. Then, 25 years later, during the Second World War, preparations had to be made for attack from both the sea and the air. A key component of the defences that were constructed is the massive concrete structure that still stands overlooking the sea on Stanger Head. I followed Kinlay through a warren of old passageways, down some concrete steps and into a cavernous space with an opening providing views to South Ronaldsay, which was just a couple of kilometres across the sound.

'This is one of several coastal defence battery gun emplacements that guard the southern entrance to Scapa Flow,' said Kinlay. 'A twin six-pounder gun would have been mounted below us and would have swivelled around to find its target – rather like the big guns on a battleship – providing a fast rate of fire against moving targets up to five kilometres away. To back up Stanger Head, there were batteries on the opposite shore on South Ronaldsay.' Kinlay pointed out the towers of the other distant gun emplacements.

'It wouldn't have been good to get caught in the crossfire,' I reasoned, imagining what it would have been like if the other batteries had opened up on the same target lying between them.

Walking away from the gun emplacement, we

With Isobel at the community centre. The mural showing the traditional way of life is seen behind us.

passed yet more concrete ruins. The entire head-land was scattered with the remains of war, demonstrating how busy and strategically impor-tant it had once been.

After the war, much of the defensive infras-tructure was demolished and removed. Flotta and its community then returned to the peaceful occu-pation of crofting. The main settlement on the island is called Whome, which boasts a shop and an old petrol pump – ironic, I thought, for a place where so much oil is pumped every day at the Flotta terminal. In the shop, which looked like a cross between a wild-west trading post and an Aladdin's cave, I met David Sinclair sitting behind his counter – just as he had done as a boy. David was born on Flotta and considers himself to be a true 'Flotterian'. At 81 years old, he had seen a lot of changes. After the war, he witnessed the impact of North Sea oil on the island which, in the 1970s, was deemed to be the perfect site for a terminal where crude oil could be piped ashore, stored and

then transferred to oil tankers for export. David showed me some photographs that chronicled the changes he had witnessed.

'During the construction period, we had 1,000 men living on the island in specially built camps. They brought a lot of money and they had their own bars and entertainments which meant that Flotta was on the celebrity circuit again – just as it had been during the war. We had some class acts, believe me! The likes of Box Car Willie and Kenny Ball and his Jazz Men. Those were the boom years!'

Across the road in the community centre, I met up with two local women, Isobel and Phyllis, who were preparing food for some guests staying at the community bed and breakfast in a former council house. Isobel was keen to show me a local art project. A colourful mural depicted the tradi-tional way of life on Flotta – haymaking, sheep-shearing, ploughing, boatbuilding, spinning and blacksmithing. It was quite a scene and very differ-ent from today's way of life. Isobel told me how sad it was to see the island nowadays. The popu-lation was aging rapidly, she said. The council had sold off many houses to private owners. She also felt there was an unspoken policy of deliberately not letting council housing stock to young fami-lies. That would force a reluctant council to reopen the island school. But without the provision of education, it's very hard for Flotta to attract the young folk it needed to sustain the community.

'I've got children the right age,' I volunteered, cheerily.

'How many have you got?'

'Five.'

'Really? With you working away from home so much too. I suppose you must have been a fast worker – or maybe you just had good neighbours!'

Abandoned crofts on Stroma.

STROMA

Stroma is a small island lying in the wild waters of the Pentland Firth between Orkney and the coast of Caithness. The name derives from the Old Norse *straumr-øy*, which means 'island in the [tidal] stream'. It measures about 3.5 kilometres from north to south and is just over 3.5 kilometres east to west. The highest point is Cairn Hill, which rises to 53 metres above the sea. A chambered burial cairn close to the lighthouse at the north end of the island provides evidence of human settlement going back to Neolithic times. The remains of what is thought to be an Iron Age fort can be found above the western cliffs. From the 8th century onwards, the Vikings were the domi-nant cultural force on Stroma, which makes an appearance in the *Orkneyinga Saga*. Dating from this Norse period are the ruins of a castle perched on the summit of a sea stack near Mell Head at the southern end of the island. Called Castle Mestag, it was once connected to the cliffs of Stroma by a bridge – or possibly by a natural arch

that collapsed a long time ago. The most curious geographical feature of Stroma is The Gloup – from the Old Norse *glup*, 'a hollow or ravine'. This is a gigantic and terrifying water-filled hole–in-the-ground that is located above the cliffs towards the north-west. It was formed when the roof of a massive sea cave collapsed, opening the interior to the sky. A 151-metre-long subterranean passage – the remaining roofed-part of the sea cave – connects The Gloup to the sea, allowing the tide to fill it twice a day. According to local legend, there is another cave called the Malt Barn at the bottom of The Gloup. Accessible only at low tide, this is where islanders evaded detection by Customs and Excise men, distilling illicit whisky for export to Orkney and Caithness.

I was intrigued by Stroma from the very first moment I saw it – on board the Orkney ferry, sail-ing from Gills Bay in Caithness to St Margaret's Hope. From a distance, the island seemed to be well populated and I could see a great number of crofts scattered about the fertile-looking lands of

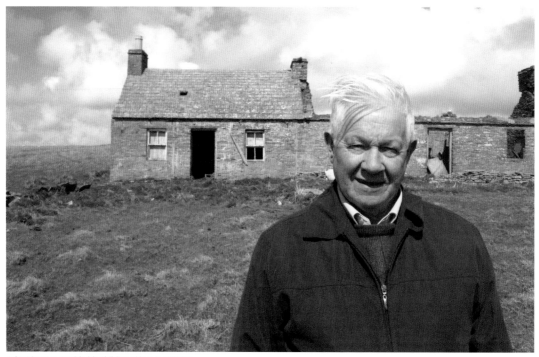

John Manson outside his childhood home, Stroma.

the east coast especially. I could also clearly make out a church in the middle of the island. But when I looked at the houses through my binoculars, I was shocked to discover that they were all abandoned and the church a gaunt ruin. What a waste, I thought. And why, I wondered, had the people left a place which, from a distance at least, looked as if it had supported a thriving community? I learned later that Stroma had been abandoned as recently as 1962. Today, its dozens of empty homes serve as a reminder that, in the modern world, despite all the sophisticated technology we have at our disposal, the business of keeping people on islands, which have been populated for thousands of years, isn't easy.

A couple of years later, I returned to the north and contacted a Stroma man called John Manson

from Caithness. Up until the age of 18, he had actually lived on Stroma and he continued to maintain a connection with the place. We arranged to travel to the island together and met at Gills Bay, where we boarded the boat to take us across. Our skipper Willie Sinclair, whose family had also lived on the island, now owns Stroma and grazes his sheep there.

John was very excited to be returning to his childhood home and stood on deck, rolling with the swell as we headed out into the choppy waters of the Pentland Firth. Over the centuries, this treacherous stretch of water has acted as a defensive moat, helping to keep Orkney and the islands of the north distinct from the rest of Scotland. The firth is full of tidal rips, whirlpools and standing waves, among them the notorious Swelkie,

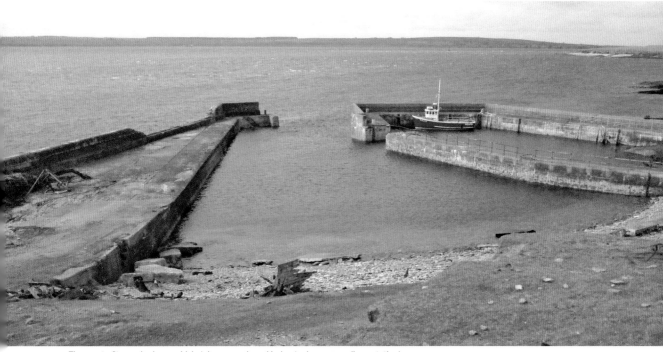

The empty Stroma harbour, which John remembered being 'as busy as a railway station'.

which lies off the north end of the island. In the language of the Vikings, *swelkie* means 'swallower'. According to the legends of the Norsemen, the whirlpool at its centre is caused by a sea witch grinding salt in her underwater mill to keep the ocean briny. Another tidal rip, which flecks the firth white with churning water is known as 'the Merry Men of Mey' – a tidal race that flows at over 30 kilometres an hour, making it one of the fastest tidal streams on the planet. Given their force and ferocity, it's not surprising that the 17th-century traveller Martin Martin took little comfort from the advice he was offered when warned about the Wells of Swinna, another formidable tidal race:

> If any boat be forced into these wells by the violence of the tide, the boat-men cast a barrel or an oar into the wells; and while it is swallowing it up, the sea continues calm, and gives the boat an opportunity to pass over.

As our boat bounced around like the proverbial cork, John told me how the men of Stroma had once made a living from this deadly stretch of water which, in the last 200 years, has claimed over 60 ships. 'Island folk were very knowledgeable of these waters and the dangers of the tidal races. They had to be. They couldn't live out here otherwise,' he said and then told me how they had fished the tidal streams, using long lines to catch cod and ling. 'They always said the cod caught in the Pentland Firth were the biggest and the best anywhere in Scotland.'

The sea and local knowledge also provided another source of income. John spoke about the tradition of the Stroma men to act as unofficial pilots. They would compete with each other to be the first to reach a ship sailing through the Pentland Firth. The winner then claimed the right to pilot the vessel through the treacherous tidal races. John told me that one man who had safely navigated a sailing ship through the Merry Men wasn't put ashore until Liverpool. He had to spend all the money he'd earned as a pilot on a ticket home.

We landed at the deserted harbour on Stroma, a place that John recalled being 'as busy as a railway station' when he was a boy. The harbour was built in 1956 after islanders petitioned Caithness Council for better and safer facilities. Ironically, instead of making life easier and stemming the exodus to the mainland, the new harbour did the opposite. It actually made it easier for people to leave. The population had reached a peak in 1901 when a census recorded 375 souls living on Stroma. But the 20th century took a heavy toll. Men left in the two world wars and life became increasingly difficult for those who chose to remain. During the months of winter, the island was often cut off for weeks at a time. In January and February 1937, no one could get to the island for three weeks. Storms demolished houses and washed boats up to 90 metres inland. Food was running out and the population was weakened by an outbreak of influenza. Help eventually arrived when two boats were able to land with much-needed supplies and a doctor to attend to the sick.

As we walked up to the first of the houses we could see on the skyline ahead of us, John began to reminisce about his early life on the island. There were over 80 folk living in two communities then – Uppertown around the harbour and Nethertown towards the north. The church was at the centre of the island. There was a shop, a post office and a school where his aunt taught 14 pupils. They used to put on a popular Christmas show with amateur dramatics every year.

'They were my happy days – my halcyon days – and it was a very close-knit community. The young looked after the old,' John said as we walked past an area of previously cultivated land.

Stroma used to be famous for the fertility of its soils, which produced an abundance of crops, including barley, and was described by a 19th-century visitor as looking like a garden. At that time, all the cultivation on the island was done with spades, a technique that was considered to be more efficient than ploughing. This allowed the islanders to produce just about everything they needed, including cheese, which was described as 'excellent' by the 18th-century writer and English spy Daniel Defoe.

'We were self-sufficient,' said John gazing across the old fields. 'Everyone kept chickens for eggs and meat. Every house had a cow for milk and cheese and a pig for fattening up. We salted fish caught in the summer to eat over winter. We hardly needed a shop at all. But then we watched the run-down of the island. The whole place was dying and it was sad to see folk moving to the mainland.'

Eventually, we arrived at the house where John had been brought up. He had lived there until the bitter end – his was the very last family to leave in 1963. The old place was now a sad and dilapidated sight. Nature was taking over. Seabirds were nesting on the gable end and sheep had used the best room as a shelter. We went inside to the but end of the old home – the kitchen-cum-living-

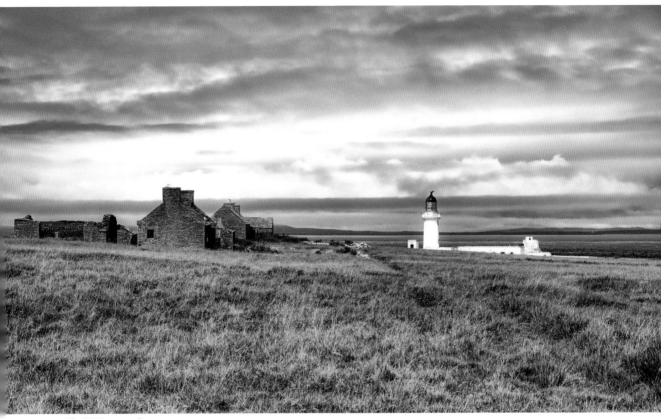

The lighthouse on Stroma.

room where the family had once eaten and where John's parents had slept. Their old box bed still stood against the wall. 'John was probably conceived there,' I thought. The kitchen table lay on its side beneath the window. I could see from John's eyes that he was looking at the room through the prism of memory, unchanged by the passing years.

'We'd gather in here of an evening, eat, sit and yarn – and maybe listen to the radio. I loved the top 20 hits on Radio Luxembourg. That was when Elvis and Cliff Richard were on the go and finding their feet on the hit parade.'

Standing ankle deep in sheep poo and other debris, it was hard to imagine the contrasting scene that memory had conjured for John – his 18-year-old self huddled over a valve radio, an oil lamp hissing on the table, the wind howling around the family home and the room filled with the metallic twangs and bluesy rhythms of Memphis.

'There's a lot of family memories in this room,' John said, wistfully. 'I've got six grandchildren and I bring them here and they take a great interest in the island and the old ways. It keeps the history going and the stories alive. If you don't pass it on, it will be lost to future generations.'

I left John at his old home and spent an hour

War memorial, Stroma.

exploring by myself. Many of the deserted crofts were still furnished. Iron bedsteads with burst mattresses stood in empty rooms. A picture hung at a sloping angle on a peeling wall. An overturned wooden chair lay in a deep drift of sheep litter. Continuing along the road and past the empty homes I came to the old church. No longer a place of worship, it seemed to be a place to store farm equipment. Across the fields I could see Willie Sinclair and another man rounding up lambs in the spring sunshine. Beside the church, I photographed an iconic old telephone box, its red paint peeling. A short distance away stood the war memorial, where someone had placed a wreath of poppies. Who, I wondered, had remembered the fallen from this forgotten island?

Below me in the sunshine was the Pentland Firth, speckled white by its tidal races and whirlpools. Stroma might be an island of ghosts yet it has the potential to be repopulated. Ironically, the swirling tides that once cut people off could, one day, attract them in the future. The wild, turbulent waters around Stroma are amongst the most powerful in the world, making this 'island in the stream' a prime location for the generation of tidal power – a development that, if it happens, might well plug this abandoned little island into the 21st century in a big way.

FURTHER READING

Barnett, Ratcliffe T. *The Road to Rannoch and the Summer Isles*, Robert Grant, 1924

Black's Picturesque Guide to Scotland, Adam and Charles Black, 1886

Charlton, Edward (ed. William Charlton) *Travels in Shetland 1832–52*, Shetland Times, 2008

Cleeves, Ann *Shetland Islands* series, Pan, 2019

Cleeves, Ann *Ann Cleeves' Shetland*, Pan Macmillan, 2015

Crawford, Barbara E. and Beverly Ballin Smith *The Biggings, Papa Stour, Shetland: The History and Archaeology of a Royal Norwegian Farm*, Society of Antiquaries of Scotland, 1999

Duthie, Jean *Out of the Farlans*, AuthorHouse, 2010

Ellis, Richard *Men and Whales*, The Lyons Press, 1999

Haswell-Smith, Hamish *The Scottish Islands*, Canongate, 2015

Howarth, David *The Shetland Bus*, Shetland Times, new edn 1998

Iversen, Kaare *Shetland Bus Man*, Shetland Times, new edn 2003

Lynn, Paul A. *Scottish Lighthouse Pioneers: Travels with the Stevensons in Orkney and Shetland*, Whittles Publishing, 2017

MacDiarmid, Hugh *On a Raised Beach: a poem*, Harris Press, 1967

MacDiarmid, Hugh 'With the Herring Fishers', poem

MacKay Brown, George *An Orkney Tapestry*, Quartet Books, 1973

MacKay Brown, George *Magnus* Polygon, 2008

MacKay Brown, George *Collected Poems* John Murray, 2006

McGoogan, Ken *Fatal Passage*, Penguin Books, 2002

Manson, T. M. Y. *Drifting Alone to Norway*, Nelson Smith Printing Services, 1996

Martin, Martin *A Description of the Western Isles of Scotland, circa 1695*, Birlinn, 2018

Mitchell, Ian *Isles of the North*, Birlinn, 2012

Muir, Edwin *An Autobiography*, Canongate, 2008

Muir, Edwin *Collected Poems of Edwin Muir*, Faber and Faber, 2003

Muir, Tom *Orkney Folk Tales*, History Press, 2014

Murray, Donald S. *The Italian Chapel Orkney,* Birlinn, 2017

Njals Saga (tr. Robert Cook), Penguin Classics, 2001

The Orkneyinga Saga (tr. Hermann Palsson and Paul Edwards), Penguin Classics, 1981

Powell, Michael *200,000 Feet on Foula*, Faber and Faber, 1938

Scott, Walter *The Pirate*, Hurst, Robinson and Co., 1821

Scott, Walter *The Voyage of the Pharos*, Chartered Institute of Library and Information Professionals Scotland, 1999

Sjoholm, Barbara *The Pirate Queen*, Seal Press, 2004

Smith, Hance D. *Shetland Life and Trade, 1550–1914*, John Donald, 1984

Statistical Account of Orkney 1795–1798

Thomson, William P.L. *The New History of Orkney*, Birlinn, 2019

Tulloch, Lawrence *Shetland Folk Tales*, The History Press, 2014

van der Vat, Dan *The Grand Scuttle: The Sinking of the German Fleet at Scapa Flow*, Birlinn, 2016

Weaver, H. J. *Nightmare at Scapa Flow*, Birlinn, 2017

Wickham-Jones, Caroline *Orkney: A Historical Guide*, Birlinn, 2019

INDEX

Agricola 155
Aikerness 136
Airtask Group 46
Ålesund 11–12
Alexander III 41, 201
Arthur, Alice 97
Auskerry 172–3, 184
Ayre causeway 214

Backarass Farm 195
Balfour, David 156–7
Balfour, Gilbert and Margaret 192–4
Balfour of Trenabie, William 195
Balfour village on Shapinsay 155–7
Baltasound 115, 116–17
Bard Head 42
Barony Mill, Birsay 143–6
Bay of Deepdale 32
Beamish, Sally 134
Bell, Joanne and Les 109–10
Ben, Jo 129
Benelip islands 94
Bergen
 Bergen to Shetland yacht race,
 Hawthorne and. 4–5, 19–21,
 39
 German occupation of 25
Birsay, Earl's Palace at 142–3
Birsay Heritage Trust 143–6
Black's Guide to Scotland (1886)
 Orkney entries 125–6, 133,
 139–40, 151, 210
 Shetland entries 14, 18, 24, 27,
 32, 39, 42, 45, 46, 74, 125–6
Bluemull Sound 106, 112
Bobby's Bus Shelter on Unst 117–18
Boddam 12, 13–14
Bonnington, Chris 212
Bordastubble standing stone 113
Bothwell, Adam 192–3
Bothwell, James Hepburn, Earl of
 194

Bound Skerry 96
Braer oil tanker 8
Brand, Rev. John 143
Brei Holm 93
Bressay 39–43
 Ham (and East, North, South
 and West Ham) on 41, 68,
 72–3, 76
 'Orkneyman's Cave' on 42–3
 Sound of 20, 35, 39, 40–41
 St Mary's burial gronnd on
 40–41
Bressay Stone 39–40
Brodgar, Ring of 140–42
Brogan, Simon 173
Bronze Age habitation, evidence of
 10–11, 16, 24, 178, 190, 192, 210
Brough Lodge 109
Brow, Loch of 15
Brown, George Mackay 126, 131, 149,
 210
Bruce, Laurence 114, 116
Bruce family on Whalsay 60–61
Bruray 93
Bruyn, Captain Claes Jansen 40–41
Burravoe, Iron Age broch at 100
Burravoe harbour 100
Burroughston Broch 157–8

Calder's Geo Cave 52
Catalina flying boat, memorial to
 lost crew on Yell 100–101
Charisma (deep-sea trawler) 64–5
Charlton, Edward 13–14, 37, 38, 47,
 49, 51–2, 55–6, 68, 73–5, 88, 91
Childe, Professor V. Gordon 142
Chiocchetti, Domenico 208
Churchill, Winston S. 205–6
Churchill Barriers 201, 206, 208
Cleeves, Anne 21–2
Clickimin, Broch and Loch of 22–3
Collafirth 54, 55–6

Columbine cutter 11
Colvadale 116
Corrigall, Betty 212–13
Coutts, Douglas 16
Cra'as Nest Museum 211
Cradle Holm 37
Croft House Museum at
 Dunrossness 12–14
Cromwell, Oliver 18
Cubbie Roo (Kolbein Hruga) 161–2
Cullingsburgh and Voe of 39
Cullivoe 106
Cunningsburgh 14

Da Kame 71, 73–4
Da Noup 71
Da Sneck o' Da Smaallie and Da
 Lum on Foula 79
Da Sneug 71, 76
Da Wart 41
Da Wastside 29, 32
Dale of Walls 32
Datside 47
Deerness 129–31
Defoe, Daniell 222
Derry Voe 58
Diodorus Siculus 125
Dore Holm 51
Drifting Alone to Norway
 (Manson, T.M.Y.) 12
Drummond, Ed 212
Duncanson, William 42
Dunrossness, Parish Church of 8
Dwarfie Hamars (and Stane) 210,
 212

East Voe 24
Easter Rova Head lighthouse 39
Eday 158, 184, 190–92
 Carrick House on 190
Edward I of England 201–2
Edward the Confessor 41

Edward VIII 83
Effstigarth 99
Egil's Saga 34
Egilsay 133, 158–63, 165
 death of St Magnus on 160–61
Queen Elizabeth 97, 188
Eric II of Norway 201
Erikson, Leif 106
Eshaness, Skerry of 51–2
Espen (*Hawthorne* crew) 19–20
Eunson, Magnus 131
Eynhallow 164

Fair Isle 41, 80–86, 187
 knitwear from 82–3
 Luftwaffe attack on 83–4
Fara 213
Fea, Partrick 168
Ferguson, Craig 126
Fethaland, fishing station at 56–7
Fetlar 99, 102, 107–12
 'Finnigert Dyke' ('Funzie Girt')
 on 108
 'Garden of Shetland' 107–8,
 108–9
Filla (Skerries ferry) 94, 96–7
Firths Voe 55
Fitful Head 12
Flotta 27–8, 213, 214–18
Fogla Skerry 87
Fort Charlotte 18, 19
Foula 24, 29, 32, 37, 41, 56, 71–80
 hardship on, history of 77
Foyn, Svend 55
Francis, Kinlay 214–17
Franklin, Sir John 133
Fresson, Captain Ted 184

Gairsay 165
Gear, Andy 102–4
George III 18
George V 217
Gibb, Robert 163
The Gloup and Gloup Holm on Yell
 99, 106–7
The Gloup on Stroma 219
Good Shepherd (Fair Isle ferry) 81, 82
Gow, John 9, 151, 190

El Gran Grifón (ship of Spanish
 Armada) 81–2
The Great Climb (BBC TV) 212
Grimister 99, 105
Grimsetter and Loch of 42
Grukalty 155
Grunay 93–4, 96
Grurwick 42
Gruting 28
Grutness 11
Gumpick 130
Gunnister Voe (and 'Gunnister
 Man') 47–9, 52
Gurness, Broch of 136
Gutcher 99, 105–6, 112

Haaf Gruney 114
Håkon, King of Norway 41, 90
Hamars Ness 110
Hamnafield 71, 76
Hamnavoe 99, 149, 152
Hannigarth 115
Hanseatic League 63–4
King Harald Hairhair 113, 114
Harald Hardrada, King of Norway
 41
Harcus, Sam 195–6, 199
King Harold Godwinson 41
Haroldswick Boat Haven 117–19
Harray, Loch of 139, 140
Hawthorne (yacht in Bergen–
 Lerwick race) 4–5, 19, 20, 21, 39
Henry, Oliver 31
Hermaness 120
Highland Park whisky 131
Hildasay 28
Hill, Oliver 212
Hillswick 49–52, 55
Hilltop Bar in Mid Yell 102
Hitler, Adolf 25, 205
HMS *Royal Oak*, loss of 205
Hoggs of Hoy 27–8
Holbrook, Mark 188
Holm Ness 37–9
Home, Sir Everard 172
Housa Voe 89–90, 92
Housay 93
Howarth, David 27

Hoy 208–14
Hudson's Bay Company 133, 150–51
Hughson, Rhoda 117

Iron Age habitation, evidence of 16,
 24, 100, 130, 136, 178, 190, 199
Irvine, Jacqueline 62
Irvine, Robbie 63–4
Isbister, Eric 80
Isbister, township of 56–8
Italian Chapel on Lamb Holm 208
Iversen, Karen and Kaare 26–7

James III 4, 71
James V 24, 134
Jamieson, Robert and Jamieson
 family 32
Jamison, James (Columbine skipper)
 11
Jarlshof 8–11

Karmøy 114
Queen Katherine Asmunnder 72
Kirkabister Ness 39
Kirkwall 41, 126, 131–6
 Bishop's Palace in 134, 136
 St Magnus Cathedral 131–3, 134,
 160
 St Magnus Festival 133–4
Kirkwall Airport 126
Kirstan Hol 87
Kitchener of Khartoum, Lord
 Herbert 147–8
Knap of Howar 197
Knowe o' Aikerness 136
Knox, John 193
Knutsson, Alv 71

Ladies Drive 46
Lamb Holm 206–8
Lander, John St Helier 83
Langa 28
Larsen, Leif 27
Laurie, John 72
Lax Firth 46
Laxo 58, 59
Leira (ferry) 39
Leonard, James 165

Lerwick 11, 17–24
 Bain's Beach 21
 lodberries in 21–2
 New Harbour Cafe in 19
 old Foula boathouse 22
 origins of 18
 pubs and bars of old town in
 19–20
 Shetland Museum in 49
 smuggling in 18th century in 21
 Up Helly Aa in 20–21, 47
Lethaby, William 214
Linga 28
Loganair 184
Longhope Lifeboat Station 214
Lumbister 99
Lunga 28
Lyness 213
Lyra Skerry 87

MacDairmid, Hugh (Christopher
 Murray Grieve) and Valda 62–3
MacLeod, Dave 212
Maeshowe 136–9, 141
Magnus Barelegs 160
Magnusson, Håkon 90
Maiden Stack 89–90, 93
Malcolm Canmore 201
Manson, Andrea 49–51
Manson, John 220–24
Manson, T.M.Y. 12
Marcus, Maggie 199
Margaret, Countess of Atholl 34
Margaret of Denmark 4, 71
Margaret of Norway 201–2
Martin, Martin 210, 221
Mary, Fr Michael 173–6
Mary, Queen of Scots 194
Mavis Grind 45–9, 104
Maxwell Davies, Sir Peter 133–4
McAllister, Colin 183–4
Melby, Hill of 32
Melsetter House 214
Mid Yell Voe (Reydarfjordur) 102
Middlemore, Thomas 214
Mill Burn 42
Millie, Bessie 151
Moclett pier 199

Monks' Stone 89
Moor Fea 211
Mor Stein monolith 157
Morris, William 214
Morten (Hawthorne crew) 19–20
Mouat, Betty 11–12
Mousa
 Broch of 32–5
 Mousa Sound and 14–15
Mu Ness 32
Muckle Flugga 56, 119–21
Muckle Hell 41–2
Muckle Roe 67–9
Muir, Billy 187–8
Muir, Edwin 129, 162–3
Muness Castle 114–15, 116
Murray, Douglas 56–8
Murton, Nicky 140, 148, 155
Murton (wave-washed rocks at)
 130

Napier Commission 165
Napoleonic Wars 42–3
National Museum of Scotland 16,
 40
National Nature Reserve at Noss 35
National Trust for Scotland 85, 86
Natural History Society in
 Edinburgh 171–2
Neolithic habitation, evidence of
 28, 142, 163–4, 179, 190, 197,
 203–4, 219
Ness of Burgi 11
Ness of Ork 157–8
The Nev 28
New Islanders 188
Nicholson, Arthur 109
Noltland, Links of (and Noltland
 Castle) 192–4, 195
North Havra 27–8
North of Scotland, Orkney &
 Shetland Steam Navigation
 Company 49
North Roe 56
North Ronaldsay 80, 183–8
Northern Lighthouse Board 8, 187
Northmavine 45, 47, 49, 52–3
Noss (and Sound of) 35–9, 42–3

Odin Stone 139–40
King Olaf Tryggvason 89
Old Haa on Yell 100
Old Man of Hoy 125, 208–9, 211–12
Old Statistical Account of Scotland
 (1795) 170
Olna Firth 46, 54
Oosta 121
Orkney 125–6
 Norse heritage 125
 Viking Earls of 131–2, 134, 147,
 148–9, 160, 173, 199
 Yole Association 151–3
Orkneyinga Saga 34, 134, 139, 160,
 161, 173, 197, 199, 219
Out Skerries ('Da Skerries') 41, 93–7
Oxna 28

Papa 28
Papa Sound 197
Papa Stour 32, 87–93
 legends of 88–9
Papa Stour Sword Dance 68–9
Papa Stronsay 173–6
Papa Westray 184, 197–9
Papil on West Burra 89
Parnaby, David 85
Peace, Don 168
Peace, John 171
Pentland Firth 125, 208, 211, 220, 221,
 224
Peterson, Danny 68–9, 91
Peterson, George 68, 91–2
Prince Philip 97
Pictish art and culture 3, 40, 146–7
Pierhead Restaurant and Bar at Voe
 46–7
Pierowall 192, 194–5, 196
The Pirate Queen (Sjoholm, B.) 194–5
The Pirate (Scott, W.) 9, 12, 151, 210
Pliny the Elder 125
Pontoppidanm, Erik 171–2
Poulson, Joan 61–2
Powell, Michael 72
Prien, Kapitänleutnant Günther
 205
Probert, Teresa 173
Puckey, Jane 92

Pytheas 125

Quendale Bay 8, 12
Quisling, Vidkun 25
Quoyness 179

Rackwick 210-11
Rae, Dr John 133
Rendall, Robert 136
Richardson, Ian 152-3
Roe Sound 68
Ronas Hill 45, 53, 55-6
Ronas Voe 53-6
 whaling stations at 54-5
Rousay 158, 161, 163-7
 Midhowe Cairn on 163-4
 Westness House on 163
Royal Victoria shipwreck 7-8
RSPB 8, 85

Sand Vatn 42
Sanday 176-83, 184
 razor clams, 'spooting' for 181-3
Sandness and Hill of 32
Sands o' Wright 203
Sandsayre 14
Sandwick (Shetland) 115, 116
Sandwick (Orkney) 142
Saxa Vord 119-20
Scalloway 17, 24-8, 115
Scalloway Castle 24
Scalloway Museum 25
Scapa Bay 131
Scapa Flow 148, 201, 205, 217
 scuttling of German battle
 fleet in 213
Scatness 11, 12
Scatsta 57-8
Scord of Sound 27
Scota Bess 169
Scott, Sir Walter 8-9, 12, 69, 151, 210
'Shanty Yell Men' 102-4
Shapinsay 155-8
Shetland 3-5
 Museum in Lerwick 89
 ponies ('Shelties') 29-31
 self-build homes in 23-4
 sheep 31

Shetland Islands Council 29, 58
 Whaling Company 54
 Wool Week 31
Shetland (BBC TV series) 21-2
'Shetland Bus' 25-7
The Shetland Bus (Howarth, D.) 27
Shurgie Scord 56
Sigurd, Jarl of Orkney 89
Simison, Freda and Kathleen 203-4
Simison, Ronnie 204
Simunsdatter, Ragnhild 90
Sinclair, David 218
Sinclair, Willie 220
Sjoholm, Barbara 195
Skara Brae 142
The Skult 28
Slater, Cissie (Mrs Kaare Iversen)
 27
Smith Douglas 9-10
Sodom 62-3
Solinus 129
Sound 99
South Ronaldsay 201-6
South Walls ('Sooth Waas') 214
Special Operations Executive 25
Special Protection Areas 15
Special Scientific Interest, Sites of
 15
Spiggie, Loch of 15
St John's Head 212
St Kilda 71, 72, 111
St Magnus Bay and Hotel 45, 49-51
St Margaret's Hope 201-3
St Nicholas's Church ('Orphir
 Round Kirk') 148-9, 160
St Ninian's Isle 15-17
St Tredwell, Loch of 197-9
Stanger Head 217
Statistical Account of Orkney (1795-98)
 184
Stenness 51
 Standing Stones of 139-40, 141
Stevenson, Alan 187
Stevenson, John 171, 173
Stevenson, Robert Louis 7, 96
Stevensons (David, Robert and
 Thomas) 7, 8-9, 96
Stewart, John, Earl of Carrick 190

Stewart Earls of Orkney 24, 114-15,
 134-6, 143
Stig (*Hawthorne* crew) 19-20
Stone age habitation, evidence of 8,
 125, 138, 163, 192, 204, 210
Stone o' Setter 190
Stoura Clett stack 42
Stout, Jimmy 84
Stroma 219-24
Stromness 134, 149-53
Stroms Heelor 81
Stronsay 158, 167-72, 173, 184, 190
 Mermaid's Chair on 168-9
 Mill Bay on 168-9
 Vat of Kirbister on 170-71
 Well o' Kildinguie on 169-71
Stronsay Beast 171-2
Sule Skerry 184
Sullom Voe 45, 47, 55, 58
Sumburgh Airport 11, 14
Sumburgh Head 3, 7-17
 lighthouse at 7-8
Sunburgh Voe 8
Swale, Jonathan 52
Swarta Skerry 28
Symbister harbour 60, 62

Tacitus 155
Tangwick Haa and Museum 51-2, 54
Tankerness 130, 131
Taylor, Frances 29-30
Temple of Stanydale 28
The Edge of the World (Michael
 Powell film) 72
Thomason, Brydon 111-12
Thompson, Stewart 82-3
Thordale Stud 29-30
Thorvald the Viking 90
Thurz, Karl Heinz 84
Tingaholm, Shetland's *ting*
 (assembly) at 27
Tingwall 46, 75, 76, 81
 Norse parliament at 24-5, 27
Tolkien, J.R.R. 11
Tomb of the Eagles 203-4
Tomkinson, Jo 29-31
Tounafield 71
Towrie, Jim and Rona 179-81

Traill-Burroughs, Lt-General F. W.
('Little General') 163, 164, 165
Tresta 27
Tresta Sands 110
Tulloch, Jimmy John 64–6
Tulloch, Willie 151–2
Twatt, Orkney 142
Twatt, Shetland 28

Ulsta ('Flukes Hole') 99–100
Unst 56, 99, 102, 112–21
Belmont ferry pier on 114
Viking longhouse sites on
113–14, 115–16
Ura Firth 49
Uyea Breck standing stone 113, 114
Uyea island 114

Vaila 29
Veantrow Bay 157
Queen Victoria 12

Vidlin 59, 94
Viking Unst Project 118–19
Virda Field 87
Voe (Olna Firth) 46–7
Von Reuter, Rear Admiral Ludwig
213

Wadbister 42
Walls ('Waas') 29–31, 75
Warness, Fall of 192
Wasso, Broch of 178
Waterston, George 85
Waulkmill Bay 148
Webb, Emma 181–3
Weisdale Voe 27
Wenham, Sheena 137–9
West Mainland 136–49
Wester Voe 11
Westerman, Adolf 49
Westray 184, 190, 192–7
folklore of, superstition in 194–5

Gentlemen's Cave on 195, 196
Noup Head on 192, 195–6
'Westray Wife' ('Orkney Venus')
192
Whale Firth 104, 105
Whalsay 58–67
Whilkie Stack 106
White Wife ('Da Wooden Wife')
at Queyon 101–2
Whitehill on Stronsay 168
Whome 218
Wills, Jonathan 35–7, 42–3
World Wildlife Fund 8
Wyre 158, 165

Yell 56, 99–107
burial grounds on 110
Windhouse (haunted house)
on 104–5

Zetland 7

PICTURE CREDITS

Title page: Dave Donaldson/Alamy Stock Photo
p. vi: Paul Murton
pp. 1–2 David Chapman/Alamy Stock Photo
p. 5 robertharding/Alamy Stock Photo
p. 6 Vincent Lowe/Alamy Stock Photo
p. 9 Arterra Picture Library/Alamy Stock Photo
p. 10 Paul Murton
p. 13 Arterra Picture Library/Alamy Stock Photo
p. 15 Paul Murton
p. 17 Cindy Hopkins/Alamy Stock Photo
p. 20 Paul Murton
p. 21 Paul Murton
p. 22 Paul Murton
p. 23 Donna Carpenter/Shutterstock
p. 26 ALAN OLIVER/Alamy Stock
p. 28 Kay Roxby/Alamy Stock Photo
p. 30 Paul Murton
p. 31 Patricia Marshall
p. 33 Loop Images Ltd/Alamy Stock Photo
p. 36 Kevin Schater/Alamy Stock Photo
p. 38 Paul Murton
p. 40 Paul Murton
p. 44 Danita Delimont/Alamy Stock Photo
p. 48 Marcin Kadziolka/Shutterstock
p. 50 Arterra Picture Library/Alamy Stock Photo
p. 52 Hannu Mononen/Alamy Stock Photo
p. 53 Paul Murton
p. 57 Danita Delimont/Alamy Stock Photo
p. 59 Paul Murton
p. 60 Paul Murton
p. 64 Paul Murton
p. 65 Paul Murton
pp. 66–7 David Pecheux/Shutterstock
p. 69 Paul Murton
p. 70 Dave Donaldson/Alamy Stock Photo
p. 73 Paul Murton
p. 75 Paul Murton
p. 76 Paul Murton
p. 78 Paul Murton
p. 79 Paul Murton
p. 81 Paul Murton
p. 83 Paul Murton

p. 84 hallam creations/Shutterstock
p. 85 Adam Seward/Alamy Stock Photo
pp. 86–7 Nature Picture Library/Alamy Stock Photo
p. 88 Paul Murton
p. 89 Scottish Viewpoint/Alamy Stock Photo
p. 91 Paul Murton
p. 92 Paul Murton
p. 93 Paul Murton
p. 94 Paul Murton
p. 95 (both) Paul Murton
p. 96 Paul Murton
p. 98 Paul Murton
p. 100 Paul Murton
p. 101 Paul Murton
p. 103 M&J Bloomfield/Alamy Stock Photo
p. 104 Paul Murton
p. 107 Paul Murton
p. 108 Paul Murton
p. 109 Anterra Picture Library/Alamy Stock Photo
p. 110 Paul Murton
p. 111 Paul Murton
p. 112 David Tipling Photo Library/Alamy Stock Photo
p. 113 (both) Paul Murton
p. 115 Stephen Finn/Alamy Stock Photo
p. 116 Sheila Halsall/Alamy Stock Photo
p. 118 Paul Murton
p. 119 Arterra Picture Library/Alamy Stock Photo
p. 120 (upper) Paul Murton; (lower)
 Giedriius/Shutterstock
p. 121 Paul Murton
pp. 122–3 orkneypics/Alamy Stock Photo
p. 127 Hemis/Alamy Stock Photo
p. 128 Simon Grosset/Shutterstock
p. 130 David HAJES Hajek/Shutterstock
p. 131 imageBROKER/Alamy Stock Photo
p. 135 (upper) Urban Images/Alamy Stock Photo; (lower)
 Jule_Berlin/Shutterstock
p. 137 David Lyons/Alamy Stock Photo
p. 138 Celtic Collection – Homer Styles/Alamy Stock
 Photo
p. 141 Paul Murton
p. 143 Steve Speller/Alamy Stock Photo

pp. 144–5 mark ferguson/Alamy Stock Photo
p. 146 Scottish Viewpoint/Alamy Stock Photo
p. 147 Paul Murton
p. 149 Paul Murton
p. 150 COLOMBO NICOLO/Shuttertsock
p. 152 Paul Murton
p. 153 Paul Murton
p. 154 Les Gibbon/Alamy Stock Photo
p. 156 Paul Murton
p. 157 Iain Sarjeant/Alamy Stock Photo
p. 158 Paul Murton
p. 159 Paul Murton
p. 162 Paul Murton
p. 165 Ashley Cooper pics/Alamy Stock Photo
p. 166 Vincent Lowe/Alamy Stock Photo
p. 167 Premium Stock Photography GmbH/
 Alamy Stock Photo
p. 170 Paul Murton
p. 171 Paul Murton
p. 174 Paul Murton
p. 175 Paul Murton
p. 177 Ian Cowe/Alamy Stock Photo
p. 178 Paul Murton
p. 180 Paul Murton
p. 181 Paul Murton
p. 182 (both) Paul Murton

p. 185 Philip Mugridge/Alamy Stock Photo
p. 186 Doug Houghton/Alamy Stock Photo
p. 187 Paul Murton
p. 189 Paul Glendell/Alamy Stock Photo
p. 190 Heritage Image Partnership Ltd/
 Alamy Stock Photo
p. 191 orkneypics/Alamy Stock Photo
p. 193 markferguson2/Alamy Stock Photo
p. 196 ChrisNoe/Shutterstock
p. 198 Hewmis/Alamy Stock Photo
p. 200 Realimage/Alamy Stock Photo
p. 202 allan wright/Alamy Stock Photo
p. 203 Paul Murton
p. 204 Paul Murton
p. 206 duchy/Shutterstock
p. 207 (both) Tom Muir
p. 209 Richard Clarkson/Alamy Stock Photo
p. 211 Danita Delmont/Alamy Stock Photo
p. 215 Paul Murton
p. 216 Paul Murton
p. 218 Paul Murton
P. 219 Paul Murton
p. 220 Paul Murton
p. 221 Paul Murton
p. 223 George Maciver/Shutterstock
p. 224 Paul Murton